ALFRED
ELMORE.

AUGUSTUS
EGG, R.A.

WILLIAM
ETTY, R.A.

THOMAS
FAED, R.A.

SIR LUKE
FILDES, R.A.

MYLES BIRKET
FOSTER.

WILLIAM POWELL
FRITH, R.A.

JOHN
ATKINSON GRIMSHAW

JAMES DUFFIELD
HARDING.

JOHN FREDERICK
HERRING, SENIOR.

FRANK
HOLL, R.A.

EDWARD
HUGHES.

WILLIAM HENRY
HUNT

WILLIAM
HOLMAN HUNT O.M.

SIR EDWIN
LANDSEER, R.A.

759.2 M111v3 FV
MAAS
VICTORIAN PAINTERS
 49.95

Victorian Painters

VICTORIAN PAINTERS

JEREMY MAAS

ABBEVILLE PRESS • PUBLISHERS • NEW YORK

First Abbcville Press edition, 1984

ISBN 0-89659-503-X

© 1969, 1978 Jeremy Maas

Printed in Great Britain

CONTENTS

NOTE ON THE CAPTIONS. All pictures are painted in oils and on canvas unless otherwise stated.

FOREWORD

This survey is an attempt to describe the character and trace the development of Victorian painting. In it I have tried to pursue a hazardous course between the general and the particular, and, in doing so, the dangers inherent in both have become increasingly apparent to me. Inevitably I came to see the truth of Carlyle's belief that 'history is the essence of innumerable biographies'.

I have tried to make this account as comprehensive as possible, but I must ask the indulgence of those who own paintings of merit by artists who are not mentioned in it. In assessing the merits of the painters who are mentioned, I have attempted a synthesis of current attitudes, seasoned with personal bias and with the estimates of the painter's contemporaries. I have quoted no less freely from critics like Thackeray and Henry James than from Ruskin, and have consulted a large number of sources to the authors of which I am greatly indebted. The bibliography also includes a few works enjoying scholarly approval, which I have only briefly, perhaps too briefly, consulted.

I am indebted to numerous galleries and museums, to their trustees, corporate bodies and private owners, whose generosity and patience have been tried to the limit. I hope that they will accept the acknowledgments in the captions to the plates as sufficient token of my gratitude. I would also like to thank all those, too many to enumerate, who have in any way contributed to this book: they include many people whose daily business has been interrupted by endless enquiries over the telephone.

I would particularly like to thank Mr Henry Ford for his constant vigilance over the typescript as it appeared and for his many helpful suggestions. My thanks are also due to Mr Nicholas Barker and Mr John Dent, and I am also very grateful to Miss Sarah Alexander who typed the script. Mr Dennis Farr of the Department of Fine Art at Glasgow University, Mr Edward Malins, Mr Eric Adams, Mr David Fuller of Arthur Ackermann & Son Ltd, Mr E. H. H. Archibald of the National Maritime Museum, Dr Jerrold N. Moore of Yale University, Mr Peyton Skipwith of the Fine Art Society Ltd, and Mr John Rickett of Sotheby & Co., all read sections of the book in typescript and made valuable suggestions, for which I offer my most sincere thanks. I would also like to record my gratitude to Mr Dudley Snelgrove of The Paul Mellon Foundation, Mrs Pat Hodgson, Mr Richard Ormond of the National Portrait Gallery, Mr John Hayes of the London Museum, Mr J. L. Howgego of the Guildhall Art Gallery, Mr Wilfrid Blunt, the Curator of The Watts Gallery, Mrs Virginia Surtees, Mr Robin de Beaumont, Miss Mary Lutyens, Mrs Charlotte Frank (whose patience must have been sorely tried during the two sessions of photography on *The Plains of Heaven*), Mr Charles Handley-Read, Mrs Anna Allen of the Tate Gallery, Miss Sophia Ryde, Miss Diana Holman Hunt, Mr Sidney Hutchison, Librarian of the Royal Academy, and his assistant, Miss Constance-Anne Parker, Mr James S. Dearden of The Ruskin Galleries at Bembridge School, Mr Edmund Brudenell, Mr Charles Jerdein, Mr N. R. Omell, Lady Rosalie Mander, Miss Mary Bennett of the Walker Art Gallery, Liverpool and Mr Alec Cotman of the Castle Museum, Norwich.

Mr Guy Phillips kindly allowed me to read and quote from his unpublished monograph on his grandfather, Atkinson Grimshaw, and Westminster City Libraries have given me permission to quote from a letter in their possession. My special thanks are due to Messrs Rodney Todd-White, who photographed many of the pictures, including the majority of the colour plates. Lastly, I would like to thank those friends and relations who have had to tolerate (I would like to think that this is the right word) my unaccustomed desire for seclusion during the writing of this book; particularly my wife, whose help and forbearance I have greatly appreciated.

J. S. M.

I

SURVEY

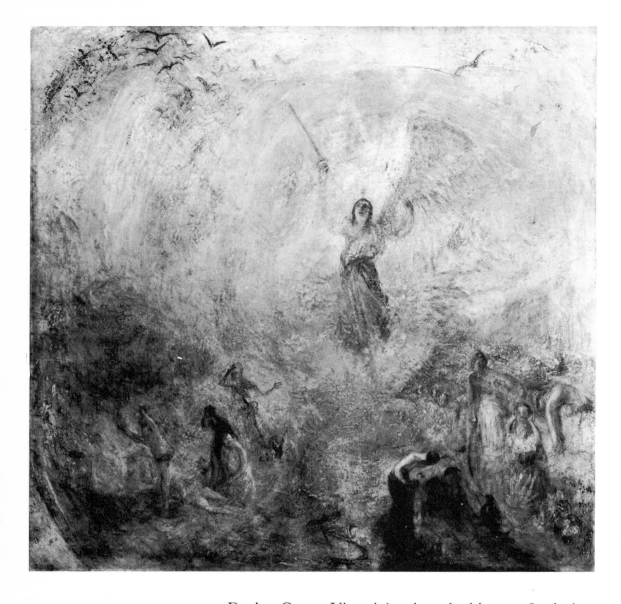

komer, Alma-Tadema, Tissot, Whistler and Sargent. Writing in 1895 the French critic Robert de la Sizeranne summed it up: 'There is an English school of painting. This is what first strikes a visitor to any International Exhibition of the Fine Arts, in whatever country it might be held.' In the galleries of other countries, he said, 'you might imagine yourself to be still in France', so dependent were their artists on Paris. Not so the English: 'Their painters seem to ignore the Continent. If they have heard of it they have borrowed nothing from it. They have thrown no bridge across the Channel.' (However, he later took into account the aspirations of the New English Art Club, formed in 1885, whose members painted 'a mass of mediocre pictures ... more or less like our own'.) He continues: 'Fifty years ago, when we were adopting a broader manner wherein drawing played a smaller part and details were sacrificed to the whole, our neighbours were reversing the process, and entering on the minutiae of the Primitives. At the present time, when the open-air school has lighted up most of our canvases, they remain boldly faithful to their startling colouring, to their laboured and complicated modelling. The assaults of realism and of impressionism are broken on their aestheticism, like the squadrons of Ney

JOSEPH MALLORD WILLIAM TURNER, R.A. *The Angel Standing in the Sun.* 30½ × 30½ inches. Tate Gallery, London.

Exhibited at the Royal Academy in 1846, with a quotation from the Book of Revelation XIX, 17-18. 'And I saw an angel standing in the sun . . .'

During Queen Victoria's reign, the history of painting in England becomes an infinitely complex skein of extraordinary richness and variety. There were contradictions, movements and counter-movements; endless and labyrinthine courses were explored, false gods pursued; and a quantity of abysmal work was produced. It was nevertheless a great age for English painting. If the period produced few artists of world stature, this was balanced by the cumulative effect of the rich diversity of high talent, occasionally bordering on greatness. If the parts are sometimes leaden, the whole is a bright golden glow. This is nowhere more obvious than in the case of the Pre-Raphaelites: seen in isolation, the work of individual artists often appears maladroit, but grouped together their brilliance is manifest, and their very failings are forgiven in the way that one condones the eccentricities of genius.

For all its weaknesses, the English School had a prevailing strength and vigour during the Victorian age that was internationally recognised, and it even served as a refuge to many foreign artists, like Her-

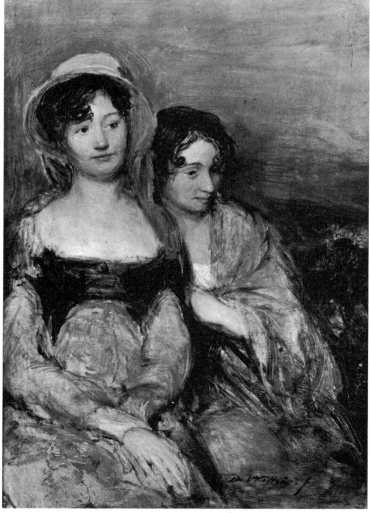

SIR DAVID WILKIE, R.A. *Two Young Girls.* 8¼ × 5¾ inches. Panel. Signed. Sir Robert and Lady Mayer.

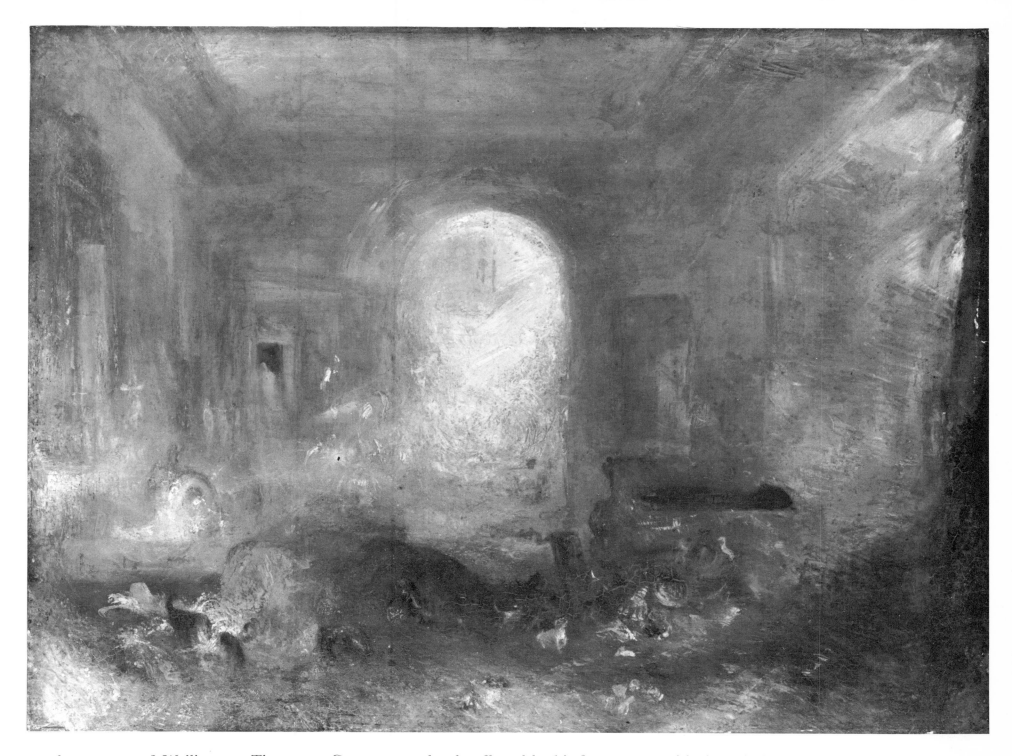

on the squares of Wellington. There are German, Hungarian, Belgian, Spanish, Scandinavian painters, but there is an English School of painting.' This is an apt summary of the individuality of English art in the Victorian age, although, at the time that it was written, internationalism was encroaching on indigenous attitudes.

If English painting of the period tended to be insular, it was sometimes surprisingly anticipatory. Notable visiting French artists, like Géricault, were often aware of this. He greatly admired the animal paintings of Ward and Landseer; and Delacroix was deeply affected by his first contact with the paintings of Constable. Turner anticipated both Impressionism and Abstract Expressionism, and French artists—like Renoir and Monet in 1870—were discovering his work for the first time. William Henry Hunt, by hatching broken colours together, anticipated the pointillism of the neo-impressionists; similarly G. F. Watts discovered in mid-century the technique of placing strokes of broken colour together. The quest for pictorial exactitude led the Pre-Raphaelites to paint outdoors directly from nature, thus anticipating the *pleinairisme* of the French impressionists by well over a decade.

JOSEPH MALLORD WILLIAM TURNER, R.A. *Interior at Petworth.* $35\frac{3}{4} \times 47\frac{3}{4}$ inches. Tate Gallery, London.

Painted in about 1837. Turner had been a regular visitor to Petworth for about seven years prior to painting this picture. His friend and patron Lord Egremont died in November 1837.

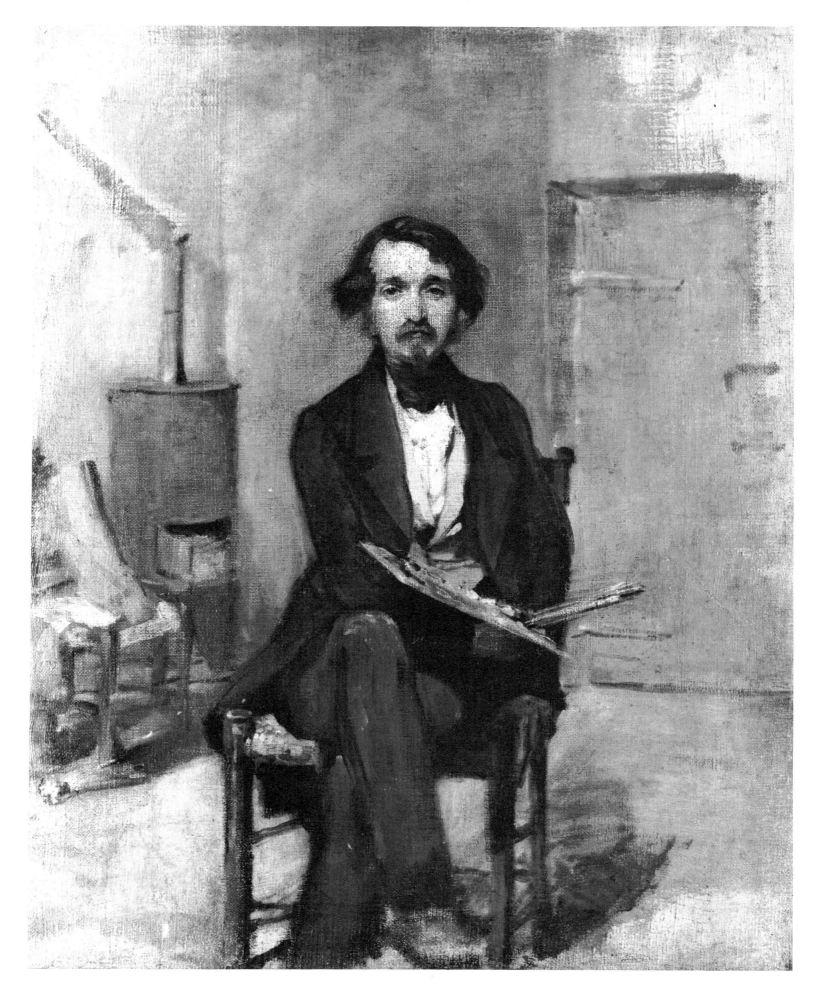

ALFRED STEVENS. *An Artist in his Studio.* $23\frac{5}{8} \times 18\frac{3}{4}$ inches. Tate Gallery, London.

Probably painted in 1840-2 at Rome towards the end of the artist's stay in Italy.

Whilst there is a vast amount of documentation covering Victorian painting, areas of doubt still remain and biographical uncertainties abound. Artists known to have flourished appear to have left a meagre legacy of paintings; paintings of great quality by artists barely heard of are still surfacing after a long period of submersion. There are scores of painters whose fame rests on just one or two paintings, like W. S. Burton with *The Wounded Cavalier* and Henry Wallis with *The Death of Chatterton*, although the former exhibited at the Royal Academy and British Institution for thirty years and the latter painted a number of pictures in the 'fifties, earning the approbation of Ruskin. In a survey of this period one is often compelled 'to row out', as Lytton Strachey said, 'over the great ocean of material and lower down into it, here and there, a little bucket, which will bring up to the light of day some characteristic specimen, from those far depths, to be examined with a careful curiosity'.

But in the ebb and flow of contradictory currents, certain beacons light the way. The existence of the Royal Academy, founded in 1768, acted simultaneously as a focus for the artistic endeavours of British painters and as an institution for certain movements to react against. Either way it constituted an energising force. The first self-conscious art movement occurred during the first year of the Queen's reign, but never actually went anywhere. It was really a kind of rebellion against authority, the authority vested in the Royal Academy. This was the formation of 'The Clique': a group of painters comprising Augustus Egg, Richard Dadd, John Phillip, H. N. O'Neil and W. P. Frith. Their aim was to revitalize what to them was the stuffy traditionalism of the Royal Academy. They were all extremely young: it was essentially a revolt of youth against age, but it also amounted to a worthy effort to *paint* better. The individuals in the group had divergent aims, which reflected the diversity of British painting as a whole. Dadd wanted to paint works of imagination; Egg, illustrations of celebrated literary works; Phillip, incidents in the lives of the famous; O'Neil, pictures which appealed to the feelings and Frith, scenes of ordinary life. Later in the century another group formed itself, with P. H. Calderon at its head, into the 'St. John's Wood Clique', which included W. F. Yeames, H. S. Marks, G. A. Storey and others, but this second group seemed to lack any clearly defined directional impulse.

Then there was the growth of private patronage, personified by men like Robert Vernon, who had accumulated a fortune by supplying horses to the army during the Napoleonic Wars. By commissioning directly from the artist he managed to assemble a magnificent collection, which is now in the Tate Gallery; similarly John Sheepshanks, the scion of an

industrial Yorkshire family, formed a collection which is now at the Victoria and Albert Museum. The Queen and Prince Albert bought a number of contemporary

WILLIAM HUGGINS. *The Stoic.* 24 × 29 inches. Private collection, Great Britain.

Inscribed on the reverse: 'one who is free from passion unmoved by joy or grief indifferent to pain or pleasure'.

ALFRED STEVENS. *King Alfred and his Mother.* Panel. 13½ × 13½ inches. Tate Gallery, London. Painted in about 1848.

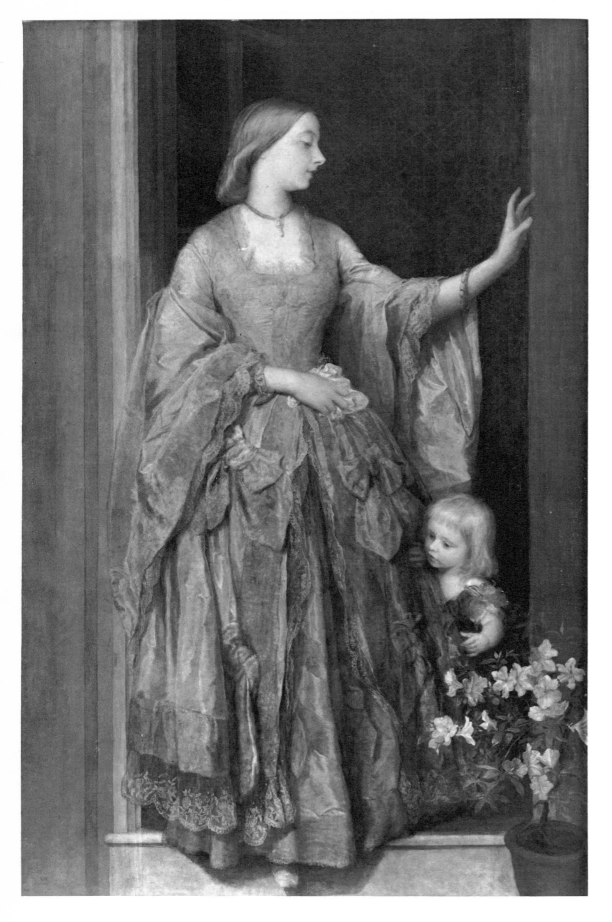

works, and did much in the way of patronage, including the granting of honours. By conferring knighthoods, baronetcies and one peerage (Leighton) on her painter subjects, the Queen raised the prestige of painting.

And never, before or since, had the prestige of English artists been so high. The letters of the period frequently refer to art and artists; and the earnings of painters, who dressed like gentlemen and often moved with ease on the hunting field or in the drawing-rooms of High Society, were correspondingly high, often through the sale of engraving rights. Millais, at the height of his fame, reputedly earned between £20,000 and £40,000 a year and is believed to have sold his *The North-West Passage* for 4,700 guineas. Frith was commissioned to record the Prince of Wales's wedding for a fee of 3,000 guineas, and reputedly collected another 5,000 guineas from the sale of the copyright to the dealer, Flatow. Holman Hunt, who was advised by Dickens on what to charge for his work, probably made the highest sum ever paid to a living British artist for an easel picture in selling the second replica of *The Light of the World* to Charles Booth for 12,000 guineas. Booth presented it to St. Paul's Cathedral, the resting place of Landseer, Turner, Leighton, Millais, Alma-Tadema, Poynter and Holman Hunt. Hunt left £163,000 with painting as his sole means of support since the age of sixteen, and with negligible help from studio assistants. At least three Victorian painters left over £200,000: they were Landseer, Linnell and John Gilbert, most of whose income was from illustration.

It was truly a prodigious age. It was the age of the polymathic artist: everyone seemed to be doing everything at once. 'It was a world', wrote G. K. Chesterton, 'in which painters were trying to be novelists, and novelists trying to be historians, and musicians doing the work of schoolmasters, and sculptors doing the work of curates'; and creative talent was dissipated in diversity. William Dyce was the archetypal *homo universalis*: science, music, church ritual, teaching and other pursuits fragmented his creative impulse. Leighton, Poynter, Stevens, Redgrave and W. B. Richmond, to name only a few, spread their energies over a wide field of activities, thus restricting their output of painting. Again and again one encounters an artist of promise whose talents were unseasonably employed on academic or other official duties.

State patronage was a mixed blessing. The status of art, particularly applied art, was enhanced by the two great International Exhibitions of 1851 and 1862. On the other hand the decoration of the rebuilt Houses of Parliament (1841–63) was a fiasco, although it had at least one beneficial result, in that it dealt the death blow to historical painting, a *genre* for which English painters were in every way unsuited; and the failure of Benjamin Robert Haydon, its arch-priest, to secure

GEORGE FREDERICK WATTS, O.M., R.A. *Lady Margaret Beaumont and her Daughter.* 76×45½ inches.

The Rt Hon. Viscount Allendale. Painted in 1862. Lady Margaret Beaumont (d. 1888) married the

1st Baron Allendale in 1856. Her daughter, Magaret Harriet, later became Lady Poltimore.

a prize contributed to his depression and eventual suicide in 1846, and ensured the total demise of historical painting as a force in English art.

The foundation of Morris and Company (1861), of the Art Workers Guild (1884) and the New English Art Club (1885), all of which had their roots in rebellion, are all milestones in the growth and development of artistic attitudes and public taste. The most vigorous seeds of rebellion were contained in what Henry James called 'the first fresh fruits of the Pre-Raphaelite efflorescence'. The forming of the Pre-Raphaelite Brotherhood in 1848, a revolutionary year throughout Europe, gave rise from the start to detonations which shook the very foundations of the artistic Establishment and echoed down the years to the death of the Queen in 1901, and even beyond.

Pre-Raphaelitism has been too often dismissed as a regrettable aberration in the English psyche, a brief period of madness, only redeemed by the tardy introduction of Impressionism by the New English Art Club. In fact, the influence of Pre-Raphaelitism, although its course is strewn with individual tragedies, was greatly beneficial. Apart from the qualified

SIR FRANK DICKSEE, P.R.A. *Harmony*. (detail) Arched top. 62 × 37 inches. Signed and dated 1877. Tate Gallery, London.
Exhibited at the Royal Academy in 1877. This picture achieved immense popularity at the time, and was bought by the Chantrey Bequest. At the Academy exhibition it was hung in the place of honour opposite Millais's *Yeoman of the Guard*.

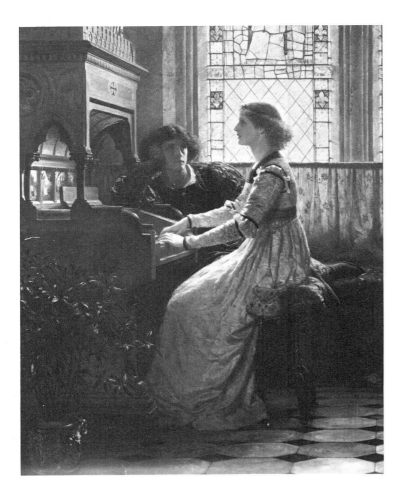

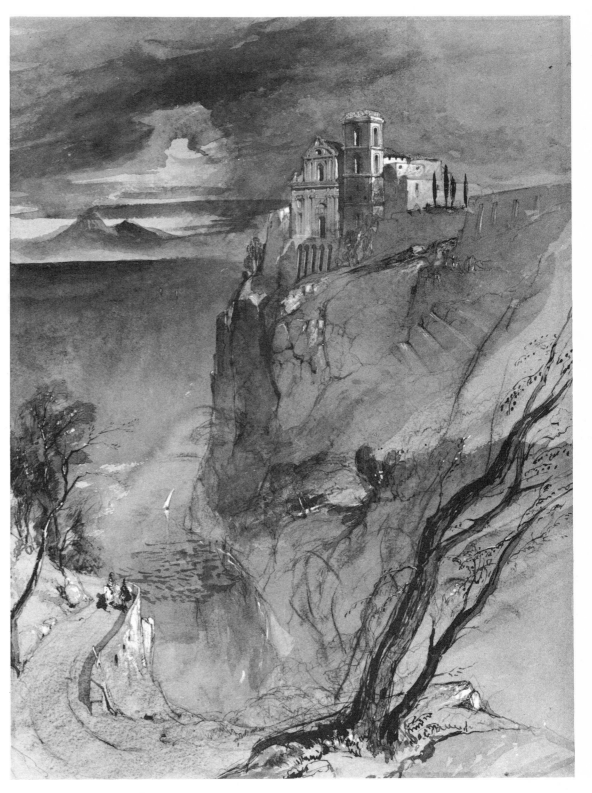

partisan, John Ruskin, many writers of the period, some not otherwise known for being sympathetic to the movement, admitted as much. P. G. Hamerton, writing in 1889, noted that Pre-Raphaelitism was 'a strong and beneficial reaction from indolent synthesis to laborious analysis, and from mental inactivity to new thought and emotion'. Another writer, G. H. Shepherd, echoed these sentiments when he wrote that 'The influence of the Pre-Raphaelite School upon the art of the last quarter of a century has been undoubtedly

JOHN RUSKIN. *Church and Vista on the Bay of Naples*. Water-colour. 15⅝ × 11¼ inches. Vassar College Art Gallery, Poughkeepsie.
Ruskin described the scene in his diary on 1st March 1841, 'I never saw a finer thing . . . a little chapel pitched half way up, with a bold arch of natural rock, and another of a ruined bridge; and the tower of a convent on the walls bright against the uppermost blue sky, formed a scene almost too theatrical to be quite right'.

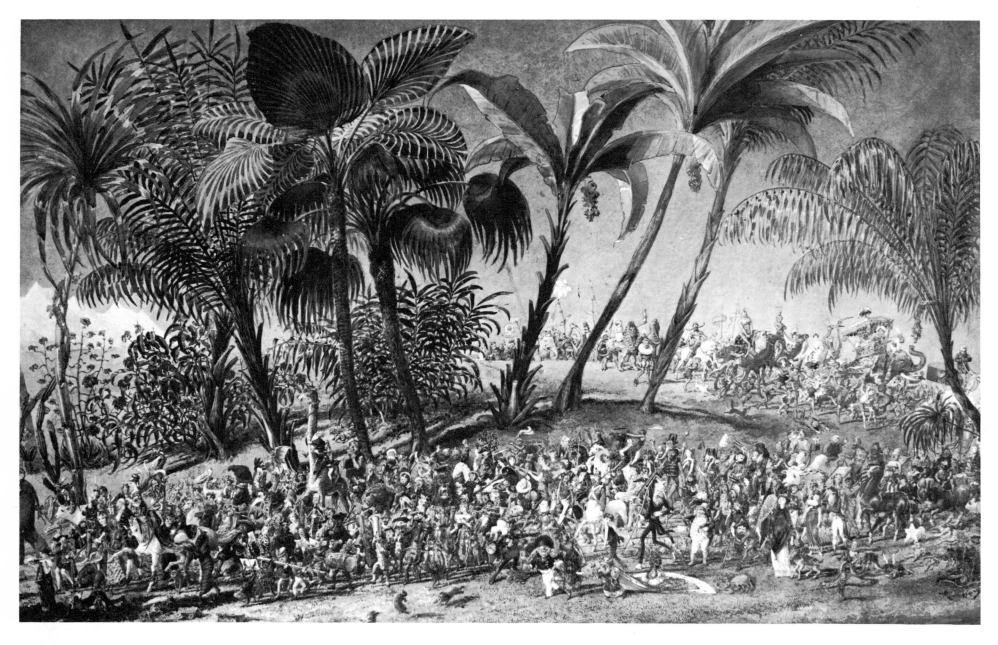

RICHARD DOYLE. *Prester John's Promenade*. Pen, ink and water-colour. $24\frac{1}{2} \times 38\frac{1}{4}$ inches. Mr James S. Schmidt.

beneficial. It has inculcated the direct study of Nature, paying little regard to conventional rules borrowed from the antique; and, although it has erred by undue contempt for principles of composition based upon centuries of experience, it has effected a reformation of great good'. Even the reliable Redgrave brothers, whose 'A Century of Painters' appeared in 1866, agreed that 'on the whole we feel that the future prospects of art will be improved rather than injured by the outbreak of what has been idly called the "new heresy"'.

The Pre-Raphaelites made artists *see* and paint what they saw with unprecedented skill; and they made a whole generation of designers and practitioners of the applied arts see anew and invest their work with an entirely new range of symbolism. As Walter Crane wrote in the 'Fortnightly Review' in December 1892, 'by their resolute and enthusiastic return to the direct symbolism, frank naturalism, and poetic or romantic

sentiment of mediaeval art, with the power of modern analysis superadded, and the more profound and intellectual study of both nature and art which the severity of their practice demanded, and last, but not least, their intense love of detail, turned the attention to other branches of design than painting'. Moreover, the works of Rossetti and, in particular, Burne-Jones, by virtue of their complete distinction from the naturalistic school, had a profound effect on the form-ative years of such twentieth century figures as Picasso and Kandinsky, just as they appealed to the French symbolists before the turn of the century.

As a result of his advocacy, the Pre-Raphaelite movement finally established the aesthetic despotism of the critic John Ruskin, whose generally beneficial but sometimes disastrous 'reign of terror' only ended with the calamitous collision with Whistler in a libel action nearly thirty years later. Ruskin's influence over the course of mid-Victorian painting was enormous. In

the 'fifties painters would doggedly paint according to his precepts: he had only to wonder why no-one ever painted apple-trees in blossom for the Academy walls a year later to be covered with orchards full of apple-trees in blossom. Ruskin also acted as a link between Pre-Raphaelitism and the applied arts. 'It is he', as Mr Denys Sutton has suggested, 'who provides a valid explanation of the love of "finish" which meant so much to the typical Victorian painter: he reminds us that this desire to produce a well turned out product was the counterpart to the solidity of English manufactured goods and furniture.' Ruskin's writings on the

Old Masters, architecture and the structure of Society, and his vindication of Turner, were of incalculable value to the formation of Victorian taste and *mores*.

The taste of the picture-buying public was an important element, influencing as it did the course of Victorian painting. William Makepeace Thackeray, an exuberant but very sensible art critic in the 'forties, was appalled at the state of public taste at the time. Writing in 'Fraser's Magazine' in 1840 he jocularly stated his intention of drawing up 'Proposals for the General Improvement of Public Taste', although this intention was not fulfilled. While he praised faintly, he

GEORGE FREDERICK WATTS, O.M., R.A. *Ariadne in Naxos*. 29½×37 inches. Guildhall Art Gallery, London.

Painted between 1867 and 1875 Watts considered that '*Ariadne* is perhaps the most complete picture I have painted'. There is an almost identical version at Liverpool, and three other versions which differ in details. *See p. 29.*

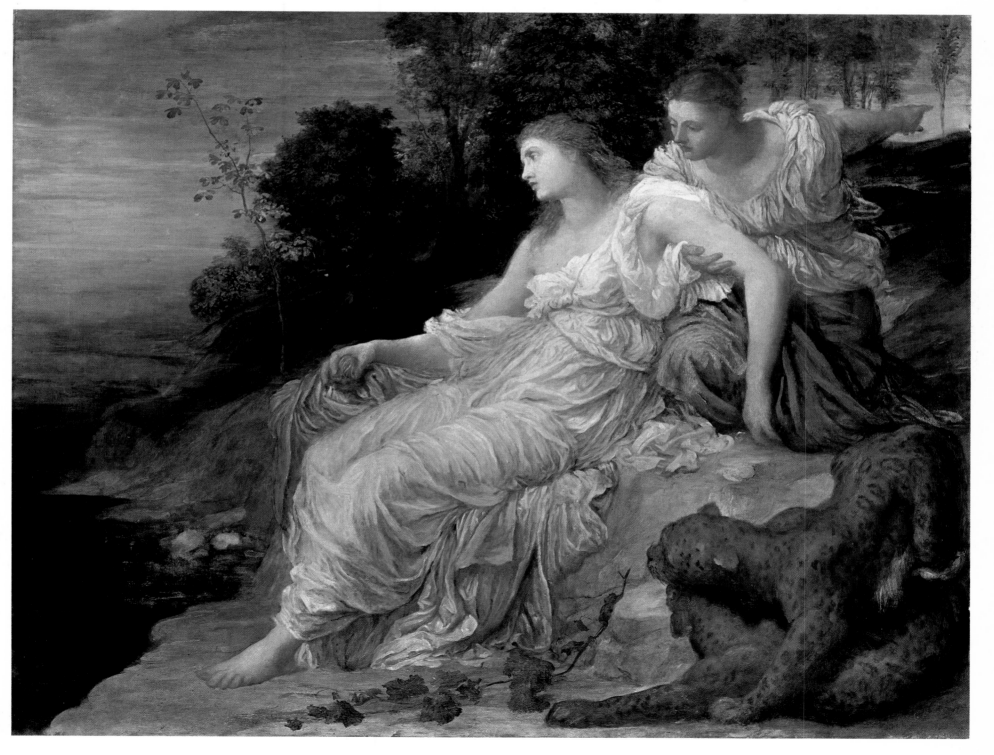

GEORGE FREDERICK WATTS, O.M., R.A. *The Sower of the Systems*. 26 × 21 inches. Watts Gallery, Compton.

Painted in 1902. Watts wrote: 'This subject was suggested by the reflection upon the ceiling from a night light. In this the painter's imagination saw the veiled figure, projected as it were, through space – the track marked by planets, suns and stars cast from hand and foot.' A larger and more developed version was exhibited at Newcastle in 1905.

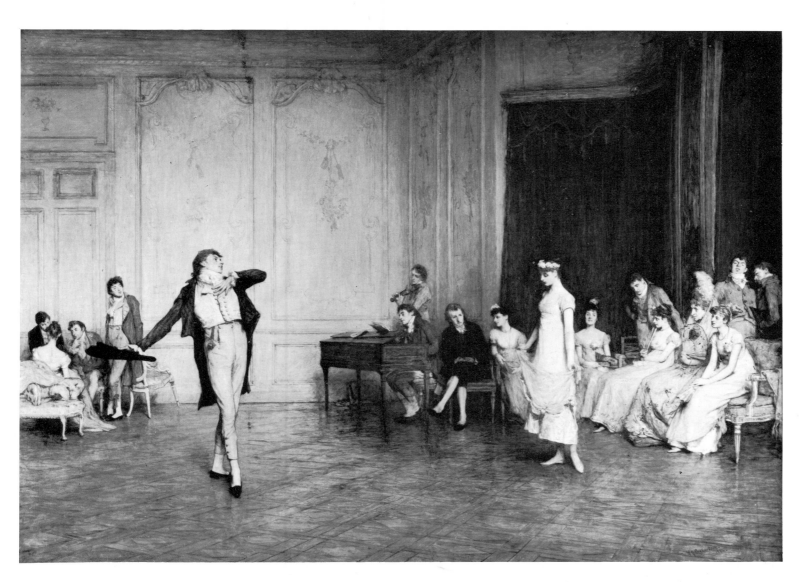

SIR WILLIAM QUILLER OR-CHARDSON, R.A. *Her First Dance.* 40×54½ inches. Signed and dated 1884. Tate Gallery, London.

The picture was bought by Sir Henry Tate in the year it was painted.

JOSEPH CRAWHALL. *Jackdaw.* Water-colour on linen. 11¼×18 inches. National Gallery of Victoria. Melbourne.

could never really conceal his mild contempt of the 'ogling beauties' or 'dangerous smiling Delilahs' so fondly painted by Chalon, and other artists of the 'Keepsake' school. And the endless array of pictures with themes from the 'Vicar of Wakefield' and 'Gil Blas' provoked his good-natured wrath. After declaring his refusal ever to mention these two works again, he is nevertheless obliged to comment on yet another *V–c–r of W–kef–ld* later in the review.

The fondness which Wilkie and some of his contemporaries displayed for the Dutch and Flemish anecdotal manner was still reflected in pictures of the period, but admiration for Teutonic paintings was becoming a new factor. The piety and purity of German painting mirrored the growing religious revival. In 1839 'The Art Union' could solemnly declare that the Germans 'are assuredly the great artists of Europe'. The avowed preference of the Prince Consort for Germanic art supported this new enthusiasm. Admiration for the pious and coldly linear paintings of the Nazarene School, a group of German expatriates headed by Peter Cornelius and Friedrich Overbeck, who lived in the early years of the century

at a deserted monastery in Italy, contributed to the formation of the Pre-Raphaelite Brotherhood. Not

until the late 'fifties and 'sixties was a more Italianate warmth injected into English painting by Rossetti. The neo-classical school, whose principal painters were Leighton, Poynter and Alma-Tadema, heralded the return to Greece and Rome in the early evening light of Victoria's reign. Albert Moore united classical principles with the new cult of Japanese art, which itself reflected an increasing interest in the exotic, culminating in the *fin-de-siècle* fantasies of Beardsley and Conder. Only in the 'eighties did Impressionism find its advocates. Among all these currents and cross-currents were numerous gifted artists who pursued solitary courses, like Etty, Dadd, Lear and Palmer: they enriched the main-stream, as tributaries feed a river. Even the spectre of historical painting still haunted the exhibitions of the early 'nineties, some thirty years after the first appearance of Whistlers' *Nocturnes*.

Meanwhile other influences were at work. It was a great age, above all in the 'sixties, for black and white illustration. At the same time art publishing contributed to public taste and art scholarship. Early magazines, like 'The Keepsake', with its engravings of blushing maidens, helped to establish a prototype of Victorian female beauty. 'The Art Journal', 'The Portfolio' and 'The Magazine of Art' were widely read. The invention of photography had serious implications for artists, and was to affect deeply the techniques of painting. The materials and methods of painting were changed dramatically in the 'fifties. The deleterious use of bitumen, or asphaltum, a tarry compound which never completely dried and was to cause the total ruination of many a picture, was superseded by the new colouring techniques of the Pre-Raphaelites. The mood of change was extended to attitudes towards the choice of media. Much of this was of accidental origin. The experiments of the Pre-Raphaelites, particularly Rossetti, who was always hesitant in his techniques, led to the narrowing of a distinction between oils, water-colours, chalks, body-colours and other media. All were employed, with scant distinction, to express equally valid pictorial statements. In their anticipation of twentieth century painting techniques, these earlier painters were demonstrably modern.

JOHN WILLIAM WATER-HOUSE, R.A. *St. Cecilia.* 48½ × 78½ inches. Maas Gallery, London.
Exhibited at the Royal Academy in 1895, with the quotation from Tennyson's 'The Palace of Art': 'In a clear walled city on the sea. Near gilded organ pipes—slept St. Cecily.' A reviewer in 'The Art Journal' wrote: 'in *St. Cecilia*, the important work which represents nearly two years unremitting toil and experiment, the aim is wholly decorative, the colour superb, and the painting swift and direct; that of a man who has reached his goal. The feeling is entirely mediaeval. ... The effect is decorative first, then somewhat ecclesiastic; entirely remote from realism and the world of our daily life'.

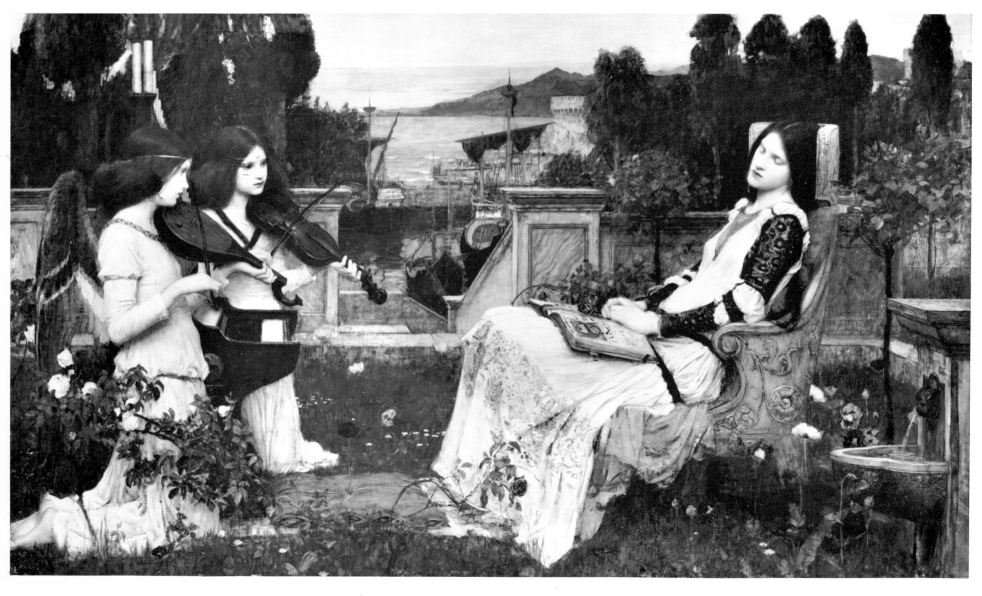

II

HISTORICAL PAINTERS

Writing in 'Fraser's Magazine' in 1838, Thackeray, with himself in the character of 'Michael Angelo Titmarsh', addresses his article to an imaginary French *Peintre d'histoire* called 'Monsieur Anatole Victor Isidor Hyacinthe Achille Hercule de Bric-abrac'. He takes the recipient of the letter on a tour of the pictures at the Royal Academy, which had been housed in a wing of the National Gallery since the year before. Underlying the deliberately facetious style there is a strong vein of common sense. While describing 'the greatest school of painting in the greatest country of the modern world', he invites 'my dear Isidor' to look 'at the first named in the catalogue, and thank your stars for being in such good company. Bless us and save us, what a power of knights is here!

> Sir William Beechey,
> Sir Martin Shee,
> Sir David Wilkie,
> Sir Augustus Callcott,
> Sir W. J. Newton,
> Sir Geoffrey Wyatville,
> Sir Francis Chantrey,
> Sir Richard Westmacott,
> Sir Michael Angelo Titmarsh.'

So much for royal recognition. Having ventured into fiction with the last name (it was a distinction he might well have claimed for his own fertile and talented draughtsmanship), Thackeray then proceeds to draw up a further list in a kind of order of merit.

> '1. Baron BRIGGS (At the very least, he is out and out the best portrait-painter of the set.)
> 2. DANIEL, PRINCE MACLISE (His Royal Highness's pictures place him very near the throne indeed.)
> 3. Edwin, Earl of Landseer.
> 4. The Lord Charles Landseer.
> 5. The Duke of Etty.
> 6. Archbishop Eastlake.
> 7. His Majesty KING MULREADY.'

Thackeray's hierarchical exercise, besides indicating his own preferences, reflected the tendency of Victorians to graduate the subject matter of painting. At the top of the list is the nebulous phrase 'High Art', that is, art which consisted of a lofty theme, unsullied by vulgar incidents: this would have included some of the higher flights of historical painting. Then came scenes from literature; landscape, portraiture and scenes from contemporary life were a long way down the list.

The painting of history had been invested with the prestige of two past Presidents of the Royal Academy, Sir Joshua Reynolds and Benjamin West, and was still considered the ultimate form of painting, just as the epic poem was considered to be the consummation of the perfections in all other forms of poetry. There is a long, dreary list of English artists, including the most

voluble of proselytes, Benjamin Robert Haydon (1786–1846), William Hilton and others, who sank almost without trace in the shifting sands of historical painting. With the discourses of Reynolds as an example, the fulminations of Haydon as a guide, and the exhortations of all who preached the gospel of High Art to encourage them, the intentions of historical painters almost invariably outran their execution. The practice of painting in dark colours, in imitation of what was considered to be the technique of the Old Masters, the persistent use of bitumen as an aid in this direction, and finally the disastrous misunderstanding of the techniques of fresco painting, have all since conspired, perhaps fortunately, to draw a heavy pall of obscurity over this school.

It is hardly surprising that historical painting, with its implications of sublimity and heroism, should have seized the imagination of painters in the first half of the nineteenth century. It was indeed an heroic age, and a romantic one: many of its painters had witnessed the rise and fall of Napoleon, after a series of awe-inspiring victories and defeats. It was the age of the great Romantic poets, the age of Beethoven and Berlioz, of Stendhal and Delacroix. Haydon recalled that in his youth he saw Nelson's funeral, and that 'his death affected me for days'. Indeed, it haunted him till the end of his life, and thirty-three years later he submitted designs for a monument to Nelson, which, characteristically, came to nothing. The survival of the Duke of Wellington, the victor of Waterloo, until 1852, was a monumental living reminder of greatness and heroism. Yet this was also an age addicted to vulgar spectacle. London's public had an insatiable appetite for panoramas, dioramas, fire-work displays and vast spectacles like the re-enactment of the Battle of Trafalgar on the Serpentine. Paintings in which the famous actors like Edmund Kean, his son Charles and William Macready, are posed flamboyantly, with their faces romantic in expression and even their leg muscles flexed defiantly, reflected the heroic attitudinising of historical painting. This kind of painting simultaneously embodied the expansionist spirit of England and a romantic reaction to the rigours of the Industrial Revolution.

The careers of practitioners in the Grand Manner were usually compounded of frustration, futility and subsequent neglect. They flitted about the fabric of Victorian artistic life, sometimes achieving momentary prominence, as in the competitions for the decoration of the new Palace of Westminster, and their works can be seen, flaking and peeling, on the darkening walls of provincial town halls. Edward Armitage (1817–1896) is remembered for his cumbersome allegory *Retribution* in the Leeds Town Hall. William Hilton (1786–1839), who was born in the same year as Haydon, exhausted himself painting pictures with titles like

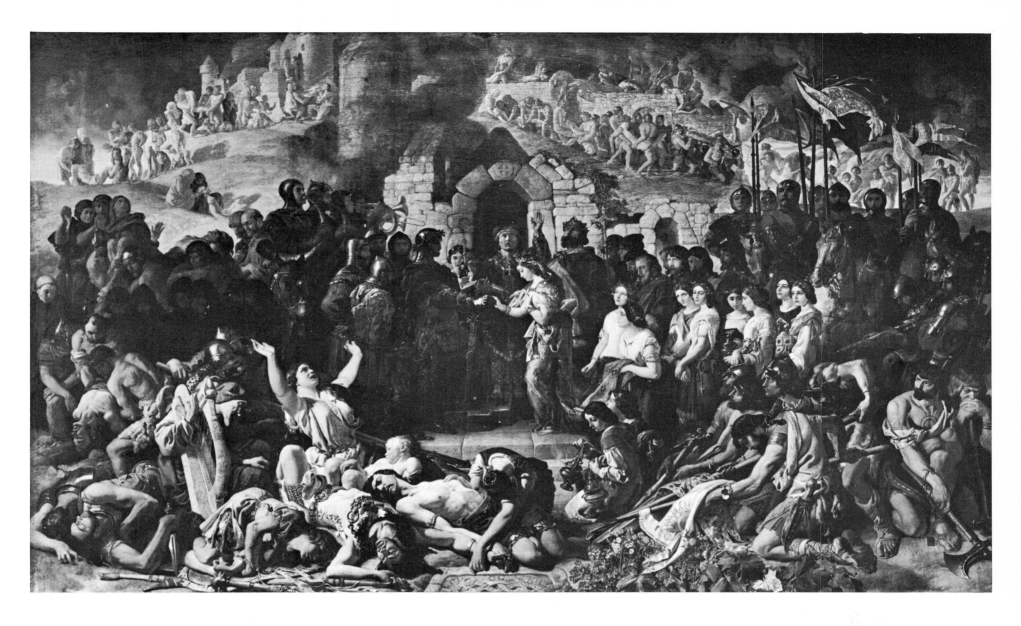

The Citizens of Calais delivering their Keys to King Edward III, while his brother-in-law Peter De Wint pursued an illustrious career in landscape painting. Hilton's *Christ Delivering Peter*, when it was shown at the International Exhibition of 1862, was, according to the Redgraves, 'a mere wreck' and 'parts of the picture were either corrugated, or gaping in wide glistening fissures. How much truly has the *brown school* to answer for: how many fine pictures has it brought to utter ruin!' The life of Joseph Severn (1793—1879), the friend of Keats and father of Arthur Severn (1842–1931), was so dogged by financial difficulties that a chance commission to copy a Gainsborough was a great windfall.

A few had miraculous escapes: George Hayter (1792–1871), whose matrimonial affairs debarred him from the Royal Academy, nevertheless found favour with the young Queen, who appointed him portrait and historical painter, and conferred a knighthood upon him. George Lance (1802–1864), a pupil of Haydon, was delivered by the accidental discovery of

still-life painting.

No such good luck attended the ludicrous career of Benjamin Robert Haydon, who presided over these would-be immortals, and on the rare occasions when fortune smiled on him, his headstrong intransigence rejected its benefits. On his arrival in London from his birth-place, Exeter, he was commissioned by Lord Mulgrave to paint a picture. This, *The Death of Dentatus*, he worked on for many years, inspired by the newly arrived Elgin marbles, for which he was an early enthusiast. Enraged when it was finally hung by the Royal Academy in the Octagon room, he made a violent attack on the Hanging Committee, even though many of Reynolds's canvases had been hung in the same room, without complaint. Throughout his tortured life Haydon inveighed against authority and antagonised patrons like Sir George Beaumont, who gave him commissions which he failed to carry out. He was imprisoned three times for debt; five of his children died; and, in spite of his subsequent overtures, he failed to be elected as a member of the Royal

DANIEL MACLISE, R.A. *The Marriage of Eva and Strongbow*. 122 × 199 inches. National Gallery of Ireland, Dublin.

Exhibited at the Royal Academy in 1854. Richard Strongbow, 2nd Earl of Pembroke and Strigul (d. 1176) married Eva, eldest daughter of Dermot. This picture was bought by Lord Northwick for £4,000 after the artist had refused to sell it to the Houses of Parliament. The National Gallery of Ireland has a watercolour study.

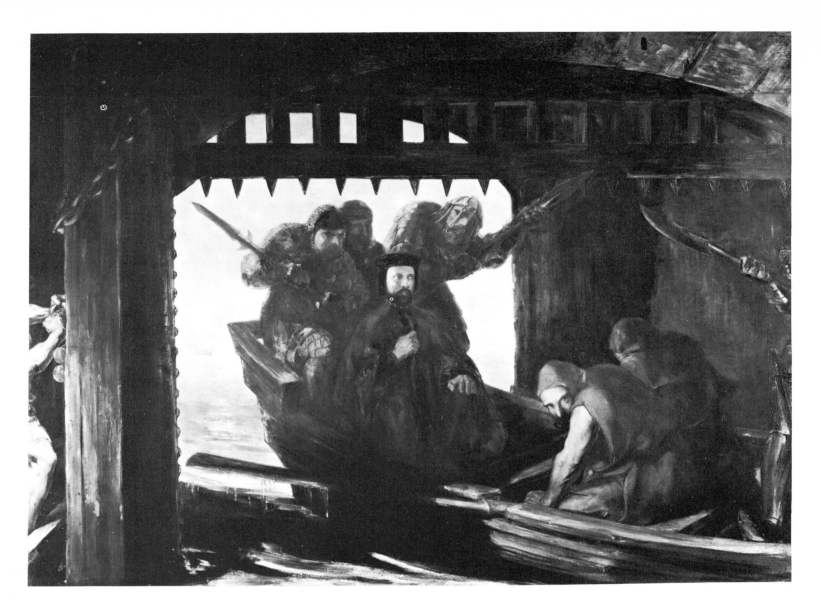

DAVID SCOTT. *The Traitor's Gate.*
53⅞ × 71¾ inches. National Gallery
of Scotland, Edinburgh.

Exhibited at the Royal Scottish
Academy in 1842. The scene shows
Thomas, Duke of Gloucester (1355-
1397), uncle of Richard II, being
rowed into Calais. He was said to
have been secretly abducted from
England by order of the King, and
then to have been murdered. A
reviewer in 'The Observer' com-
mented on the 'mystery and grand-
eur of effect in this picture' and 'a
moral dignity overawing the spec-
tator'.

Academy. He had moments of success: three pre-
Victorian paintings were exhibited before admiring
crowds. One of them, *The Raising of Lazarus*, now at
the Tate Gallery, measures fourteen by nearly twenty-
one feet. Although he eschewed bitumen and berated
Wilkie for using it, the condition of many of his
paintings has deteriorated through the inadequacies
of his own techniques. He scorned what he considered
the easier road to success: 'Portraiture' for instance,
according to him, 'is always independent of art and
has little or nothing to do with it'. By a strange
paradox, for this was a manner of painting he normally
derided, his most successful pictures were his rare
attempts at subjects drawn from everyday life, like
Chairing the Member (at the Tate Gallery). And by a
further paradox, he is now mainly remembered for his
extraordinarily vital diary, which was first published
in 1853 by Tom Taylor in twenty-seven volumes.
There is more genius contained in a few phrases from
his diary than in all his life's work in painting. When
George IV sits down in the coronation chair, 'a being

buried in satin, feathers and diamonds rolls gracefully
into his seat. The room rises with a sort of feathered,
silken thunder'. Elsewhere he describes the Duke of
Sussex's voice as 'loud, royal and asthmatic'. And as
a record of artistic life in London it is invaluable.

Three of the most successful painters in the Grand
Manner were all born in the same year. David Scott
(1806–1849) was a deeply imaginative painter; a
product of Edinburgh, he studied in Rome and Paris.
Philoctetes left in the Isle of Lemnos and *The Traitor's Gate*,
at Edinburgh, are both powerful exercises in romantic
art. Both Scott and Haydon were disappointed in their
efforts to win recognition in the Great Competition.
The Irishman Daniel Maclise (1806–1870), whose
funeral oration was delivered by his friend Dickens,
and who was the object of Thackeray's admiration,
might have had good reason to regret his commission
to paint two large frescoes for the new Houses of
Parliament, since they absorbed all his energies for a
number of years and contributed to his decline in
health and eventual death. He was a painter of

brilliant if uneven talent. These two frescoes, *The Death of Nelson* and *The Meeting of Wellington and Blücher* are, in spite of darkening and a film of dirt, enduring works of art, and illustrate well his ability to achieve coherence on a large scale, and at the same time exert an emotional appeal. An idea of the original colouring may be formed from the sketch for *Nelson* at the Walker Art Gallery, Liverpool. His easel paintings are generally in a good state of preservation, and reveal his qualities and weaknesses. *Noah's Sacrifice*, to which Turner reputedly added a rainbow on varnishing day at the Royal Academy, was painted a year before the formation of the Pre-Raphaelite Brotherhood. It anticipates the movement in its sharp outlines and clear, light colouring, and it reveals an obvious resemblance to the Nazarene style. *The Marriage of Eva and Strongbow* of 1854 is a massively powerful work, which Maclise sold to Lord Northwick, after refusing to sell it to the Houses of Parliament. Its composition, in the shape of an oval vignette, in which the drama of the central situation is played out while all about is in confusion, was a favourite formula later used in the two frescoes. For all his great abilities, Maclise's work is often marred by harsh colouring, unreal facial expressions, and faulty anatomy. Revered during his life-time, he awaits, with Watts, his reinstatement.

An infinitely more complex figure was William Dyce (1806–1864). The Royal Scottish Academy referred to him in a Minute following his death as 'one of the most remarkable men connected with the art of the present century' and praised one 'whose learning, accomplishment, genius and artistic power would have secured for him a place in the art annals of any country'. He began painting in Aberdeen, rather in the manner of Raeburn, in his teens. In 1828, on his second visit to Rome, he painted a *Madonna and Child* which was acclaimed as a masterpiece by Overbeck, leader of the Nazarenes. From then on, Dyce enjoyed a European reputation. Deeply devout, he was a leader of the High Church movement, a composer of church music and a notable contributor to musical scholarship. His concern with church music and ritual induced him to publish an edition of the Book of Common Prayer, and on another occasion he produced a long essay on ecclesiastical architecture. He also wrote a very sensible pamphlet called 'Shepherds and the Sheep' in answer to Ruskin's 'Notes on the Construction of Sheepfolds'. He was an active member of the Royal Academy (he declined the Presidency in 1850), and an expert on industrial art, especially stained glass, which he both designed and executed. He played a leading part in the establishment of the Schools of Design at Somerset House in 1840—the first attempt by any British government to support the arts. His talents even extended to learned writings on electro-magnetism. An eighty-four page pamphlet issued by Dyce on 'The National Gallery, its Formation and Management' received the whole-hearted approbation of Prince Albert, who had already noted with approval the high opinion that the Nazarenes and the Munich School had of the artist. A prize-winner in the Houses of Parliament competition, he was allotted as his subject *The Baptism of Ethelbert* in the central space behind the throne in the House of Lords. He accordingly toured Italy on behalf of the Commission to study fresco painting by the Old Masters.

Such time as could be spared from his arduous official duties he devoted to painting. The strong affinities with the Nazarene School, members of which he had met in Italy, informed his work throughout the 'forties. This in turn engendered sympathy with the aims of the Pre-Raphaelite Brotherhood, with which he later identified himself. Before 1848, however, he was painting in clear muted colours with a rather hard line. After four journeys to Italy he was familiar with Italian painting, being especially impressed by

WILLIAM DYCE, R.A. *The Meeting of Jacob and Rachel.* 22⅞ × 22⅞ inches. Kunsthalle, Hamburg.

Exhibited at the Royal Academy, 1853. The subject is from Genesis XXIX 1-12. Of the many variants Dyce made of this picture, which shows strong Nazarene affinities, one is at the Leicester Art Gallery and there is a drawing at the Aberdeen Art Gallery. Richard Muther wrote of Dyce: 'Where the Nazarenes make a pallid, corpse-like effect, a deep and luminous quality of colour delights one in his pictures . . . the charming work *Jacob and Rachel* . . . might be ascribed to Führich, except that the developed feeling for colour bears witness to its English origin'.

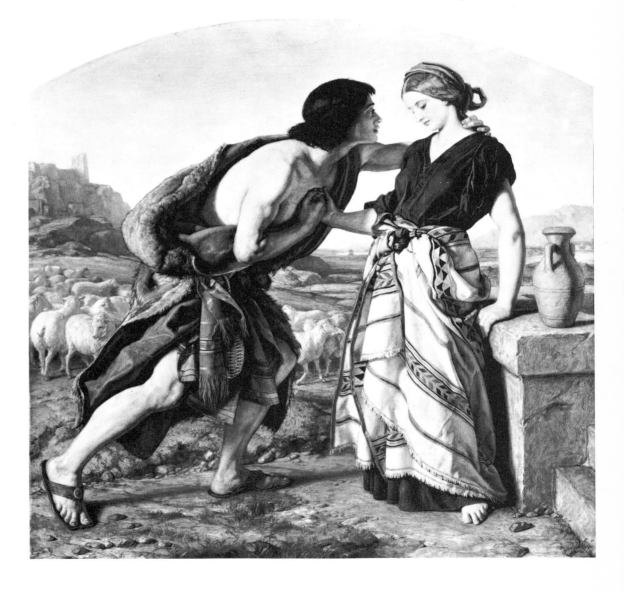

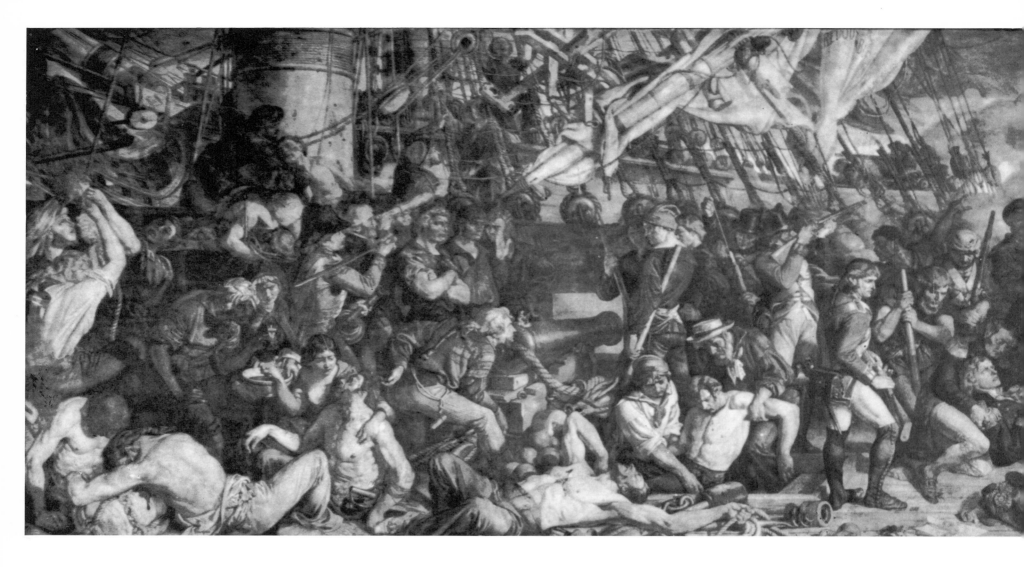

DANIEL MACLISE, R.A. *The Death of Nelson*. Waterglass painting. 145 × 560 inches. House of Lords.

Painted in 1863-5. There is an oil study and a pencil study at the Walker Art Gallery, Liverpool. The method of fresco painting, which had been introduced from Germany by Prince Albert, was to paint in water-colour on a dry wall of mortar, lime and sand and then spray the finished work with liquid silica. Maclise became converted to the method only after lengthy discussions with German painters, including Kaulbach. This fresco is the companion to *The Meeting of Wellington and Blücher*, which was completed in 1861. Frith wrote of the two frescoes in 1888: 'In these pictures may be seen the prodigality of imagination, the marvellous rendering of detail to the destruction of breadth, and the want of character which the neglect of direct imitation of nature is sure to produce'.

the 'prodigious vigour and force' of Guercino's frescoes at Piacenza, and by Domenichino and Pinturicchio, particularly the latter, for his sweetness of expression, a predictable taste in a good Victorian like Dyce. From this period dates *Joash shooting the Arrow of Deliverance*; this painting and the later *Jacob and Rachel* both show a strong Nazarene influence. These promised well for the style of historical painting which, translated into fresco, was to adorn the walls of the Houses of Parliament, a task which occupied Dyce from 1848 to his death. This promise was largely to be unfulfilled. While painting in England was wavering between frivolity, high seriousness without real profundity, and pseudo-religious sentiment, Dyce stood out as a figure of Miltonic stature: in the sonorous spirituality of his painting may be discerned a sense of seventeenth century *gravitas*, in which piety was no obstacle to a sensuous delight in nature. This contrasted with the spirit of opportunist materialism, which, in some degree, afflicted all the work of Frith and the later work of Millais. Like Ford Madox Brown, whose early influences resembled his own, Dyce was to attain full maturity under the Pre-Raphaelite spell, and the experiments of both artists in outdoor naturalism were to contribute a new dimension to Pre-

Raphaelitism. One only regrets the fragmentation of his life's work between official duties and artistic creation.

Another painter who fell early under the spell of the Nazarenes was John Rogers Herbert (1810–1890). A striking figure with a swarthy complexion, piercing eyes and long beard, he looked and spoke like an ancient prophet, forever proclaiming 'the nobility of Art'. He may never have been to the East, but he painted a large number of biblical scenes with some accuracy, and these became widely known through chromolithography. *Our Saviour, subject to His Parents at Nazareth*, exhibited in 1847 and now at the Guildhall Art Gallery, was condemned by a writer in 'The Fine Arts Journal' for its 'Puginesque conventionalities' (Herbert was a convert to Roman Catholicism). It was also, in the similarity of subject, an interesting forerunner of Millais's *The Carpenter's Shop*. Edward Matthew Ward (1816–1879) was of a more conventional mould, treating themes from history and historical fiction with a pleasing touch. Like Dyce and Herbert, he had come early under Germanic influence, having been trained partly in Munich. If he tended to overcrowd his more ambitious canvases, he could occasionally turn his hand to scenes of intimate charm.

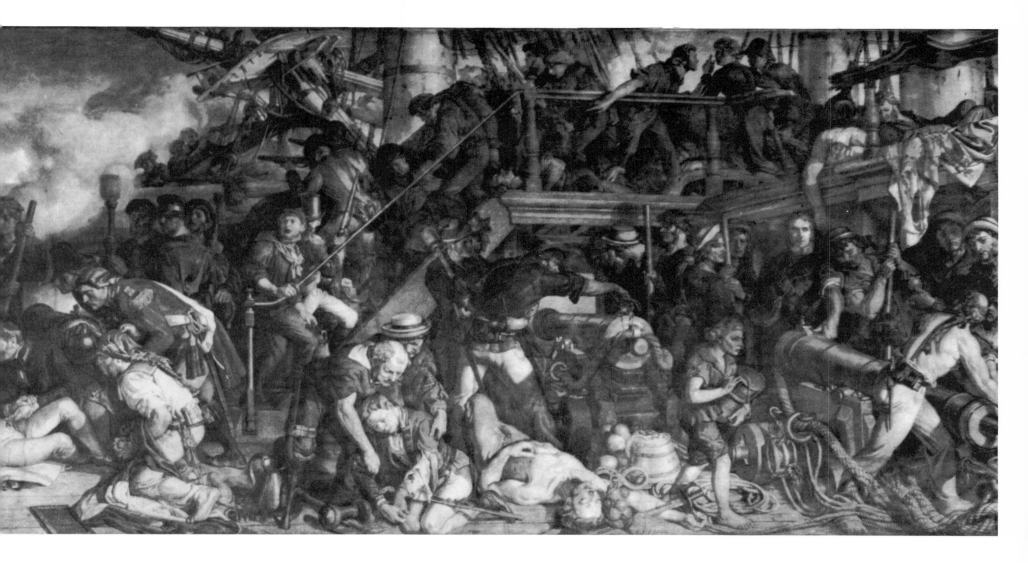

In 1834 the Palace of Westminster was destroyed by fire. The architect Charles Barry was chosen by a select committee to design the new Houses of Parliament. By 1840 work was sufficiently far advanced for decoration to be considered. The State was now forced to exercise patronage on an unprecedented scale, a course which Haydon had for a long time urged by pestering successive Prime Ministers with manifestos and interviews. In 1841, a select committee heard a number of witnesses expatiating on methods and subjects for a series of fresco paintings: these witnesses included Charles Eastlake (1793–1865), whose painting had long since been submerged by his official duties, and William Dyce, who demonstrated from the start the fullest knowledge of fresco painting techniques. Already at least one witness, Mr W. J. Bankes, was favouring the importation of a German artist. The committee decided to appoint a commission to deal with the subject.

This was duly set up with the untried young Prince Consort as its President. Meanwhile Eastlake had been pumping the German artist, Peter Cornelius, who was on a visit to London, for information concerning fresco painting. The Commission announced a competition for cartoon drawings 'executed in chalk or charcoal . . . illustrating subjects from British History, or from the works of Spencer, Shakespeare or Milton'. The enthusiasm with which Haydon heard the news was unbounded; it more than compensated for the failure of the Select Committee to call him as a witness. There now began a series of competitions, which continued over the next twenty years, and was designed to sift and evaluate talent; in fact it caused distress and frustration to numerous English artists. However, the anonymity of the competitions may have alienated established artists who disliked being passed over for unknown aspirants, but it did manage to bring young talent, like that of George Frederick Watts (1817–1904), to early public notice. The first prizes of £300 each were awarded to Edward Armitage for *Caesar's Invasion of Britain*, to Charles West Cope (1811–1890) for *The First Trial by Jury* and to G. F. Watts for *Caractacus led in Triumph through the Streets of Rome*. £200 prizes were awarded to John Callcott Horsley (1817–1903), to John Zephaniah Bell (1794–1884), an obscure pupil of Archer Shee, to Henry James Townsend (1810–1890), now barely remembered for a handful of book illustrations, to W. E. Frost (1810–1877), a follower of Etty, and to Edmund Thomas Parris (1793–1873), painter by appointment

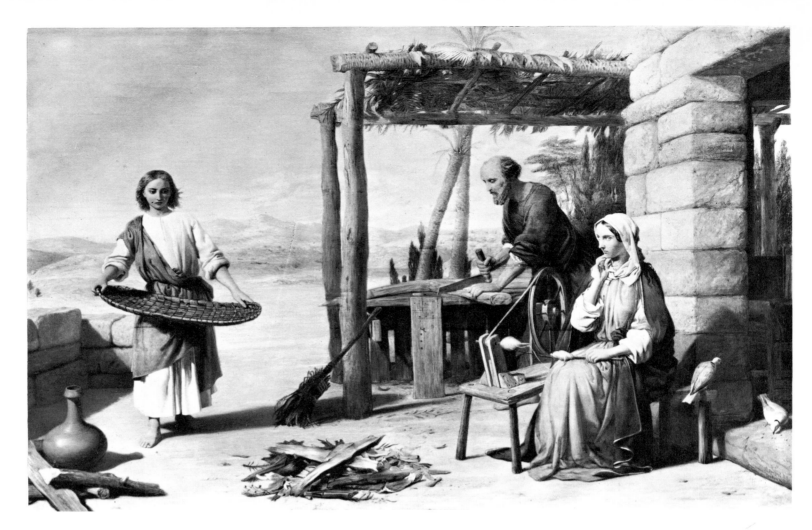

to successive Lord Mayors of London and specialist in the 'ogling beauties' of the Keepsake variety, who was described by the 'Literary Gazette' of the same year as 'one of the most successful artists in decorating gorgeous apartments with beautiful art' (clearly he was a forbear of the Interior Decorating profession). £200 prizes also went to Henry Selous (1811–1890) and John Bridges (fl. 1818–1854), both of whom are now shrouded in obscurity, as well as to Joseph Severn.

The day on which Haydon heard that he had failed to win a prize was 'a day of great misery'. He never recovered from the blow. Three years later, hounded by creditors, and smarting from the insult of a public who flocked to the Egyptian Hall to see not his exhibition but Barnum's dwarf, General Tom Thumb, he tried to shoot himself and then cut his throat with a razor in his studio, where the unfinished *Alfred and the first British Jury* still stood on his easel.

So the competitions dragged on. Dyce, John Rogers Herbert, E. M. Ward, Daniel Maclise and others received commissions for frescoes and easel paintings. Long before the deaths of some of the artists concerned, the frescoes began to bloom with mould mixed with London dirt. Executed in a medium never fully understood and acknowledged at the time to be unsuited to the London atmosphere, the frescoes have all but perished, along with the style of painting for which they had been intended as a vehicle.

Of the prize-winners in the first competition, C. W. Cope and J. C. Horsley went on to paint a variety of subjects, but did their best in scenes from contemporary life. Only one giant emerged from the ruins of this grandiose project: George Frederick Watts. He is the first truly Victorian colossus, whose life-span extended five years beyond that of his sovereign. Time has dealt cruelly with his reputation, but this was already declining in some circles long before his death. In 1893, George Moore was asking brusquely 'Have we not begun to suspect our praise today is a mere clinging to youthful admirations which have no root in our present knowledge and aestheticisms?' He goes on to describe Watts as 'a sort of modern Veronese in treacle and gingerbread'. Henry James joined the issue five years later. Like Moore he admired Watts as a portraitist, but confessed that 'his compositions, his allegories and fantasies are beyond me'. With acute perception but less than total accuracy, for Watts was capable of springing surprises to the last, James adds, 'Mr Watts's imagination strikes me as productive just in proportion as his subject is concrete. There is nothing so concrete as a charming woman or a distinguished man'.

Yet Watts, who was the son of an impoverished piano manufacturer, was an artist who painted in the grandest manner, and, like Alfred Stevens, Leighton and Ricketts, excelled in sculpture. Although his schooling was patchy and he spent only a few weeks at the Royal Academy Schools, his precocity is evident from the famous self-portrait, painted when he was seventeen, and from *The Wounded Heron* exhibited at the Royal Academy in 1837 and now at the Watts Gallery at Compton, near Guildford. After winning a first prize in the Houses of Parliament competition he spent four years in Italy, where he was lionised by Lady Holland. She was the first of a succession of women who cocooned him against the sharp realities of life: hence, no doubt, his subsequent loss of touch with public sentiment. Returning to England in 1847, in low spirits, he embarked first on a series of large essays in realism, depicting the sufferings of the poor, and then on a long series of didactic allegories. From these years dates *Time and Oblivion*, which, following his dictum 'I paint ideas, not things', was an allegory containing symbols expressing a timelessness that would outlast the passing scene. The picture made a deep, though not lasting impression on Ruskin, who later lost patience with these vagaries. Mr Ronald Chapman in 'The Laurel and the Thorn' quotes the story of Ruskin shouting fiercely at Watts outside an exhibition of Old Masters at Burlington House: 'paint that as it is', pointing to a pile of refuse at the foot of a grimy lamppost, 'that is the truth'. Watts, like Tennyson, was searching for philosophical truths in a mythology he never really believed in, in an attempt to counter the doubts caused by scientific discoveries. If the allegories appeared, at least for a time, to have a relevance for his contemporaries, they have no message for our own generation, nor are they redeemed by a persistent inner sense of design like that underlying the structures of Burne-Jones. This does not discount their pictorial value and quality of paint. Always there is a dramatic sense of power in Watts's compositions, and in colouring he has been repeatedly compared to Titian. In pictures like *Ariadne in Naxos*, where the allegory is not strained to breaking point, the gentle allure of his colour harmonies is evident. There are several versions of this painting and Watts himself regarded it as 'perhaps the most complete picture I have painted'.

In 1851 Watts became the permanent guest of Mr and Mrs Thoby Prinsep at Little Holland House. As Mrs Prinsep said with slight exaggeration, 'he came to stay three days, he stayed thirty years'. Here he lived a life of Olympian detachment, meeting many of the most important figures of his day. It is from this period that most of his portraits date. For one disastrous year, at the age of forty-seven, he was married to the sixteen year old actress Ellen Terry. In 1886 he married again: this time to Mary Fraser-Tytler, who gave great comfort to him during the last eighteen years of his life. With only two years to live, he painted a picture of extraordinary imaginative power, *The Sower of the Systems*, representing a 'veiled figure, projected as it were through space—the track marked by planets, suns and stars cast from hand and foot'. In this picture the demented spirit of the Victorian historical painting seems to rush screaming into the twentieth century.

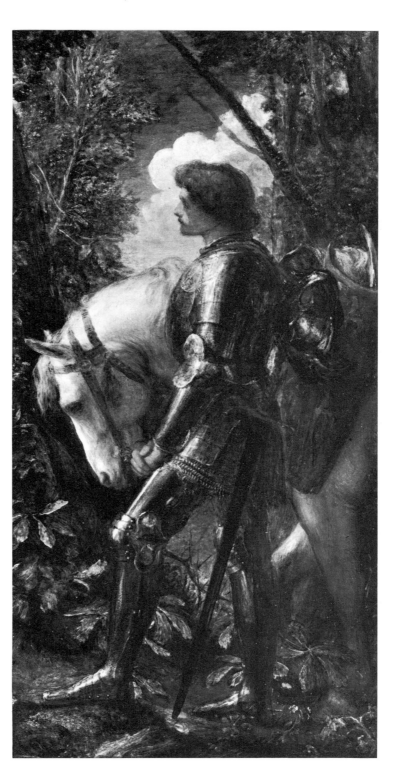

The Sower of the Systems by G. F. Watts is reproduced in colour on p. 18.

Ariadne in Naxos by G. F. Watts is reproduced in colour on p. 17.

GEORGE FREDERICK WATTS, O.M., R.A. *Sir Galahad.* Panel. 21 × 10¼ inches. Private collection, London.

Exhibited at the Royal Academy in 1862. A large version, now at the Fogg Museum, U.S.A., was painted during 1862. In 1897 another large version, painted over a water-colour, was presented to Eton College to be hung in the chapel. Another small version is known to have existed. There has been much speculation as to who was the inspiration for the features of Sir Galahad. It was long believed that Ellen Terry posed for the picture, but Arthur Prinsep was the model for an earlier study. It has recently been suggested that Watts saw none other than himself in the role of Sir Galahad.

III

LANDSCAPE

THE HEIGHTS

The year in which Queen Victoria came to the throne saw the death of John Constable (1776–1837). He left no clearly-defined school, but had extended the range and sympathy of English landscape painting; he had drawn attention to the countryside of England, to its fields and lanes, to the seaside and to the weather. From his very earliest years he had set out to paint nature as it was: his shadows were real shadows, cast by trees and clouds, with real sunlight dappling through them; his fields showed the play of light and wind; when he painted the sea, water and clouds moved and mingled according to the caprices of nature. The spell of formalised landscape cast by Claude Lorraine over Richard Wilson and his followers was at last broken. Constable had done for painting what Wordsworth and Coleridge had done for poetry when they banished 'poetic diction'. After his death one undisputed master was left to reign supreme.

Joseph Mallord William Turner (1775–1851) still had fourteen years to live. This strange individual was the son of a barber, and towards the end of his life

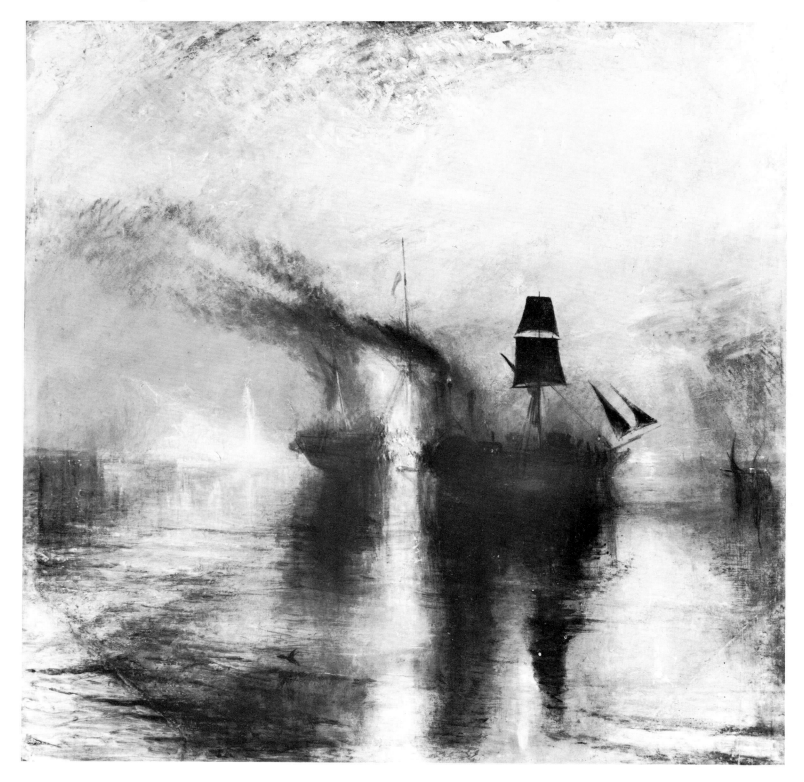

JOSEPH MALLORD WILLIAM TURNER, R.A. *Peace – Burial at Sea.* 34¾ × 34¾ inches. Tate Gallery. London.
Exhibited at the Royal Academy 1842. Painted in 1841-2, the painting depicts the burial at sea of Sir David Wilkie.

owned a public house near the London Docks. Although he was often not understood, he was considered to be the greatest painter in the land, a position powerfully enhanced by the perceptive championship of John Ruskin. One cannot resist quoting here part of the Redgraves' famous description of him at this time: 'In the last twenty years of his life . . . his short figure had become corpulent—his face perhaps from continued exposure to the air was unusually red, and a little inclined to blotches. His dark eye was bright and restless—his nose, aquiline. He generally wore what is called a black dress-coat, which would have been better for a brushing—the sleeves were mostly too long, coming down over his fat and not over-clean hands. He wore his hat while painting on the varnishing days—or otherwise a large wrapper over his head, while on the warmest days he generally had another wrapper or comforter round his throat—though occasionally he would unloose it and pick up a little of the colour from his ample palette. This, together with his ruddy face, his rollicking eye, and his continuous, although, except to himself, unintelligible jokes, gave him the appearance of one of that now wholly extinct race—a long-stage coachman.'

Some of his contemporaries suspected—Ruskin, at least, was sure—that Turner was the greatest landscape painter England had ever produced. Not until the early years of this century did it become possible to see the entire range of his work, and therefore he has only gradually come to be regarded, in our own age, as among the greatest of all landscape painters. He ranged in spirit from the naturalism of Constable to the mysticism of Blake, but without the concentration in either field to rival these two artists in the kind of painting which was peculiarly theirs. His true greatness lay in the representation of the cosmic forces of nature, expressed, in his finest works, through the medium of form and colour. The sense of sublimity in nature in his landscapes and the heroism of man amidst the destructive forces of nature in his subject pictures, painted with power and grandeur on vast canvases, marks Turner as one of the strongest currents in the tide of the Romantic Movement. Even in his early water-colours the composition sometimes looked forward to the vortical works of his maturity. Immediate influences apart, Turner's pictures at various times anticipated Impressionism and Abstract Expressionism, and much of this at a time, particularly in his later years, when his methods and outlook were at variance with those of his contemporaries, in their movement towards a smooth finish and detailed realism.

It is both true and in a sense misleading to say that he dwarfed his contemporaries, since this implies that little of interest was being done by anyone else, which, of course, is far from the case. After all,

admiration for Shakespeare does not preclude appreciation of Marlowe and Webster. Turner's immediate influence was deleterious. Writing in 1883 Ruskin conceded that 'in some respects, indeed, the vast strength of this unfollowable Eremite of a master was crushing, instead of edifying, to the English schools. All the true and strong men who were his contemporaries shrank from the slightest attempt at rivalry with him on his own lines:—and his own lines were cast far.' It is easy to understand how stalwarts like Copley Fielding felt suffocated when they contemplated pictures like *The Fighting Téméraire*, which was exhibited at the Royal Academy in 1839. In this justly famous picture, Turner reached the full extent of his prowess as a painter of finished pictures. In the first years of the Victorian period he had exhibited the remarkable *Snow Storm, Avalanche and Inundation* wherein water and earth are seemingly dissolved into one element, in a whirling maelstrom of fire. The triumphant fusion of the human element with the vast unbridled forces of nature shows a clear advance on his *Snowstorm: Hannibal and his Army crossing the Alps* of some twenty-five years earlier, and is typical of one aspect of his later manner. Throughout the 'forties Turner continued to paint scenes of Venice, at the same time lightening his palette, allowing whites, light blues and pinks to predominate. Whilst these pictures demonstrate the ever-evolving fusion of form and content they do not always convincingly show improvement on his Venetian pictures of the 'thirties. It is when the palette of the Venetian pictures of the 'forties is applied to subjects like *Norham Castle* and *Sunrise, with a Boat between Headlands* that its use is most happily vindicated. In these pictures, too, Turner's oil painting techniques most nearly approached his thinly washed water-colours, which hover on the brink of pure abstraction.

Subject pictures also continued to claim his attention in the 'forties. The elegiac grandeur of his *Peace—Burial at Sea* is one of the most moving pictorial statements of the Victorian Age. The subject is a memorial tribute to Sir David Wilkie, who was buried at sea on his return from the Middle East. The contrast between the sombre tones of the sails and the black reflections, with the brilliant glow where the body is being lowered is rich in epic poignancy, recalling the dark harmonics of Milton's *Lycidas*. His last landscape painting to be exhibited, in 1844, is another kind of tribute: this time to the age of the railway. The story of the inception of *Rain, Steam and Speed*, of how Turner put his head out of a train during a rainstorm, to the amazement and inconvenience of a fellow passenger, is well known. This wonderful synthesis of mechanism with landscape is a master-stroke of Romanticism, treated in the tradition of old master painting: the burnished glow of the engine reminds one of the way Rembrandt

treated a warrior's helmet. No picture painted by Turner reveals more forcibly the wide gulf between him and his contemporaries.

In 1847 Turner exhibited no pictures at the Royal Academy, for the first time for twenty-three years. The pictures of his declining years show signs of incoherence and hesitancy, even in the choice of canvas shapes. Although he did not exhibit again, he attended varnishing days up to 1851, the year of his death.

Turner's death signalled the end of an era: an era which began and ended with himself. As one of the great pillars of the Romantic Movement his evolution from an eighteenth century painter of delicate topographical water-colours to the creator of landscapes of unparalleled grandeur may be compared with the progression of Beethoven from the early formalised chamber music to the Choral Symphony and the late quartets. Like Constable before him, Turner left no recognisable school. But his influence was as profound as it was pervasive. No contemporary English landscape painter could be quite himself so long as Turner was alive: only originals like Samuel Palmer and the great water-colourists, Cox, De Wint and Cotman could be completely faithful to the guiding principles of their chosen media, and flourish unembarrassed. In this they were helped by the existence of the Old Water-Colour Society which acted as a stabilizing force.

Turner inhibited most of his aspiring contemporaries, such as J. B. Pyne, an insipid painter of landscapes in the manner of Turner's middle period, and Clarkson Stanfield, one of the best sea painters of the nineteenth century, held in great esteem during his life time but handicapped by a sense of inferiority to Turner. Artists like Landseer wisely stuck to subject painting, although his occasional pure landscapes show what he might have achieved. It is only when we come to painters like Francis Danby, John Martin and, later, Edward Lear, that we find anything approaching the Grand Manner in pure landscape painting. Of these three, John Martin (1789–1854) was the least good painter. On the other hand no other of Turner's contemporaries came nearer than Martin to a life-time of sustained landscape painting in which attempts upon the sublime were so successfully matched in execution. Martin was born in a one-roomed cottage at Haydon Bridge in the South Tyne Valley, one of twelve children of whom only four survived..He began painting early in life; when he was fourteen he was apprenticed to a coach-builder to learn heraldic painting. Shortly after this he became the pupil of a Piedmontese painter, Boniface Musso, who had settled in Newcastle. A little later Musso settled in London where he was joined by Martin, who began working as a china painter with Musso's son. After many vicissitudes, including attempts to augment his earnings by hawking drawings based on memories of his native Northumberland, and painting in the evenings, he had a picture accepted by the Royal Academy. In 1812 his *Sadak in search of the Waters of Oblivion* caused something of a stir. But his *Joshua commanding the Sun to stand still* of four years later made him famous, and his *Belshazzar's Feast* of 1821, from which a large number of engravings were made, became one of the most popular paintings of the age.

By the time Queen Victoria came to the throne, Martin's curious obsession with schemes for improving London's sewage system and water supply had brought him face to face with the Victorian bogey: ruin for himself, his wife and six surviving children. A timely decision to paint *The Coronation of Queen Victoria*, involving a visit to his studio by all the central figures, pulled him back from the edge of the abyss and set him squarely on the road to renewed fame. In the first seventeen years of the Queen's reign until his death in 1854, Martin produced a considerable number of highly original works, in addition to copies of his earlier successes, many of which are now lost. *The Assuaging of the Waters* clearly demonstrates the great originality of Martin's imagination. Although depicting water in motion was not his strong point, the picture as a whole has a romantic amplitude which was often attempted, though seldom so successfully in nineteenth century landscape painting. Martin's faults as a painter were well summed-up by Wilkie in a letter to Sir George Beaumont: '. . . although weak in all those points in which he can be compared with other artists, he is eminently strong in what no other artist has attempted'. His sense of colour, with its violent contrasts, its garishness, particularly in his use of blues and yellows; his treatment of foliage which looks like dried sponge; his poor painting of figures, too often applied to the landscape like a cosmetic: all these betray his weakness in the handling of paint. He was often repetitive, and in this he was no doubt victim of the overwhelming public enthusiasm for certain of his pictures. Ruskin frequently scourged him in print —for example: 'Martin's works are merely a common manufacture, as much makeable to order as a tea-tray or a coal scuttle'. For all this, Martin was an incomparable showman—he has been compared to Cecil B. De Mille—and in an age which loved wonders, he could conjure up pictures which even now can thrill.

The three *Judgment Pictures*, which were acclaimed as his masterpieces when they were exhibited a year after his death, are evidence of his ability to stun his public and induce a sensation of awe. Indeed, so successful were they in this respect that these large canvases, measuring nearly six by ten feet each, were launched on a spectacular tour through England and

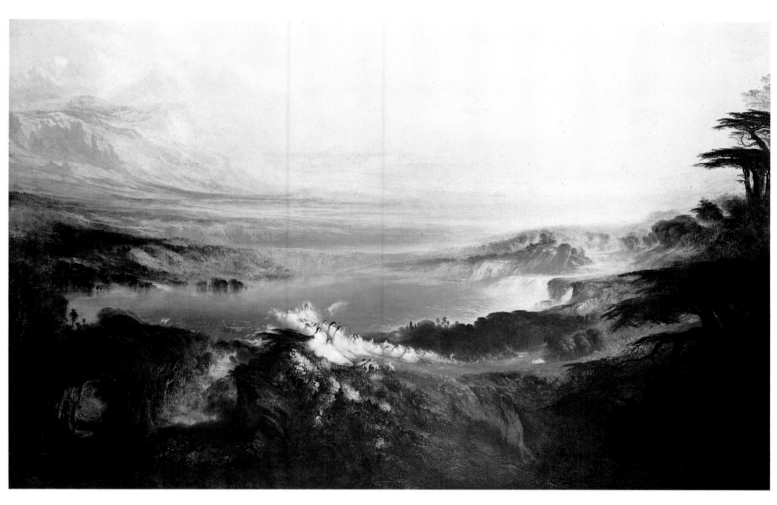

the United States for a period of twenty years. The first of these, *The Great Day of His Wrath*, now at the Tate Gallery, is a cataclysmic illustration to extracts from Chapter 6 of the Book of Revelation. Here Martin plagiarises *The Opening of the Seal* in which Danby had himself plagiarised Martin some twenty-five years earlier. It is said that its scarlet colouring was inspired by the glow of the furnaces in the Black Country at night. *The Plains of Heaven* from the same Book ('and I saw a new heaven and a new earth') is a paean of rapturous serenity with its Brucknerian mountains, translucent blue skies, langorous groups of seraphic damsels basking in forest glades and banks of wild flowers which might have blossomed in the visionary world of Samuel Palmer. The third and largest, *The Last Judgment*, is an ambitious attempt to combine the serenity and catastrophe at the sounding of the Last Trump. Martin hurled every device in his awe-inspiring arsenal into the painting of this picture. The result is indeed catastrophic, but not in the sense that Martin intended, although it is redeemed as usual by a sheer stupendousness that compels admiration.

In 1853 Martin suffered a paralytic seizure which rendered him speechless and his right hand useless; he died in the following year. The Redgraves observed that 'if, in his life-time, Martin was overpraised, he was certainly unjustly depreciated afterwards.' When

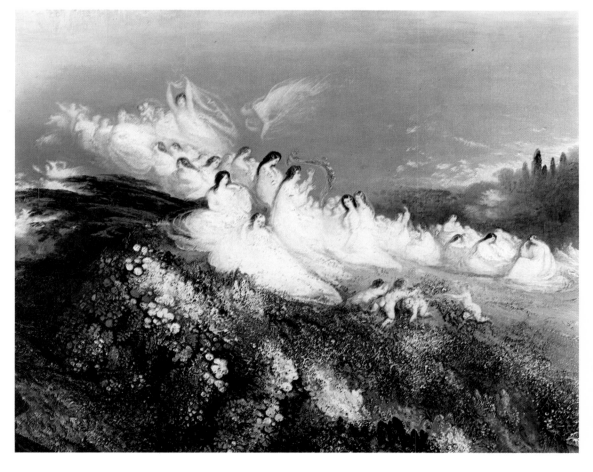

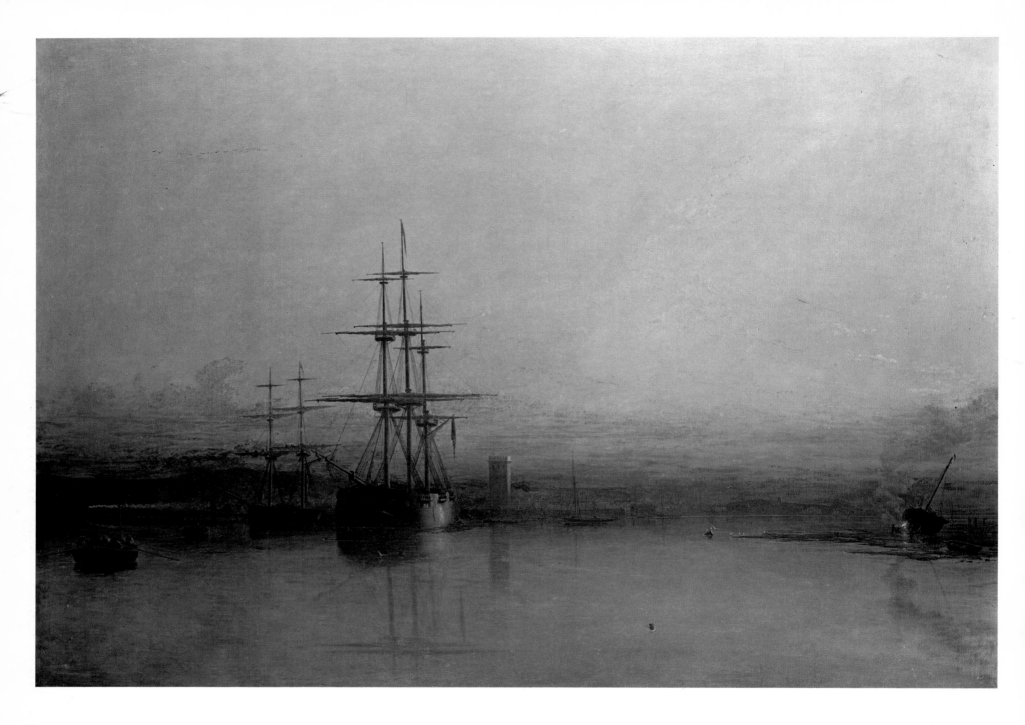

FRANCIS DANBY, A.R.A. *Dead Calm – Sunset, at the Bight of Exmouth.* 30 × 42 inches. Geoffrey Grigson, Esq.

Exhibited at the Royal Academy in 1855.

his *Judgment Pictures* returned home from their tour, many years after his death, they were unsaleable.

Like Martin, Francis Danby (1793–1861) was a purveyor of the sublime, and was as prodigious in his pictorial effects as both artists were prolific paternally. Danby's artistic career progressed by fits and starts, determined by the headstrong precipitancy of his ways. One of twin brothers, he came to England from Ireland at the age of twenty with his teacher, J. A. O'Connor. Their intention had been to make an assault upon London; however, when their money ran out, they were obliged to walk to Bristol, whence they hoped to return to Dublin. Danby decided to remain in Bristol, where he lived for eleven years. When he reached London, his ambition was doubt-

less stirred by the sight of Turner's paintings at the Royal Academy. He made his London *début* with the exhibition of *The Upas, or Poison Tree of the Island of Java* in 1820. This wildly romantic picture, which caused a sensation at the time, has now tragically disintegrated owing to the use of bitumen. In 1821 came his beautiful *Disappointed Love* now in the Sheepshanks Collection. It is clear that Danby was maturing at the right time; Turner and Martin were already before the public and the lush imagery of the Regency poets had richly furbished the public's imagination.

The Delivery of Israel out of Egypt strongly shows the influence of Martin, although this superb picture is in no sense a servile imitation. There is less sense of straining after the infinite, and a fuller understanding

of oil painting technique than in Martin; the figures are better drawn and the colouring richer and more pleasing. Danby had now been elected A.R.A. and had the world apparently at his feet. Then a matrimonial scandal caused him to leave the country and forfeit his ambition to be elected an R.A. Apparently Danby's wife lived with a fellow Bristol artist, Paul Falconer Poole, and Danby eloped to Geneva with his current mistress, his own seven children and three of hers. When Danby died in 1861, Poole married his widow, and with a strange poetic justice, became an R.A. himself. Danby's exile lasted about eleven years, during which he visited Norway. It is interesting, however, that Danby was already adept at depicting places he had never visited. On his return to London, he found that the artistic scene had shifted noticeably. Subject painting with a realistic finish was generally fashionable. Happily Turner and Martin were still painting, so that Danby was able to celebrate his return with the exhibition in 1840 of *The Deluge*, his largest picture. In 1841 his *Lienfiord Lake, Norway* was exhibited, one of his few pictures to show an actual place, and possibly one of his finest landscapes.

Probably the best of Danby's later paintings was *The Evening Gun*, which did more to reinstate him than any other. Its showing at the Paris International Exhibition of 1855 elicited Théophile Gautier's comment: 'The tranquility, silence and solitude in this canvas are deeply affecting. No-one has better expressed the solemn grandeur of the ocean'. Indeed the picture affirms Danby's special ability to paint the red glow of sunsets. Throughout his life Danby was an accomplished water-colour painter. His water-colours, sometimes in monochrome wash, often reveal solitary figures seated by pools in forest clearings, perhaps reflecting the romantic yearnings of his own socially erratic career. His final pictures were mostly repetitions, only occasionally recapturing some of the ardour

JOHN MARTIN. *The Assuaging of the Waters.* 56 × 85 inches. Church of Scotland, Edinburgh.
Exhibited at the Royal Academy in 1840. Martin painted a water-colour of the same subject in 1838.

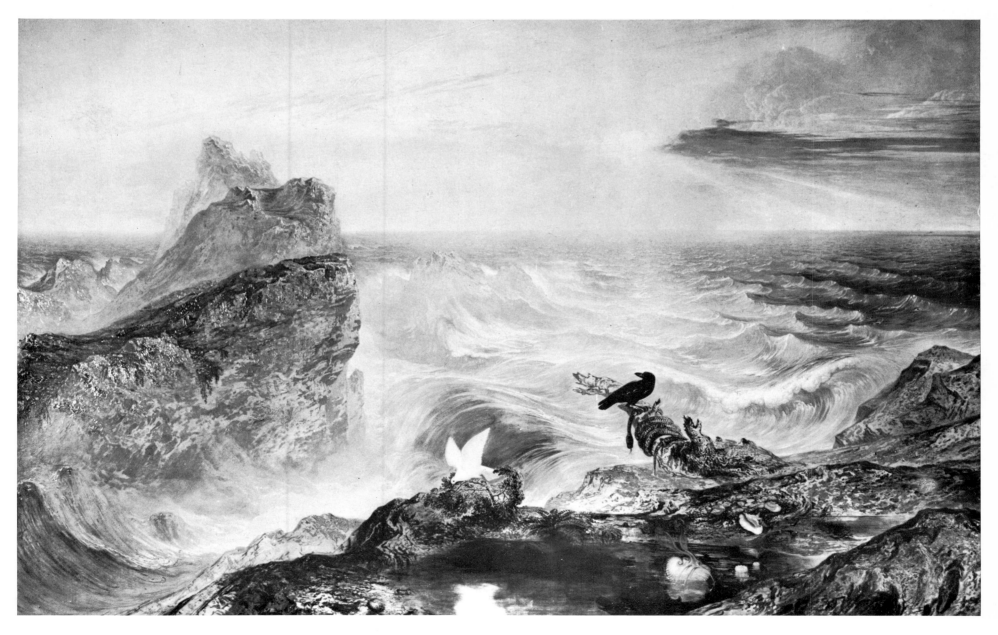

of his earlier work. Danby's son James (1816–1875) is remembered only for the occasional small canvas which turns up in the sale-rooms and, although weaker in execution, may be mistaken for his father's work. Another son, Thomas (?1817–1886), became a water-colourist. Mention may also be made of another of Danby's pupils, Samuel Jackson (1794–1869) who painted pleasing water-colour landscapes in the British Isles, the Continent and the West Indies. The latter particularly show the influence of Danby.

The name of Paul Falconer Poole (1807–1879) is, for obvious reasons, frequently coupled with that of Francis Danby. They even appear to have possessed similarities of temperament, particularly in their ungovernability. Poole is a difficult artist to classify, and his appearance in a chapter on landscape painters would be as anomalous as it would in any other chapter, were it not that the landscape backgrounds to his pictures reveal an individual approach to the subject. Both the strengths and the weaknesses in his painting have been attributed to his lack of any academic training. He was never strong in figure painting, and his early canvases, mostly of family groups in idyllic surroundings, are both weak in handling and ill-composed. His inner strength only becomes apparent in pictures like *Solomon Eagle exhorting the People to Repentance during the Plague of London* of 1843, and *The last Scene in Lear* of 1858. So idiosyncratic is the prevailing style of his paintings, that his pictures, seen in isolation, rarely impress as much as they should. Their effect is achieved by expressing mood through colour, usually a kind of golden glow, and an almost mystical fusion of figure with landscape. These qualities are wonderfully demonstrated in one of the last great ideal landscapes of the Victorian age, *The Vision of Ezekiel*, painted in the 'seventies. Palmer, Linnell, Smetham and Lear were still painting at this time, but we respond to this picture with the critical apparatus applicable to a Turner or a Danby. The only other landscape painter who succeeded in scaling the heights with a fair degree of consistency was Edward Lear, and the merits of this strangely gifted artist are discussed in a later chapter.

THE VALLEYS

While the heights were being stormed by the Triumvirate of Turner, Martin and Danby, and the mountain passess swarmed with legions of aspiring Olympians, a number of artists brooded on God, Nature and Man in the shaded valleys below. Regardless, at first, of public recognition and material wealth, these artists, with William Blake as the presiding genius, translated the symbols of his transcendental vision into the medium of landscape; and although the fire was burning low by the time of the Queen's accession, the cinders smouldered fitfully throughout the nineteenth and into the present century. These followers of Blake

added to landscape painting a new impulse which even now seems unlikely to die out.

In 1818 John Linnell was introduced to Blake, and Linnell's house in Hampstead became the *venue* for a group of painters. Among them were Samuel Palmer, Edward Calvert, Francis Oliver Finch, the brothers John and Cornelius Varley, Welby Sherman, George Richmond and the sculptor Frederick Tatham. The circle called themselves 'The Ancients', in allusion to the superiority of ancient over modern man. Such was their reverence for Blake that they always kissed the bell-pull before entering his house.

Blake's only incursion into landscape came in 1821, with the publication of *The Pastorals of Virgil*. The cutting of blocks to produce wood-cuts was an unfamiliar technique to Blake and the apparent crudity of the wood-cuts helped to invest them with the kind of primeval power associated with the world of pastoral vision. The impact of these wood-cuts on the eagerly impressionable members of the circle was decisive. Samuel Palmer (1805–1881) wrote of them: 'They are visions of little dells, and nooks, and corners of Paradise; models of the exquisitest pitch of intense poetry. I thought of their light and shade and looking upon them I find no word to describe it. Intense depth, solemnity and vivid brilliancy only coldly and partially describe them. There is in all such a mystic and dreamy glimmer as penetrates and kindles the inmost

SAMUEL PALMER. *The Streamlet.* Pencil and red chalk, water-colour and body-colour. $7\frac{1}{2} \times 16\frac{3}{4}$ inches. Signed and dated 1861. Theodore Besterman, Esq.

Exhibited at the Old Water-Colour Society in 1861. In 1861 Palmer was very depressed. In July one of his sons had died; in September he moved to Reigate, Surrey; in May 1862 he moved again to Redhill, close by, where he remained until his death.

soul and gives complete and unreserved delight, unlike the gaudy daylight of this world.' Edward Calvert observed that they were 'humble enough and of force enough to move more simple souls to tears'.

The ideals of this group of artists—one of the first of many to be formed in the nineteenth century—with

SAMUEL PALMER. *A Sketch of Clovelly Park, looking towards the Cliffs on the further side of Mouth-Mill Ravine.* Water-colour. $10\frac{1}{4} \times 14\frac{3}{4}$ inches. Signed. Mr D. C. Baker.

Exhibited at the Old Water-Colour Society Winter Exhibition 1865. In November 1864 the artist wrote to L. R. Valpy, who owned the water-colour at the time: 'In your North Devon cornfield, there is a bit of white left as a good place for a rabbit, in case of making a picture from it. Now, if I were to put in a good rabbit, it would unfinish the corn; and work upon the corn would ruin the distance, which is the point of the case.'

its revisionist fervour, anticipated the reversion to first principles implicit in Pre-Raphaelitism and Ruskinism. It was to be expected that Ruskin would find Palmer's studies of foliage 'beyond all praise for carefulness'. But while Ruskin was in effect supporting the ideals of Pre-Raphaelitism, Palmer's vision was really imbued with the spirit of Blake who saw '. . . a World in a Grain of Sand/And a Heaven in a Wild Flower'. In the late 'twenties the centre of gravity had shifted from Linnell's house in Hampstead to Shoreham in Kent, where Palmer, acting as host to members of the circle, produced the sublime works of his visionary period. But the mystical concentration, too intense to last, was doomed to flicker and die. At some point, a little over half-way between the death of Blake in 1827 and Palmer's marriage to Linnell's daughter in 1837 (and a honeymoon in Italy), the visionary flame was apparently spent.

The apparent loss of vision—and with it an unquestionable loss of originality—has generally filled Palmer's apologists with dismay. The explanations hitherto advanced, although valid in themselves, are only partly adequate. There is no doubt that the main

underlying cause was his marriage to Linnell's daughter, Hannah. Most of the other factors were dependent in some way on this fundamental cause. An immediate reason may be confidently deduced: the two-year honeymoon in Italy, in which the fragile fabric of his visionary world was transformed under the glare of the Mediterranean sun. Then there was the problem of money, and the influence of his new father-in-law. John Linnell was to become increasingly the patriarchal figure, to whose daughter Palmer was expected to do his duty as a man of the world. Linnell became ever more over-bearing, and eventually his attitude was adopted by other members of his family, even at a later date by Palmer's son and biographer. To achieve Linnell's ends, Palmer was gradually talked out of his Shoreham dream, and, although he always valued his past association with Blake, he later hesitated to discuss it. Throughout the remainder of his life he kept the works of his Shoreham period in a 'Curiosity Portfolio', to be opened for those who showed any interest. It seems certain that Linnell put it about that Palmer's work at Shoreham was evidence of madness. As the public found the work of this period

difficult to understand anyway, this indictment found easy acceptance. There is little doubt that Linnell regarded Palmer as a plagiarist of his own work—forgetting the friendly interchange of ideas in his Hampstead house.

The effect of all this on Palmer was predictable: a loss of self-confidence led to a frantic search for a style that would appeal to public taste. Unfortunately the stigma which clung to the Shoreham works now lurked like a spectre behind anything he attempted. Palmer had always complained that his pictures were either 'skied' or stuck into obscure corners at exhibitions at the 'Old Water-Colour' Society, and the attitude persisted. Throughout his life his technical virtuosity never deserted him—indeed it improved—but an echo here of the style of Cox and there of De Wint betrayed his predicament. Consequently it is not always easy to date the works of his later periods with certainty. He rarely dated his pictures to the year, although the time of day and day of the month is often clearly inscribed. There is, nevertheless, an underlying consistency of handling and medium in his work. Some of the water-colours of the 'fifties and 'sixties are astounding in their technical brilliance and a sense of perception predictable in one who had passed through the fire of the Shoreham period. As a young man Palmer had painted views around Lynmouth and throughout his life he continued to paint scenes in Devon, many of them near the coast. There is no trace of hesitancy in his view of the cornfield near Clovelly. The brilliance of the sun-drenched corn and the rhythmical sweep of the undulating landscape affirm his mastery.

The differences with Linnell persisted throughout his life. Paradoxically, while the course of Linnell's painting career ran all too smoothly, his spiritual life—in contrast to that of Palmer—was chaotic. Linnell was attracted by various low church sects, and he was forever vacillating between them. Palmer, attracted by liturgy and plainsong, had consistent leanings towards the **High Church**. This deepened the **rift** between them. Eventually, when Palmer found himself still unable to meet the material demands of his marriage, Linnell made Hannah an allowance. This melancholy situation had one most happy result: it enabled Palmer to return to his earlier vision. Apart from his naturalistic landscapes, Palmer did a large number of water-colours with a sumptuous, if rather hot, tone, of subjects like *St. Paul landing in Italy* and *The Dell of Comus*. Many of these productions owe much to Claude and the Italianate landscape tradition. But towards the end of his life, Palmer's self-confidence returned and he recaptured something of his early visionary period.

Perhaps the culmination of his return to the visionary world of Shoreham was the series of etchings, planned for his translation of Virgil's 'Eclogues'. Palmer's genius

had glowed across the nineteenth century like the tail of a comet, finally descending in an incandescent glow, barely perceptible to the public eye.

Edward Calvert (1799–1883), thanks to a private income, was, by 1837, in the words of Palmer's son 'a dreamy intellectual dallying with art'. The original works of his visionary period, which lasted from Blake's death in 1827 until 1837, numbered barely a dozen. The exquisite wood-cuts of this period are among the most perfect work ever done in the medium. The main body of his work done during the last fifty years of his life is of scant artistic value, consisting usually of 'filletted' women in vague attitudes of pagan worship among Arcadian landscapes. In them there is little real poetry and the palette is muddy. He did, however, paint seriously for a brief period in the 'thirties when he befriended Etty, and some of his nudes bear a startling likeness to those of Etty. In a memoir of Calvert, written by his third son, there is an anecdote worthy of Mr Pooter. 'In 1850 Calvert attended a posthumous sale of Etty's work. A painting by Calvert was offered for sale as being by Etty. Impelled by honesty and pride, Calvert called out "That's not Etty's!" The auctioneer retorted, "A gentleman present has declared that this study is not genuine,

EDWARD CALVERT. *Allegorical Scene*. Body-colour. 5 × 3¾ inches. Private collection, U.S.A.

including an essay on Blake published in 1868 which was one of the first to establish Blake's true importance. Smetham began his career as a portraitist but was defeated by the advent of photography. He was a devout Wesleyan, whose work shows more affinity with Blake and Palmer than with the Pre-Raphaelites. His was clearly a minor talent but it did not deteriorate with age, although he spent the last years of his life insane. The horizons in his landscapes sometimes recall Lear and Holman Hunt, while the treatment of the foregrounds, often depicting Pagan subjects, suggests Shoreham as his spiritual home. Smetham's biographer William H. Davies lists the adverse influences in his life as 'Photography, Pre-Raphaelitism and Ruskinism'. The path the Victorian painter had to tread could be stony indeed.

The majestic span of life allotted to John Linnell (1792–1882) easily encompassed that of his son-in-law, Samuel Palmer. In his youth he had been one of the first to recognize the genius of Blake, and had become one of his first patrons. At the time of Linnell's death, Whistler was painting the last of his *Nocturnes* and Sickert and Wilson Steer had begun their painting careers. His longevity and a large circle of acquaintances in the artistic world might lead one fairly to

but buyers would do well to bear in mind that the same gentleman was himself bidding for it''.' Calvert retired in confusion.

James Smetham (1821–1889), although a painter and etcher, is remembered today mainly as a friend of Rossetti and Ruskin, and for some critical articles,

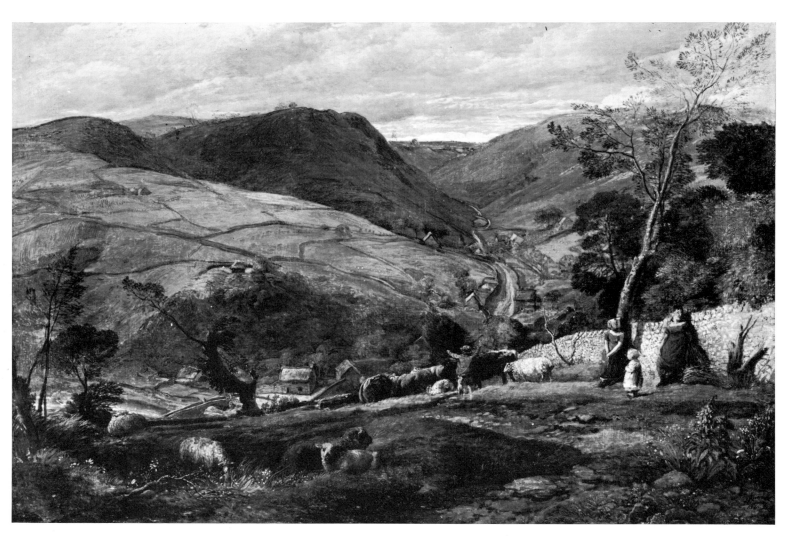

expect a wide divergence of styles. This is not, however, the case. True, Linnell began life as a portrait painter, but a glimpse at the landscape backgrounds to some of his portraits reveals the true direction of his talent, to which the artistic climate of his time gave nourishment. One cannot help wishing, in passing, that the same might have applied to Gainsborough, who died four years before the birth of Linnell.

In his youth, Linnell had been taught by John Varley, and had as a fellow pupil William Mulready, who was seven years his senior. After living for some years in Hampstead, he moved first to Porchester Terrace, and then in 1852 to Redhill in Surrey. Here he lived for exactly thirty years, and painted ideal views based on the Surrey landscape. His method was to paint his subject in brown on a white ground, after having made a number of sketches and studies. It seems that the finished picture was never painted direct from nature. This may partly account for the sad record of repetitiveness, even of exact duplication, which has weakened his subsequent reputation. At their best his paintings display great power in their evocation of the English countryside. These, with a daring use of colour, as often as not depict harvesters

JOHN LINNELL. *The Last Gleam Before the Storm.* 50½×65 inches. Signed. Walker Art Gallery, Liverpool.
 Probably painted in the years 1847-8.

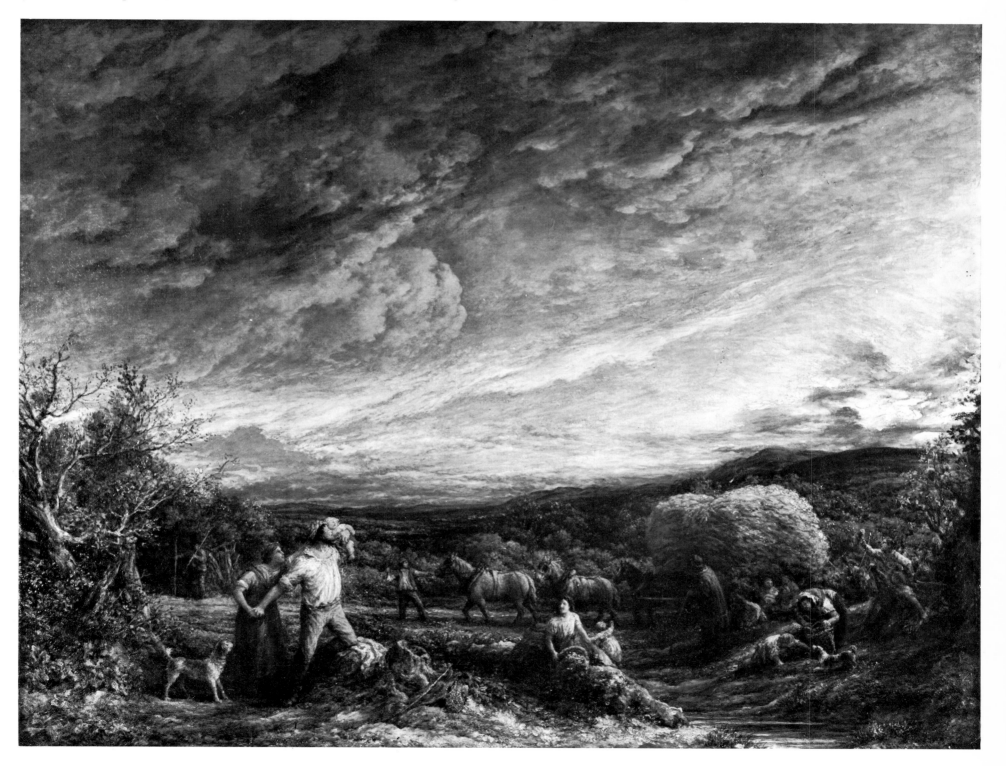

returning home, with a pale new moon shining in the early evening sky. Some pictures he worked on for a considerable number of years. The dark green of the fields and the louring sky reveal a deep feeling for nature. Generally it is the skies that impress most in his pictures. At worst, the composition of his landscapes is muddled, the colours jarring and the treatment diffuse. Linnell's paintings are idiosyncratic, and easily recognisable. In a rather gratifying way they betray their early origins in the meetings of 'The Ancients'.

John Varley (1778–1842), his brother Cornelius Varley (1781–1873) and Francis Oliver Finch (1802–1862) were all almost exclusively water-colourists, and although they moved freely in Linnell's Hampstead house, they really belong to the earlier tradition of water-colour painting. John Varley was a famous teacher of the art, and some of the best Victorian landscape painters, including Palmer and Linnell, received lessons from him. It seems that Varley's creative vision had been cross-fertilized by his contact with these two artists. By 1837 his technique had undergone a significant change, charging his later works with a new character, compounded of dark mysteriousness and a hitherto uncharacteristic urgency of line. The tonal range is deeper and richer. Varley's widow described how 'sometimes he would pass a wash of thin paste over the paper which enabled him to get the lights out more readily; and he enriched the dark with gum Arabic water.' Varley, with his technical virtuosity, had passed into the Victorian age with ease, only to die five years later in poverty. Cornelius, always a more original artist, though less prolific and totally without influence, was much attracted by science, and lived to be awarded a gold medal at the 1851 Exhibition for a 'graphic telescope' he had patented in 1811. Francis Oliver Finch contented himself with painting rather stilted classical compositions, using the 'hot' colours which afflicted water-colour painting at the time.

THE PLAINS

The greater part of early Victorian landscape painting consists of pretty, undisturbing scenes painted with a degree of professionalism just adequate to the demands of a growing picture-buying public. The sheer quantity of landscape production in the nineteenth century is overwhelming. Dr T. S. R. Boase cites F. R. Lee as 'the perfect figure of the unintellectual, superficial artist that England has frequently produced, painting competently and repetitively . . . when emotion and observation were alike at a discount.' The assessment might equally apply to any one of a legion of worthy landscape painters, who catered for a public taste seemingly overstrained by the paintings of Turner and Constable and not yet prepared for the exacting demands of Pre-Raphaelitism and the well-meaning tyranny of Ruskin.

And yet there is much that is pleasing in early Victorian landscape, with two painters of undisputed genius in Cox and De Wint. Most of these landscape artists grew up in the shadow cast by Constable, whose influence ran, not deeply, but insidiously, and whose work was too often adapted to a formula by lesser artists. Some of these, like F. W. Watts, Warren and Churchyard, appear to have been directly influenced by him. As Wordsworth did in poetic terms, Constable encouraged a sense of communion with both the timeless and the ephemeral manifestations of nature. The eyes of artists were opened to what Constable called the 'chiaroscuro of nature', the play of light and shade on landscape. Unfortunately, Constable's method of landscape composition lent itself all too readily to facile adaptation. What from Constable's brush seemed an uncomplicated evocation of the English countryside was in reality a complex yet perfect display of interrelating light and shade touched by that divine bounteousness which motivates the true artist; in the hands of his followers similar scenes seemed trivial and afflicted with a fatal lack of authority. As popular pictorial statements their pictures were as valid as Constable's, but they were weakened by the absence of his insight.

Naturalistic landscape painting, of which Constable was the first exemplar, remained the fundamental aim of this group. But the practice of ideal landscape painting, the esoteric aspirations of the Virgilian landscape painters, the flourishing water-colour school, and, later, the Pre-Raphaelite strain, were the four polarities upon which the naturalists turned. Fortunately, few of this group attempted to scale the heights, as this usually resulted in disaster. Such was the case of J. B. Pyne (1800–1870) whose yellow pastiches of Turner after Claude, so much admired at the time, are sorry examples. Müller (who was taught by Pyne), Stanfield, Cox and Landseer were all attracted by mountain scenery, but their flirtations with ideal landscape were kept discreetly incidental to the main body of their work. The visionary world of early Palmer and Linnell seemed to affect only those who later fell under the Pre-Raphaelite spell, like Dyce and Smetham.

Many of the best landscape painters, particularly those of the Norwich School, were equally skilled in oils and water-colours. Cox and De Wint were both essentially water-colourists: the former took up oil-painting seriously rather late in life and the latter mysteriously met with little success in this medium. David Cox (1783–1859) was born in a poor suburb of Birmingham. His father was a blacksmith and whitesmith; his mother came from a more prosperous home, and it was from her that he learned the solid set of

Lunton.
31 May 1857.

principles which governed his life. Whilst he was convalescing after an accident, the young Cox was given a box of colours by a cousin. With this he began to paint kites brought to his sick bed, and made copies of old prints. Encouraged by these early symptoms of talent, his parents allowed him to attend lessons at a night school run by Joseph Barber. After a brief period of miniature painting, he took up scene painting at the theatre in Birmingham. In 1804 he paid his first visit to London, supposedly in the pay of the famous circus proprietor, Astley. If he worked for Astley at all, it could not have been for long, since it is said that his employer, ignorant of painting, once expected him to paint a drum with both ends showing. Undeterred, Cox embarked immediately on a life-time of professional painting, and by 1805 he was exhibiting at the

Royal Academy. He had moved to Dulwich Common, where he set up as a drawing-master. He was only moderately successful, but teaching helped him to acquire patrons, and to offset his other difficulties. He travelled three times to the Continent between 1826 and 1832; otherwise he lived and worked in Derbyshire, Yorkshire, and North Wales, finally settling down in 1841 at Harborne, then a small village near Birmingham, from which he travelled extensively.

David Cox was prodigious in his output. Much that he did was repetitious, largely because of the tremendous appetite of the wealthy drawing-room scrap-book compilers, whose tastes inclined to pretty landscapes done to a formula. Cox worked fast, using a large swan's quill brush, loaded with colour, very wet,

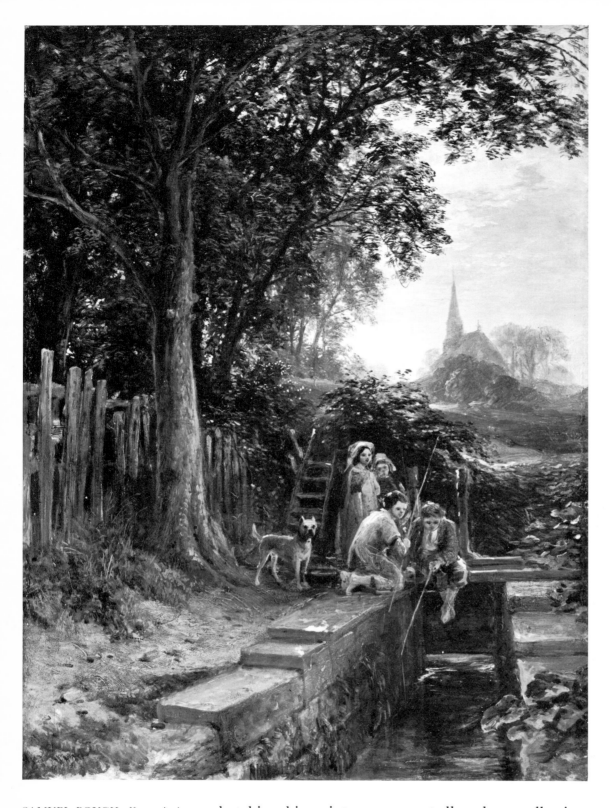

SAMUEL BOUGH. *Young Anglers by a Canal*. Panel. 19 × 14 inches. Maas Gallery, London.

Rhyl Sands by David Cox is reproduced in colour on p. 53.

manner. When asked what happened when one of the many black specks appeared in a clear sky, he replied: 'Oh, I just put wings on them and they fly away as birds.' Cox's landscapes are redolent of wind and rain, and they grew in power towards the end of his life, when he could paint as he liked, unaffected by the whims of fashionable patrons.

Cox often regretted his tardy enthusiasm for painting in oils, and his success in this medium certainly invokes sympathy with this regret. It was not until 1840 that William Müller, twenty years his junior, gave Cox his first serious lessons in oil painting. The rediscovery of oils accelerated Cox's retirement to Harborne, and for the next eighteen years he abandoned himself freely to his new enthusiasm of which he soon had complete understanding. This may be seen in the study of *Fish: Skate and Cod*, painted about 1840, and now at the Birmingham Art Gallery. His finest achievement must be *Rhyl Sands*, which stands out like a solitary beacon in English landscape painting. This lovely painting, of which there are several versions, anticipates the shore-scenes of Boudin and Wilson Steer. Had English landscape painting evolved naturally from paintings like this, it would certainly have been better able to absorb alien influences in the last years of the century. To the very last phase belong some of the paintings which come closest to Turner, but now the intention had begun to out-run the execution. After suffering a succession of bronchial illnesses, David Cox died, a venerable Victorian.

David Cox junior (1809–1885) inherited a smaller talent, fatally imitating his father's style; this leads to confusion in the uninitiated, although some of his fairly large landscapes display a certain character and distinction of their own. Edmund Wimperis (1835–1900) did some fine landscapes rather in the manner of Cox, both in water-colour and oil, first exhibiting in the year of Cox's death. Other followers include Thomas Collier (1840–1891), William Collingwood (1819–1903) and his cousin William Collingwood Smith (1815–1887), both of whom were pupils of J. D. Harding; Collingwood Smith taught Josiah Whymper (1813–1903), who produced a number of Cox-inspired landscapes. Samuel Bough (1822–1878), a native of Carlisle who was self-taught, painted some fine landscapes somewhere between those of Cox and Müller in manner.

hatching his paint over repeatedly, always allowing the preceding touches to dry; nearly always the outline had been sketched in with charcoal or black chalk, often whilst he was out on a walk. His range of colours was limited, but highly effective. In 1836 Cox discovered the famous wrapping paper, made from linen sailcloth well bleached. When this coarse paper, of which he bought a ream (weighing a hundred and eighty pounds) was exhausted he was unable to replace it. Its texture exactly suited his strong yet nervous

Peter De Wint (1784–1849) was born at Stone in Staffordshire, into a family of Dutch/American stock. So parallel were their careers, and so apparently similar their work, that De Wint and Cox are often mentioned in the same breath. Yet the more closely one considers these two artists the more widely opposed they are seen to be. De Wint showed an early fondness for painting. His first contract was as an apprentice in London to the high-living John Raphael Smith; Smith

enjoyed a reputation as a mezzotinter, colour print engraver and portrait draughtsman. The young De Wint spent four years painting pastel portraits and engraving, and shortly afterwards took up oil painting. But De Wint, who had inherited a certain wilfulness from his parents, soon found that water-colours were easier to sell and this was confirmed when he noted the agonies experienced by his friend William Hilton in the quest of High Art and academic distinction. In no time De Wint was receiving free lessons from John Varley and then from Dr Monro, who had taught Turner and Girtin. By 1807 he was exhibiting at the Royal Academy; by 1808 at the Associated Artists; three years later he was a member of the Water-Colour Society. From then on his future was assured, and he painted prolifically until his death in 1849. He travelled extensively throughout England, particularly in and around Lincoln, Cumberland, Yorkshire and Derbyshire, going abroad only once, to Normandy.

The water-colours of De Wint are among the most beautiful of the nineteenth century, and when they are not weakened by fading, it is the colours which beguile. Colonel Grant aptly praises his water-colour painting for 'its lovely harmonies, its perfect unity, its Girtin-like simplicity and unrivalled succulence'. Choosing as often as not a wide and shallow panorama for his shape, he painted with two brushes, both large, but one old and blunt and the other new and pointed. Working quickly with the new brush, wet with colour, he would lay in the subject, and while the paper was still wet would add one harmonious tint after another. He would then work on the foreground with the old

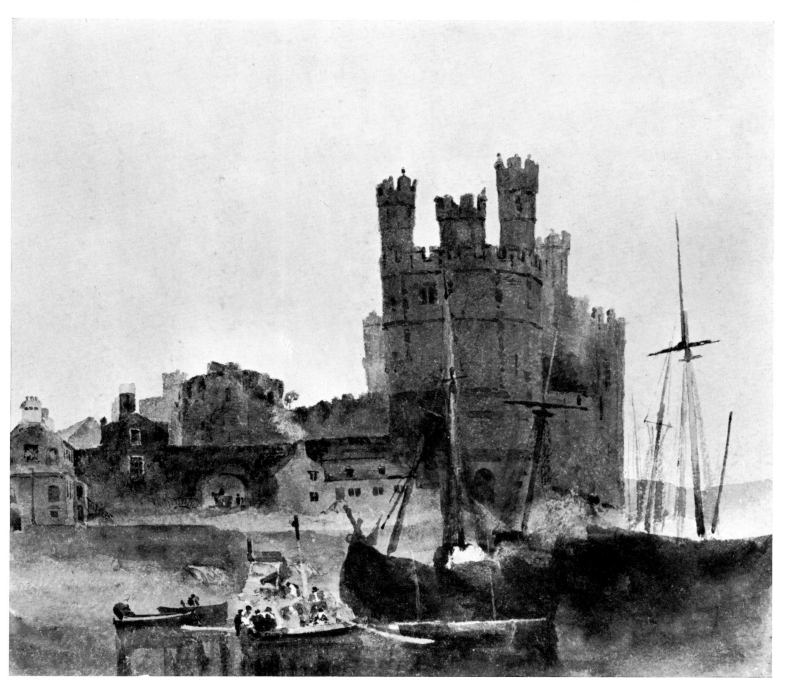

PETER DE WINT. *Caernarvon Castle*. Water-colour. 10 × 11½ inches. Fitzwilliam Museum, Cambridge.

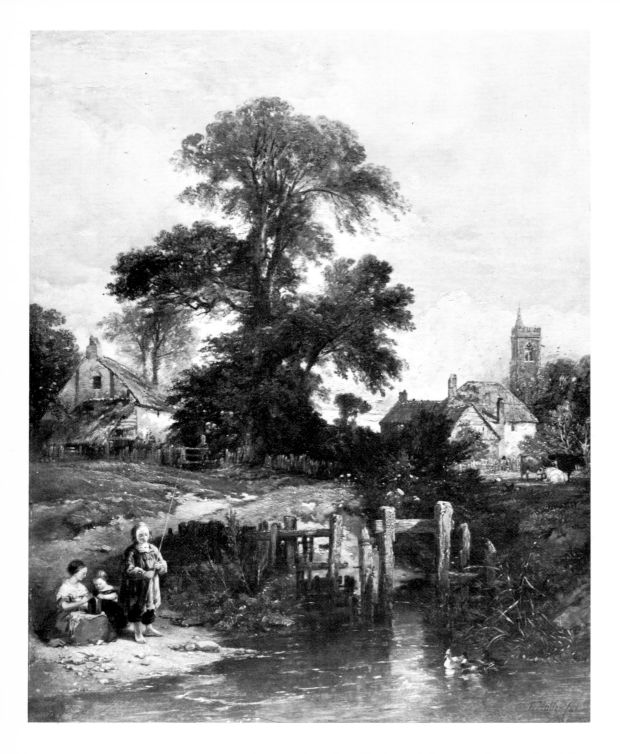

WILLIAM JAMES MÜLLER. *Gillingham on the Medway.* 42 × 34 inches. Signed and dated 1841. Guildhall Art Gallery, London.

A Suffolk Landscape by F. W. Watts is reproduced in colour on p. 54.

William Müller (1812–1845) was born in Bristol, where his father was curator of the museum, and died there at an early age of a heart ailment. His paintings display considerable technical virtuosity, ranging from the Turneresque to serene landscapes with quiet overtones of Constable and to the uneven swagger of his later works, which were noticeably more colourful after tours abroad. Edward Duncan (1804–1882) enjoyed a great reputation in his day. Although he may be seen at his best as a marine painter, he was capable of rendering fine landscapes. His innumerable studies of figures, horses and cattle sometimes combine the delicacy of Frederick Tayler with the sharp observation of Charles Keene. Frederick Tayler (1802–1889) had the distinction of having once shared a studio in Paris with Bonington. Although Tayler was able to produce refined landscapes, he was a better figure draughtsman; on at least one occasion Cox invited him to paint figures into one of his landscapes. Alfred Clint (1807–1883) was the son and pupil of George Clint, and exhibited landscapes at the Royal Academy for over forty years. He could devise fine effects, at times rivalling Danby in the red glow of his sunsets. The Barkers of Bath were an indefatigable family of landscape painters whose roots were deep in the eighteenth century, with Gainsborough as an immediate influence. Benjamin (1776–1838) was exhibiting in the last year of his life, a year after the Queen's accession; Thomas (1769–1847) also exhibited until his death nine years later. Another talented regional artist was Edmund Bristow (1787–1876), who appears to have lived at Windsor all his life; at his death 'The Art Journal' was unable to write his obituary, because nothing was known about him. He painted many pleasing views in and around Windsor. Thomas Baker (1809–1869), known as 'Baker of Leamington', was another moderately gifted regional artist, whose views of the Midlands received local support.

The reputation of Frederick William Watts (1800–1862) suffered during his life-time, and has done ever since, from a disturbing similarity between his landscapes and those of Constable. Although they both seem to have lived in Hampstead at the same time, Constable makes no mention of him, which is hardly surprising since he was not over-liberal in his comments on contemporary painters, nor is it likely that he would pay much attention to possible rivals. Certainly Watts cannot be accused of deliberate deception, but the charge of plagiarism is harder to escape. The subject matter and composition of his pictures, the profusion of lock-gates, barges and rivers, are Constable's currency. And yet somehow in the hands of Watts this currency never becomes counterfeit. His landscapes at their best are full, lush and always distinctive. The self-taught Alfred Vickers (1786–1868) had far less talent, and after a late start—

and worn brush, all the while scraping and adding neat little touches. He used many of the pigments used by Cox, but added to the range. With Cox's water-colours the eye goes straight to the middle distance then up towards the sky; with De Wint the foreground leads the eye to the middle distance.

De Wint's lack of success with oils and our comparative ignorance concerning his oil-paintings (the Redgraves do not even mention them) render a just appreciation of them a difficult task. In subject matter they recall Linnell, but the handling is distinctly his own, which was strong and assured, yet sometimes verging on coarseness.

he was forty-five before the Royal Academy would accept one of his canvases—he produced an enormous quantity of perfunctorily pretty landscapes which pleased then, as much as now, a public that demands no more of a landscape. The career of Vickers's extremely promising son, Alfred Gomersal, was cut short at the age of twenty-six in the first year of the Queen's reign. Thomas Creswick (1811–1869) was born in Birmingham and taught by J. V. Barber, whose father had given lessons to David Cox. His love of open air painting shows in his delight in natural observation, particularly in his treatment of rivers, trees and foliage. He is best known for his landscapes done in the north of England. And yet there is something claustrophobic about his wooded river scenes, for which he used a rather monotonous palette. Of these last three artists, Creswick, whose pictures never conflicted with the canons of good taste, came closest to being the Victorian Establishment figure, down to the inevitable Memorial Exhibition.

The paintings of Sebastian (1790–1844) and Henry Pether (*fl.* 1828–1862) fall squarely into the tradition of the picturesque in art. This tradition had its roots in the middle and late eighteenth century romanticism of Horace Walpole and William Beckford, respectively owners of the two great architectural extravaganzas, Strawberry Hill and Fonthill; in the poetry of Thomas Gray; and in the Gothic horror stories such as

Walpole's 'Castle of Otranto' (1764) and Ann Radcliffe's 'The Mysteries of Udolpho' (1794), which

THOMAS CRESWICK, R.A. *Landscape.* 27×35 inches. Royal Academy, London.

Exhibited at Philadelphia, U.S.A. International Exhibition 1876. This was Creswick's Diploma Work; he was elected R.A. in 1851.

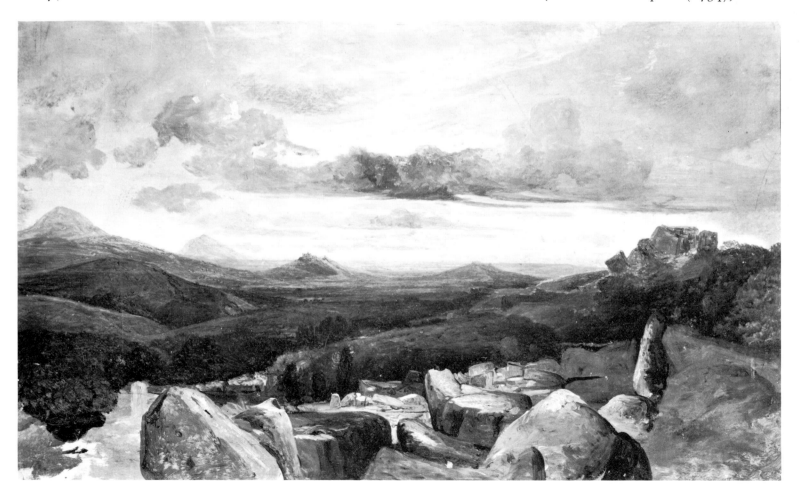

ALFRED CLINT. *Landscape with Mountains and Rocks.* 12½×19½ inches. Victoria and Albert Museum, London.

were later to be ridiculed in Jane Austen's 'Northanger Abbey' and Thomas Love Peacock's 'Nightmare Abbey', both published in 1818. This hyperbolical literary romanticism, together with the Byronic cult and the northern romances of Sir Walter Scott, contributed generously to the subject matter of contemporary painters. The Revd William Gilpin did much to foster the picturesque in his series of illustrated tours between 1782 and 1800. Soon no drawing-room album was complete without one or two of Gilpin's monochrome sketches, and there was a proliferation of water-colour transparencies of romantic moonlight scenes with ruined castles and lakes, designed to be held up before candles so that the candle light would shine through the moon, the window in the castle turret, and the reflections in the water. Romantic castles, grottoes and ruined abbeys were designed as tableaux, made up of cork, wood, plaster and other sundry materials. The careers of Sebastian and Henry Pether represent the culmination of this agreeable species of landscape, although it was later translated into a more homely setting by Atkinson Grimshaw. The confusion which always seems to surround the ubiquitous Pether family is a reflection of their scant treatment in art histories. Abraham (1756–1812), who was a cousin of William (?1738–1821), the mezzotint

WILLIAM ETTY, R.A. *Landscape.* Millboard. 18½ × 24 inches. City of York Art Gallery, York.

Painted in about 1840. Perhaps a view of the grounds at The Plantation, Acomb, near York. A standing female nude study (back view) is painted on the reverse.

THOMAS SIDNEY COOPER, R.A. *Cattle, Early Morning.* 23½ × 35¼ inches. Signed and dated 1847. Tate Gallery, London.

W. Q. Orchardson, when he was once staying with T. S. Cooper, met the latter coming in before breakfast with a canvas under each arm. Cooper explained with pride that he painted two pictures before breakfast every morning of his life (he was still exhibiting at the age of ninety-nine). Orchardson's later comment was: 'No wonder his pictures are all alike and all equally bad; he has perfected his imperfections'.

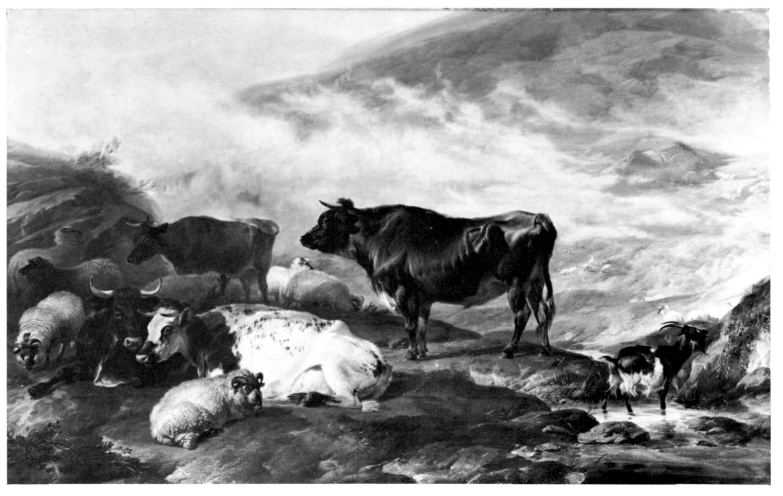

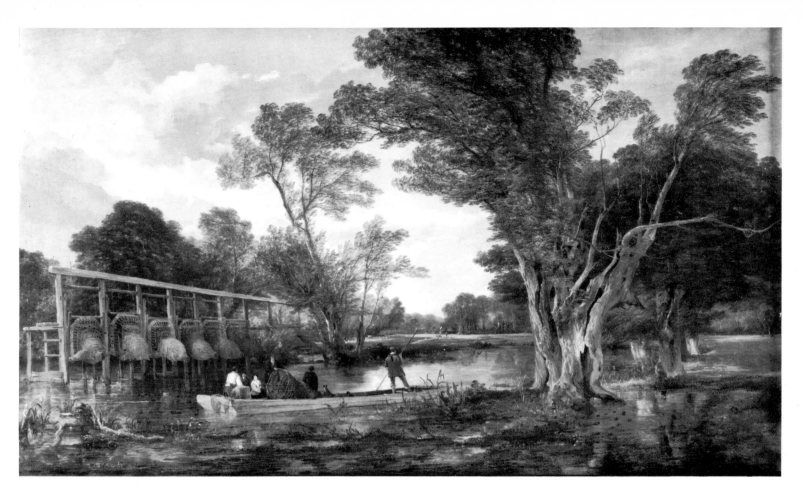

FREDERICK RICHARD LEE,
R.A. *Morning in the Meadows.* 43×71
inches. Royal Academy, London.
 This was Lee's Diploma Work; he
was elected R.A. in 1838.

FREDERICK RICHARD LEE,
R.A. *The Miller's Boat.* $34\frac{1}{4} \times 44\frac{1}{2}$
inches. Guildhall Art Gallery,
London.
 Exhibited at the Royal Academy
in 1847.

engraver, was their father, and acquired the nickname
'Moonlight Pether'. Certain facts are known about
Sebastian; scarcely any about Henry. Sebastian's life
is a tortured mosaic of poverty, illness and failure. His
first claim to fame came from his alleged invention of
the stomach-pump, which was introduced into the
medical profession by a surgeon friend called Jukes.
After this singular feat, he became a prolific painter
of moonlight landscapes, exhibiting belatedly at the
Royal Academy, until his death from consumption in
1844. Sebastian's pictures are rather repetitious,
often in imitation of the Dutch manner, and with the
cold nocturnal colours. But they are picturesquely
romantic, and certainly amount to more than a mere
footnote to early Victorian landscape painting. It is
not always easy to see where Sebastian's pictures end
and Henry's begin, unless they are signed. Henry
more frequently used a signature, and his pictures,
if less inventive in romantic imagery, are painted with
more refinement, and show a sense of topography and
local atmosphere, as in his view near the Tower of
London.

Another painter of landscapes who deserves notice
is William Etty (1787–1849), an occasional renegade
from nude painting. He sometimes introduced natural-
istic backgrounds into his pictures, which reveal an
instinctive, yet unfulfilled landscape painter. Through-
out his correspondence, Etty alludes lyrically to the

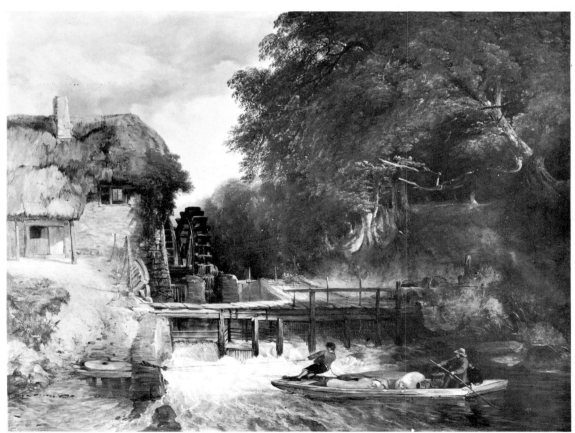

English landscape: 'From my room here I look over
the Vale of York, and cattle, cows etc., quietly feeding

The Tower of London by Moonlight by
Henry Pether is reproduced in
colour on p. 54.

51

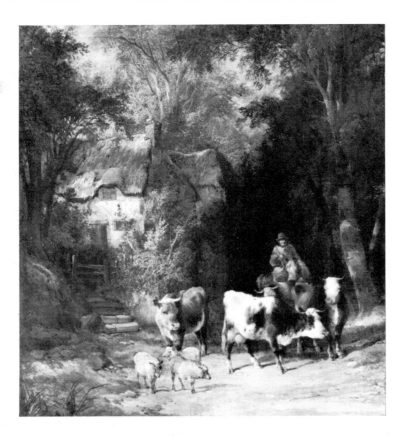

in the peaceful meadows . . . There, the river winds its serpentine length; and there, the square sail seems sailing through the meadows . . . Rich foliage, and apple-trees bearing fruit are the foreground of the picture.' His biographer, Gilchrist, records an early desire to paint pure landscapes. Very few of these have survived. Two of his best differ in style. *Landscape*, painted about 1840, is a lovely composition, delicately composed of lime and dark greens, pale blue sky and grey roofs. It is utterly different from *The Strid, Bolton Abbey*, probably painted about a year later, which has a spontaneity that suggests a painting done on the spot.

Edwin Landseer (1802–1873) was the archetypal Victorian artist, revered by his contemporaries from the Queen downwards. When he died the Queen noted in her journal: 'I possess 39 oil paintings of his, 16 chalk drawings (framed), two frescoes and many sketches.' But it was the small landscapes and sketches she liked most, and these were nearly all done before her accession. His *Lake Scene: Effect of Storm* (at the Tate Gallery), dating from about 1833, is a vivid example of his marvellous use of paint, and one is

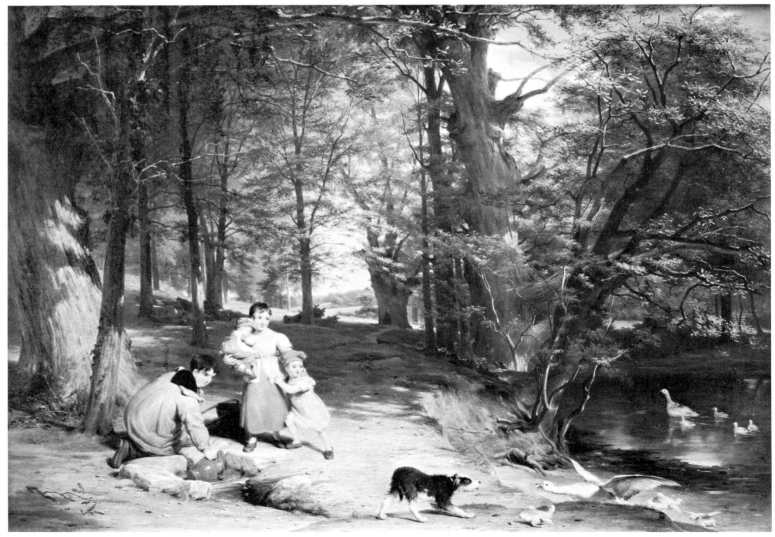

reminded that he was born in the same year as Bonington. The landscape backgrounds to his animal paintings, which occupied him for the greater part of his life, display a harder Germanic finish, no doubt revealing the influence of Prince Albert. But the landscapes became increasingly incidental to the animals. He is the foremost of a group of artists who painted animals in landscapes, including Thomas Sidney Cooper (1803–1902), who had studied under Verboeckhoven in Brussels. Cooper exhibited assiduously at the Royal Academy, painting up to a short time before his death at the age of ninety-nine. Occasionally, in the mid-fifties, his paintings achieve a Pre-Raphaelite smoothness, but the final reaction to seeing the plethora of cattle scenes is a feeling that cows look better on pasture than on canvas. Cooper

occasionally collaborated with Frederick Richard Lee (1798–1879) who has left an abundant legacy of adequately executed landscapes Neither better nor worse was George Shalders (?1825–1873). Richard Ansdell (1815–1885) was a painter after the pattern of Landseer, often filling his landscapes with four-square portraits of the squirearchy. William Shayer (1788–1879) was another artist as prolific as he was long-lived, exhibiting a total of 426 paintings during his life-time. He belongs to the tradition of Morland and Wheatley, bringing to it a marine flavour. Most of his best landscapes are shore-scenes with fishermen, animals, nets and boats. At his best, he painted very well indeed, but always one senses a fatal conformity. William Witherington (1785–1865) likewise began his career as a direct lineal descendant of the Morland/

DAVID COX, SENIOR. *Rhyl Sands.* 19×25 inches. The Rt Hon. Lord Clwyd.

Cox made several replicas of each of his more successful oil paintings, but always contrived to vary the incidents. The large finished, though perhaps least successful of the versions of this picture, is at Birmingham. An earlier version, more closely related to Lord Clwyd's, was probably painted in 1854, and is now at Manchester. *See p. 46.*

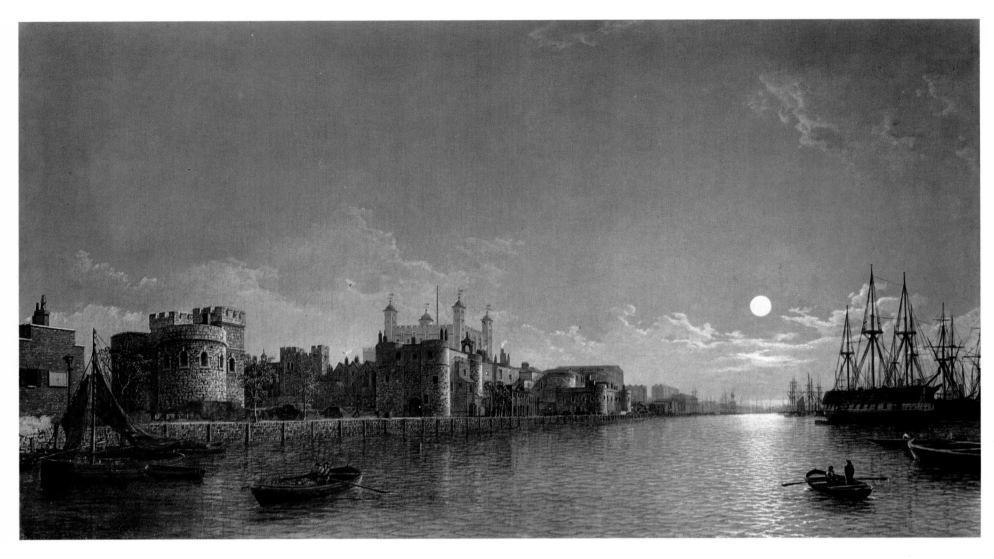

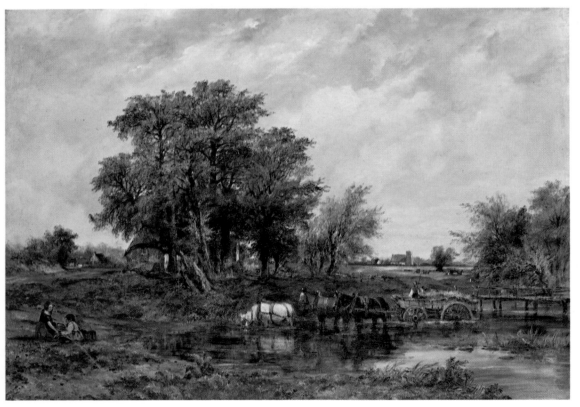

Wheatley tradition, later changing his style to conform to public demand, and painting like Creswick or Lee. Augustus Wall Callcott (1779–1844) celebrated the Coronation year by being knighted; he died seven years later, one of the first of a line of monumentally Victorian artists. Never more than a pleasing painter, Callcott could turn his hand to almost any kind of landscape to order. Colonel Grant has isolated five main classes in Callcott's work—British Landscape, Flemish views, Italian views, Seascapes and Classical Compositions. In his heyday, lines of carriages waited outside his studio, while distinguished visitors attended his own private view of pictures destined for the Royal Academy on the next day. A revival of interest in Callcott's pictures seems as unlikely now as it was fifty years ago.

William Collins (1788–1847) had a delightfully fresh if limited talent, and had been a friend and disciple of Wilkie. He is often seen at his best in shore-scenes, which, unlike Shayer's, have delicacy and refinement; there is often a group of children in the foreground. Constable, whose landscapes Collins's own sometimes recall, knew him but resented Collins's early success. Writing to Archdeacon Fisher in 1825,

he noted that 'Collins has a coast scene with fish as usual, and a landscape like a large cow-turd'. Both in oils and water-colours Collins had a nice, if rather suburban touch. His son, christened Wilkie in tribute to his friend, is remembered as the author of 'The Woman in White'. William Havell (1782–1857) and James Duffield Harding (1797–1863) are better known as water-colourists, although Havell also did oils, often of wooded landscapes somewhat in the manner of early Constable. They are distinctly his own, but the colouring tends to monotony. Harding, praised by Ruskin, was versatile: he produced drawings, water-colours, lithographs and oil-paintings. His oils, although not without merit, today command little attention. The small oils of Thomas Churchyard (1798–1865), executed in or around Woodbridge, Suffolk, have rather more vitality. He had a genuine, if fragile talent but, like F. W. Watts, he had a greater respect for Constable than was healthy for him.

London enjoyed the status of being a centre for all the arts, but had a rival in the city of Norwich, once a city of industry and trade, slumbering peacefully on the River Wensum, seemingly unaware of the Industrial Revolution, which served to increase its

isolation. The flat landscape and wide horizons had fired the imagination and talents of East Anglian

JAMES STARK. *Rocks and Trees.* Water-colour. 9 × 13¼ inches. Castle Museum, Norwich.

Opposite page, above:
HENRY PETHER. *The Tower of London by Moonlight.* 22 × 38 inches. Signed. Ministry of Public Building and Works, London.
 Painted in about 1850-5. *See p. 50.*

Opposite page, below:
FREDERICK WILLIAM WATTS. *A Suffolk Landscape.* 40 × 54 inches. Arthur Ackermann & Sons Ltd., London. *See p. 48.*

JOHN SELL COTMAN. *From my Father's House at Thorpe.* 27 × 37 inches. Inscribed and dated 'Jan. 18, 1842'. Castle Museum, Norwich.
 Painted on his return from his last visit to Norfolk in the autumn of 1841.

artists for some fifty years. The first and greatest Norwich School painter, John Crome, had died in 1821, leaving John Sell Cotman (1782–1842) as his most notable successor. Cotman's career had nearly drawn to a close by 1837 and for the last eight years of his life he was drawing-master at King's College in London. During these last years Cotman painted a number of large, strongly coloured water-colours, which often have a highly charged sense of drama. But it is the works of his middle phase which had a profound, if not immediate influence on English landscape painting. His modernity shows in his simplification of natural forms, painted with an apparently cavalier use of colour. A singularly apt tribute to Cotman is contained in Mr John Russell's review of the John Nash exhibition at the Royal Academy in 1967: 'He [Nash] had already learned from Cotman that painters are free to disentangle, simplify and re-organise the facts of Nature. They could leave a lot

out, if they felt like it, and they could develop their own habits of emphatic patterning; but those patterns had to be based on a profound understanding of form and not on some sloven's whim.'

The paintings of the Norwich School have a distinct overall personality and this makes attribution a hazardous affair, leaving one with the impression that it makes its greatest impact as a whole rather than through individual artists. However, certain artists like John Middleton (1827–1856), John Berney Ladbrooke (1803–1879), James Stark (1794–1859), Henry Bright (1810–1873), Alfred Stannard (1806–1889), Old Crome's son, John Berney Crome (1794–1842), Cotman's two sons, Miles Edmund (1810–1858) and John Joseph (1814–1878), have sufficient individuality—and indeed far more talent than some of their better known national contemporaries—to set them apart. The greater contribution of the Norwich School is, however, a collective one The view may be local, but the naturalism is universal, and was rarely painted without a high degree of excellence

IV

MARINE PAINTERS

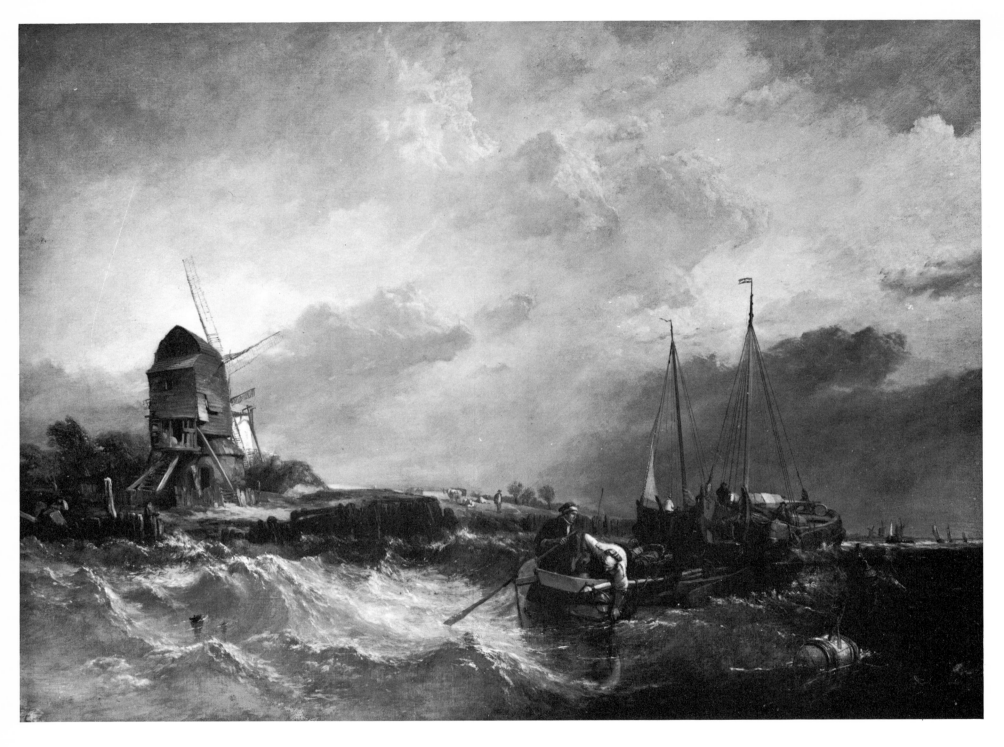

'*From childhood they dabbled in water, they swam like fishes, their playthings were boats.*'—Ralph Waldo Emerson on the English.

Britain in the nineteenth century was at the height of her maritime power, and, when Victoria came to the throne, was the greatest industrial and trading nation on earth. An island, with no place further than seventy miles from the sea, the country boasted the world's mightiest seaport, in the Thames Estuary, from which the great East Indiamen sailed to the India and China seas; then there were Newcastle and Bristol, centres of the coal and tobacco trades respectively, and their great rival Liverpool, with its trade in cotton and its command of the Atlantic trade-routes. Despite the gradual change from sail to steam, the great ships still presented a romantic appearance, and the skyline of every port was cross-hatched with masts and rigging, an alluring prospect to artists of the Island Race. The painting of water came naturally to landscape painters, living in a country surrounded by sea and traversed by innumerable rivers. Discussing the representation of water as a subject for painters in 'The Art Journal' of January 1863, Professor Ansted noted 'its infinite mobility; its variety of colour as produced by reflection and refraction; and its wonderful influence

in forming and changing the features of earth on land and by the sea.'

Many of the English sea painters were essentially landscape painters, although some of them are remembered best for their marine paintings. Incomparably the finest sea painter was Turner. The sea and events connected with it stirred him greatly and inspired him to paint some of his most moving pictures. Often in his marine painting there is a brooding sense of disaster, renewal and change: the sculptor Thomas Woolner describes how Woodington, a fellow sculptor, 'was on a steamboat returning from a trip to Margate when in the midst of a great blazing sunset he saw the old Téméraire drawn by a steam tug (to be broken up at Rotherhithe). The sight was so magnificent that it struck him as being an unusually fine subject for a picture . . . but he was not the only person on board who took professional notice of the splendid sight', for also noticing and making busy little sketches on cards was Turner. The result, *The Fighting Téméraire*, was shown at the Royal Academy in 1839, and was greatly loved by Victorians and by succeeding generations. The terror of storms, tempestuous seas, flapping sails and boatloads of puny humanity inspired some of his finest shipping scenes.

Prodigious events appealed to the great Romantic: when a $14\frac{1}{2}$ foot whale was displayed to the public, Turner, with his usual interest in marine matters, went to see it. This, together with his fondness for reading accounts of whaling in the northern seas, probably inspired a series of whaling pictures painted in 1845–6. Apart from Turner (and Constable and Bonington before the Victorian era), Cotman was the only other painter who treated sea subjects with real genius, although much of his best work had been done before 1837. His ability to achieve grand effects by simplification was something new in English art and was particularly suited to marine painting in watercolours, for rendering broad masses of light and shade.

One of the most distinguished of Victorian sea painters was Clarkson Stanfield (1793–1867). The son of an Irish actor and writer, he was brought up in a seafaring community. Although he showed early promise as a draughtsman, the sea won him, and he entered the Merchant Service in 1808. Four years later he was press-ganged into the Royal Navy, and it was whilst he was on board H.M.S. Namur that he painted scenery for shipboard theatricals. Shortly afterwards he was retired disabled after injuring his foot on an anchor. He took up scene painting in

Dutch Fishing Boats by J. M. W. Turner is reproduced in colour on p. 71.

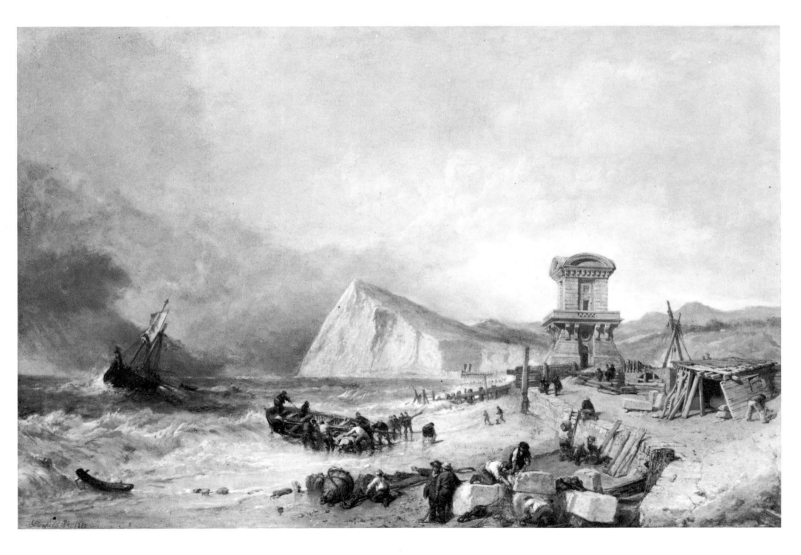

CLARKSON STANFIELD, R.A. *Shakespeare Cliff*. 23 × 36 inches. Signed and dated 1862. National Maritime Museum, Greenwich.
 A life-boat is being made ready to go to a brig in distress.

Edinburgh, and it was here that he formed a lifelong friendship with David Roberts. By 1829 the two artists were working together on large dioramic views, a series of tableaux on a slowly unrolling backcloth. One of Stanfield's included the progress of a ship from its manufacture to its wreck. He soon began to devote more time to easel painting, exhibiting a large number of pictures at the Royal Academy, and becoming a member in 1835. Broken-hearted by the sudden death of his friend Roberts in 1864, Stanfield survived him by less than three years. His pictures show a deep understanding of the sea, but while clouds and water are rendered exactly, they are often betrayed by a theatricality of effect (the canvases are sometimes so cluttered up with driftwood, buoys and other paraphernalia that one wonders how the ships could pursue their courses without extreme peril) and by a lack of real understanding of paint. Clouds and sea never merge, as they do in Turner and Cotman. To Thackeray, Stanfield's style is 'as simple and manly as a seaman's song. One of the most dexterous he is also one of the most careful of painters'. He was too careful for Ruskin who wished him 'less wonderful and

more terrible'. The simple virtues that served him well during his lifetime have not saved him from declining in public estimation. When Stanfield died, Queen Victoria considered Edward William Cooke (1811–1880) to have taken on his mantle. Cooke, who had had no formal training, was taught by his father to paint, draw and engrave. He emerged as a considerable figure on the Victorian scene, both as a painter and as an accomplished scientist, particularly in botany, becoming a Fellow of the Royal Society. In painting he showed more skill than Stanfield, and often worked up his subjects from small sketches done on the spot. Although he had a marvellous eye for detail and feeling for composition, the colours sometimes lack warmth.

Another artist who took up scene painting in his formative years was George Chambers (1803–1840). Born in poverty, the son of a seaman, he went to sea at the age of ten. He was soon delighting his shipmates with his drawings. Although he was never healthy as a boy, his determination and considerable talent, together with the kindly patronage of a Wapping publican, brought him to the notice of the public.

EDWARD WILLIAM COOKE, R.A. *Venice*. 15⅝ × 26¼ inches. Signed and inscribed 'Venezia 1850'. Frank T. Sabin Ltd., London.

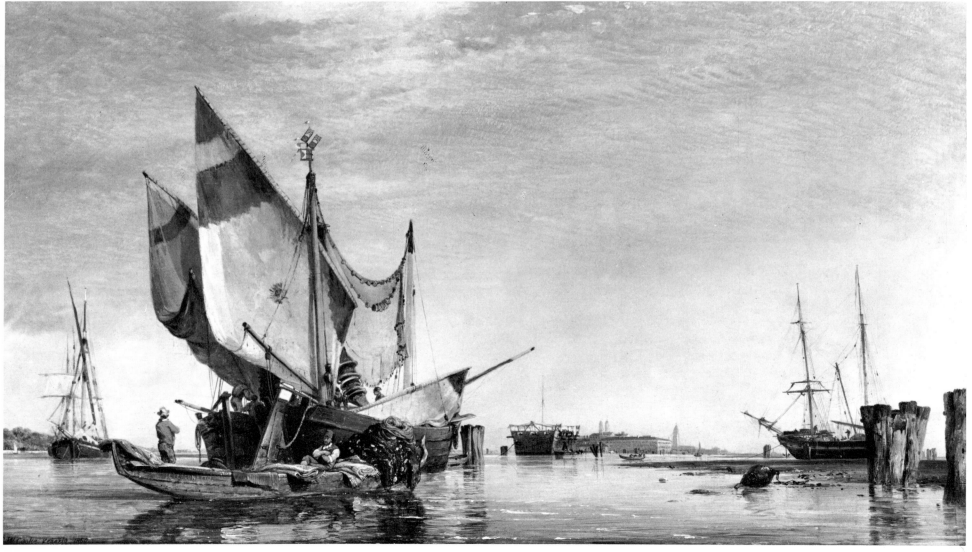

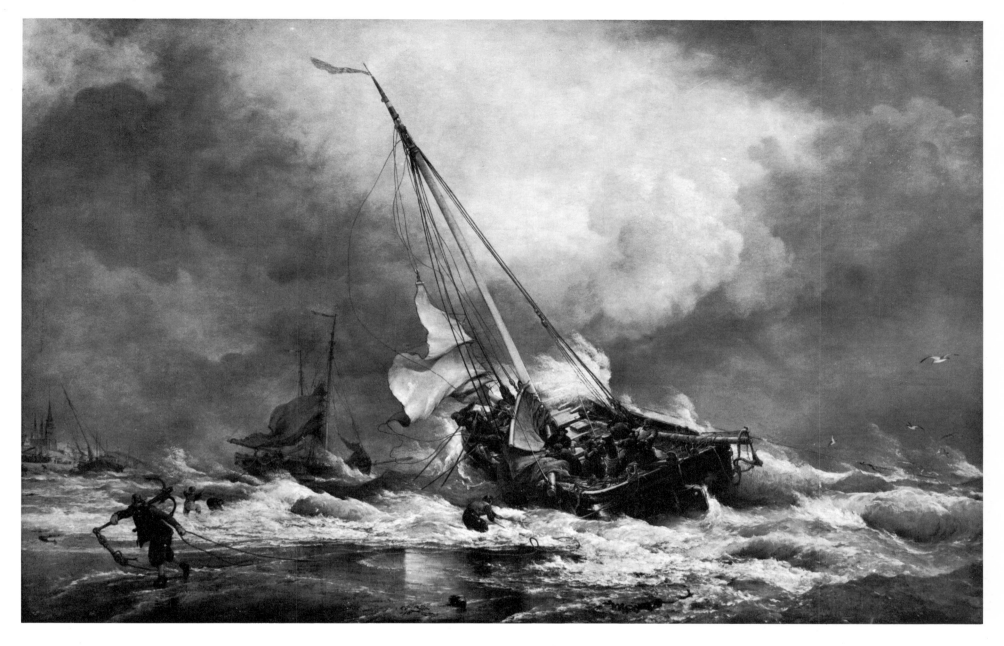

From 1827 until his early death he exhibited at the Royal Academy. He was buried, like Bonington, at St. James's Chapel, Pentonville. He was prolific and a more fluent painter than Stanfield, but less fortunate in his rewards. The work of Chambers and Stanfield illustrates the growing naturalism of nineteenth century sea painting, distinguishing it from the mannered tradition of Van de Velde. On the other hand, artists like Turner and David Cox (who was also capable of painting fine sea subjects) were preparing the way for the impressionism of Whistler and Steer. Another element was soon to join these, in the Pre-Raphaelitism of John Brett and Henry Moore. Meanwhile the hackneyed convention of Van de Velde continued to be brilliantly exploited by artists like John Schetky (1778–1874), a Scotsman (despite the name), who exhibited sea paintings at the Royal Academy for nearly seventy years. His paintings are characterised by a lightish palette and rather flat drawing with a high finish. Schetky was always accurate and sympathetic in his painting, and it seems natural that he should have been employed as Marine Painter by the sea-loving William IV, and later by Queen Victoria. Newcastle produced a sea painter of great, though sometimes uneven, natural talent in James Wilson Carmichael (1800–1868). He lived in his native town until 1845, when, already well-known for his sea pictures, he came to London. Some of the sketches he made in the Baltic during the Crimean war were engraved for 'The Illustrated London News'. Last exhibiting at the Royal Academy in 1859, he retired to Scarborough, where he died.

The tradition of ship portraiture continued to find expression through artists like John Ward (1798–1849), a native of Hull. His work reveals the influence of William Anderson, who died in 1837. In the work of William John Huggins (1781–1845) can be found the ultimate expression of the nineteenth century ship

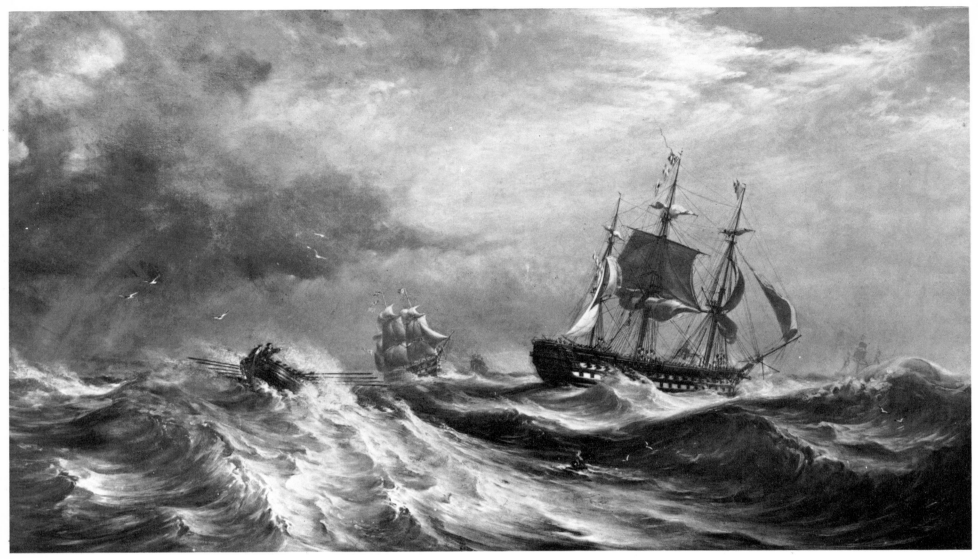

portrait. He was assisted by J. M. Huggins, whose work is almost undistinguishable. Samuel Walters (1811–1883) of Liverpool, later assisted by his son George, painted accurate ship portraits and shipping scenes; and Joseph Walter (1783–1856), a native of Bristol, painted in an attractive manner, combining traditionalism and naturalism. With James Webb (c.1820–1895) we are brought back to the naturalists: Webb had a fine feeling for atmosphere and his pictures are painted with lively freedom.

Two painters who excelled in water-colour contributed substantially to the naturalistic tradition: they were Edward Duncan (1804–1882) and Antony Vandyke Copley Fielding (1787–1855). Both enjoyed a high reputation during their life-time, particularly the latter; this was due to the championship of Ruskin who claimed that 'no man has ever given, with the same flashing freedom, the race of a running tide under a stiff breeze; nor caught, with the same grace and precision, the curvature of the breaking wave, arrested or accelerated by the wind.' Equally at home by the lake or on the open sea, Copley Fielding did indeed

convey the appearance of water, in a number of brilliantly executed water-colours; many of them are now sadly faded, owing to his persistent use of indigo. Duncan, the son-in-law of W. J. Huggins, never achieved the fame of Copley Fielding during his life-time, but it is difficult now to escape the conclusion that the quality of his work was in every way equal to that of Copley Fielding, and certainly not so uneven. Other excellent marine water-colourists were Charles Bentley (1806–1854), William Callow and his brother, John (1822–1878), Edwin Hayes (1820–1904), another native of Bristol, William (1803–1867) and John Joy (1806–1866)—known as 'The Brothers Joy'—whose collaboration resulted in an important legacy of water-colours, Thomas Sewell Robins (d. 1880), who achieved great popularity, and Thomas Bush Hardy (1842–1897), a competent but highly repetitive painter.

The passing of the age of sail was a stimulus to the historical sea painters, and the romantic history of naval engagements, voyages of discovery and piracy supplied the themes. This *genre* produced no great art,

JOHN BRETT, A.R.A. *Echoes of a Far-off Storm.* 42 × 84 inches. Guildhall Art Gallery, London.
Exhibited at the Royal Academy in 1890.

but it contributed to later Victorian iconography. Notable among the practitioners was Oswald Walters Brierly (1817–1894) whose patriotic subjects like *The Retreat of the Spanish Armada* earned him the post of Marine Painter to Queen Victoria. William Lionel Wyllie (1851–1931) was a far more interesting artist.

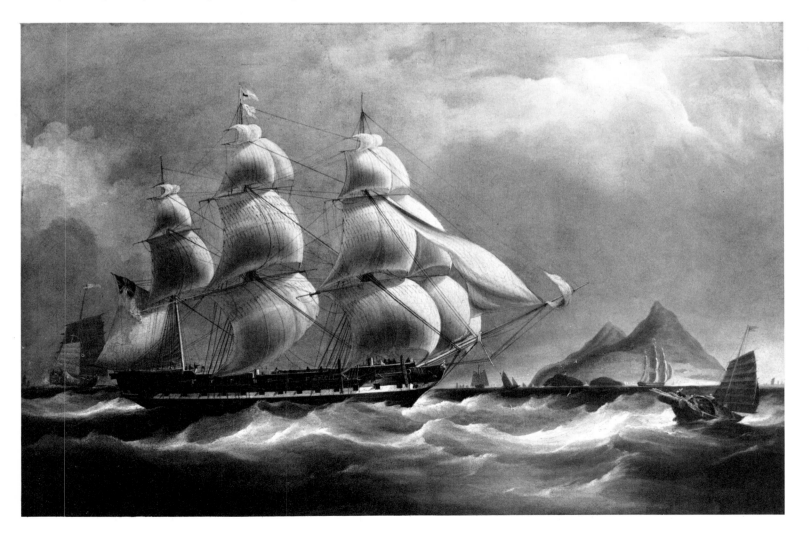

WILLIAM JOHN HUGGINS. *The Asia East Indiaman in the China Seas.* 32 × 50 inches. Signed and dated 1836. National Maritime Museum, Greenwich.

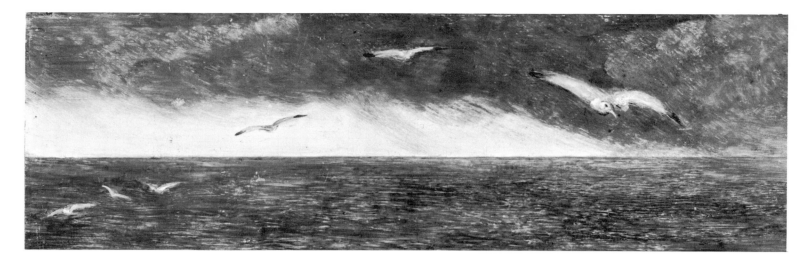

Only occasionally did he stray into historical painting,
as in *The Battle of the Nile* of 1899, and his early work
shows a strong feeling for composition and atmosphere.
His later sea paintings and etchings always main-
tained a high level of achievement. His brother Charles

William Wyllie (1853–1923) was another accom-
plished sea painter. The sea attracted a number of
subject painters, like James Clarke Hook (1819–1907),
Stanhope Forbes (1857–1947), Henry Scott Tuke
(1858–1929), a fine painter, who specialized in paint-

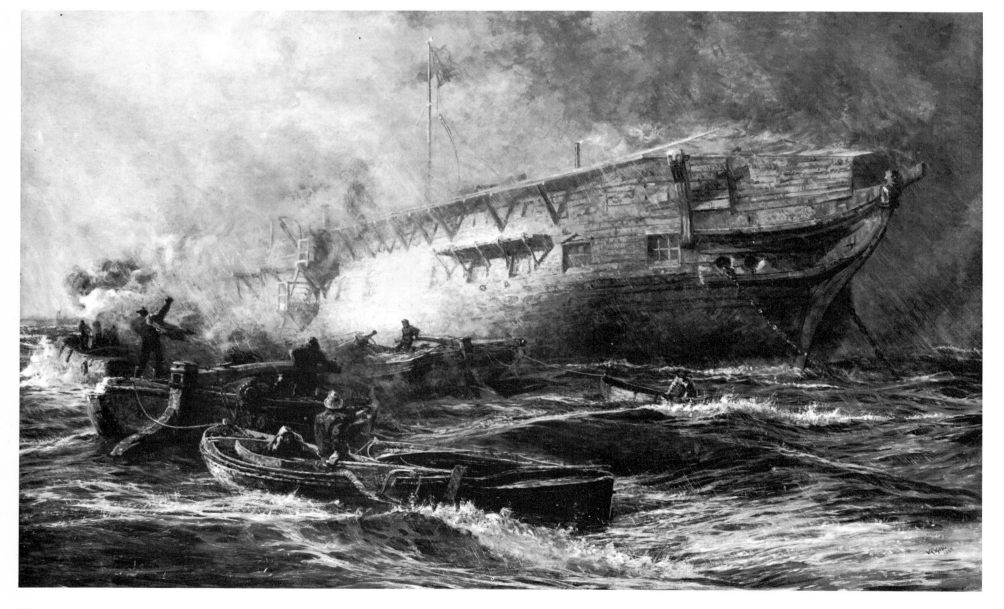

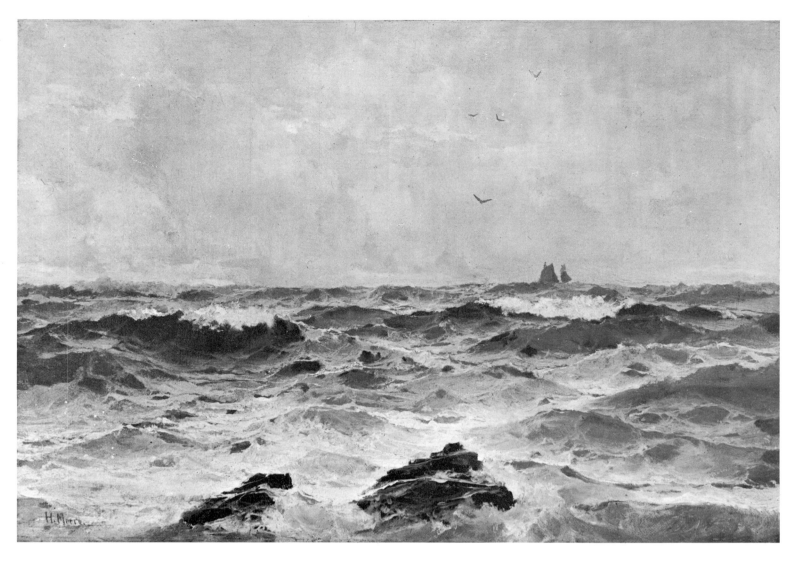

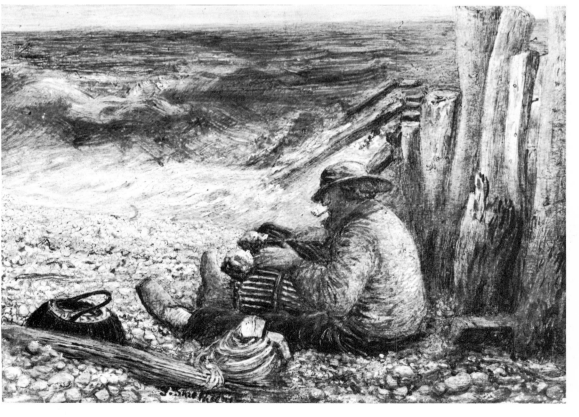

ing male nudes, usually bathing, in the open air; and John Robertson Reid (1851–1926), whose Cornish fisherfolk and fishing craft were familiar favourites at the Royal Academy. A better painter was Charles Napier Hemy (1841–1917), who, after an early flirtation with Pre-Raphaelitism, became a salty chronicler of maritime pursuits. Frank Brangwyn (1867–1956) was already famous before the end of the century for his sea paintings, which were usually painted at first with a greyish palette, and then, after his return from the East, in his twenties, with brilliant colour.

James Smetham, John Brett (1830–1902) and Henry Moore (1831–1895) took Pre-Raphaelitism to the sea-side and the open sea. Moore and Smetham displayed a canny attitude towards Pre-Raphaelite principles, but Brett allowed himself to be sadly misguided: after his early successes, *The Stonebreaker* and *Val d'Aosta*, he fell victim to Ruskin's autocracy, and developed an interest in botany, geology and astronomy. Plying up and down the South coast and sometimes to the Channel Islands in his yacht he painted endless coastal scenes, usually in minute detail. He occasionally achieved true merit, but only when, paradoxically, his work came nearest to the bright

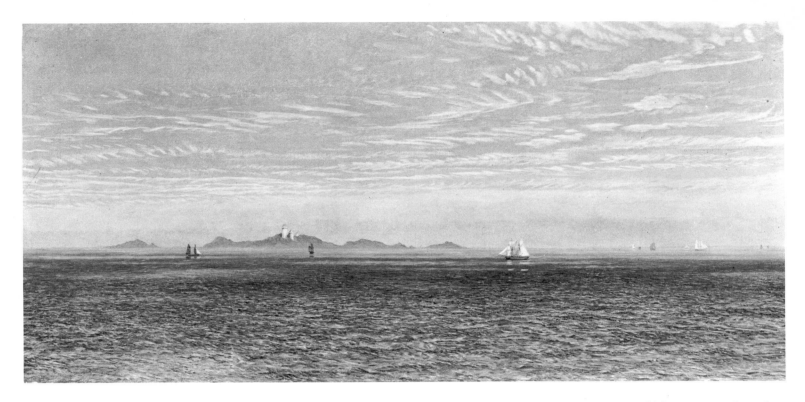

flame of Pre-Raphaelitism. Henry Moore employed an altogether looser style in his sea pictures. An adventurous colourist, he painted pictures which, like Smetham's, often convey a fine sense of atmosphere. Whistler and Tissot found their subjects on the River Thames: in the *Nocturnes* the reflections of lights in water, seen through twilight mists, resume the tradition of Turner; Tissot painted many of his most enchanting pictures on board ship, to a background of masts and rigging, faultlessly drawn. Philip Wilson Steer (1860–1942), guided by the early example of Monet, painted his luminous shore-scenes in the 'nineties, and then, like Turner, refined his style to the point of almost complete abstraction.

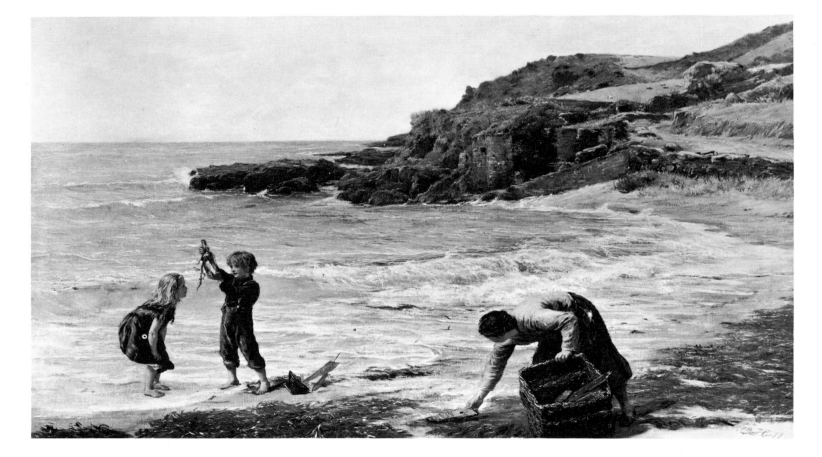

V

SPORTING PAINTERS

'*The Englishman associates well with dogs and horses*'—Ralph Waldo Emerson.

The year 1837 saw the English tradition of sporting painting in an advanced stage of transition. Among the causes were a changing attitude to certain aspects of sport, the triumph of the railway over the stagecoach, the increasing humanitarianism of the laws relating to poaching, and, not least, the recent deaths of some of England's greatest sporting painters.

Rural England at the beginning of Queen Victoria's reign would, at first sight, have presented an appearance similar to that of Regency times. If the cities were becoming visibly more democratic, the countryside was still in the hands of the landlords. Field sports were as popular as ever—less rowdy than before, and more respectable—but no less humorous. Jorrocks echoed the sentiments of great numbers of the rural population in his apostrophe ' 'Unting is all that's worth living for—all time is lost wot is not spent in

'unting . . . it's the sport of kings, the image of war without its guilt, and only five-and-twenty per cent of its danger.' With the new systems of drainage and the enclosure of open fields, culminating in the General Enclosure Act of 1845, Victorian huntsmen had to jump farther, higher and more frequently than their ancestors, who were more prone to be unseated by the branch of a tree, a favourite subject with Rowlandson. The England of Cobbett had yielded place to the England of Surtees, whose creation Mr Jorrocks, the sporting grocer, reflected the growing classlessness of the hunting field. In Surtees's works, with their humorous illustrations by John Leech (1817–1864), the gentle absurdities of an era are brought vividly to life. Cock-fighting, bear-baiting and other brutalities were by now a thing of the past, washed away by the rising tide of humanitarianism, evangelicalism and respectability; so also were the ferocities of the prize-ring. The harsh poaching laws of 1816, with transportation as punishment, with the wars, involving organised bands of poachers against gentlemen and game-

JOHN FERNELEY, SENIOR. *Hunters Intrepid, Conqueror and Bay Bolton, with Silkman and Darnley in the background.* 46½ × 73½ inches. Arthur Ackermann & Sons Ltd., London.

This picture is recorded in Ferneley's account book no. 663, Oct. 1853, and was painted for William Angerstein.

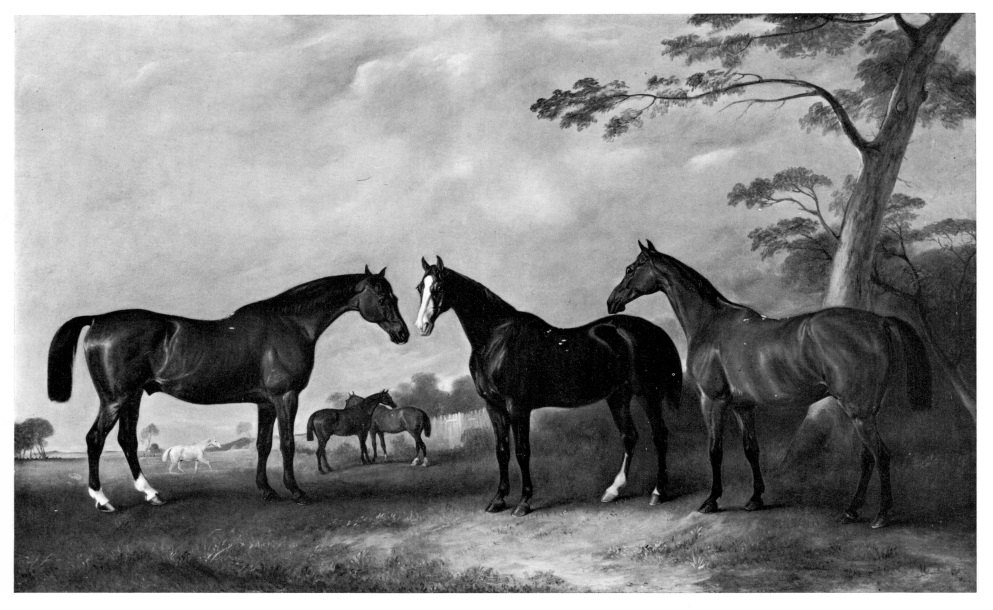

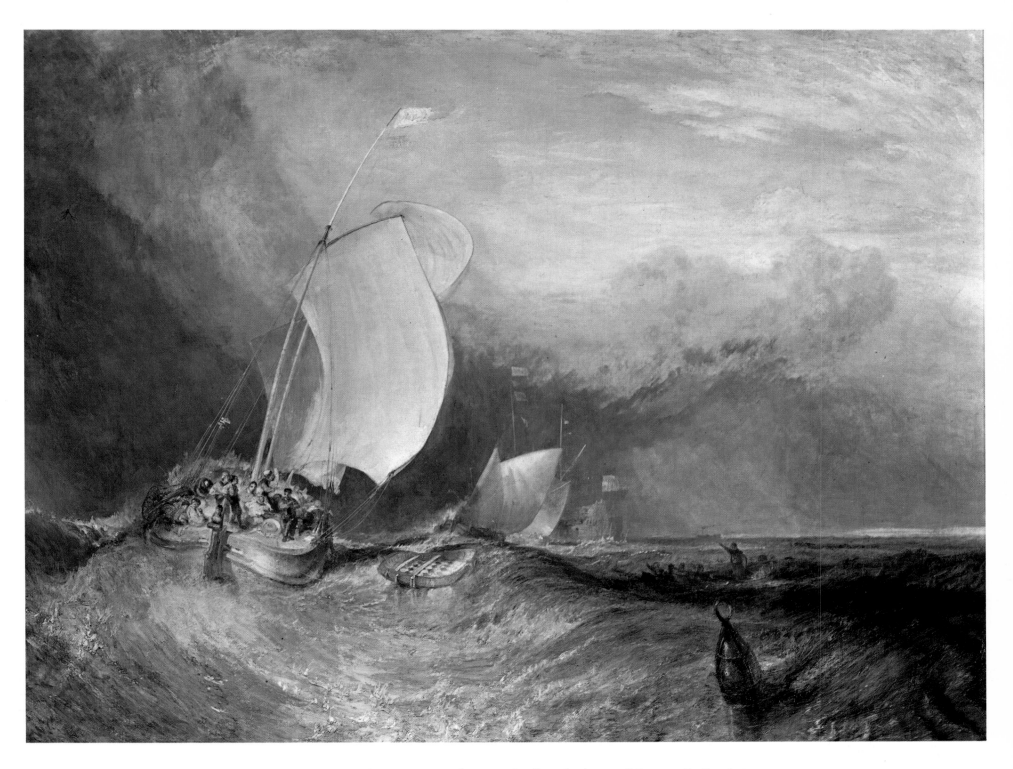

keepers, and with the setting of man traps and spring guns, were palliated by an Act of Parliament in 1827, and further victories were won by the humanitarians in a succession of new game laws. This led to a greater freedom in the pursuit of game, and with the rising middle classes now able to shoot and fish with greater impunity, so sporting painters increasingly depicted these practices. The existence of the fashionable Jockey Club ensured the survival of horse-racing and its continuity as a subject for painters.

The first thirty or so years of the nineteenth century were the golden age of the stagecoach. The brilliant aquatints and oil paintings of James Pollard (1792–1867) and others depicted the bustle of arrivals and departures of stagecoaches. Before the building of Paddington Station, the White Horse Cellar in Piccadilly (the site of the present Ritz Hotel) was the coach terminal for traffic to the West. The appearance of the railways extinguished a way of life. Roads and inns were neglected; innkeepers, post masters, coach proprietors, coachmen and ostlers were ruined. And Pollard, like Henry Alken, his vogue outlived, died in poverty. In the decade before the accession of the Queen, a number of great sporting artists had died:

JOSEPH MALLORD WILLIAM TURNER, R.A. *Dutch Fishing Boats.* 68⅝ × 78¼ inches. The Art Institute of Chicago.

Painted in about 1837-38. *See p. 61.*

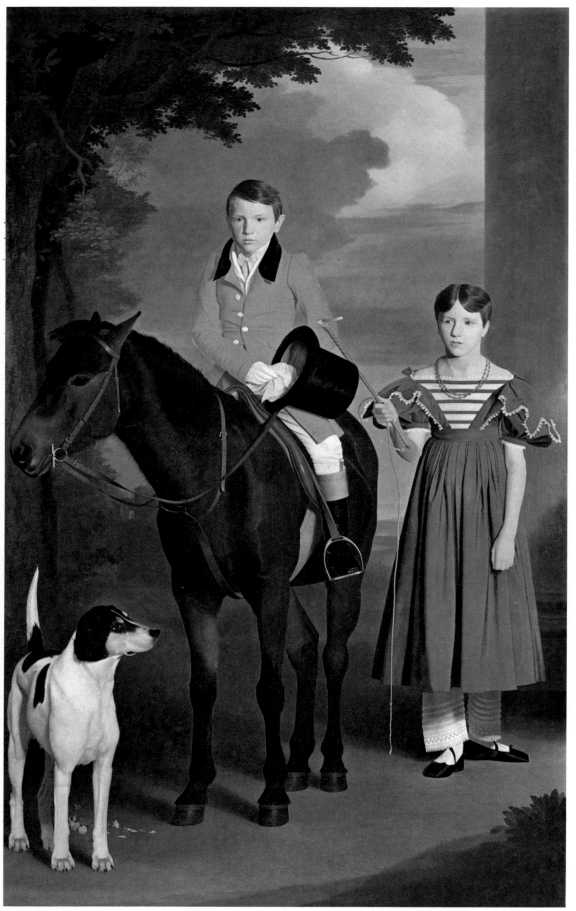

JACQUES-LAURENT AGASSE. *John Gubbins Newton and his Sister Mary.* 92½×56½ inches. Mr and Mrs Paul Mellon.

This picture, which is ascribed to Agasse, was painted during the 'thirties. The Gubbins-Newton family lived at Milla(i)ton, Bridestowe, Devon.

J. N. Sartorius in 1828, Philip Reinagle in 1833, Ben Marshall in 1835, Dean Wolstenholme senior in the Coronation year; and Charles Towne was to die three years later. Of the many sporting painters who survived into the new reign some had their best work already behind them. This is true of Agasse, John Ferneley (1782–1860), Henry Alken (1785–1851), Richard Barrett Davis (1782–1854) and James Ward (1769–1859).

Born in Leicestershire, the son of a wheelwright, John Ferneley followed in the tradition of Stubbs and Ben Marshall, under whom he probably studied in London in 1803, after an early apprenticeship with his father. By the age of eighteen he was proficient enough at painting to sell his *Great Billesdon Coplow Run* to the Duke of Rutland. The Duke commissioned further pictures and soon Ferneley was painting large hunting subjects. In 1806 he was employed by Assheton Smith, who had just purchased the Quorn Hounds; and eight years later Ferneley finally settled down at Melton Mowbray, Leicestershire, where he lived and worked for the rest of his well-ordered life. He soon gained a reputation as a painter of horse portraits, and of hunting and racing subjects. Some of Ferneley's pictures were of a colossal size—one of them was thirty feet long and contained thirty-two nearly life-size portraits—but when he was not working on a grandiose scale, he was capable of great refinement, in contrast to the earthy muscularity of Ben Marshall.

It might be said that Francis Grant (1803–1878), so far from having to start the hard way like most sporting painters, was born with a silver paintbrush in his mouth. The fourth son of the Laird of Kilgraston, he was educated at Harrow and was intended for the law; but an early interest in painting, and the fact that he had run through his inheritance, decided him to take up painting as a career. He was fortunate enough to meet John Ferneley at Melton Mowbray. Ferneley gave him lessons and soon the two artists became great friends. It was not until he was thirty-one that Grant first exhibited a picture. From then on his future was assured, and he became a favourite with English Society, marrying a niece of the Duke of Rutland. He was soon a fashionable portraitist, usually of equestrian subjects, and a painter of hunting and shooting parties. His pictures are painted with a convincing style, displaying a kind of Romantic flamboyance free from the occasional stiffness one finds in his contemporaries. *The Melton Hunt Breakfast*, exhibited in 1834, became one of the most famous of all nineteenth century sporting pictures, which was all the more remarkable as it depicts an indoor scene. But the picture that made his name was *H.M. Staghounds on Ascot Heath*, exhibited at the Royal Academy in 1837. *Master James Keith Fraser on his Pony*, exhibited eight years later, is an elegant example of his manner.

A Royal Academician in 1851, he became President on Sir Charles Eastlake's death. Having declined the offer of burial in St. Paul's Cathedral he was buried in Melton Church.

No artist can have done more to popularise hunting in the nineteenth century than Henry Alken. And no name is more familiar than that of Alken in the history of English sporting painting, since there was scarcely a time between the early eighteenth and the late nineteenth century when no member of this painting family was in the saddle or at the easel. Henry painted an enormous number of pictures, water-colours and drawings. Many of these were engraved, and found their way into every household

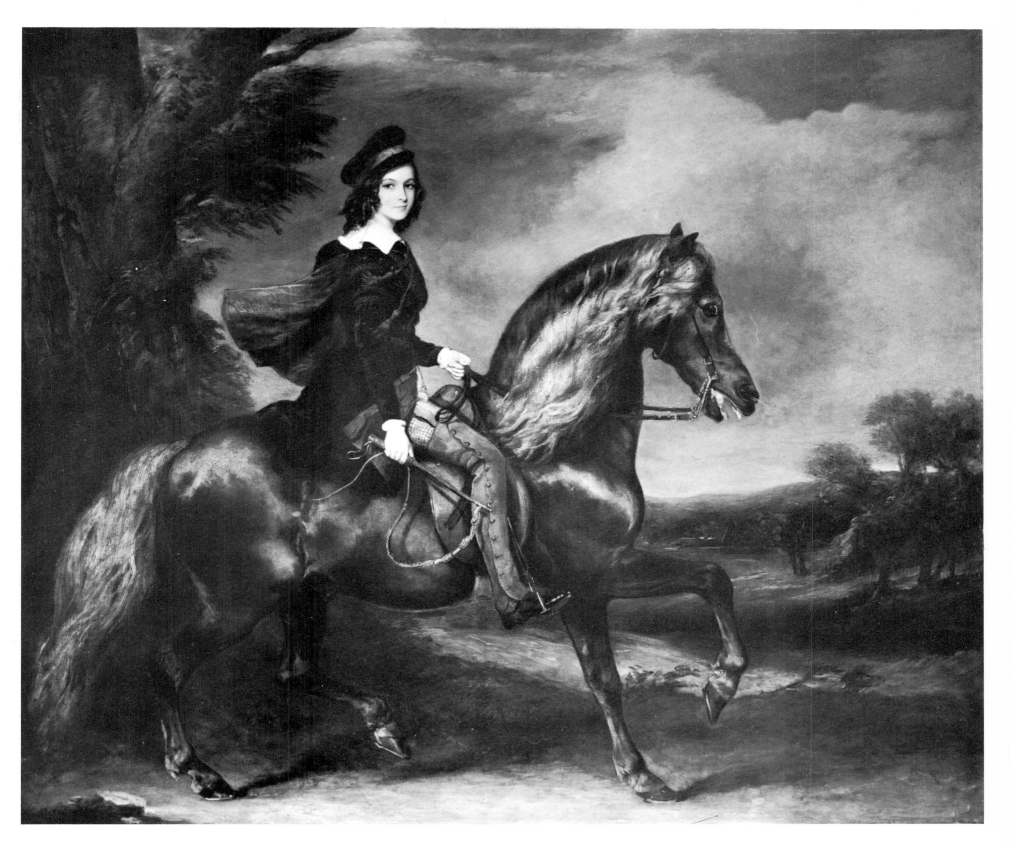

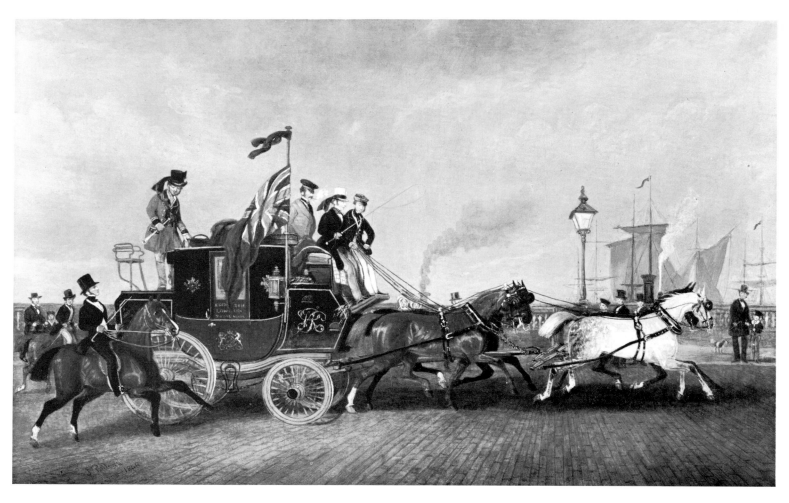

JAMES POLLARD. *The Last Run of the Royal Mail Coach from Newcastle to Edinburgh, July 5 1847.* 17¼ × 26¾ inches. Signed and dated 'J. Pollard 1848'. Mr and Mrs Paul Mellon.

The first owner of this picture was Edward MacNamara, who was a close friend of Pollard and had the sole contract for the Royal Mail. MacNamara founded the London General Omnibus Company in 1855.

HENRY ALKEN, SENIOR. *The Meet.* 12 × 16 inches. Arthur Ackermann & Sons Ltd., London.

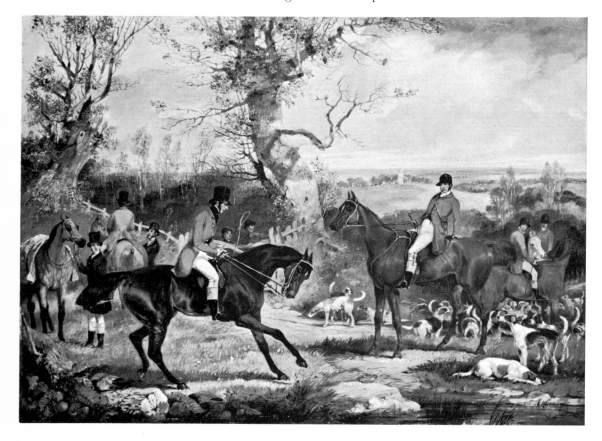

that rode to hounds, and into many that did not. His feeling for landscape and for the characteristics of horse and hound and the turf reveals deep understanding of his subject. His popularity has never been in doubt. Walter Shaw Sparrow observed that 'even pawnbrokers never turn Alken with his face to a dusty wall'.

The same might be said of James Pollard, whose versatility matched Alken's. His first painting was an inn sign; his earliest successes were of large groups of horsemen. He is best known for his lovely aquatints of coaching scenes, both from before and after the arrival of the railways. Shooting, fishing and the race course all found lively and colourful expression in his paintings and prints.

Abraham Cooper (1787–1868), who was the son of a tobacconist, enjoyed a considerable reputation in his day. He was largely self-taught, except for a few lessons from Ben Marshall; perhaps, like David Cox in his youth, he was once employed, at the age of thirteen, by Astley's Circus, which was managed by his uncle. His job was to take part in mimic battles and pageants, an experience which no doubt proved useful for his battle and sporting pictures. He was a painter of more than average talent, excelling in horse portraits and shooting scenes. Cooper has, however, been rather eclipsed by his more celebrated pupil, John Frederick Herring (1795–1865). This artist is said to have decided to become a painter when, at the age of nine-

teen, he saw the St. Leger run at Doncaster. He began making a living as a coach painter and then for some years he was a coach driver on the 'York and London Highflyer', painting in his spare time. Some friends introduced him to Abraham Cooper, and from then on he made an enviable reputation as a horse painter, exhibiting frequently at the Royal Academy. He was patronised by the Queen, the Duchess of Kent and the Duke of Orléans. His knowledge of animal form has been equalled by few other English sporting artists: he was always accurate, particularly in portraying thoroughbreds, but his later work painted in Victoria's reign tended towards a rather dry finish.

The merits of Jacques Laurent Agasse are discussed elsewhere; many of his best sporting pictures were painted before 1837. However, his portrait of *John and Mary Gubbins Newton*, painted at the very outset of the Queen's reign, reveals him as a painter of consummate power and as a portraitist of almost unnerving insight. Richard Barrett Davis and Henry Barnard Chalon (1770–1849), like Agasse, both shared the advantages of Royal patronage, and it was with the Chalon family that Agasse stayed when he first came to England in 1800. Again, like Agasse, Chalon had been employed by George IV as an animal painter, continuing under William IV. R. B. Davis was the son of a huntsman to the Royal Harriers and, as a result, his early drawings came to be seen by George III, who recommended him as a pupil to Sir William Beechey. Both Davis and Chalon were competent horse painters who could be relied upon to paint well on demand. Two sets of brothers, John Dalby (c.1810–c.1865) and David Dalby (c.1790–c.1845), and Henry Barraud (1811–1874) and William Barraud (1810–1850), and Dean Wolstenholme Junior (1798–1882), son of a more famous sporting painter, underline the system of apprenticeship and family continuity which applied to the artist in much the same way as to the blacksmith, wheelwright or coach-painter. With other painters like Henry Hall (exhib. 1838–1882), Thomas Brettland (1802–1874) and F. C. Turner (1795–1865), they ensured the continuity of a tradition, which was maintained into the present century by Alfred Munnings (1878–1959). Charles Cooper Henderson (1803–1877), best known for his coaching subjects, was an early pupil of Samuel Prout and once a rival of James Pollard; he combined a genuine talent for his subject with a feeling for atmosphere. His coaching scenes were the last to depict a form of transport which was by then an anachronism.

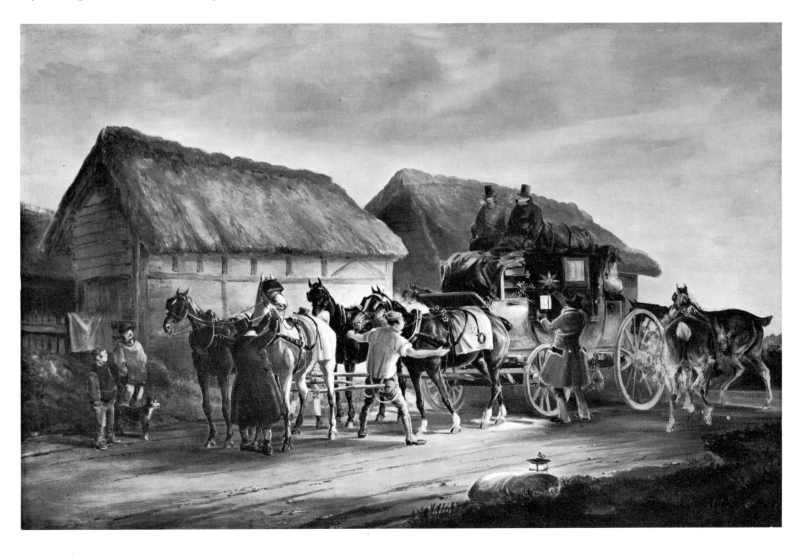

CHARLES COOPER HENDERSON. *Coaching scene – the Night Team, The Brighton Mail*. 20¾ × 30 inches. Signed with initials. Arthur Ackermann & Sons Ltd., London.

Engraved by B. Papprill and published in 1837 by Fores.

VI

ANIMAL PAINTERS

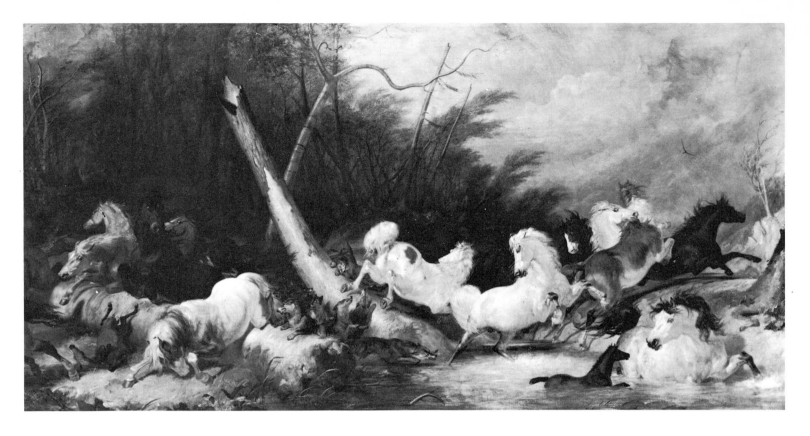

THOMAS WOODWARD. *Horses suprised by Wolves.* 28⅞ × 54 inches. Signed and dated 1842. Tate Gallery, London.

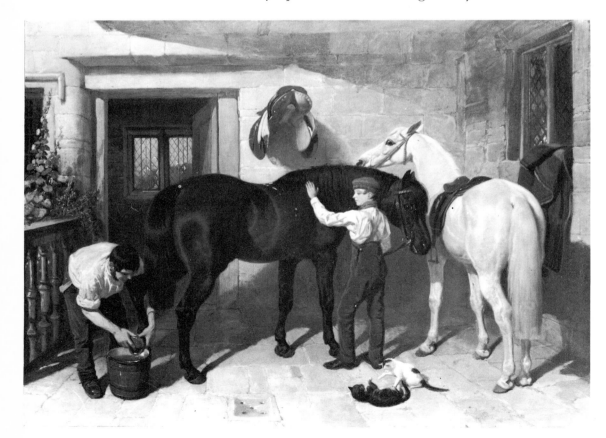

JOHN FREDERICK HERRING, SENIOR. *Groom and Horses in a Stable Yard.* 27 × 37 inches. Signed and dated 1849. Arthur Ackermann & Sons Ltd., London.

The saddled grey is Herring's Arab Imaun.

In the Jubilee year of 1887, thousands of prisoners all over the British Empire were released. All sentences had been remitted in honour of the Queen—all, that is, except those for cruelty to animals, which was to the Queen 'one of the worst traits in human nature'. This was symptomatic of the legendary love of animals borne by Englishmen from Royalty downwards, a characteristic which has always confounded other races and led to the opinion that the English treat their animals better than their children. The ownership of wild and exotic pets by the educated and moneyed classes reached bizarre heights in Victorian England. Rossetti could disconcert visitors to his Cheyne Walk house by showing them his menagerie, which included wombats, moles, dormice, armadillos and tortoises.

The 13th Earl of Derby kept a large menagerie, which Edward Lear was engaged to paint for four happy years. But it was the animal-loving instincts of the House of Hanover which acted as the most powerful stimulus to animal painting. George III kept for a time an elephant and a zebra, while his brother, the Duke of Cumberland, owned lions and at least one tiger. George IV spent large sums of money with Edward Cross, a dealer in foreign birds and animals. He had commissioned Stubbs to paint his red deer, and one of his last acts of patronage was to commission Agasse to paint his white-tailed gnus and an ill-fated Nubian giraffe, which died of exhaustion soon afterwards. Queen Victoria was particularly fond of dogs, as is witnessed by countless small tombstones at Windsor and Balmoral, and her patronage of Landseer is part of the great Victorian legend. The Queen and Prince Albert employed Herring, Morley and R. B. Davis to paint their horses, and Thomas Sidney Cooper to paint the Victorian Jersey cows. Other scarcely remembered artists like Charles Burton

Barber (1845–1894) and Friedrich Wilhelm Keyl (1823–1873) were employed lower in the hierachy, painting litters of kittens and families of ducks.

The Zoological Society of London had received its Royal Charter in 1829, and it was there that Edward Lear exercised his early talent as an animal painter. Agasse likewise found much of his material there. The animal population of the London Zoo grew apace: Baedeker in his 1889 edition noted 'the unpleasant odour' which was 'judiciously disguised by numerous flowers'. Gentlemen returning from foreign travels would include in their retinues monkeys, parrots, cheetahs, wild boars, snakes, bears, and other miscellaneous creatures, providing an inexhaustible supply of exotic beasts for the artists of the day.

By the early nineteenth century animal painting had reached a high degree of artistry. Géricault was much impressed by the animal paintings when he visited the Royal Academy in 1821: '*Vous ne pouvez pas vous faire une idée des . . . animaux peints par Ward et par Landseer . . . les maîtres n'ont rien produit de mieux en ce genre.*' Eighteenth century England had produced one of the greatest animal painters of all time in George Stubbs. Other important animal painters—usually of horse-portraits—were Ben Marshall, Sawrey Gilpin and John Ferneley. Stubbs, Gilpin and Ward were more inclined to paint animals in romantic landscapes, often horses in varying degrees of terror against a background of lightning. But the majority of English animal painters confined themselves to horses, hounds and the race-track, in the certainty of unfailing patronage.

In 1837 James Ward (1769–1859) was sixty-eight, with another twenty-two years to live. The son of a drunken grocer, Ward had, like De Wint, been apprenticed to John Raphael Smith, and had associated with his dissolute brother-in-law, George Morland. Ward's vast romantic landscapes inhabited by large sinewy animals were much admired, and are an important feature of the Romantic movement in Europe. His last years were clouded by a series of skirmishes with his family and the prevailing artistic Establishment, which numbered among its members the redoubtable Edwin Landseer (1802–1873). Landseer's merits as a landscape painter are treated in another chapter. He showed early promise as an animal painter, being elected A.R.A. in 1826 as soon as he reached the qualifying age of twenty-four; he became a full R.A. in 1831. An early glimpse of him is given by C. R. Leslie who described him as 'a curly headed youngster, dividing his time between Polito's wild beasts at Exeter Change and the Royal Academy Schools'. From an early age, it was evident that Landseer's work, like that of Stubbs, was based on a sound knowledge of anatomy, not merely on sentiment. He and J. F. Lewis once dissected a lion. 'I

advised him to dissect animals', wrote B. R. Haydon, who had also discovered Thomas Bewick sketching the Elgin marbles. In 1824 C. R. Leslie took Landseer on his first visit to the Highlands and introduced him to Sir Walter Scott at Abbotsford. This introduction led to a series of paintings of stags and other wild life in the Highlands, although he never entirely neglected the more domestic animals. It was inevitable that he should come into early contact with the Queen, who found him 'very good looking', although small in stature. It seems that he had beautiful manners and a light-hearted temperament with a gift for mimicry, in spite of a fundamentally nervous and melancholic disposition. Having once refused, he finally accepted a knighthood in 1850, and in 1865 he declined the presidency of the Royal Academy, although actually elected to that office. Some seven years previously Landseer had sculpted the four lions for the Nelson Memorial in Trafalgar Square, from photographs and the plaster casts of a lion that had been chosen as a model, but had become ill and died before it could sit: 'anything as fearful as the gases from the royal remains it is difficult to conceive even in spite of friend Hill's nostrum, for the renewal of healthy atmosphere' was Landseer's comment on this unfortunate beast. His health finally broke down in 1869: passing into bouts of madness and self-pity, aggravated by alcohol, he died four years later, leaving a huge fortune of about £200,000, and was buried in St. Paul's Cathedral.

To many modern eyes Landseer is difficult to accept. The multitude of mouldering prints and poor reproductions of the works most endearing to his contemporaries are to many people their first, but hardly the best, introduction to his work. And to a certain extent we are affronted by the cruelty of many of his subjects, and again by the fact that he could amuse his patrons by investing his animals with

SIR EDWIN LANDSEER, R.A. *Dog*. Millboard. 4×7 inches. Initialled and dated 1860. Private collection, Great Britain.

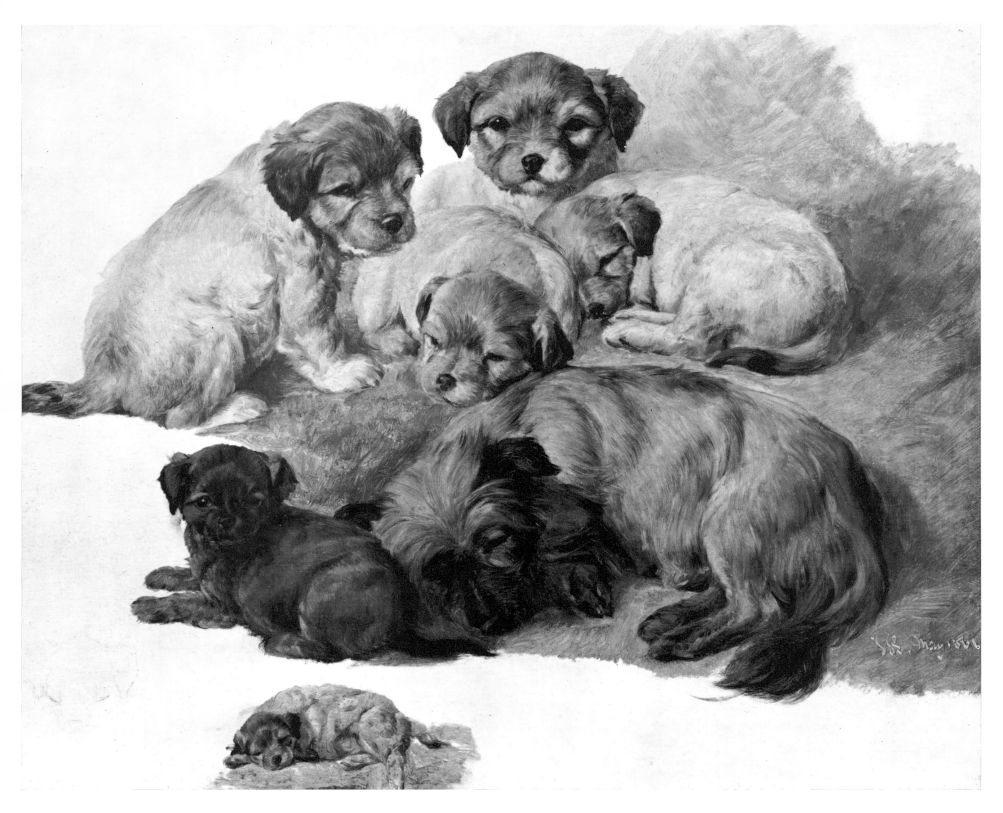

human qualities, thus pointing a facile moral. The charge of cruelty is the more easily parried: Landseer never gloated over cruelty; he merely observed, and wonderfully well at that. The comical dogs and monkeys are less easily forgiven: at the time the Pre-Raphaelites reacted strongly against the so-called 'Monkeyana'.

A close inspection of Landseer's use of paint is a revealing experience. It is only in the later landscape backgrounds, when he used a rock garden as a miniature representation of the Highlands, that the technique falters. Nor did he ever paint by recipe. Textured renderings always matched the subject. Until the 'forties he favoured wooden panels and millboards coated with a preparation of gesso, size and lead white to give a billiard-ball surface. In the later 'forties he used large canvases, with a more fashionable degree of finish, but with less success. Landseer's ability to

paint animals is richly displayed in *Isaac van Amburgh with his Animals*. The Queen thought it 'most beautiful . . . a wonderful piece of painting . . . just exactly as I saw him'. Indeed the Queen was so fascinated by the American lion-tamer's performance, that she saw his act at least five times, to the disgust of Macready. Perfectly acceptable though they are as animal paintings, his two famous pictures *The Stag at Bay* and *The Monarch of the Glen* are regarded by many as monuments to the baser elements of Victorian taste.

'Landseer! If I had had Landseer through my hands for six months I could have made a man of him!' The author of these stirring words was a Liverpool-born artist called William Huggins (1820–1884). Extravagant pleas have been made on behalf of this artist in recent years, and it cannot be denied that his reputation was worth reviving. Out of a seemingly enormous output, there are many works by him which strengthen his claim to be considered certainly the most original, even the best Victorian animal painter. His earlier works show him in the grip of grandiose literary and religious themes, and he became a member of the Liverpool Academy in 1850, only to retire six years later in defiance of its Pre-Raphaelite enthusiasm. Happily, he developed a *penchant* for painting lions, tigers and other members of the cat family at Chester Zoo, and at Wombwell's

SIR EDWIN LANDSEER, R.A. *Horses in a Stable*. Pen and ink. 4¼ × 7 inches. Villiers David, Esq.

SIR EDWIN LANDSEER, R.A. *Dignity and Impudence*. 35 × 27¼ inches. Tate Gallery, London.
Exhibited at the British Institution in 1839 under the title *Dogs*. Richard Muther wrote of Landseer that he 'discovered the dog . . . and in addition to this, he "Darwinizes" them: that is to say, he tries to make his animals more than animals; he lends a human sentimental trait to animal character'. The blood-hound in this picture was called Grafton.

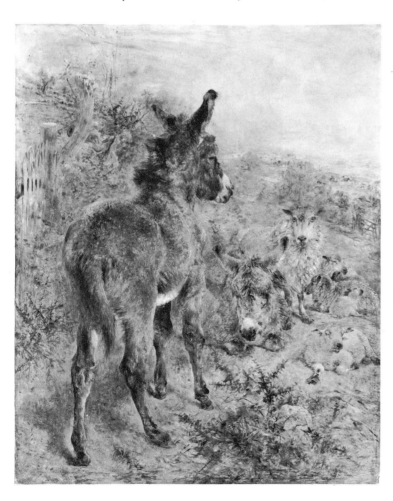

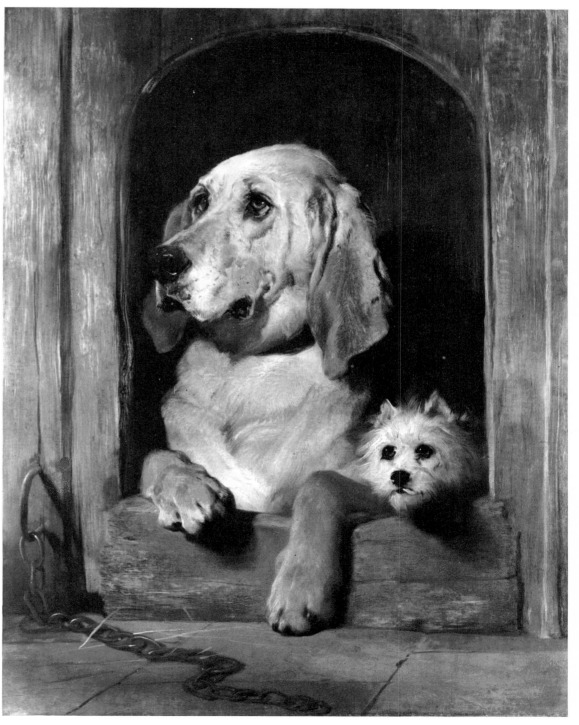

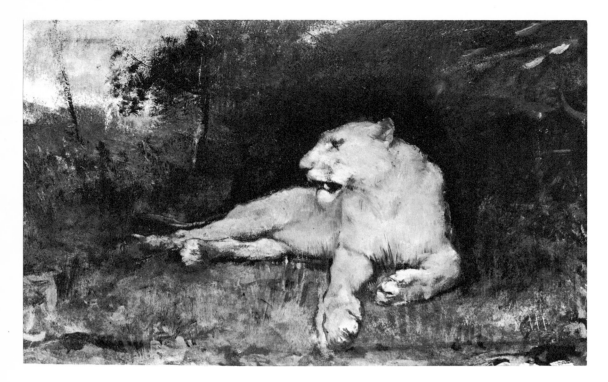

JOHN MacALLAN SWAN, R.A. *A Lioness Watching*. Panel 14 × 21 inches. Guildhall Art Gallery, London.

A Pair of Leopards by William Huggins is reproduced in colour on p. 89.

menagerie whenever it happened to stop near Merseyside. From 1857 onwards he exhibited at the Liverpool Institute of Fine Arts and at the Royal Academy. In 1861 he moved to Chester, and after a brief spell in Wales, he returned there, later retiring to Chriselton on the river Dee, where he died.

Huggins's originality lay not so much in his materials as has been claimed: his use of a very smooth white millboard, on which he painted with bright transparent pigments, was a method already in use by Landseer, and Mulready had demonstrated a similar technique on canvas. It lay more in his daring use of colour, combined with a virtuoso handling of the brush and unerring draughtsmanship. His knowledge of anatomy was at least comparable to Landseer's. His dashing colour often caused offence, but Huggins was insistent that twenty years of exposure would mellow the paint to the required colours. At one exhibition Huggins outraged the public by showing a purple donkey. From this distance of time, it is a relief to suppose that the colours have altered less than Huggins had anticipated, and they still give his paintings their special flavour. The uniqueness of his vision and his flamboyant use of colour are both apparent in *The Stoic*, contrasting with the cool splendour of *A Pair of Leopards*. In contrast to the scintillating plumage of Huggins's palette is the low-keyed approach of John Swan (1847–1910). In his paintings panthers and leopards stalk dark primeval jungles. He had an uncanny ability to evoke the sheer animalism of nature's wilder predators. No less capable of this was Briton Riviere (1840–1920), who, after an early courtship with Pre-Raphaelitism, painted animal pictures with genuine understanding in the broken colour method he had learnt from his friends of the London Scottish Group. Henry Stacy Marks (1829–1898) had similar early Pre-Raphaelite leanings, and in preferring, as he said, 'birds to human sitters', he formed a fair assessment of his own abilities: his bird pictures are accurate, lively and humorous, without being sentimental.

A passing mention may be made of the Herring family, if only because of the farmyard scenes painted by J. F. Herring, senior (1795–1865). These are painted with sympathy, and his studies of domestic and farmyard animals, like puppies, ducks and geese, have an easy charm. His son of the same name had less talent, and seems to have played down his father's stature in order to increase his own. Jacques Laurent Agasse (1760–1849) was of an altogether different order. Born in Switzerland, the son of a Huguenot aristocrat, he was brought over to England by the Hon. George Pitt. He had studied painting under David and Carle Vernet and anatomy at the veterinary school in Paris. Agasse was a regular exhibitor at the Royal Academy from 1801 to 1845 and was, as we have seen, employed by George IV. Unfortunately he was rarely successful in his choice of subject matter, although the titles of his later exhibited works (*Making the Most of Their Pen'orth* of 1843 and *The Important Secret* of 1845) suggest that he at least tried. It seems that he spent much of his time painting animals at London Zoo, but many of these paintings are either lost or attributed to other hands. The

WILLIAM HUGGINS. *Head of a Lion*. Pencil. 4 × 3 inches. Inscribed. Villiers David, Esq.

quality of the paint in some of his finished pictures invites comparison with David. Richard Ansdell (1815–1885) was a slighter artist, although his popularity has never faltered, mainly because of his more felicitous choice of subject-matter. A Liverpool-born artist, who became President of the Liverpool Academy, he first exhibited at the Royal Academy in 1840, with two pictures: *Grouse Shooting—Luncheon on the Moors* and *A Galloway Farm*. His *Stag at Bay* of 1846 would lead one to suppose, correctly, that he was in the Landseer tradition—although his animals and birds do not stand comparison with those of the older painter. As Bryan's Dictionary puts it 'he . . . followed too closely the inaccuracies of the bird-stuffers'. The same might be said of Ramsay Richard Reinagle (1775–1862), an artist whose paintings of game merely underline

the superiority of Snyders, to whom he has been compared.

The last of the Victorian animal painters all preferred the medium of water-colour or, in the case of Lear, pen and ink. As a means of depicting the fleeter characteristics of wild animals and birds, it was considered by some artists to be more expressive. It had certainly proved its worth in the eighteenth century as a vehicle for the exactitude demanded by the study (largely pioneered by English scholars) of Natural History, in the hands of such artists as George Edwards, Isaac Spackman, Peter Paillou and Charles Collins, all of whom specialised in birds. Botany had been well served by the exquisite water-colours of James Sowerby, whose thirty-six volumes of 'English Botany' occupied him for twenty-four years. The little

BRITON RIVIERE, R.A. *Fidelity.* 31½×45½ inches. Lady Lever Art Gallery, Port Sunlight.

Exhibited at the Royal Academy in 1869 as *Prisoners*. The picture indicates the continuity of the tradition of canine pathos, exemplified in Landseer's *The Old Shepherd's Chief Mourner* of 1837.

tail-pieces of Thomas Bewick, an artist of international reputation whose 'The History of Quadrupeds and Birds' made natural history an art form without sacrificing accuracy, are delightful ornaments to English art during the Regency. The first painter of animals in water-colours who lived to become a Victorian was Robert Hills (1769–1844). But his best work was already well behind him, and is always to be found in his sketches which were probably done from nature. He would patiently compile his pictures from a series of worked-up drawings, each losing a little of the spontaneity of the preceding one until he reached the finished product, which was usually in hot opaque colours. His favourite animals were deer, and their characteristics are always conveyed with real, if monotonous, sympathy: a contemporary magazine (1830) observed that 'Mr Hills has lived upon the same piece of venison for the last twenty years'. Frederick Tayler (1802–1889) never lacked spontaneity, as one might expect of an artist who had once shared a studio with Bonington in Paris. His sketches,

usually in pencil and wash, are free and dashing, although somewhat lacking in strength. He appears to have added figures and animal life to the paintings of several of his contemporaries, notably to those of George Barret, many of whose stilted classical compositions were rescued by him from still-birth. David Cox collaborated with him on at least one occasion.

The animal drawings of Edward Lear done in Queen Victoria's reign belong more to literature than to art, and are little more than an agreeable footnote to nineteenth century painting. In the early 'thirties he was a draughtsman in the gardens of the Zoological Society, and this in 1832 resulted in the publication of a folio volume entitled 'Illustrations of the Family of *Psittacidae*', with forty-two lithographic plates. After his discovery by the 13th Earl of Derby he stayed at the earl's seat at Knowsley between 1832 and 1836. Here he compiled his 'Book of Nonsense' for his patron's children, accompanying the text with the inimitable pen and ink sketches, but it was not until 1846 that it was published. In that year, Lear

gave the Queen twelve drawing lessons: 'had a drawing lesson from Mr Lear, who sketched before me and teaches remarkably well', she recorded in her diary.

The sophisticated genius of Joseph Crawhall (1861–1913) places him in the role of natural successor to William Huggins, although in character and technique his works have little in common with those of the sturdy Liverpool artist. Crawhall was born into a cultured family at Morpeth in Northumberland. His father and grandfather, both called Joseph, were talented amateur artists with an interest in field sports. An early promise in draughtsmanship was greatly encouraged by the critical enthusiasm of his

father, whose friend Charles Keene also offered encouragement. Except for a brief period of tuition in Paris, Crawhall was virtually self-taught. His schoolfriend, E. A. Walton, persuaded him to study in Glasgow. Here he became a founder member of the Glasgow School, a group which looked toward the Barbizon painters. It also had a great admiration for Whistler and, probably through him, for Chinese and Japanese art, as a brief glance at any of Crawhall's works would suggest. Crawhall is supposed to have sat for twenty minutes in complete silence before the first Japanese print he ever saw, and then to have turned to the owner and bought it. In 1882 he went to Paris and entered the studio of Aimé Morot, who was the apostle

JOSEPH CRAWHALL. *The Black Rabbit.* 9¼ × 13¼ inches. Body-colour on linen. Private collection, London.

John Lavery, in his autobiography, quoted Frank Linder as saying that 'his *Black Rabbit* may well be the nineteenth-century equivalent of Dürer's wonderful *Hare*'.

on a white horse.' He had a photographic memory,
but only after studying a subject in detail did he
paint it. So self-critical was he that he destroyed
hundreds of his drawings. Perhaps he excelled in his
drawings of birds. His *Pigeon* is one of his finest: the
carefully modulated tone of the white pigeon, with
its suggestion of featheriness, is floated like a cloud on
a slate-blue background.

The last artist in this account brings us, fittingly,
almost up to the present day. Beatrix Potter (1866–
1943), like Crawhall, was possessed of a kind of genius.
'The Tale of Peter Rabbit' although written and illus-
trated some time before and refused by every publisher
except, by coercion, the last, was first published
privately in the same year as the Queen's death. 'The
Tailor of Gloucester' was printed privately in the next
year. Her early work, bright, perfect and professional,
shows her to have mastered the medium to a rare
degree. Millais gave her encouragement: he once said
to her 'Plenty of people can *draw* but *you* have observa-
tion'. She drew many subjects: landscapes, village life,
flowers, fungi, and always animals, mostly in the
Lake District where she spent the greater part of her
life. The characters in her books, however apparently
fanciful to the reader, are based on a lifetime of
accurate observation.

of painting from memory. This meeting was to have
a profound effect on his subsequent work. After a
spell in Morocco he returned to England, where he
divided his time between sporting pursuits in York-
shire and his base at Ealing. He painted little during
the last ten years of his life.

He liked particularly to paint in water-colour on
holland, a variety of fine linen fabric: this is a notably
intractable vehicle for water-colours, but Crawhall
mastered it absolutely. His sister, Elspeth Challoner,
described Crawhall drawing: 'he had no hesitancy . . .
He knew exactly what he wanted to get his effects.
At one time, he tilted the paper to allow the paint to
run just as he wanted. Another time he drew (with a
broken wrist) with a stationary pencil, and twirling
paper; another, he drew the background and left the
anatomy of the subject blank and with a touch here
and there the picture was complete—an Indian Brave

VII

PAINTERS ABROAD

When Queen Victoria came to the throne in 1837, her future Consort, on the advice of the King of the Belgians, was travelling diligently in and around Switzerland, since rumour had already linked their names together. Of the forty-four places he visited, he sent her views of all but two: from the Rigi he sent her an Alpenrose, and from Ferney a scrap of Voltaire's handwriting. By contemporary standards, particularly English ones, this enormous capacity for tourism was by no means exceptional. For by this year a great new age of travel had begun, as the whereabouts of some of the new Queen's subjects who earned a living by painting will show. After four years in Switzerland, Francis Danby was probably in Paris and due to embark on another four-year period of wandering about Europe. On his own in Italy since the age of fifteen, Alfred Stevens was learning to draw and paint, and, at the age of sixteen, Madox Brown was studying under Baron Wappers in Antwerp. George Chinnery, now somewhat overweight, was painting, 'taking snuff, smoking and snorting' in Macao, a thin sliver of land on the Chinese coast. James Holland had recently left Italy for Portugal, where he painted some of his finest water-colours. After some years of apprenticeship in Paris, William Callow was now established there as a teacher, and poised for a tour of Germany and Switzerland. Thomas Shotter Boys was working on his aseptically pure water-colours somewhere in France, while J. D. Harding was painting his way down the Rhine. Somewhere in Italy the comical figure of Edward Lear, with pebble glasses, protruberant nose and stomach, large beard and spindly legs, sitting astride a horse, swatting flies and cursing the discomfort and filth of village inns, must have appeared to startled natives as the embodiment of English eccentricity. This was his first journey abroad. In Italy, too, was another remarkable artist, Samuel Palmer, honeymooning with Linnell's daughter, Hannah. Also with the Palmers were George Richmond and his wife.

Those about to pack their bags, lay in a stock of canvas and paint, and consult the steam-packet timetables were John Frederick Lewis, who left in the following year for the Middle East, not to return for thirteen years; David Roberts, who, with a fine Scottish sense of economy, crammed all his Middle Eastern experience into two years, with rich results; the delicate William Müller, with only a few years to live, about to experience the ecstasy of Cairo, then an 'Arabian Nights' city; David Wilkie bound for the Middle East, never to return; John Ruskin, unwontedly island-bound for a few years, about to issue forth on the series of tours which occupied him for nearly fifty years. Two years later, poor Richard Dadd also went to Egypt, where, it is said, he lost his reason while painting in the heat of the sun.

The age of the Grand Tour, a prerogative of the rich aristocracy, was nearly dead, for a new age of travel had been born in the 'thirties, more democratised, more adventurous, and predominantly English. The opening of the Liverpool & Manchester Railway on 15th September, 1830, by the Duke of Wellington, caused a quickening of the pulse, transforming with great speed the habits of mankind. The Iron Duke himself soon came to regret that the railways allowed the 'lower classes to travel about needlessly', but within a few years England was covered by a web of railways. 'The early Scotchman', as Sydney Smith wrote, 'scratches himself in the morning mists of the north, and has his porridge in Piccadilly before the setting sun.' Soon the tentacles of the railway age spread to Europe: to France in 1832, to Belgium and Germany in 1835, to Austria in 1838, to Italy and Holland in 1839, to Switzerland in 1847 and to Spain in 1848. On the Continent, however, and particularly in France, the progress of the railways was spasmodic. In 1850 the traveller arriving by steamer at Calais, Havre, Brest or Bordeaux could not have continued by rail to any point on France's north-eastern, eastern or southern frontiers, whereas a traveller at Bremen or Hamburg could travel by rail direct to Cracow or Prague, and near to Cologne and Munich. By 1870, however, France under the Second Empire had managed to lay over 11,000 miles of rail. It was the same story with steamships. In 1816 England had fifteen steamships totalling 2,612 tons; by 1848 there were 1,253, totalling 168,078 tons. A contemporary journalist wrote: 'we have reached in a single bound from the speed of a horse's canter, to the utmost speed comparable with the known strength and coherence of brass and iron' ('The Economist', January 1851). A guidebook of 1854 notes that 'splendid steam packets leave London Bridge for Calais, Boulogne and Havre almost every day'. Others 'start daily from Dover and Folkestone' and 'two or three times a week from Brighton to Dieppe, and from Southampton to Havre'. In the Balkans and Middle East such amenities were still rare. Edward Lear, attempting to describe a train and a steamboat to an ignorant Turkish Bey in the fortress town of Kroja, in Albania, resorted to imitating the noises they made. His performance—'Tiktok, tik-tok, tik-tok, tokka, tokka, tokka, tokka - tok' (crescendo) and 'Squish-squash, squish-squash, squishsquash, thump-bump'—was so entertaining that the Bey demanded frequent encores.

The methods and conditions of travel in Europe, particularly where there were railways, were agreeable. Before the railways ousted them, the usual vehicles were diligences, mail-coaches, and postcarriages. In the backward Balkans and Middle East journeys 'are made only on horse-back', a means of transport highly extolled by one contemporary guide-

book because 'there is none of that languor and feverishness that so generally result from travelling on wheels . . . You are in immediate contact with Nature.' Baedeker's guide for as late as 1876 confides bleakly that 'there are no railways in Syria'; and regrets that for long journeys through the desert there is no alternative to the camel, 'a sullen looking animal', whose dung 'is used in many parts of Syria as fuel'. Baedeker advises that 'on arrival at a Syrian port the traveller's passport is sometimes asked for, but an ordinary visiting-card will answer the purpose equally well', and devotes two closely printed pages to 'Intercourse with Orientals'. Murray's Handbook for Travellers in Greece for 1872 enjoins the traveller to follow 'the sensible recommendations of Mr Lear', and further warns him that 'Greece and all parts of the East abound in vermin of every description . . . some by their bite occasioning serious pain or illness'. Such, presumably, were those that elicited Lear's cry of anguish: 'O khan of Tirana! rats, mice, cockroaches, and all lesser vermin are there. Huge flimsy cobwebs, hanging in festoons above my head; big frizzly moths, bustling into my eyes and face.'

The majority of travellers to Europe and the Middle East were English. They swarmed everywhere. Switzerland, for example (which still had only 850 miles of railway system in 1870), could hardly contain the myriads of them. Johannes Brahms wrote to a friend in 1886 'It is magnificent here. Incidentally, there are many beer gardens where the English do not penetrate; for my comfort that is no small matter.' The domination of British tourists is implicit in contemporary phrase books ('I want to see the British Consul'). The English were blithely assured of their superiority, and the internal politics of countries they visited were beneath their contempt. If you should stumble on a Revolution, advised Walter Bagehot, there is no danger 'if you go calmly and look English'. Knowledge of the language was not considered a necessity: one English lady found she needed only two words of Italian, '*Quanto?*' and '*Troppo*'; and one gentleman considered that the one word '*Anglais*' met his needs throughout France.

Amongst the throng of tourists were large numbers of English artists touring Europe and the Orient in search of colour and exoticism. Some of these, like Holman Hunt, went in search of Scriptural subjects. Others, like Lewis, found their subjects in the bazaars of Cairo, or like Roberts, in ruins, churches, bedouins and their tents. Lear responded to strange, romantic scenery; Ruskin to mountains and church architecture. Sometimes the discomforts were appalling: 'the landscape painter', lamented Lear, 'has two alternatives; luxury and inconvenience on the one hand, liberty, hard living, and filth on the other; and of these two I chose the latter, as the most professionally

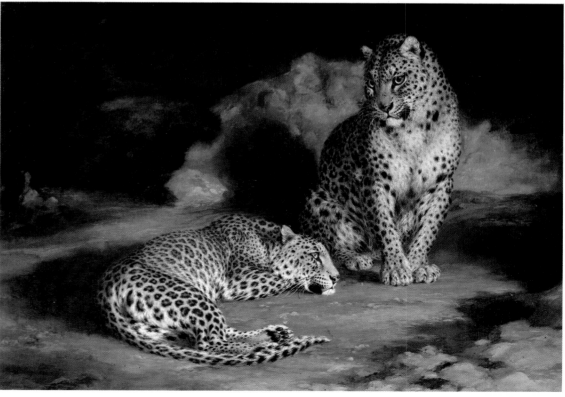

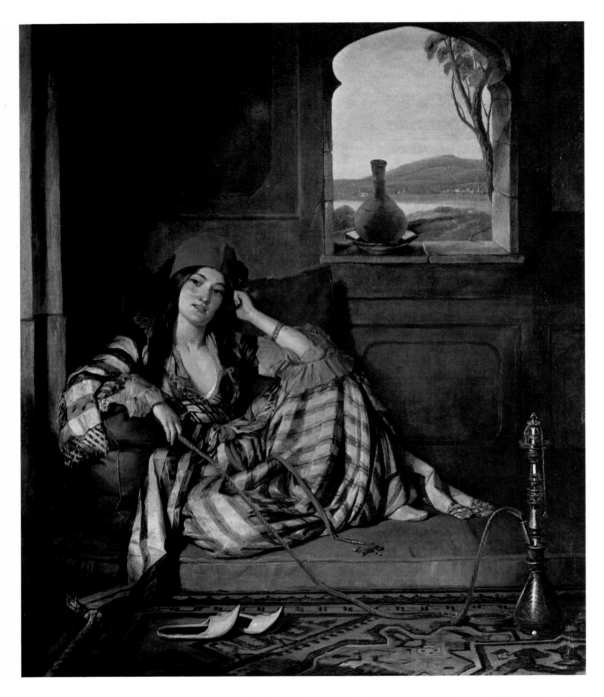

JOHN FREDERICK LEWIS,
R.A. *A Houri*. 30 × 25 inches. Mr
and Mrs Paul Mellon.

for *The Scapegoat*, was attacked by robbers near the Pools of Solomon on his way to Hebron; only after resolutely brandishing his revolver was he left in peace. Working away at *The Scapegoat* in the blazing sun, he was often harassed by hostile mounted Arab tribesmen 'their faces covered with black *kufeyiahs* and carrying long spears, while their footmen carried guns, swords and clubs'. The imperturbable artist placidly continued painting, steadying his touch by resting his hand on his double-barrelled gun. Further attacks on subsequent days were parried by threats of intervention by the British Consul. The Middle East was always close to turmoil. The Crimean war raged in the north, and it was while toiling away at *The Scapegoat* that Holman Hunt was brought news of the Battle of Inkerman. Eventually his courage and *sang-froid* so impressed the Arabs that they invited him to become their Sheikh. The picture itself was finally exhibited at the Royal Academy in 1856, after the death of two goats from exhaustion, and the use of a third. The reception of this picture, intended as it was to convey a symbolical message of 'the Church on Earth, subject to all the hatred of the unconverted world', was lukewarm. Indeed, to Ruskin 'it was a mere goat, with no more interest for us, than the sheep which furnished yesterday's dinner'.

On his first arrival in Cairo, Hunt had written to Millais complaining bitterly of his difficulty in getting Arab women to sit for him. Sometimes they were very beautiful, but more often than not they were inexpressibly ugly: when one of them finally deigned to remove her veil he 'discovered that nature had blessed her with some nasal departure from the monotony of ideal perfection.' Thomas Seddon (1821–1856) had accompanied Hunt on his journey to Palestine, without Hunt's high-minded devotional impulse, but partly through a wish to compensate for his own lack of any real training by 'novelty of motive', partly to observe closely Hunt's technical mastery, and partly to avoid working in his father's furniture business. After returning to England, he set out again for the East in 1856, only to die in the same year in Cairo, where he is buried. Further hazards of travel included the everpresent possibility of quarantine: David Roberts had once languished for thirty-five days in a kind of lazar house in Seville, because of a plague of cholera.

Holman Hunt recalled of his first view of Cairo 'the interior of the bazaars, the streets, the mosques, the fountains, the tombs of the caliphs, the view from the Citadel, the avenues of lebek, the gates, old Cairo, all in turn offered a perfect subject for a painter of contemporary phases of Eastern life'. But he 'had no ambition to illustrate Cairo' and absorbed all that he saw 'to make the records of ancient history clearer'. It was left to painters like Lewis and Roberts to paint the scene before them.

useful, though not the most agreeable' ('Journal of a landscape painter in Greece'). While painting in Albania, he was frequently pelted with stones by natives screaming '*Shaitan*' (devil), and by endless rain. When he visited Petra he came near to losing his life. A peace-loving man who, according to Holman Hunt, was as 'uncombative as a tender girl', he was surrounded by hysterical Arab robbers, manhandled, had his clothes torn, his beard pulled and his pockets picked of all they contained 'from dollars and penknives to handkerchiefs and hard-boiled eggs'. Reluctant to use his '5-barrelled revolver', he paid the marauders off with twenty dollars, and fled from the Wadi Mousa, only to be attacked again by large bands of *fellaheen*, who left him penniless. Holman Hunt, accompanied by the wretched animal which was to act as the model

John Frederick Lewis (1805–1876) is one of the most completely satisfying painters of the Victorian age. In a richly varied life, when he was either close to the top of the artistic Establishment of London, or idling among the fleshpots of Cairo, he managed to combine a degree of dedication to his calling with an artistry that showed no falling off as he grew older, so that when he was too weak to hold a brush he was able to say that it was the head that painted and not the hand. The eldest son of Frederick Christian Lewis, the engraver, was born, it is said, in the same house as Edwin Landseer, and began his artistic career by painting animals, a training which stood him in good stead in the Middle East. At the age of nineteen he published a set of six quarto plates of 'Studies of wild animals', thereby attracting the attention of George IV who employed him for some years to paint animals and sporting subjects in Windsor Park. So far, Lewis had confined himself to painting in oils. Having almost by accident become 'fascinated with the ease and with the simplicity of the tools required for working in

water-colours', he soon became proficient in that medium. By 1829 he had become a full member of the Water-Colour Society. His first contact with the South came in 1832, on a two-year visit to Spain, which included a visit in the Spring of 1833 to Tangiers. Like John Phillip, he was stirred by Spain: its effect on his painting was galvanic, and from these years date the works of his maturity. His work began to be characterised by richness of colour and closeness of observation. He rendered warm tints with careful stippling and the use of body-colour for the high-lights. His fame began to spread, earning him the nickname 'Spanish Lewis', and was further enhanced by the publication of two volumes of lithographs, 'Sketches and Drawings of the Alhambra' (1835) and 'Lewis's Sketches of Spain and Spanish Character' (1836).

At this point the smooth progress of his career became erratic. In 1839 the secretary of the Water-Colour Society received a letter from Lewis 'dated from Rome' to say that illness and other circum-

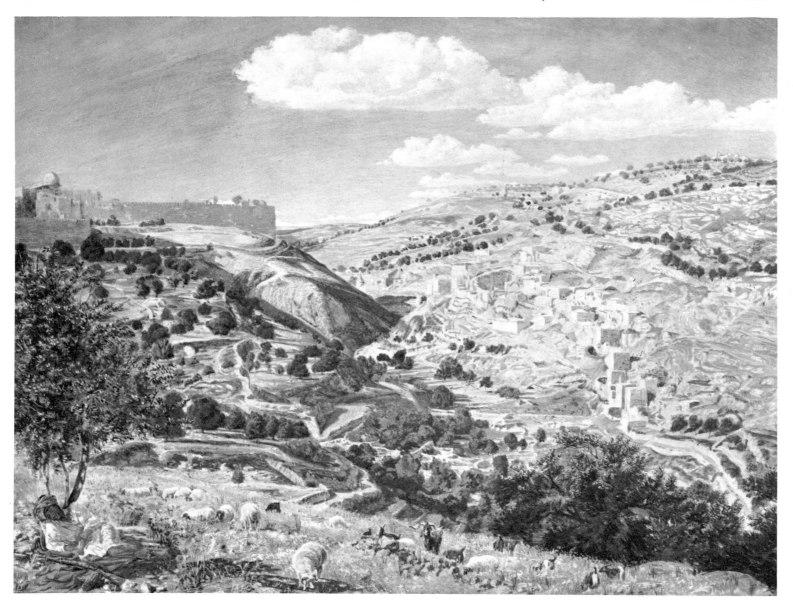

THOMAS SEDDON. *Jerusalem and the Valley of Jehoshaphat from the Hill of Evil Counsel*. Body-colour. $9\frac{1}{2} \times 12\frac{1}{8}$ inches. John Gere, Esq.

This is a smaller version of the picture, now at the Tate Gallery, which Seddon painted over a period of five months in 1854. Another yet smaller version, which belonged to Rossetti and was said by him to have been painted over a photograph, is at the Ashmolean (see Chapter 13).

stances prevented him from exhibiting that year. However in 1841 he sent in two pictures, including apparently *Easter Day at Rome*, his only work done in Italy. Nothing more was heard from him until 1844, and then it was from Cairo. In fact, Lewis was absent from England for thirteen years. He had apparently gone from Paris to Rome, then on to Corfu, Albania, Athens and Constantinople, finally reaching Cairo in the winter of 1842. From there, when his lethargy permitted, he made occasional sorties up the Nile into Nubia. It was in Cairo that his old friend, the novelist Thackeray, paid him a visit. Thackeray discovered him in a 'long, queer, many-windowed, many galleried house', with a great hall of audience, its ceiling 'embroidered with arabesques'. This house, with its divans and fountains, was 'more sumptuously furnished' than the houses of the 'Beys and Agas his neighbours'. Here, amidst the pipe-bringing servants, Lewis was an exotic host, in a dark blue costume with embroidered jacket, his beard curling nobly over his chest, his Damascus scimitar on his thigh. 'Here he lives like a languid lotus-eater—a dreamy, hazy, lazy, tobaccofied life', wrote Thackeray.

Meanwhile, in London, Lewis's long absence caused his name to be struck off the list of members of the Water-Colour Society. On hearing of this he wrote begging to be re-instated, and this was done; and he caused a sensation at the exhibition in 1850 with *The Hhareem*. Its high finish and brilliance of colouring caused the public to place him with the Pre-Raphaelites, although he had never met any members of The Brotherhood. In 1851 Lewis returned, and until his death continued to exhibit his eastern scenes. In Cairo he had again taken up oil-painting, which gave his pictures, as the Redgraves wrote, 'a richness of colouring and a brilliant perfection of completeness which seem almost peculiar to himself; his drawing is so exceedingly accurate, and his manual dexterity so great, that he is able to combine the utmost finish without oppressing you with any sense of the labour of execution.' It is in this last respect that Lewis's technique is superior to that of most of the more self-conscious Pre-Raphaelites, and none of his contemporaries could equal his treatment of brilliant colours seen through a diffused light. He became President of the Water-Colour Society in 1855, to resign two years later in favour of an almost total commitment to oils. He had already been elected R.A. His industry as a painter was exceptional: he would start work at eight and work without interruption throughout the

JOHN FREDERICK LEWIS, R.A. *Two Women in a Harem*. Pencil, water-colour and body-colour. 14×17½ inches. Charles Jerdein, Esq.

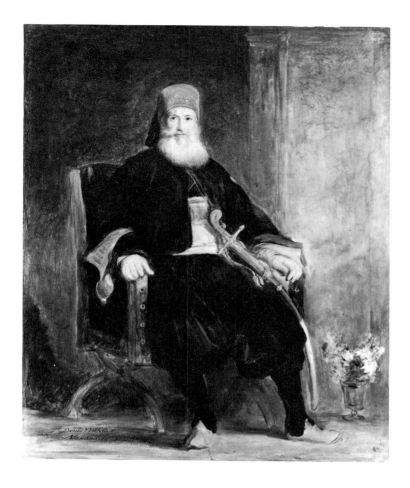

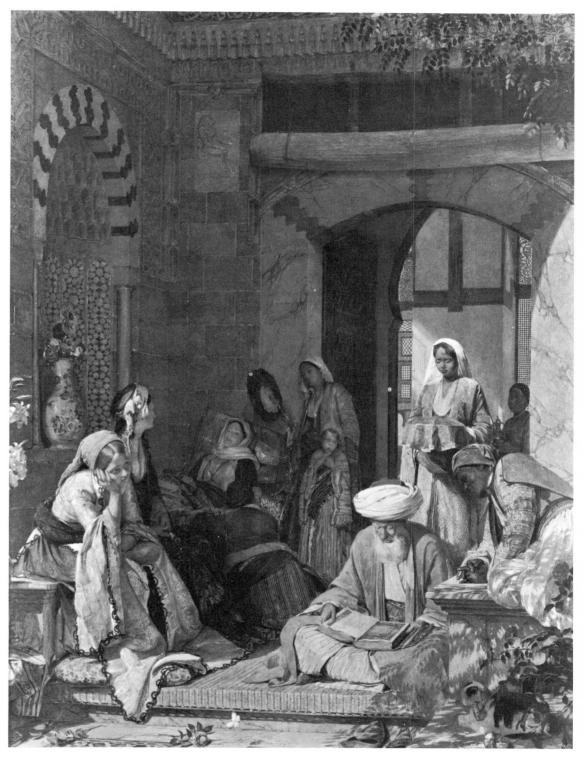

day, taking tremendous trouble in the preparation of his colours, which were mostly mineral and were chosen with great care. He painted with very small sable brushes, using hog's hair brushes only for backgrounds or for scrubbing in. Lewis fully deserved the panegyric that Ruskin gave him in the Academy Notes of 1856: 'Labour thus concentrated in large purpose—detail thus united into effective mass—has not been seen till now.' Most refreshingly and strikingly, his pictures are entirely free of anecdote, cloying sentiment or moral fervour, thus marking him as a forerunner of the aesthetic movement.

Lewis was one of the last artists to see Sir David Wilkie alive; he had met him in Constantinople and seen him leave for Cairo. Wilkie had been turning over in his mind for some time the possibility of doing some biblical painting, derived not from imagination but from observation, a motive curiously similar to that of Holman Hunt, but without Hunt's high religious purpose. In the Autumn of 1840, he decided to go to the Middle East, leaving behind him a trail of commissions and uncompleted portraits. He spoke to his friend William Collins on the eve of departure of 'the advantage he might derive from painting upon Holy Land, on the very ground on which the event he was to embody had actually occurred'. By way of The Hague, Cologne, Munich and Vienna, he reached Constantinople in October 1840. Here he was delayed for five months because of the war between Turkey and Syria, but he was able to paint some lovely water-colour sketches and a fine portrait of the Turkish Sultan. After further irritating delays caused by plagues and quarantine, he reached Jerusalem. Here he did some more fine water-colour sketches, which were never worked-up. Then he sailed on a steamer with a cargo of soap for Alexandria, where he had time to paint another exquisite portrait, this time of Mu-hemed Ali. According to Benjamin Robert Haydon, who had talked to William Woodburn, one of the last to see Wilkie alive, 'he quacked himself to death; his

JOHN FREDERICK LEWIS, R.A. *The Prayer of Faith*. Water-colour. 23 × 17¾ inches. Signed and dated 1872. Charles Jerdein, Esq.
Exhibited at the Paris Universal Exhibition 1878.

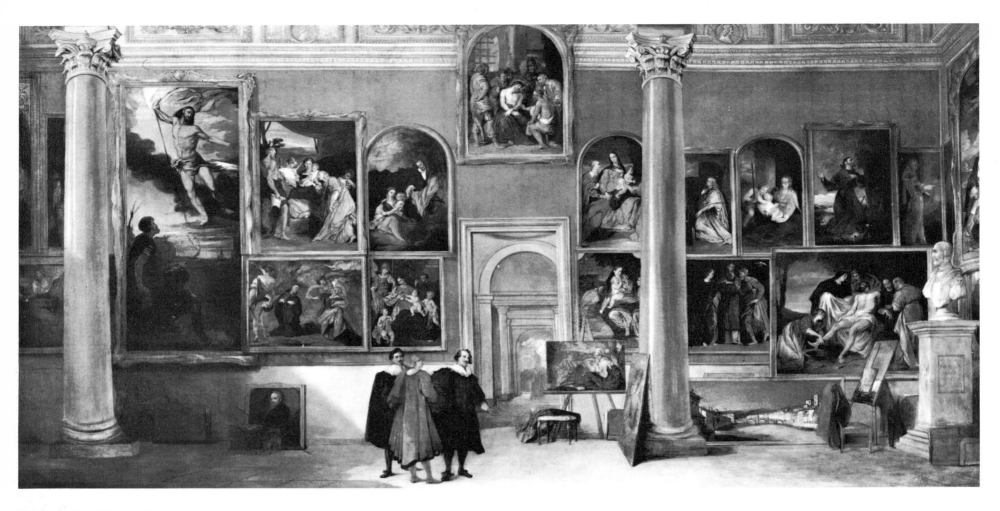

JOHN SCARLETT DAVIS. *The Art Gallery of the Farnese Palace, Parma.* 38¼ × 73¼ inches. Initialled, inscribed 'Parma', and dated 1839. Marchioness of Dufferin and Ava.

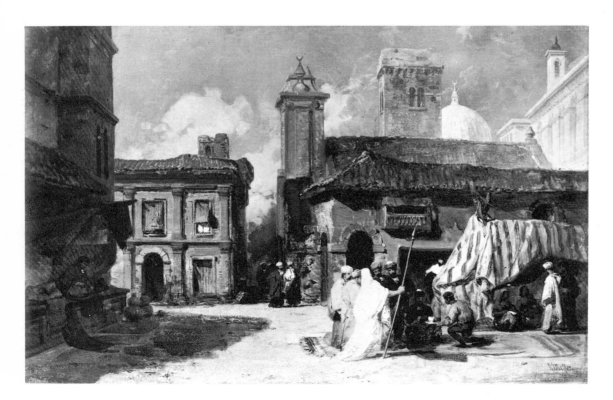

only anxiety wherever he went was, if there was a medical man in town'. Wilkie left Alexandria for England on the 'Oriental' steamer, and he soon had attacks of illness, exacerbated by rashly eating fruits and ices in Malta harbour. He grew steadily worse and died at sea the next day, 1st June, 1841. In the evening his body 'was committed to the deep with all due rites and honours', an event which was to be immortalised in Turner's *Peace – Burial at Sea*.

John Scarlett Davis (1804–1845), a native of Hereford, pursued a solitary course, painting numerous interiors of Italian churches and museums, reproducing the Old Master paintings on their walls with extraordinary fidelity. Like Bonington, who was two years his senior, he had studied at the Louvre, which may account for a certain apparent similarity in their work.

William Müller made three separate journeys abroad during Queen Victoria's reign. The first, in 1838, took him through Greece to Egypt, where David Roberts was also at work; in 1840 he toured northern and central France, staying for a while in Paris; in 1843 he joined a party bound for the Middle East, this time going to Smyrna and Rhodes. Although the effect on his style of painting was, to a degree, predictable, he lacked the judgment and refinement of Lewis and the control of Roberts. His palette became richer and the chiaroscuro stronger, but too often one feels that he had looked too long at Rembrandt and Delacroix, and not long enough at his subject: his exuberant style often degenerates into a mire of coagulated colour and the delicacy he showed in his

water-colours escaped him. However, works like *An Eastern Street Scene* at the Tate Gallery show the redeeming qualities of ordered composition and a fine colour sense.

A more disciplined artist was David Roberts (1796–1864), who has been called 'the Scottish Canaletto' (another case of that curious inferiority complex with which the British regard their artists). Roberts was born at Stockbridge, near Edinburgh, the son of a poor shoemaker. After a seven-year apprenticeship to a house-painter in Edinburgh, he took up scene painting. It was at the Theatre Royal, Edinburgh, that he first met Clarkson Stanfield, with whom he formed a life-long friendship. Both painters came to London in 1822, and soon after their arrival worked together at the Drury Lane Theatre, at the same time busily painting easel pictures and exhibiting at the Royal Academy. In 1826 Roberts became scene painter at Covent Garden Theatre, and designed and painted the sets for the first London production of Mozart's 'Il Seraglio'. Three years later Roberts went abroad for the first of many tours. In 1830 he got as far as Cologne, but turned back because of political disturbances there. Two years later he set off, on the advice of Wilkie, for another tour of France and Spain, visiting Tangiers and Morocco. If he was cool about Spanish cooking ('Between oil and garlic it is difficult to tell what you are eating'), he was enthusiastic about the architecture, and made over 250 sketches; working these up occupied him for the next four years. In 1838, by way of France, Italy and Malta, he arrived again in the Middle East. On his arrival in Egypt he dined with the British Consul in Alexandria, who arranged for him to travel up the Nile to Ethiopia. He spent the next year in Palestine, dressed as an Arab, painting and drawing industriously. On his return to England in 1840 he found, with some difficulty, a publisher for his drawings. The fruits of his labours were published in the six volume 'Views in the Holy Land, Syria, Idumea, Arabia, Egypt and Nubia' (1842–9). After being elected R.A. he resumed his travels—to Northern France in 1843, Belgium in 1844–5, to both these countries again in 1849, Italy and Austria in 1851, Italy again in 1851 and lastly Belgium in 1862. He spent the last four years of his life painting a series of pictures called 'London from the River Thames'.

Like Lewis, Roberts was very prolific: for nearly thirty years he rarely failed to exhibit at the Royal Academy. The works of his maturity fall into three distinct groups: from 1838 to 1848, Spanish; from 1851 to 1860, Italian; and from 1860 to 1864, London. And yet his style varied little. The subtle whiff of local flavour captured by Lewis often eluded Roberts: not for want of accuracy—he employed pencil and ruler, like an architect, on his canvas—and the groups of figures are always spirited, and carefully placed;

yet somehow, whether he is in Luxor or Venice, the colouring belongs to Roberts, not to the locality. However, there is a kind of stringent professionalism and purity of vision about his work which compels admiration.

If the coolness of Roberts's artistic vision remained constant on his first contact with the warm south, that of his fellow Scotsman, John Phillip (1817–1867) burst into colourful bloom, burgeoning with warmth and life. Phillip was an original member of the Clique, together with Egg, Dadd, O'Neil and Frith, and his earlier works were, by general consent, anaemic imitations of David Wilkie. Born in Aberdeen and, like Roberts, the son of a shoemaker, he began his working life as an errand boy to a tinsmith. An early

JOHN PHILLIP, R.A. *La Gloria.*
56½ × 85½ inches. Signed with mono-
gram and dated 1864. National
Gallery of Scotland, Edinburgh.

Exhibited at the Royal Academy
in 1864. The artist considered this
his best picture.

Opposite page, below:
FREDERICK GOODALL, R.A.
*Early Morning in the Wilderness of
Shur.* 56 × 134 inches. Signed and
dated 1860. Guildhall Art Gallery,
London.

Exhibited at the Royal Academy
in 1860. An Arab sheikh is ad-
dressing his tribe, on breaking up
their encampment at the 'Well of
Moses' on the eastern shore of the
Red Sea.

enthusiasm for painting brought him to London and
eventually, in 1837, to the Royal Academy Schools.
Two years later he returned to Aberdeen where he
remained for some years painting portraits and High-
land genre scenes. Delicate health prompted his first
visit to Spain in 1851; he settled at Seville, and the
inhibitions which had constricted his development
evaporated in the sun. The gaiety, animal vigour,
colourful clothing and festive nature of the Spaniards
inspired his painting. His figures became flesh and
blood, his composition lively, his colours richer and
brighter, although he was not yet adept at modulating
them carefully over relatively large areas. His tech-
nique improved on acquaintance with the paintings
of Velasquez and Murillo. Soon his Spanish pictures
began to appear at the Royal Academy and he
acquired the nickname 'Spanish Phillip'. In 1856 he
paid his second visit to Spain, accompanied by
Richard Ansdell. A year after being elected R.A.

in 1859, he visited Spain for the third and last time:
going farther afield, he saw Madrid, Segovia, Toledo,
Cordova and Seville, studying Velasquez again, and
copying him. From this time onwards he painted some
of his finest pictures, with complete assurance of
handling, the colours even richer and more subtly
modulated. Pictures like *La Bomba* and *La Gloria* (by
which Phillip expressly asked that his achievement
should be judged) are characteristic of his best period.
He visited Rome in 1866, and died shortly afterwards.

In 1854 war broke out between the Russia of Tsar
Nicholas I, Tennyson's 'icy Muscovite', on the one
side and Palmerston's England, Napoleon III's France,
and Turkey, on the other. After two years of fighting,
where disease vied with the battlefield as the most
potent destroyer of soldiers, the Treaty of Paris
finally secured for the Western allies the terms for
which they had professed to contend. Wars supplied
artists with some useful subject matter – then, and for

some years to come: notably for paintings like Henry O'Neil's *Eastward Ho!* and *Home Again*. The Light Brigade charged again and again on canvas and in picture-books. More interesting, though, was the arrival on the scene of the first war-photographer, Roger Fenton, and the first two war-artists, William Simpson (1823–1899) and Edward Angelo Goodall (1819–1908). Both are rather minor artists, and best known in water-colour. Simpson devoted forty years of his life to painting wars. He was first commissioned to paint scenes in the Crimea. Eighty of these appeared as chromo-lithographs in 'The Seat of the War in the East' (1855). He also painted a picture of Balaclava for the Queen. After the war he joined the Duke of Newcastle's party which explored Circassia. In 1859, soon after the first Indian Mutiny, he was commissioned by a firm of publishers to paint scenes in India. Subsequently we find him on the staff of 'The Illustrated London News', travelling to Abyssinia and India. The Franco-Prussian War of 1870 and the Afghan war eight years later provided him with further material.

E. A. Goodall was one of a large family of artists. In 1841 he accompanied the Schomburgk Guiana Boundary Expedition as draughtsman, exhibiting a picture painted in British Guiana at the Royal Academy four years later. On the outbreak of the Crimean war he was sent by 'The Illustrated London News', to which he sent back numerous sketches: these were swiftly engraved on wood-blocks to be studied avidly by the Victorian public. After this Goodall went further afield and painted delicate water-colours in Italy and Egypt. Frederick Goodall (1822–1904), his younger brother, exhibited an enormous number of Eastern scenes at the Royal Academy for forty-two years, bearing such titles as *Bedouin Mother and Child—*

Afterglow and *An Intruder on the Bedouin's Pasture*: in their almost unrelieved tedium, they are a long way from the splendours of J. F. Lewis.

The topographical tradition in water-colour painting of Thomas Malton and Edward Dayes persisted until the death of William Callow (b.1812) in 1908. He, Thomas Shotter Boys (1803–1874) and James Holland (1800–1870) were cast in the mould of Bonington. Indeed, Boys had known Bonington in Paris, and may have studied under him. Callow met

JOHN PHILLIP, R.A. *A Chat round the Brasero.* 36×48 inches. Initialled and dated 1866. Guildhall Art Gallery, London.
Exhibited at the Royal Academy, in 1866. 'Spanish' Phillip died within a year of exhibiting this picture.

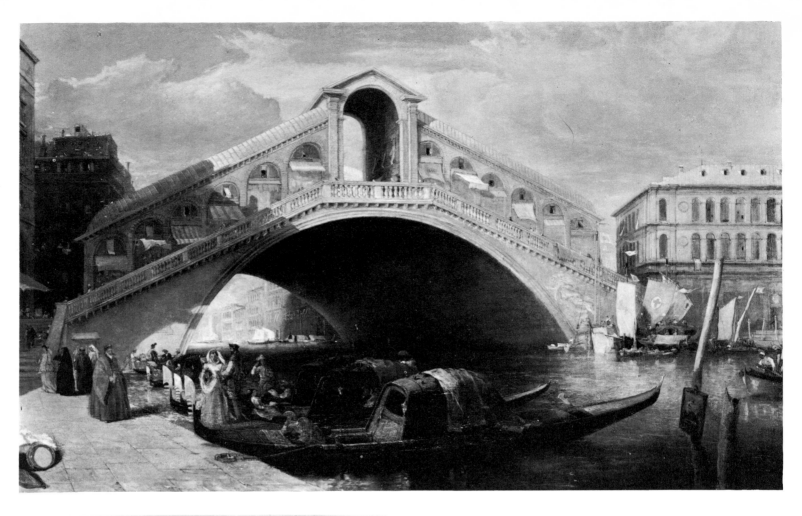

Boys, a 'clever but eccentric artist' on his second visit to Paris in 1831 and learnt a great deal of the theory and practice of art from him, 'and it was from him', he wrote, 'I first acquired my love for making water-colour drawings of picturesque old churches and houses, for which subjects I have had a partiality ever since'. Subjects like these, together with landscapes, were to form the main body of their work. James Holland, who was born two years before Bonington and began his career by painting flowers in James Davenport's factory, was another who followed in the steps of Bonington. His views of Venice, many dashingly painted in oils with an adventurous use of colour, show an assurance of manner which suggests a further debt to Turner. Edward Pritchett (exhib. 1828–1864) was also attracted to Venice: his views of the city, in both oils and water-colour, were exhibited regularly at the Royal Academy and then the British Institution; the influences on him were clearly similar to those on James Holland. Although he was largely repetitive, some of his work indicates a strong talent for the picturesque. The cream of this group's achievement, however, lies in the best water-colours of Boys, Callow and Holland, which, as worthy successors to the work of Bonington, assured the continuing strength of the English water-colour tradition. Another august name in this tradition was Samuel Prout

(1783–1852), whose water-colours of crumbling stone and brick buildings in Northern Europe excited the reverence of Victorians and the not uncritical adulation of Ruskin; a pupil of Prout, James Duffield Harding (1797–1863), described by Ruskin as 'brilliant and vigorous', is another agreeable draughtsman, highly esteemed by Victorians, but now considered an artist of only moderate talent.

In a rather turgid account of the geological structure of land and seascape throughout the world in a series in 'The Art Journal' of 1863, the geologist David Ansted attempted to supply a scientific gloss to Ruskin's exhortations concerning Truth in Art. The author observed that 'all appreciation of grand scenery dates from a very recent period . . . the recognition of any real beauty and interest in mountainous and wild countries was hardly ever made, even a century ago— being as much a growth of modern taste and modern cultivation as are the novel, and other peculiarities of literary composition'. He went on to note that mountains and difficult terrain up to a short time before were avoided wherever possible; this no longer being the case, he analysed their 'physiognomy and characteristic features', as an aid to the artist. One artist who surely benefited by Professor Ansted's advice was Elijah Walton (1833–1880) whose precisely geological water-colour views of the Alps are among his best works. If there was one individual who would have profited little by Ansted's series of articles, it was Edward Lear (1812–1888). No artist understood the geological characteristics of strange and wild landscapes so well, and no other artist had travelled as extensively over so many years as Lear, who observed and recorded in water-colour and oils on a prodigious scale. Lear was the second youngest of twenty-one children, brought up in a fair degree of comfort, only to be forced to earn a living at the age of fifteen, through the imprisonment of his father for bankruptcy. After being taught to draw by his sister, Sarah, he was able to obtain free-lance work. Shortly after this, he began to draw in the Zoological Gardens.

From his first tour of the Continent in 1837 until his death at San Remo in 1888, Lear was hardly ever still. With his restless passion for work, his curiosity, his nervous condition—he was subject to mild epileptic seizures, sometimes as many as eighteen in a month— he traversed Europe and Asia, usually alone, but in later years with his man-servant Kokali. Writing letters to his sister, Ann, to relatives and friends, keeping his Journals, and painting, he was in as many as five or six countries a year, from the Lowlands to Prague, to Vienna, Dubrovnik, Albania, Greece, Palestine, Egypt, Sicily, Italy, France and England. The years 1873 to 1875 saw him in India and Ceylon, at first delirious with 'violent and amazing delight at the wonderful varieties of life and dress here', drawing

and painting feverishly; finally weary of 'this most miserable Indian journey', he sailed for Brindisi. The last years of his life were spent at San Remo, where he died far from his many friends.

Lear's painting was always inspired by the romantic element in landscape. Jagged mountains, huge trees, distant views at sunset, precipices, ravines: these he treated with a technical skill and a character absolutely unique to him. The structure of his water-colours is predominantly linear, and in his oil-paintings his handling of paint is at times almost abstract: an oil sketch by Lear can resemble the work of Sidney Nolan. A Pre-Raphaelite influence, by reason of his association with Holman Hunt in the 'fifties, is also discernible: the mountainous background to *The Scapegoat* looks as though it might have been painted by Lear. Mr Brian Reade, in his introduction to the Lear Exhibition at the Arts Council in 1958, gave a vivid account of Lear's methods: 'He would set out with his gear and his manservant, select a site, lift his spectacles, gaze at the scene before him through a monocular glass, and then, readjusting his spectacles, begin to draw rapidly in pencil. Certain details would be inscribed in longhand with colour notes in Lear's own special phonetic spelling, "rox" for rocks, "ski" for sky, and so on. Sometimes he

would apply water-colour in generalized tints over large areas with great dash. Much of this work must have been done indoors. In the evenings too he would "pen over" the pencil and water-colour sketches, graduating minutely the receding planes and out-lining the forms rather sharply, so as to give an effect of crystalline elegance.' Lear's work undoubtedly suffered from over-production, but no one would have been more surprised than he to learn that he is now considered, and rightly so, to be one of the most original landscape painters of the nineteenth century, standing fully in the tradition of Martin and Danby.

For sheer prodigality of character, career and production it would be hard to find another artist to equal George Chinnery (1774–1852): of his total span of seventy-eight years, the last fifty were spent entirely in the Far East, for reasons that were, at least at first, more matrimonial than artistic; and, oils apart, his vivid drawings and water-colours are only exceeded in number and fluency by Rowlandson's. Chinnery's father, who was of East Anglian stock, was an amateur painter, who encouraged his son to paint and draw at an early age. In 1791, Chinnery was a contemporary of Turner at the Royal Academy Schools; Sir Joshua Reynolds, then President, died the following year.

When he was only seventeen, he exhibited a

Forest of Bavella, Corsica by Edward Lear is reproduced in colour on p. 108.

EDWARD LEAR. *Dubrovnik, Yugo-slavia.* Pen, ink and water-colour. 13½ × 21 inches. Mrs E. P. Card. Annotated, inscribed and dated 'Ragusa, 6 a.m. 5th May, 9 a.m., 5 p.m. 6th May 1866 (43)'.

portrait, and portraiture continued to prove a lucrative mainstay for the rest of his life. This portraiture always betrayed an early debt to Reynolds and Romney, just as his pencil and wash groups show the influence of Cosway. For the next four years he exhibited a succession of portraits at the Royal Academy, until, at the suggestion of an influential uncle, Sir Broderick Chinnery, he crossed over to Dublin. Here he was the guest of James Vigne, a jeweller, whose daughter, Marianne, he married in 1799. In Dublin he painted a number of miniatures, showing the effect of his contact with John Comerford the miniaturist, and his first landscapes; it was in the Irish capital that he left a durable mark, the revival of the dormant Society of Arts in Ireland. Three years later he returned to England with his wife and two children, to live at Gilwell Park, Essex. It seems that extravagance and a wayward nature were by now contributing to a breakdown in his marriage, and he seized the first opportunity to sail for India, where he arrived later in the same year. He remained for twenty-three years, living mostly in Calcutta. There he became a well-known figure with the British Raj, undertaking a number of portrait commissions—he was reputedly earning up to £500 a month—and filling hundreds of sketchbooks with brilliantly observed scenes of Indian life. He was 'the ablest limner in the land' according to his friend Sir Charles D'Oyly, and he devoted his leisure to 'smoky meditation'—

assuredly a reference to an addiction to opium. This opium dream was rudely awakened by the successive arrivals of his daughter, his wife and his son. Chinnery tried to keep up appearances for a time in spite of the existence of two illegitimate sons by an unknown mother; then, in his own words, 'he had to bolt for China for £40,000 of debt'. 'To get so heavily involved', a contemporary commented, 'is a sign of his genius.'

In the early summer of 1825, at the age of fifty, he reached Macao where he remained, occasionally visiting Canton and Hongkong, until his death. His wife followed him about four years later, but he took refuge in Canton, where he thanked providence for the 'Chinese government that forbids the softer sex from coming and bothering us here'. Mrs Chinnery was accordingly refused permission to disembark and, languishing on board the ship, she caught smallpox and died. From now on Chinnery settled into a comfortable pattern of life drinking vast quantities of tea, and eating so much that four bearers were needed to carry his personal chair around the alleyways of Macao; making innumerable drawings of the Chinese going about their daily tasks, water-colour views, and oil-paintings of English and Chinese officials, views of Macao, junks and market scenes. Although never allowing his work to become orientalised, he founded what has become known as a 'Chinnery School'. He employed a number of assis-

Dent's Verandah, Macao by George Chinnery is reproduced in colour on p. 117.

GEORGE CHINNERY. *Portraits of Sir Jamsetjee Jejeebhoy and a Man Servant* (detail). $28\frac{1}{2} \times 21\frac{3}{4}$ inches. John Keswick, Esq., C.M.G.

Sir Jamsetjee Jejeebhoy was a prominent Parsee merchant from Bombay. He was said to have made a fortune from the sale of opium. He was also a great benefactor and was made a baronet by Queen Victoria. It seems likely, since he has a Chinese manservant, that the picture was painted while he was on a visit to Macao.

tants and copyists, whose names sound like a jingle from 'The Mikado'—Protin Qua, Sun Qua, Fal Qua, Tin Qua, Yin Qua and Lam Qua. Lam Qua acquired a certain status by actually sending pictures for exhibition at the Royal Academy. Chinnery mixed and ground his own pigments, and used thin canvases of local manufacture. He was fond of vermilion, using dabs of it for eyes, lips, nostrils and ears; and Chinese white for flecks of light in the landscapes. He continued to send pictures to the Royal Academy until his death from apoplexy in 1852. Chinnery occupies a special place in Victorian painting: not only was he the only important European artist of the time to live and work in the Far East for the greater part of his life, but his paintings, in oils and water-colour, and his drawings have a vigorous and fluent character entirely their own, earning the praise of Sir Francis Chantrey who said that he never saw a figure drawn by Chinnery that he 'could not cut a statue from'.

VIII

EARLY GENRE

Reviewing the Royal Academy Exhibition in June 1863, 'The Art Journal' critic, to avoid discussing the pictures room by room, decided to 'distribute under distinct headings the diversified works here thrown confusedly together'. It is no surprise that the first division consisted of 'HIGH ART: HISTORY— SACRED AND SECULAR.' This section contains some engaging titles: *La Toilette des Morts*, 'an incident in the tragic life of Charlotte Corday' by E. M. Ward; *The Power of Music*, by H. N. O'Neil, a sequel to his successful *Mozart on his Death-bed giving Directions for the Performance of his last Requiem* and, selected for praise by the reviewer, *Robespierre receiving Letters from the Friends of his Victims which threaten him with Assassination*, by William Henry Fisk (1827–1884). One is momentarily startled to see the name of Leighton appearing in such company. The next category in descending order is 'SUBJECTS POETIC AND IMAGINATIVE'. Here there are Millais's *The Eve of St. Agnes*, with its vestigial Pre-Raphaelitism and *My First*

Sermon, his earliest experiment in the sentimental treatment of childhood, which was commended by the Archbishop of Canterbury whose spirit was 'touched by the playfulness, the innocence, the purity, and may I not add, the piety of childhood'; William Powell Frith (1819–1909) is represented by *Juliet*, his *Derby Day* being five years behind him; Paul Falconer Poole (1807–1879) shows a pastoral scene with amorous peasants. Henry William Pickersgill (1782–1875) shows *Desdemona's Intercession for Cassio*, while Frederick Richard Pickersgill (1820–1900) has *Ferdinand and Miranda*; and the reviewer notes 'the tender refinement' of *Hermione* by William Maw Egley (1826–1916). The next division is 'PORTRAITS', where the reviewer confesses to bewilderment 'at the inordinate number of them'. Then, noting that 'England, happy in her homes, and joyous in her hearty cheer, and peaceful in her snug firesides, is equally fortunate in a school of Art sacred to the hallowed relations of domestic life', he reaches 'SCENES DOMESTIC—

SIR DAVID WILKIE, R.A. *The Bride at her Toilet*. 38¼ × 48¼ inches. National Gallery of Scotland, Edinburgh.

Exhibited at the Royal Academy in 1838. Thackeray wrote of it: 'The colour of this picture is delicious, and the effect faultless: Sir David does everything for a picture nowadays but the *drawing*. Who knows? Perhaps it is as well left out.'

GRAVE AND GAY'. To this category he appends 'OUT-DOOR FIGURES—RUDE, RUSTIC AND REFINED', with the lame explanation that 'the experience of the kitchen and the parlour finds its correspondence in the incidents of the field or the garden'. The list ends with animal, fruit and flower, sea and landscape painting.

This second hierarchical exercise in grading the subjects of art, coming twenty-five years after Thackeray's, besides stressing the nagging Victorian obsession with subject matter, affords a useful glimpse of a typical exhibition nearly at mid-point in the reign of Queen Victoria. At first sight it would appear to differ little from an exhibition of 1837. But the Royal Academy in 1863 had been through the fire of Pre-Raphaelitism, the embers of which still glowed; historical painting was now fused with subjects from Northern and Southern mythology; Roberts, Lewis and Goodall were sending in exotic Eastern subjects; the neo-classical influence was making itself felt: genre was creeping into the marbled palaces of Greece and Rome. Hierarchy of subject apart, it is clear, however, that by far the greatest number of pictures are of domestic scenes, in or out of doors, often with an anecdotal interest, sometimes from contemporary life and at other times from history and literature, and often thickly coated with sentiment. 'They are subjects', wrote Henry James, 'addressed to a taste of a particularly unimaginative and unaesthetic order—to the taste of the British merchant and paterfamilias and his excellently regulated family. What this taste appears to demand of a picture is that it shall have a taking title, like a three-volume novel or an article in a magazine: that it shall embody in its lower flights some comfortable incident of the daily life of our period, suggestive more especially of its gentilities and proprieties and familiar moralities.'

Among the many thousands of Victorian painters who practised genre painting, most are now forgotten, while some are remembered only for a few paintings of a very high order; some few, like W. P. Frith, could devote a lifetime to genre painting, and rarely turn out a bad picture. It was only comparatively recently that Mr Graham Reynolds sympathetically drew our attention to their productions, and new discoveries are coming to light all the time. The main appeal these paintings now have for us is their simple charm, their value as documents of social interest and, more often than is sometimes acknowledged, their painterly qualities. The frequent charge that one genre painting is very like another, while containing an element of truth, arises usually out of a lack of sympathy for the subject. Never before had an age been visually so well documented.

This kind of painting had been popular in England since the time of Hogarth, but it was David Wilkie

(1785–1841), 'a raw tall, pale, queer Scotsman', who established its ascendancy in Victorian England. Although he survived the Queen's accession for only five years, the last two of which were spent in the Middle East (from which he never returned), his influence pervaded painting throughout her reign. Ironically, Wilkie's own personal reputation was in decline by 1837. His great successes lay far behind him: coming to London in May 1805, 'he saw a picture of Teniers', in the words of Sir George Beaumont, 'and at once painted *The Village Politicians*'. The Dutch

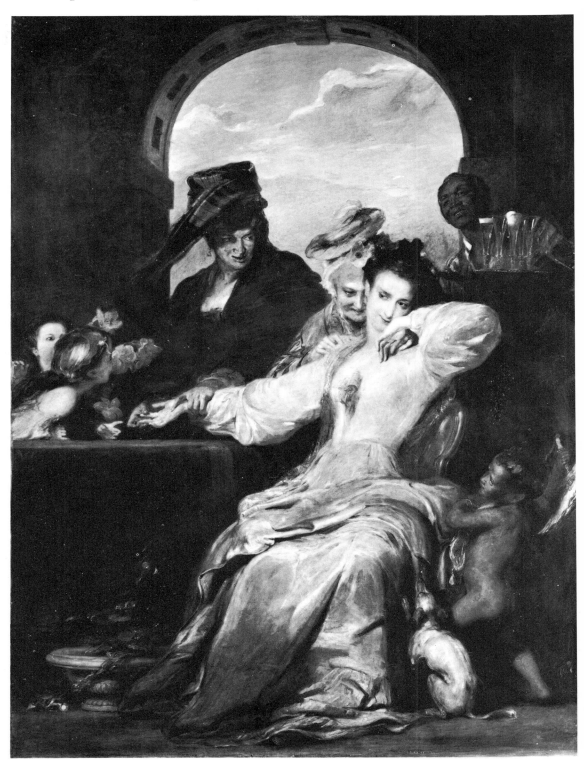

SIR DAVID WILKIE, R.A. *The Empress Josephine and the Fortune-Teller*. 83×62 inches. Signed and dated 1837. National Gallery of Scotland, Edinburgh.

Exhibited at the Royal Academy in 1837. The picture illustrates an incident in Martinique, the Empress Josephine's native island, when a negress read in the palm of her hand that she would one day be crowned and be greater than a Queen.

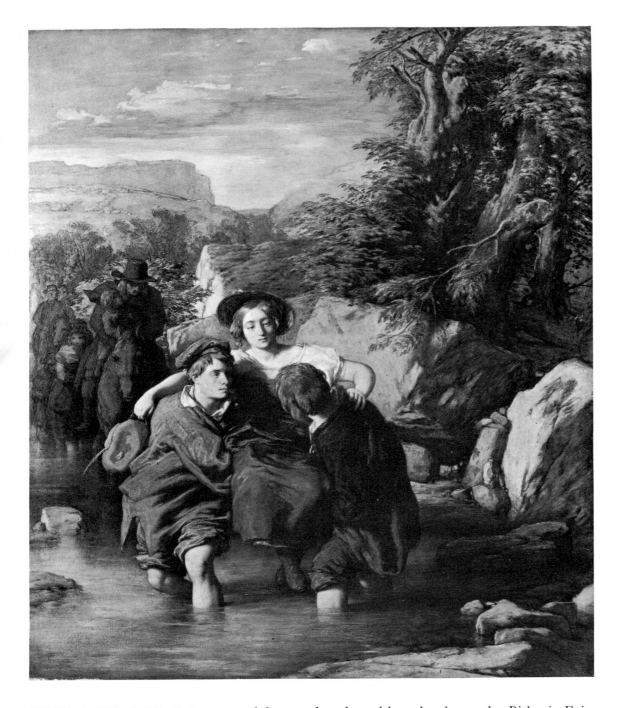

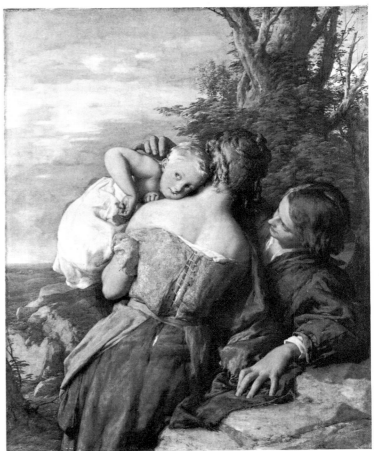

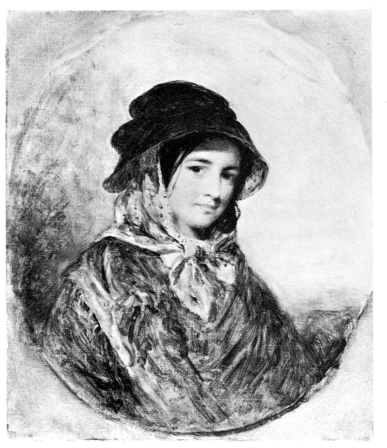

model was already evident in the early *Pitlassie Fair*. These early works were followed by the immensely popular *Blind Fiddler*, *The Village Festival*, *Blindman's Buff*, and the highly esteemed *Reading the Gazette of the Battle of Waterloo* of 1822. Wilkie's dominance in genre was then supreme. While his earlier work wore a brighter plumage (C. L. Nursey, a pupil of Wilkie, described to Holman Hunt how his master had painted *The Blind Fiddler* 'without any dead colouring, finishing each bit thoroughly in the day'), his later work became broader and darker, with the use of bitumen working its usual havoc. It also became more international in style, more heroic, although to Thackeray his pictures seemed 'to be painted with snuff and tallow-grease'. Tragically teetering on the edge of the abyss of High Art, he went to Palestine in search of material for biblical paintings, anticipating a similar quest by Holman Hunt nearly twenty-five years later. He had

visited Madrid in 1827, the first of a long line of painters including Roberts, Lewis and Phillip, to do so. But it was the genre pictures of his early and middle period, together with those of his rival William Mulready (1786–1863), which determined the course of Victorian subject painting. The subject-matter of his pictures was already tending towards children and dogs set in simple domestic surroundings. Although never mawkish, Mulready's pictures tended, more than Wilkie's, to sentiment. During the latter half of the century sentimentality, the right wing of hypocrisy, swelled from a thin coat to a thick sludge: Mulready died in the year in which Millais's *My First Sermon* was exhibited at the Royal Academy.

Like Wilkie, Mulready was already an established figure long before 1837. After an early career as a landscape painter of some sensitivity, he was, from 1807, converted by the example of Wilkie to genre painting. Again the grouping is reminiscent of Ostade and Teniers. But he was not what Horace Walpole called one of those 'drudging Mimicks of Nature's most uncomely coarsenesses', but an observer of rare talent. Although his pictures never acquired the same individual fame as Wilkie's, there is a greater consistency about his painting which never degenerates into monotony. Mulready, moreover, was a great colourist. Never darkening his canvases with bitumen, he painted as the Pre-Raphaelites did later, in thin glazes over a white ground, achieving a transparent luminosity of colour. Four years before the foundation of the Brotherhood, Thackeray noted his 'brilliant, rich, astonishingly luminous and intense' colours.

Not unlike Mulready was Thomas Webster (1800–1886), whose best-known picture is *The Village Choir*, at the Victoria and Albert Museum. His studies of schoolboy pranks are genuinely humorous and never treacly. The same cannot be said of the 'dangerous smiling Delilahs' painted by artists like Edmund Thomas Parris (1793–1873), Charles Baxter (1809–1879) and Frank Stone (1800–1859). Hovering on the brink of genre painting, they are merely a framed version of 'The Keepsake' beauties. While its artistic

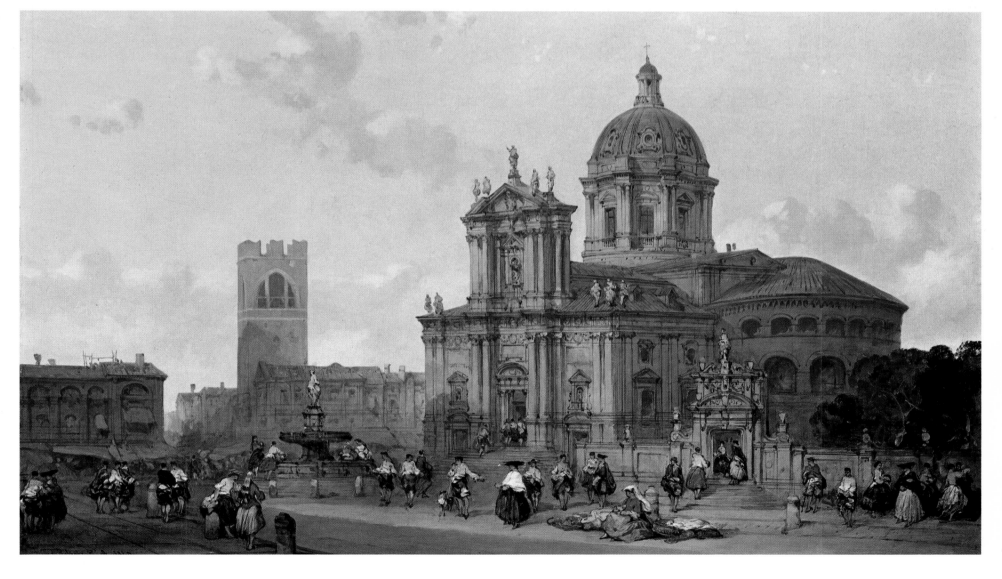

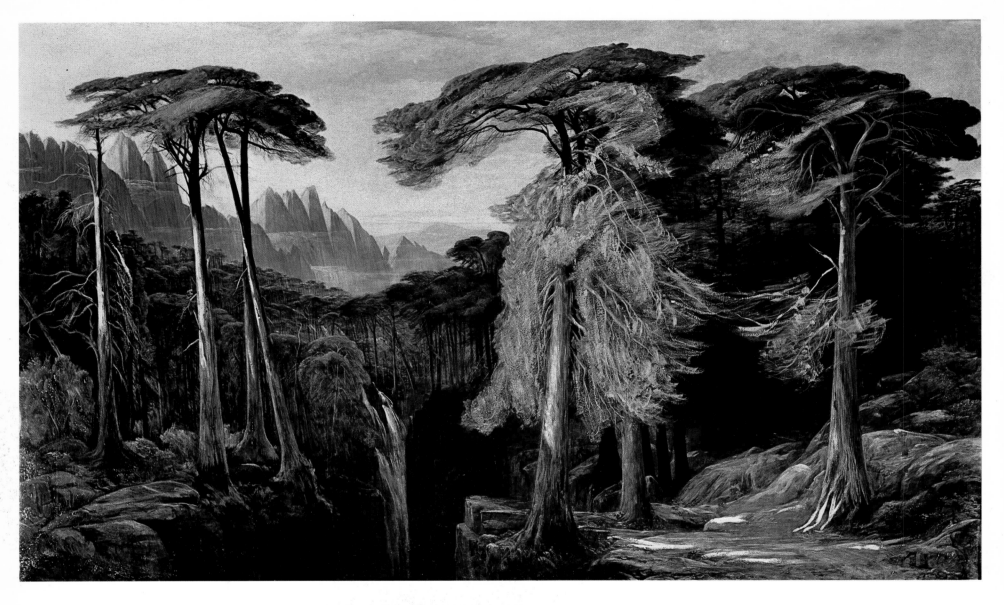

EDWARD LEAR. *Forest of Bavella, Corsica.* $57\frac{1}{2}\times95$ inches. Alexander Martin, Esq.

Lear was in Corsica in 1868. This picture probably dates from 1878-80, and is said to have been bought by the Earl of Derby, the son of his first patron. Lear made a number of sketches of Bavella, which made a deep impression on him. He wrote in his diary on 29th April 1868: 'a painter . . . might and should endure anything short of starvation, to see what I have seen of Bavella'. *See p. 100.*

value amounts to very little, this kind of painting retains for us a certain period charm. Far more interesting are the figure sketches of William Henry Hunt (1790–1864); always painted in delicate stippled water-colours, they depict amusing scenes from everyday life. His single figure studies are painted with an exquisite under-statement, rare at the time. E. M. Ward is an instance of an historical painter, who, taking time off from the onerous rigours of painting on a large scale, could depict delightful little scenes from everyday life. William Gush (exhib. 1833–1874) was an aptly named portraitist of some charm, whose portraits were painted in 'The Keepsake' tradition.

In 1843 appeared Mulready's illustrations to 'The Vicar of Wakefield', published by Van Voorst. They coincided with the rise of a school of historical genre painting, which up till the end of the century was to engage the talents of subject painters. Charles Robert Leslie (1794–1859) was the first of a line that ended with Seymour Lucas, G. D. Leslie, F. W. Topham and others. Most of the subjects were drawn from

literature: the works of Cervantes, Molière, Shakespeare and Goldsmith being the most popular. Easily topping the list was the 'Vicar of Wakefield'. William Powell Frith was one of the first to illustrate the work of a contemporary novelist, in 1842, with the subject of Dolly Varden from Dickens's 'Barnaby Rudge' which was published in the same year, although the novel is set in the age of Goldsmith. In the mid to late nineteenth century, characters from literature were joined by cavaliers, roundheads and groups at the court of Charles II. Although this kind of painting led to flights of ineffable vulgarity, it is well to be reminded that it was paralleled in France and Italy by painters of the Meissonier stamp like François Brunery, Georges Croegaert and Adolphe Lesrel; even Paul Delaroche exhibited *Cromwell looking at the Dead Body of Charles I* at the Royal Academy in 1850. At its worst this style of painting degenerated into the 'Cardinals tippling' variety which pandered to the meanest tastes on both sides of the Channel. To the uneducated patron historical accuracy was of little account.

C. R. Leslie, the biographer of Constable, was one
of the first to practise historical genre painting success-
fully. He was born in London of American parents,
and brought up in Philadelphia. Coming to England
he was patronised by Lord Egremont and, like Turner,
stayed frequently at Petworth. A love of Hogarth and
the theatre is discernible in his pictures. He could be
delightfully brash, as in *Les Femmes Savantes*, or low-
keyed as in *Le Bourgeois Gentilhomme*, both depicting

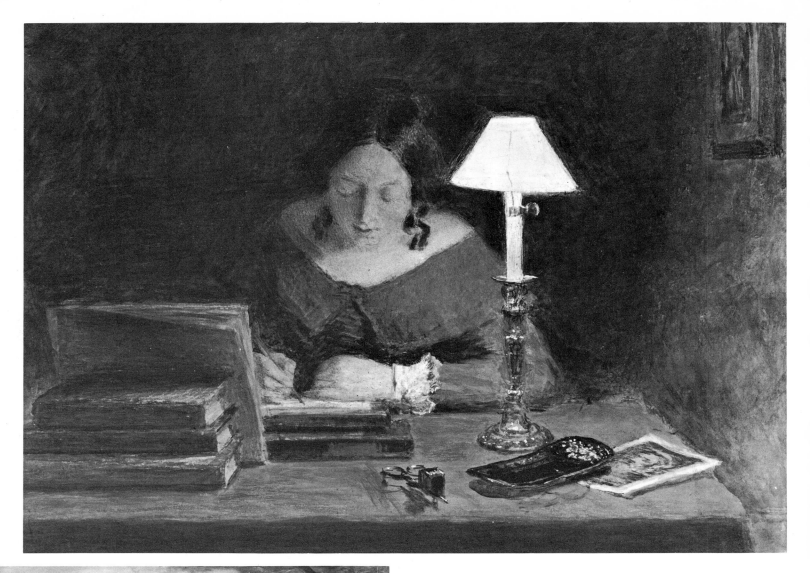

WILLIAM HENRY HUNT. *Girl writing by Lamplight*. Water-colour and body-colour. 11 × 15 inches. Maas Gallery, London.

A pen and ink study for this subject is privately owned in London.

AUGUSTUS EGG, R.A. *Scene from 'The Winter's Tale'*. 34 × 46 inches. Signed and dated 1845. Guildhall Art Gallery, London.

Exhibited at the Royal Academy in 1845. The subject is from Act IV, Scene iii 'Come buy of me . . .' Egg was a proficient actor and played in Dickens's company of amateurs.

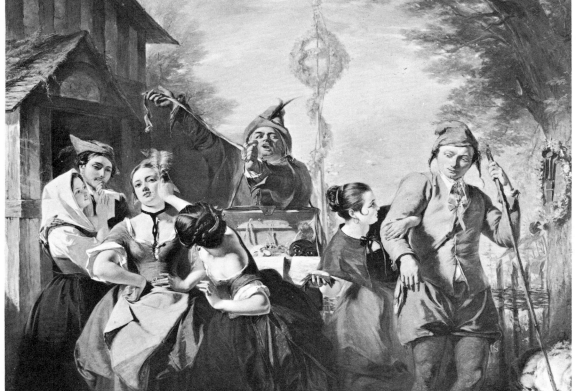

scenes from Molière. Pictures of this kind were also rooted in the Boydell tradition of Shakespearian illustration. Henry Perronet Briggs (?1791–1844) painted Shakespearian scenes which link this tradition with Leslie.

Of the members of The Clique, Richard Dadd, Augustus Egg, John Phillip, W. P. Frith and H. N. O'Neil, it was Frith who achieved the widest fame. Egg was later to be affected by the Pre-Raphaelite movement; that he was already a painter capable of a smooth finish is apparent from *Scene from the Winter's Tale*, exhibited in 1845. If Dadd is to us the most interesting of this group, Frith, who was born in the same year as the Queen and lived to within a few months of the accession of George V, gained the most worldly success. Like Watts, he lived to be derided by the new aesthetes and branded as a bourgeois reactionary. He was regarded as a particularly virulent specimen of Victorian philistinism. His highly entertaining memoirs, written when he was over seventy, while they give us vivid glimpses of the Victorian artistic scene, contain many examples of almost ingenuous opportunism which strengthened this atti-

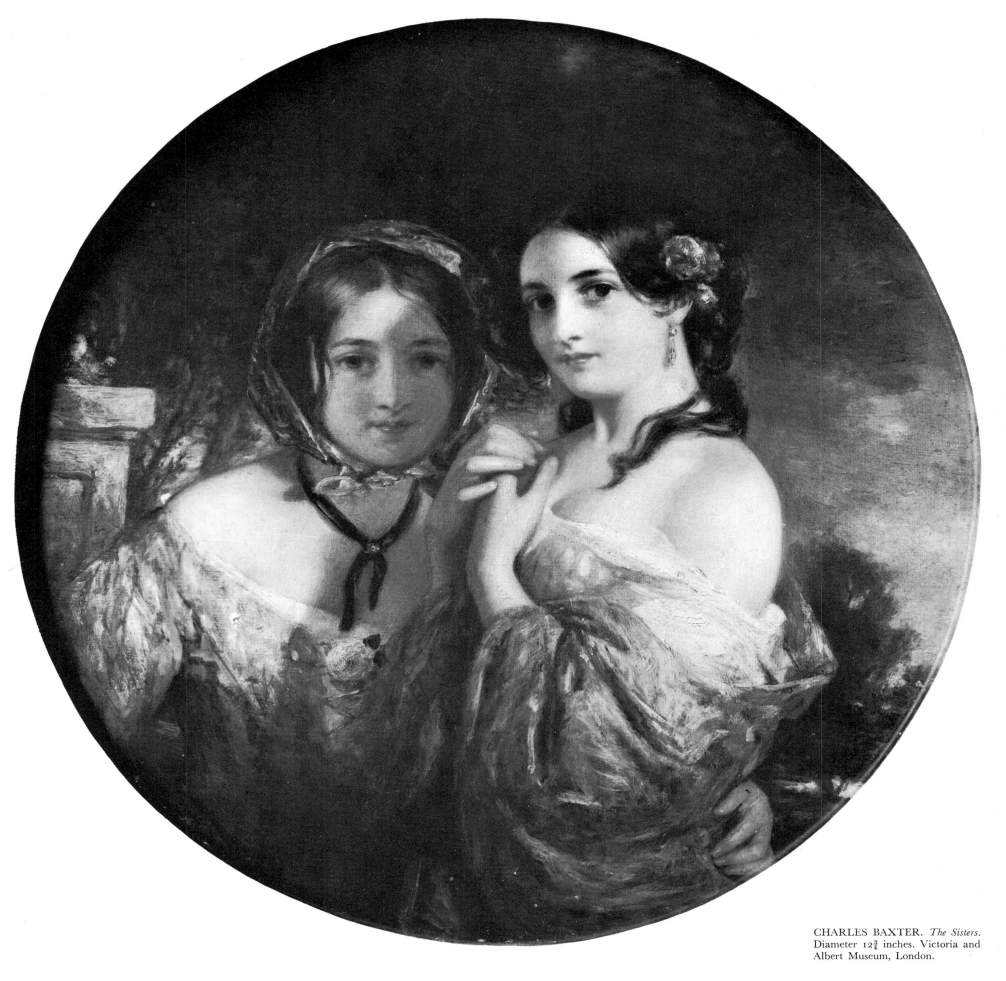

CHARLES BAXTER. *The Sisters.*
Diameter 12¾ inches. Victoria and
Albert Museum, London.

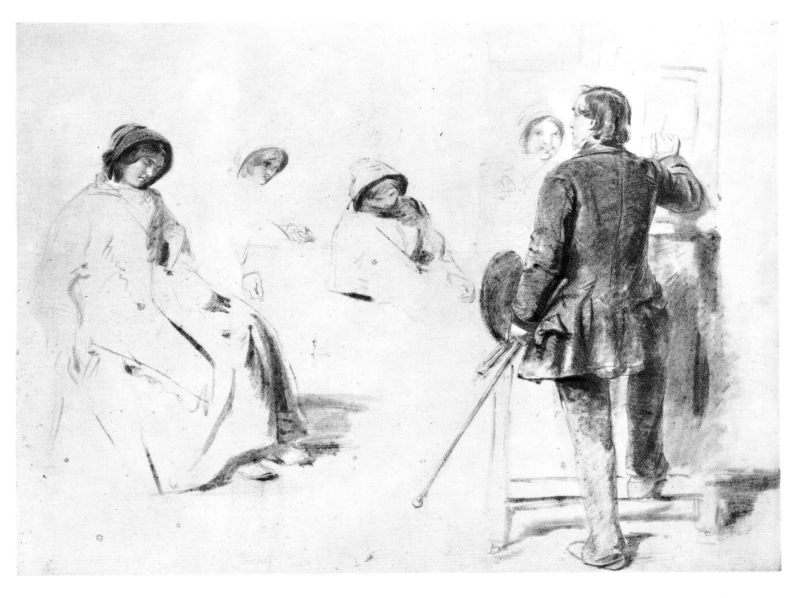

Life at the Seaside (*Ramsgate Sands*) by
W. P. Frith is reproduced in colour
on p. 118.

tude. (Whistler, on reading in Frith's memoirs that it was just a toss-up as to whether Frith became an auctioneer or a painter, concluded that 'he must have tossed up'.) If Frith was not noticeably bothered by the pursuit of high ideals, at least he was consistent, after a hesitant start, in his intention, declared in 1837, to paint scenes of ordinary life (even though he never entirely forsook historical genre painting); and if he made a lot of money by charging high prices and by the sale of copyrights, he was doing no more than were many of his contemporaries who thrived on a far more rarefied plane. His great masterpieces, *Life at the Seaside* (*Ramsgate Sands*), *The Derby Day* and *The Railway Station*, the first of which was bought by the Queen, cast him in the role of a showman, as John Martin was in landscape before him. They were immensely popular, and judged purely as pictorial documents his paintings are still regarded as being amongst the best of the Victorian age.

Frith had a sure sense of what the public wanted, and as a craftsman and purveyor of the popular, his attitude was not very different from that of the professional sporting painter or even of novelists, such as Dickens or Trollope. Although his first avowed hopes were of painting scenes of ordinary life, his earlier pictures were scenes from Shakespeare, Goldsmith, Scott and other favourites; these were painted with freedom and obvious relish, in response to popular taste. It was only in 1852, after the trail had been blazed by the Pre-Raphaelites, that he began to paint his large panoramic *Ramsgate Sands*, 'with all its drawbacks of unpicturesque dress', and, since 'photography was in its infancy at the time', relying on numerous sketches. It achieved instant success when it was shown at the Royal Academy two years later. With the other two great panoramas still to come, it would be tempting to say that Frith never looked back; but look back he did. Noting in his diary that 'bad times have come upon us' (a reference to the revival of historical genre painting in the 'sixties'), he painted, at the suggestion of the dealer, Gambart, the large *Charles II's Last Sunday*, 'a matter of everlasting regret to me, from my conviction that my reputation will rest on the pictures I have painted from the life about me'.

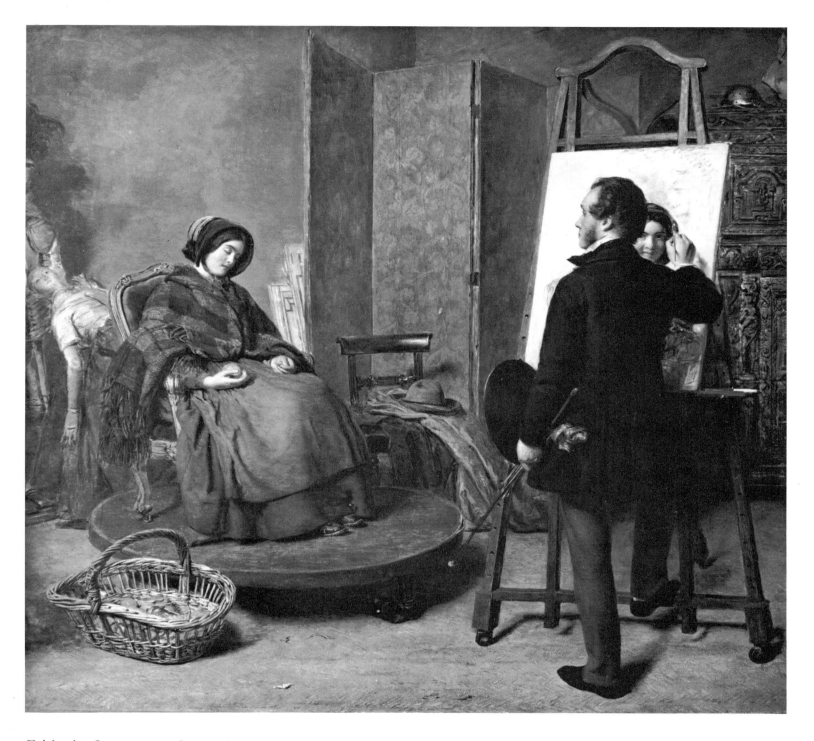

Frith, in fact, never deserted his early love for historical genre pictures: subjects from Sterne, Boswell, Fielding and Shakespeare occupied him at least until 1899 when he exhibited a picture illustrating an incident from Pepys's diary, *Charles II and Lady Castlemaine*. *The Derby Day* (1858), even more ambitious than *Ramsgate Sands*, maintained the appeal of scenes from contemporary life. Even Ruskin admired it as 'a kind of cross between John Leech and Wilkie, and a dash of daguerreotype here and there and some pretty seasoning with Dickens's sentiment'. This was followed by *The Railway Station* of 1862, *The Salon d'Or, Homburg* of 1871, the five Hogarthian *The Road to Ruin* scenes of 1878, protected by 'the policeman and the rail',

a feature becoming normal at exhibitions of Frith's pictures, and *The Private View of the Royal Academy, 1881*, exhibited in 1883.

In painting scenes from everyday life, Frith was the great exemplar. He was, however, preceded by a pioneer, Richard Redgrave (1804–1888), a painter of nice talent, who like Dyce, Eastlake and others, devoted much of his life to official duties. In succession to Dyce he worked for several years on the system of national art education; he was Keeper of Paintings at the Victoria and Albert Museum, then known as the South Kensington Museum, and Inspector of the Queen's Pictures. Such time as could be spared from official duties, and, during the summer, painting, he

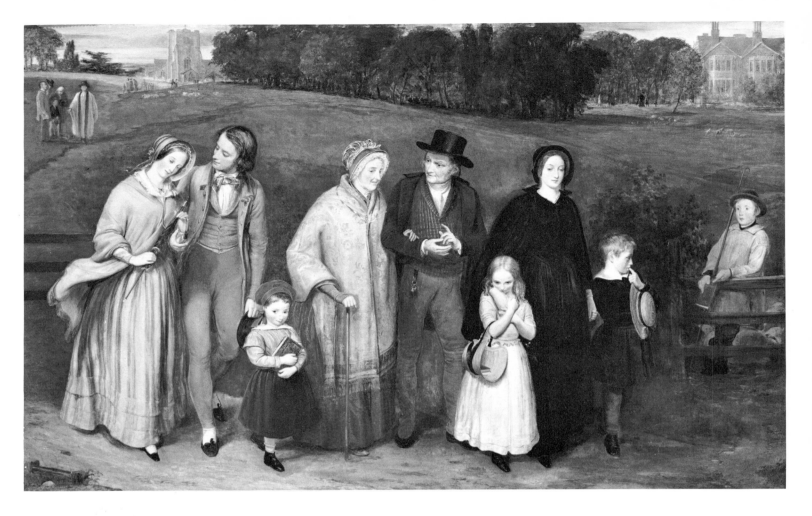

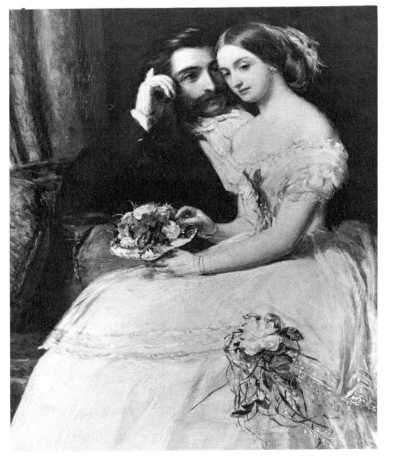

spent on designing pottery and glass. He was also, with his brother, co-author of the first important survey of British painting, 'A Century of Painters'. His first exhibited pictures were social commentaries, but so strong was academic and public antipathy for figures clothed in contemporary dress, that he was obliged to resort to period costume. With *The Poor Teacher*, exhibited at the Royal Academy in 1843, we have one of the earliest examples of a picture in contemporary dress. The version at the Victoria and Albert Museum is a later one painted for Sheepshanks, the Leeds collector who, objecting to the loneliness of the sweet-faced teacher, asked the artist to add the children in the background. This episode is all the more interesting in that it is an early example of a painter altering a picture to suit the whim of one of the new class of rich bourgeois collectors. (Poynter altered his *Israel in Egypt*, under similar circumstances, some twenty years later.) Redgrave's later works are the usual compound of contemporary and historical genre scenes, and some brilliant landscapes.

The remaining members of The Clique, John Phillip (1817–1867) and Henry Nelson O'Neil (1817–1880) went their several ways: Phillip, in pursuit, it will be remembered, of his aim to paint incidents in the lives of famous people, painted scenes like *The Marriage of H.R.H. The Princess Royal and Prince*

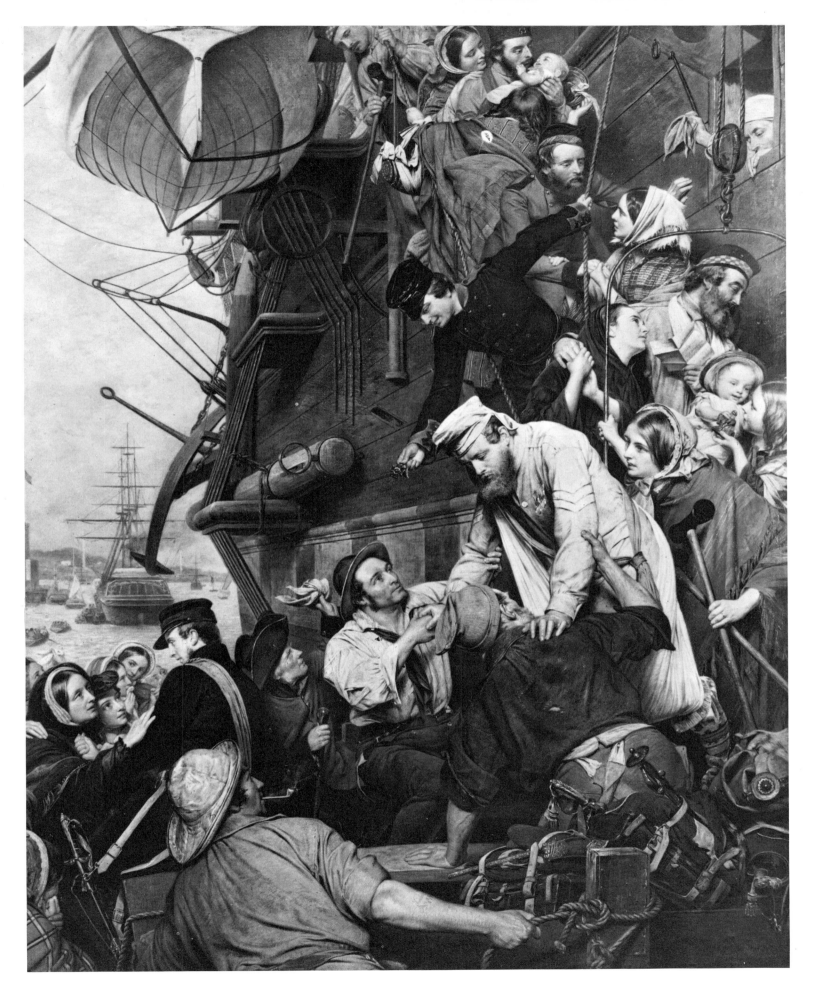

HENRY NELSON O'NEIL, A.R.A
Home Again, 1858. 53½ × 42¼ inches.
Signed and dated 1859. Appleby
Bros., London.

Exhibited at the Royal Academy
in 1859. This is the sequel to his
popular *Eastward Ho! August* 1857,
which showed troops embarking for
the Indian Mutiny. In this painting
they are seen returning.

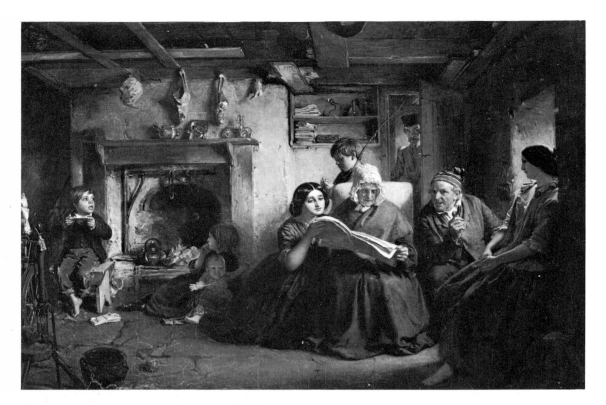

Frederick William of Prussia (1858), a commission previously declined by Frith who was absorbed in *The Derby Day*. His earlier work bears a close affinity to that of his fellow Scotsman, Wilkie. O'Neil, on the other hand, with the intention of depicting striking situations which appealed to the feelings, achieved success of Frith-like proportions with *Eastward Ho! August 1857* and its only slightly less popular sequel, *Home Again, 1858*. The Crimean War and the Indian Mutiny, with their implied themes of separation and family loss, were to provide a rich new vein of material for subject-hungry genre painters. Similarly, *Volunteers* by Arthur Boyd Houghton (1836–1875) was inspired by the uncertainties of French policy in the 'sixties. The growing tide of emigration supplied further themes, all allied to separation and departure. Madox Brown's *The Last of England* is among the most moving. Railway stations are featured in pictures like *Parting Words—Fenchurch Street Station* (1859) by F. B. Barwell (exhib. 1855–1887); *Waiting for the Train* (1864) by Erskine Nicol (1825–1904); and Frith managed to record almost every emotion and incident commonly

THOMAS FAED, R.A. *The Soldier's Return*. Millboard. $14\frac{1}{4} \times 19\frac{1}{4}$ inches. Sir David Scott, K.C.M.G., O.B.E.

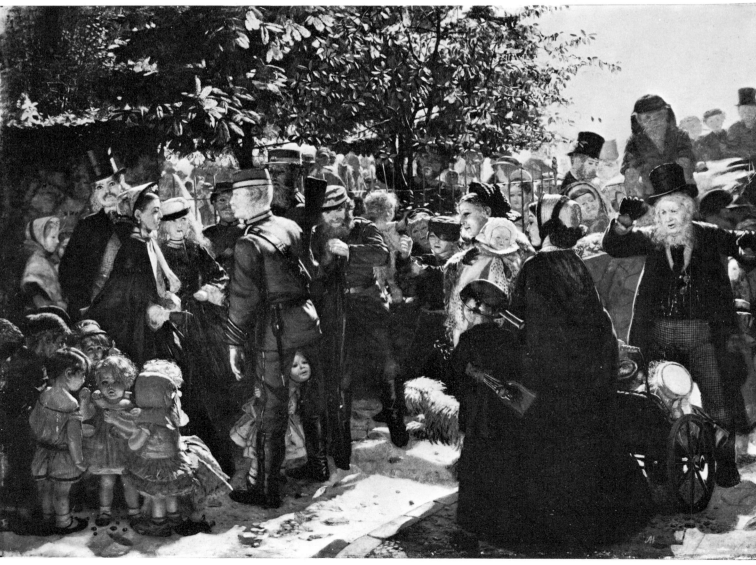

ARTHUR BOYD HOUGHTON *Volunteers*. $12 \times 15\frac{1}{2}$ inches. Signed. with initials. Tate Gallery, London.

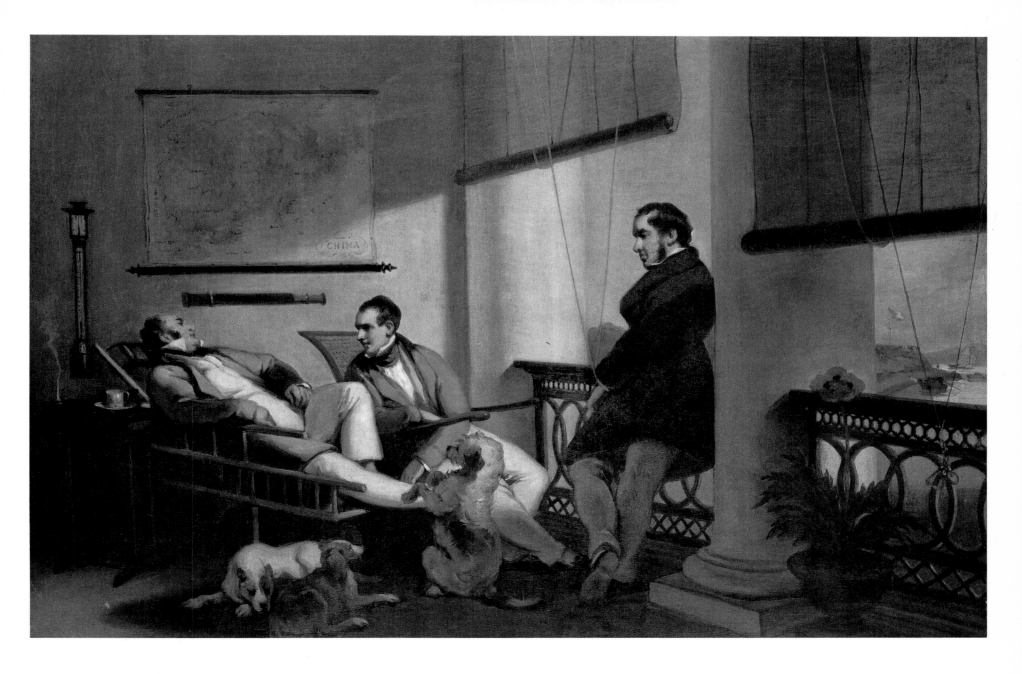

seen on a platform in *The Railway Station*. The Victorians liked pictures, and other art forms, which tapped the full gamut of emotion.

Pictures from which moral undertones were more or less absent were becoming increasingly popular; and Frith's crowded canvases often showed the way. Thus, *A Summer Day in Hyde Park* by John Ritchie (exhib. 1858–1875), is a serenely painted idyll, in which the figures do little more than pass the time of day. The light and dark colour harmonies and the careful grouping owe much to the example of Frith. Less like Frith and betraying more of the artist's country of origin in its harder colouring is the enchanting *Dancing Platform at Cremorne Gardens* (1864) by the German-born Phoebus (?)Levin (exhib. 1855–1874). The indoor scenes of James Collinson (?1825–1881), one of the seven original members of the Pre-Raphaelite Brotherhood, are often free from moralizing to the

point of total reticence, perhaps reflecting his personal habit of somnolence, which made him the butt of the Brotherhood. The eloquence of his pictures results from his dexterity in rendering the surfaces of materials and everyday objects, as in *The Empty Purse*. Another painter who kept the moralising very muted was George Elgar Hicks (b.1824, exhib. until 1892), an otherwise not greatly interesting artist, who painted lively scenes like *The General Post Office: One Minute to Six* (1860) and *Billingsgate* (1861) which were exhibited at the Royal Academy in successive years.

Poverty, prostitution, illicit love, illness, death, bereavement and sudden destitution were all favourite themes, and received similarity of treatment by genre painters from one end of the Victorian age to the other. Encouraged by the forceful example of the Pre-Raphaelites, many of whose pictures, like Madox Brown's *Work* and Holman Hunt's *The Awakening*

GEORGE CHINNERY. *Dent's Verandah, Macao.* $17\frac{1}{2} \times 25\frac{3}{4}$ inches. W. J. Keswick, Esq.

Dent and Company was a firm in Macao, second only in importance to Jardine and Matheson. The portraits are of Mr Durand, Mr Hunter and Captain Hall. William Hunter was an American with the firm of Russell and Company. Captain (later Admiral Sir William Hutcheon) Hall (1788-1878) was in China in the same years as Chinnery only between 1841 and 1843. A study for part of this picture, dated 1842, is privately owned. *See p. 101.*

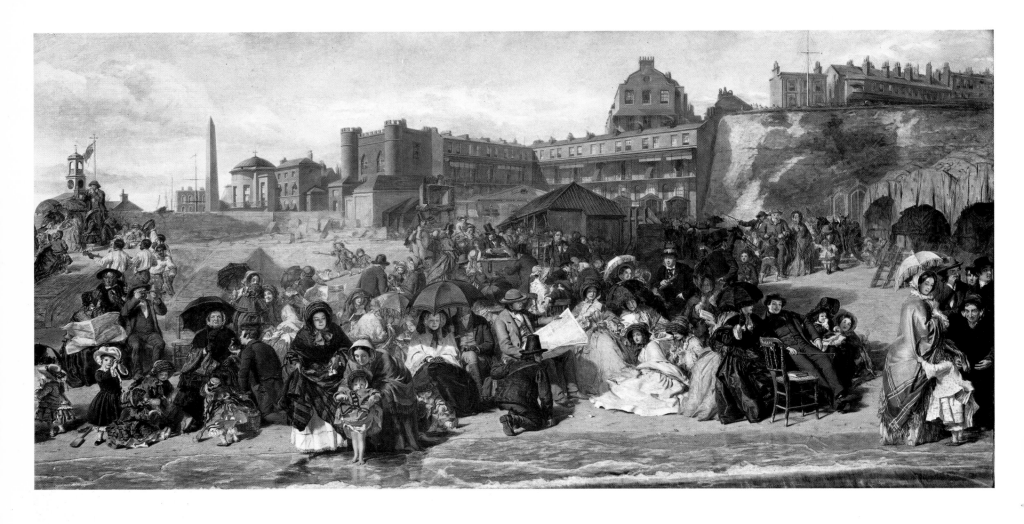

WILLIAM POWELL FRITH, R.A. *Life at the Seaside (Ramsgate Sands)*. 30 × 60½ inches. Her Majesty The Queen.

Exhibited at the Royal Academy in 1854. The picture, for which Frith made preliminary sketches at Ramsgate in 1851, was begun in April 1852 and finished in 1854. It was bought by Queen Victoria from a picture dealer at the Private View of the Academy exhibition for 1,000 guineas. This was Frith's first large-scale work depicting a scene from every-day life. There is a small preliminary sketch at the Dunedin Public Art Gallery and a full scale replica, dated 1905, at the Russell-Cotes Museum, Bournemouth. *See p. 112.*

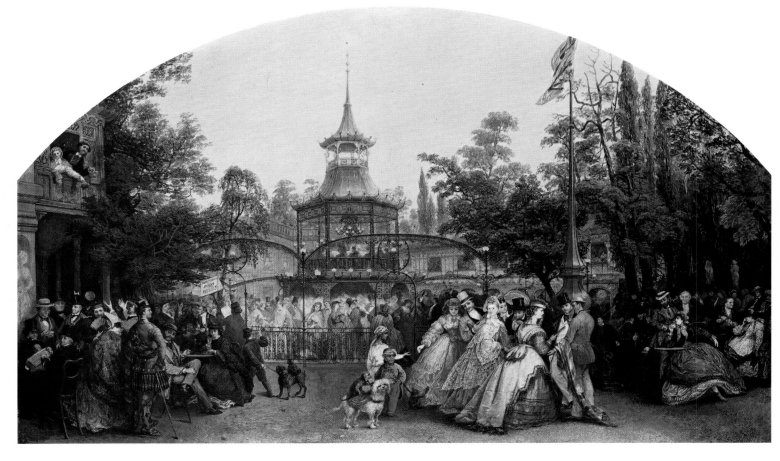

PHOEBUS (?) LEVIN. *The Dancing Platform at Cremorne Gardens*, 26½ × 43 inches. Signed and dated 1864. The London Museum, Kensington Palace.

Exhibited at the Royal Academy in 1855. Cremorne Gardens were the scene of musical entertainments, fireworks, dancing and exhibitions. They were closed in 1877 after complaints from local residents.

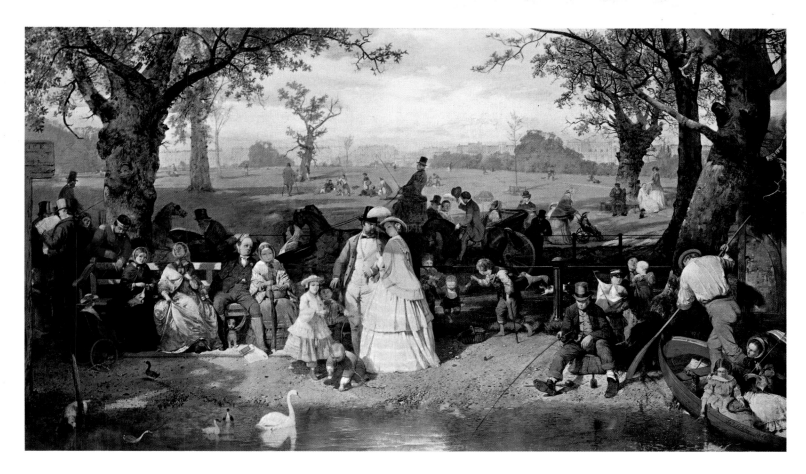

Conscience (Sir Colin Anderson), provoked a grudging degree of acceptance for an uncompromising modernity of subject, narrative painters were able to exploit these themes without inhibition. Scenes of rustic poverty were a favourite with Thomas Faed (1826–1900), a Scotsman who worked ably in the tradition of Wilkie. The elaborate preliminaries of Victorian mating habits provide the themes of many paintings. Typical of these are *The Long Engagement* (Tate Gallery) by Arthur Hughes (1832–1915) which shows the predicament of an anguished young curate, unable to marry from lack of preferment, and *Broken Vows* (Tate Gallery) by Philip Hermogenes Calderon (1833–1898), in which a girl discovers her fiancé flirting with another, are typical. *First Love* by Frederick Smallfield (b.1829, exhib. until 1888), on the other hand, is charmingly uncomplicated. The fraught *Too Late* (Tate Gallery) of William Lindsay Windus (1822–1907) mixes the themes of love and incurable illness, for here a lover returns to his fiancée to find her dying of consumption. There is more hope implied in the title *An Anxious Hour* (Victoria and Albert Museum) by Alexander Farmer (fl. 1855–1869) wherein a mother watches in distress over her stricken child.

The theme is paralleled by a similar situation in *The Sick Bed* (Glasgow) by Edward Prentis (1797–1854), and later in the century in *The Doctor* (Tate Gallery) by Luke Fildes (1844–1927). These themes were but a short step away from bereavement; G. E. Hicks's

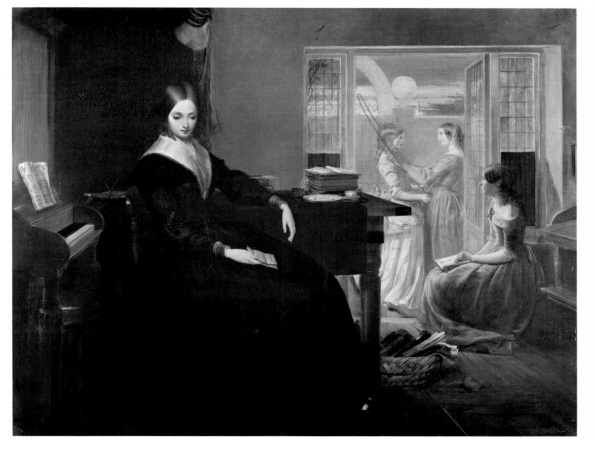

CHARLES ROBERT LESLIE, R.A. *Les Femmes Savantes*. 39 × 30 inches. Victoria and Albert Museum, London.

Exhibited at the Royal Academy in 1845. The scene is from the play by Molière (Act III, Scene ii) where Trissotin reads his sonnet. *See p. 109.*

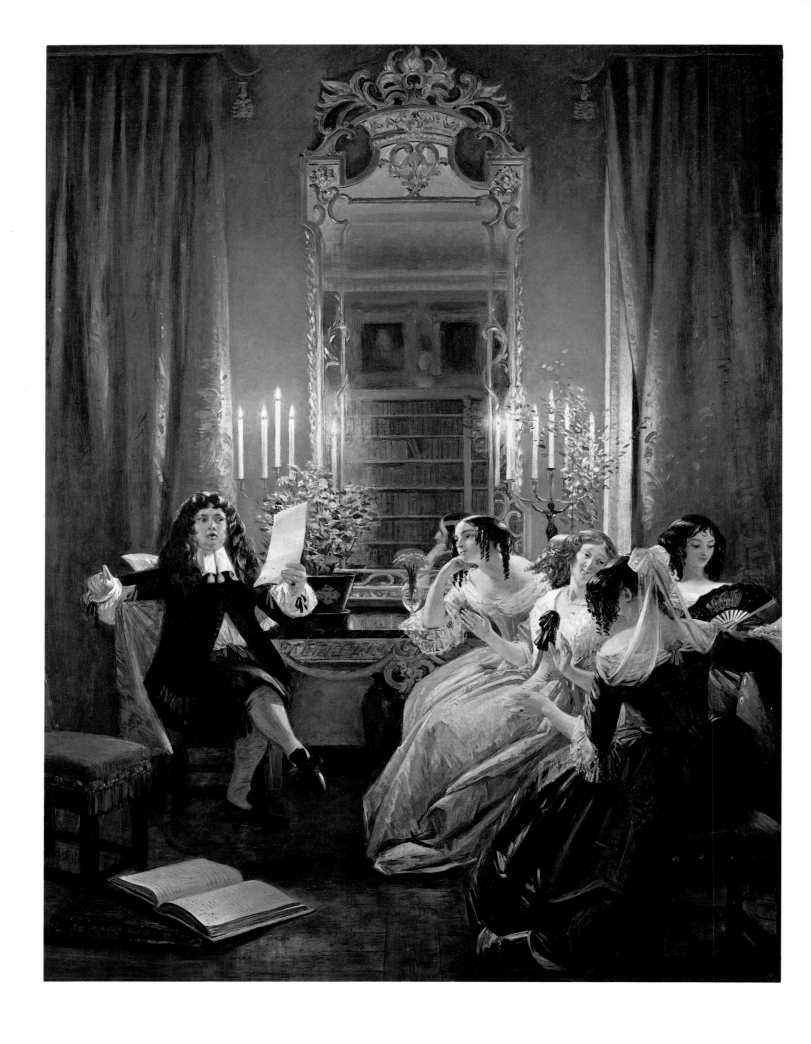

Woman's Mission—Bad News (1863) shows a woman sympathising with a bereaved husband; before the sophisticated social services that we now enjoy, the destitution that could afflict widows, orphans and the poor was severe. Their plight is movingly depicted in *Nameless and Friendless* by the little-known Emily Mary Osborn (1834–c.1895). The seeds of this kind of tragedy had already been sown in *The Last Day in the Old Home* (Tate Gallery) by Robert Braithwaite Martineau (1826–1869): here, a profligate and ruined husband, with glass of champagne raised, is surrounded by his neglected family, while his mother negotiates with the auctioneer's agent for the sale of the house and its

contents. Martineau, who worked for a time in Holman Hunt's studio, reputedly took ten years to paint the picture which connects the subject matter, sentiment and composition of Frith to the finished manner of the Pre-Raphaelites. In its rich Pre-Raphaelite colouring and over-loaded anecdotalism it is the apotheosis of Henry James's 'three-volume novel' and explains his rage when he described this sort of picture as 'an almost touching exhibition of helplessness, vulgarity [and] violent imbecility of colour'. The robust appeal of pictures like these, which offended the refined sensibilities of Henry James, is linked with the humanitarian idealism of the Victorians.

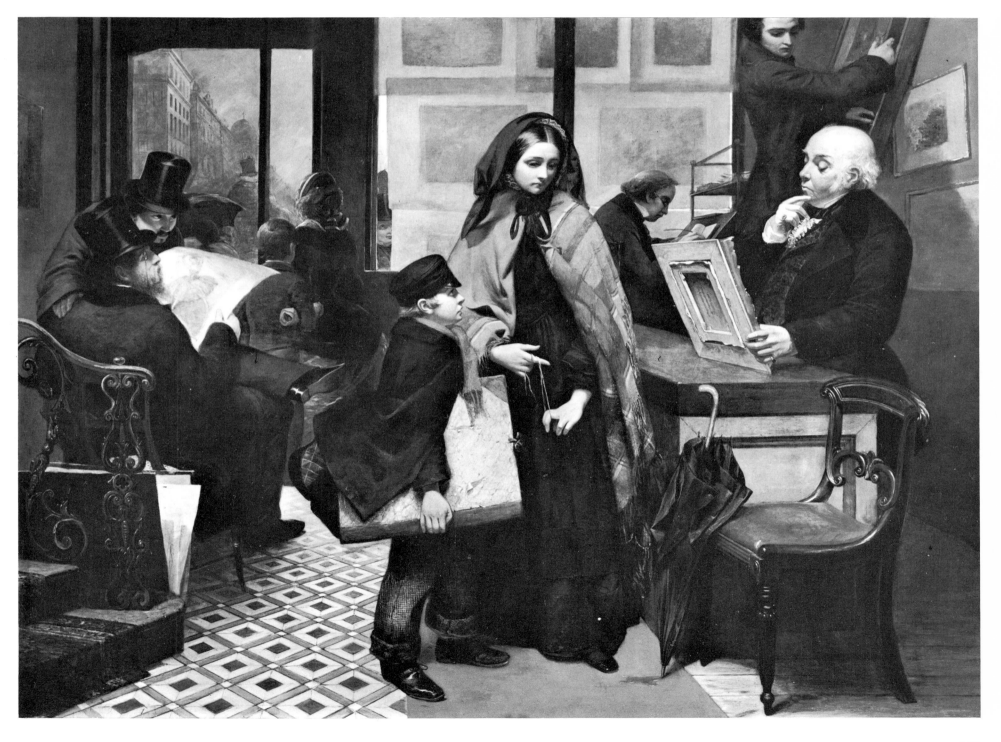

IX

THE
PRE-RAPHAELITES

The formation of the Pre-Raphaelite Brotherhood in the autumn of 1848, by seven very different but enthusiastic young men with an average age of slightly over twenty, was like a small pebble dropped in the pool of established artistic and literary convention founded on the principles of centuries. The small pebble caused a tidal wave which diminished after four years, leaving a series of irregularly widening ripples which began to subside only very much later. The revolutionary impulse of this movement started when a young man, William Holman Hunt (1827–1910), who was the son of a warehouse manager, and who had studied painting and earned a precarious living from it since the age of sixteen, attended the great Chartist meeting on 10th April, 1848, in the company of his friend John Everett Millais (1829–1896). Millais was an artist of rare precocity who had entered the Academy Schools at the age of eleven and won the gold medal for historical painting at the age of seventeen.

Revolution was in the air all over Europe in 1848. The Chartist meeting threatened the nerve centres of society in England: the Queen withdrew to Osborne and the Duke of Wellington stationed troops and guns at the approaches to Westminster. Hunt and Millais decided that the moment was ripe for a revolt in painting. Their attack was to be aimed at what they considered to be the out-worn creative conventions of the time, which were, in any case, based on fallacies. It was a decision of some temerity because old habits,

WILLIAM HOLMAN HUNT, O.M. *The Flight of Madeline and Porphyro during the Drunkenness attending the Revelry.* 30½ × 44½ inches. Signed. Guildhall Art Gallery, London.

Painted in 1848 and exhibited at the Royal Academy in the same year. The picture illustrates the flight of Madeline and Porphyro in Keats's 'Eve of St. Agnes'. Sketches for this painting are in the collection of Miss Burt and there is a finished study for it at the Walker Art Gallery, Liverpool.

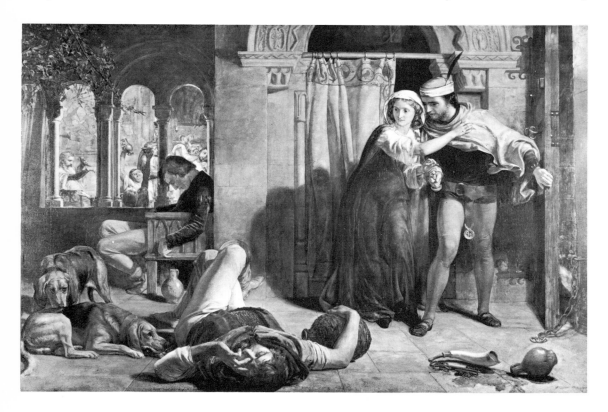

vested interests and the power of the Royal Academy were formidable obstacles. Established principles were promptly and ruthlessly analysed and deep-rooted heresies dismissed. Hunt, to the end of his life the Pre-Raphaelite perfectionist, had already demonstrated his reluctance to take everything on trust. He had already practised *plein-air* painting, and his entry at the Royal Academy in 1848 of *The Flight of Madeline and Porphyro during the Drunkenness attending the Revelry* was prophetic. That the subject illustrated, 'The Eve of St. Agnes' by the still little-known John Keats, whose works had not been reprinted in England until two years previously by Moxon, and that the foreshortening of the 'porter in uneasy sprawl' presented a challenge to the young painter, were further evidence of both the revolutionary zeal and the patience that were to characterise the Pre-Raphaelite manner.

Two years previously Hunt had been profoundly impressed by his reading of the second volume of Ruskin's 'Modern Painters'. Here was the creed for which he had been searching, and the famous sentence, 'Go to nature in all singleness of heart, selecting nothing, rejecting nothing', resounded like a clarion call to action. Ruskin's insistence on the purity of the earlier Italian masters had an almost expiatory ring about it which could, if harnessed properly, be used to make the revolt an act of purgation. Hunt discussed his ideas with Millais, and described to him the system of painting which could further their aims: this was to adopt the bold bright colours used by the old Italian masters, before the time of Raphael.

It was at this point that they were befriended by Dante Gabriel Rossetti (1828–1882) who had admired Hunt's *Madeline and Porphyro* in 1848. He had studied under John Sell Cotman at King's College (a bizarre juxtaposition), and earlier in the same year under Ford Madox Brown (1821–1893). Rossetti's father was a political refugee from Italy and Professor of Italian at King's College; his mother, a Polidori, was half-English and half-Tuscan. Always diffident and impulsive in matters of painting, he agreed to take lessons from Hunt. The company was now three, and Rossetti, ever interested in conspiracies and with a romantically poetic temperament, became the galvanising force. Restless, enquiring, sociable and quixotic, he impressed his personality on this triple alliance, and gave it a sense of direction. It was now to all appearances a perfect entity, each member supplying what the others lacked: Hunt had a kind of obstinate faith, Rossetti, drive and eloquence, and Millais a most enviable talent. As if this were not enough, they decided to increase their numbers to seven.

This was largely Rossetti's doing. With an Italianate tendency towards excess, and with an early lack of true understanding of the aims of this secret society, he recruited Thomas Woolner (1825–1892), the sculptor-

poet, largely on the grounds that he lived next door, and would therefore be easily available for meetings. Then there was James Collinson (?1825–1881), according to Rossetti, 'a born stunner', who managed to paint when he was not falling asleep. William Michael Rossetti (1829–1919), Dante Gabriel's brother, having a full-time job with the Inland Revenue, did not paint at all (although he had a nice talent for drawing), but was to act as the secretary. Finally Hunt introduced Frederic George Stephens (1828–1907), who made a few attempts at painting, and then spent forty years as Art Editor on 'The Athenaeum'. These, then, were the original seven members. Rossetti's meeting in 1848 with Madox Brown was to have a profound influence. Brown had for two years previously been experimenting in a new realistic style, after having seen the works of Holbein at Basle and the Italian masters at Rome and visited the Nazarenes, Cornelius and Overbeck. He was older than the members of the Brotherhood, and never became a member himself, but he added weight to their aspirations with his experience and knowledge, and he wrote articles for 'The Germ', a magazine published by the Brotherhood briefly in 1850.

The aims of the Pre-Raphaelite Brotherhood were summarised by W. M. Rossetti as: '1, To have genuine ideas to express; 2, to study Nature attentively, so as to know how to express them; 3, to sympathize with what is direct and serious and heartfelt in previous art, to the exclusion of what is conventional and self-parading and learned by rote; and 4, and most indispensable of all, to produce thoroughly good pictures and statues.' 'The name of our Body,' wrote Hunt, 'was meant to keep in our minds our determination ever to do battle against the frivolous art of the day, which had for its ambition "Monkeyana" ideas, "Books of Beauty", Chorister Boys, whose forms were those of melted wax with drapery of no tangible texture.' While the Brotherhood was revolutionary in every sense, it was also a catalyst for forces already at work. The phrase 'Truth to Nature' has been the slogan of many an *avant-garde* movement, but in the case of the Pre-Raphaelites it simply meant giving pictorial expression to the close study of nature, exemplified by Ruskin's pre-occupation with geology, and by the fashion for botanical observation that went back to Erasmus Darwin's 'The Loves of the Plants' (1789) and other records of scientific observation. In the exact rendering of naturalistic detail they had been preceded in varying ways by Mulready, Lewis and Linnell. Turner, Landseer and Mulready had all painted on a white ground to achieve brilliant colours, while the bright sharp colouring of J. F. Lewis's water-colours 'with every separate leaf quivering with buoyant and burning life', had already attracted the notice of Ruskin five years earlier.

SIR JOHN EVERETT MILLAIS, Bt., P.R.A. *Two Girls in a Garden.* Pen and ink. 8½×6 inches. Signed with monogram and dated 1850 and signed 'John E. Millais'. The Countess of Iveagh.

All manner of factors contributed to the blinding flame of early Pre-Raphaelite vigour: the mediaevalism of Rossetti, his mystical involvement with the world of Dante and his love for Elizabeth Siddal (1834–1862) who became the muse of the movement. Also contributing to their fervour were the close social and creative relationships formed with leading literary figures, in which William Bell Scott (1811–1890) formed an introductory bridge, reflecting the idea of universality of the arts which was central to their creed, the 'exquisite, patient, virtuous manipulation' of their work, the early divergence of their aims, in fact the sheer muddle of the whole thing. There was scarcely a single English painter active during the next thirty years who was not to a greater or lesser degree touched by the flame of Pre-Raphaelitism. Nor was its influence confined to painting: it spread to literature, book design, furniture, wall-paper, houses and clothes. The very youth of members of the Brotherhood was an important factor since, as Robin Ironside wrote, 'the vision was suddenly mature while the visionaries themselves were happily too immature

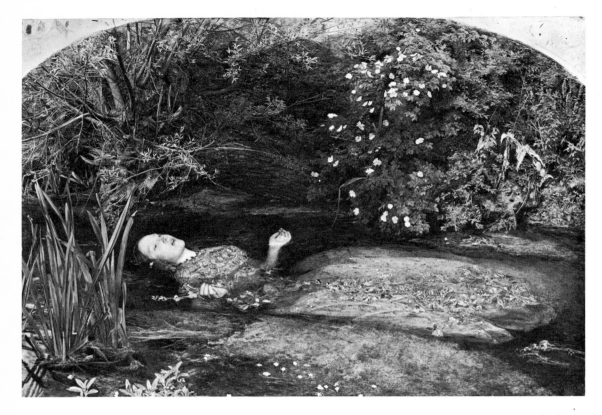

attention. What was once a device became a habit to many of these painters; Madox Brown could never rid his pictures, so often disfigured by rows of grinning teeth, of awkward gestures.

All three pictures received a reasonably friendly welcome, although 'The Athenaeum' detected foreign and archaic mannerisms. The reception of their pictures in 1850 was quite another matter. Millais's *Christ in the House of His Parents* (*The Carpenter's Shop*), now at the Tate Gallery, sparked off a storm of abuse and earned the movement its first notoriety. Dickens hurled his celebrated thunderbolt in 'Household Words'. In this picture, he declared, there is 'a kneeling woman so horrible in her ugliness . . . she would stand out from the rest of the company as a

to criticize its validity'; and some, at least, of these visionaries lived long enough to fan the flames and make new recruits.

All seemed to go well at first, after a moment of irritation. Rossetti was the first of the Brotherhood to exhibit a picture: *The Girlhood of Mary Virgin* (now at the Tate Gallery), at the Free Exhibition, Hyde Park Gallery, in 1849, to the annoyance of Hunt and Millais, who had not previously been informed. This picture, painted under the surveillance of Hunt and Madox Brown, was Rossetti's first. It was not until 1853 that it was bought by a Belfast shipping agent. Later in 1849, at the Royal Academy, appeared Hunt's *Rienzi vowing Justice for the Death of his young Brother* and Millais's *Lorenzo and Isabella* (now at Liverpool). Hunt's picture is difficult to assess, since he reworked it forty years later, because of an early varnishing accident. Millais's picture, on the other hand, was the first of a seven-year succession of Pre-Raphaelite masterpieces by this artist. Painted on a wet white ground, and, in pursuance of the Brotherhood's ideal of naturalism, from non-professional models (in this case members of their circle), it was a triumphant vindication of 'hard edge' Pre-Raphaelitism, in which areas of minute detail worked in vibrant colours are placed side by side, like so many pieces of stained glass. This method of working, which caused many Pre-Raphaelite pictures to be better in parts than as a whole (this was Théophile Gautier's only complaint when he reviewed Hunt's pictures at the Paris International Exhibition in 1855), was deliberately used to give figures an awkwardness of gesture, in order, as befits an *avant-garde* movement, to arrest

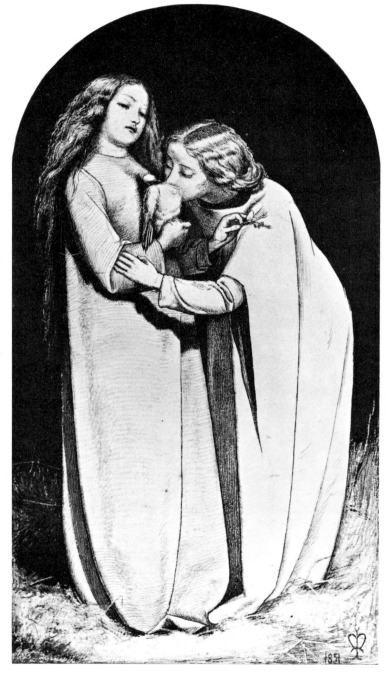

monster in the vilest cabaret in France or the lowest gin shop in England'. 'The Times' wrote of a 'morbid infatuation which sacrifices truth, beauty and genuine feeling to mere eccentricity'. 'The Athenaeum' was no less scathing. What they mainly objected to was realism in a sacred setting. Ironically, this was almost the only picture, with its expressive angularities and Christian conviction, in which Millais had any 'genuine ideas to express'. The Pre-Raphaelites did not flinch: only Rossetti reacted by ceasing to exhibit and confining himself mainly to the medium of watercolour as being best suited to his volatile creative temperament. Over a number of years he worked in a dream world of mediaeval mythology, deeply imbued with poetry, ultimately painting strangely sacramental portrait compositions of intricate design.

Much to the general discomfort, the Academy exhibition of 1851 contained five more pictures by these recalcitrant young men, including one by a newcomer. The Brotherhood had now become a Movement. Millais showed three paintings: *The Return of the Dove to the Ark* (Ashmolean, Oxford), a cool piece of virtuoso painting in which the angularities have noticeably softened; *The Woodman's Daughter* (Guildhall), illustrating a poem by Coventry Patmore, in which the characters are for the first time in contemporary dress, although the wood belongs to the world of Uccello's *Hunt by Night;* and *Mariana*, their first subject from Tennyson, a sumptuous display of colour. Hunt showed one of his most technically brilliant pictures, *Valentine rescuing Sylvia from Proteus* (Birmingham). The newcomer, Charles Allston Collins (1828–1873), was the same age as Rossetti and F. G. Stephens; he exhibited his *Convent Thoughts* (Ashmolean, Oxford). The press reacted with another chorus of abuse, but now occurred an event of prime importance to the future of the Movement. John Ruskin, signing himself as 'The Author of "Modern Painters",' lent the weight of his reputation by writing two letters to 'The Times' largely in defence of the Pre-Raphaelites, none of whom he had met, and whose supposed 'Romanist and Tractarian tendencies' he discountenanced.

With Ruskin's advocacy, and the first concessions to popular taste by Millais, W. M. Rossetti was able to write two years later, 'our position is greatly altered. We have emerged from reckless abuse to a position of general and high recognition.' In the Academy of 1852, Millais's *A Huguenot refusing to shield himself from Danger by wearing the Roman Catholic Badge* and *Ophelia* became very popular, with the former containing the first fatal seeds of vulgar sentiment. His *Ophelia* looks very much as she was—Elizabeth Siddal in a bath, with lighted candles beneath to keep her warm—but the naturalism in his treatment of the little stream is of a notably high order. Hunt's *The Hireling Shepherd* (Manchester), also painted at Ewell, near Surbiton, and

intended as 'a rebuke to the sectarian vanities and vital negligences of the day', was his first picture with a moral. Painted in 'a landscape in full sunlight, with all the colour of luscious summer,' the outdoor naturalism, in spite of the overloaded symbolism of the picture's subject, strikes a welcome note. Not in the exhibition, but painted in the same year, was *Strayed Sheep*, which Ruskin praised for its 'absolutely faithful balances of colour and shade by which actual sunlight might be transposed'. For all its naturalism, Hunt's eccentric colour sense and his straining after visual truth resulted in a picture that goes beyond the limits of realism.

Millais, never wholly involved with the aims of the Pre-Raphaelite Brotherhood, hankered after popularity and academic distinction. In 1853, he achieved both. *The Order of Release* needed police protection from its admirers, and he was elected A.R.A. in November. The first wide fissure had appeared in the already crumbling walls of the Pre-Raphaelite edifice. Collinson and Stephens, for personal reasons, had already resigned from the Brotherhood. On hearing of Millais's election, Christina Rossetti wrote a sonnet beginning 'The P.R.B. is in its decadence' and Dante Gabriel mourned that 'now the whole Round Table is dissolved'. Rossetti, always sociable, discovering and encouraging talent, was pursuing a solitary creative course. Hunt, 'yearning for the land of Cheops', went to the Middle East for two years. Millais continued to paint Pre-Raphaelite pictures for another three years;

Mariana by Sir John Everett Millais is reproduced in colour on p. 120.

WILLIAM HOLMAN HUNT O.M. *Strayed Sheep*. 17 × 23 inches. Signed and inscribed 'W H Hunt 1852 Fairlt'. Tate Gallery, London.
Exhibited at the Royal Academy in 1853 (under the title *Our English Coasts 1852*). Painted in the summer and autumn of 1852 at Fairlight, near Hastings. It was exhibited in 1855 at the *Exposition Universelle* in Paris, where it was admired by Delacroix.

always attractive in their appeal, they reached their apotheosis in *The Blind Girl* (Birmingham) and *Autumn Leaves* (Manchester), both exhibited in 1856. The first is a consummately beautiful essay in compassion and the second a strangely rapturous evocation of autumn, painted in strong, broad and clear colours. A year before this, Millais had married Effie, whose previous marriage to Ruskin had been annulled. Two years before, Millais had completed the brilliant portrait of Ruskin at Glenfinlas. His style was now becoming increasingly free and the subject matter more sentimental. Sometimes he took children as his subject, as in *My First Sermon* and *The Minuet*; at other times his inspiration was religious, as in *The Enemy Sowing Tares*, or historical, as in *The Romans Leaving Britain*. By 1868 he was visiting Paris with Frith, an arch-enemy of the Pre-Raphaelites. Shortly after this, when he was not grouse shooting or fishing, he was painting large numbers of vapid Scottish landscapes. *The Boyhood of Raleigh* and *The North-West Passage* both (particularly the latter) well painted, brought him further popularity. With their frank appeal to mawkish sentiment, *Cherry Ripe* and *Bubbles* represented his nadir. In his last years he was in great demand as a portraitist. In exactly inverse proportion to the decline of his creative idealism the honours accumulated. He became a baronet in 1885 and was elected P.R.A. in 1896, on the death of Leighton. Hunt, with a wit rare to him, wrote to congratulate Millais for having 'gone a letter

higher—from P.R.B. to P.R.A'. An estimate of Millais's work will depend to some extent on one's attitude to Pre-Raphaelitism. One thing seems fairly certain: but for the corporate idealism of the Brotherhood, which gave support to Millais's early enthusiasm, it is unlikely that he would have painted as well as he did during his early years.

Until his death in 1910, Holman Hunt remained an impenitent Pre-Raphaelite. Two pictures arrested public attention. *The Light of the World* (1854) which

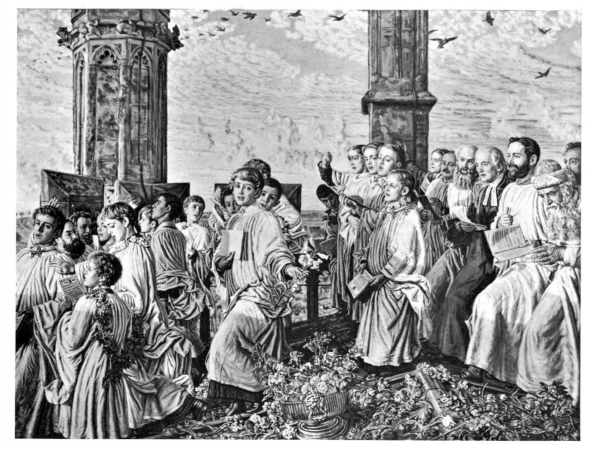

Hunt painted in an orchard by moonlight, became a famous symbol of Christianity, for long the inevitable frontispiece to Bibles and Prayerbooks. He had intended *The Awakening Conscience* as a pendant to it. With symbolism as cluttered as the objects in the room, it is nevertheless a powerfully urgent Pre-Raphaelite genre painting. In all his pictures Hunt betrayed a *louche* colour sense, mixing pea-greens, yellows, pinks and mauves. His fondness for this last colour may well have been stimulated by the discovery by Sir William Perkin in 1856 of the first aniline dyestuff, which was mauve in colour. Symbolism and oriental knick-knacks crowded his pictures to the last. Two pictures of his

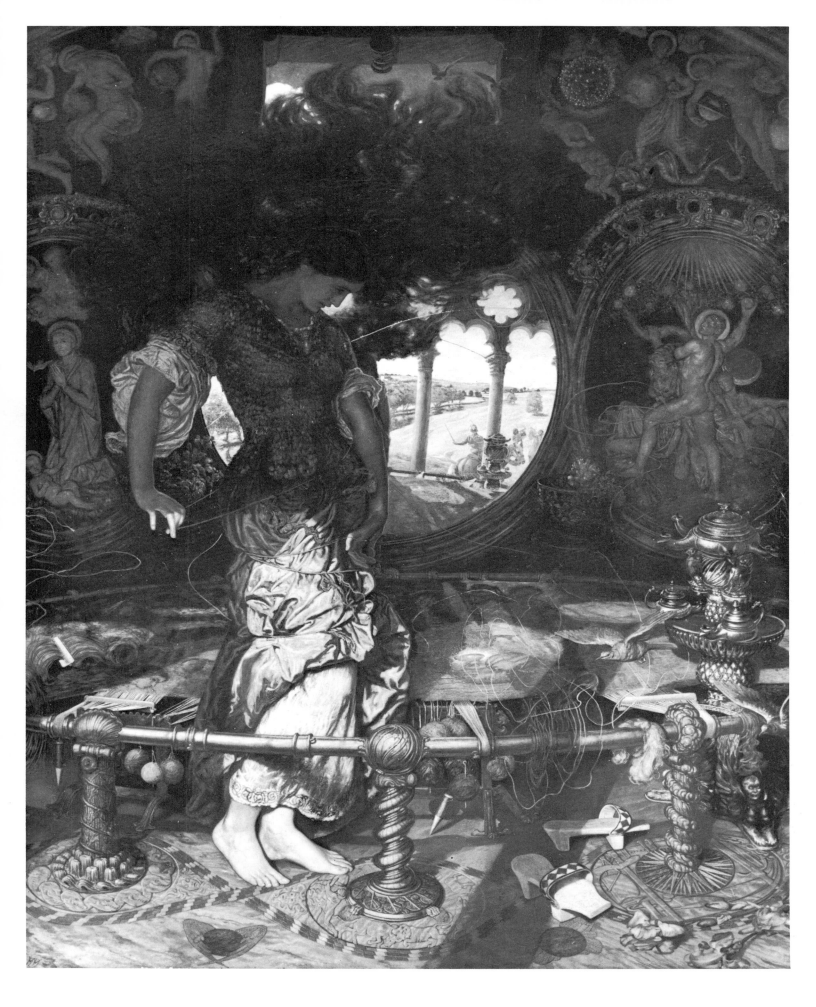

WILLIAM HOLMAN HUNT, O.M. *The Lady of Shalott.* $74 \times 57\frac{1}{2}$ inches. Signed with monogram. Wadsworth Athenaeum, Hartford, Connecticut.

Exhibited at Tooth's Gallery in 1905. It was painted during the years between 1886 and 1905. There is a smaller version, painted between 1890 and 1905, at City Art Galleries, Manchester. The picture illustrates Tennyson's poem. It is astonishing to reflect that Holman Hunt, an original member of the Pre-Raphaelite Brotherhood, could complete a powerful Pre-Raphaelite picture half a century after the formation of the Brotherhood.

Opposite page, right:
SIR JOHN EVERETT MILLAIS, Bt., P.R.A. *Autumn Leaves.* $41 \times 29\frac{1}{2}$ inches. Signed with monogram and dated 1856. City Art Galleries, Manchester.

The picture was painted at Annat Lodge, near Perth, where Millais lived for a while after his marriage. The models were his two sisters-in-law, Alice and Sophie Gray, Matilda Proudfoot, a girl from the School of Industry and Isabella Nicol, who lived at Low Bridgend. Holman Hunt quotes Millais as having said in the autumn of 1851. 'Is there any sensation more delicious than that awakened by the odour of burning leaves? To me nothing brings back sweeter memories of the days that are gone; it is the incense offered by departing summer to the sky; and it brings one a happy conviction that time puts a peaceful seal on all that is gone.' To Ruskin it was 'by much the most poetical work the painter has yet conceived; and also, as far as I know, the first instance existing of a perfectly painted twilight'.

129

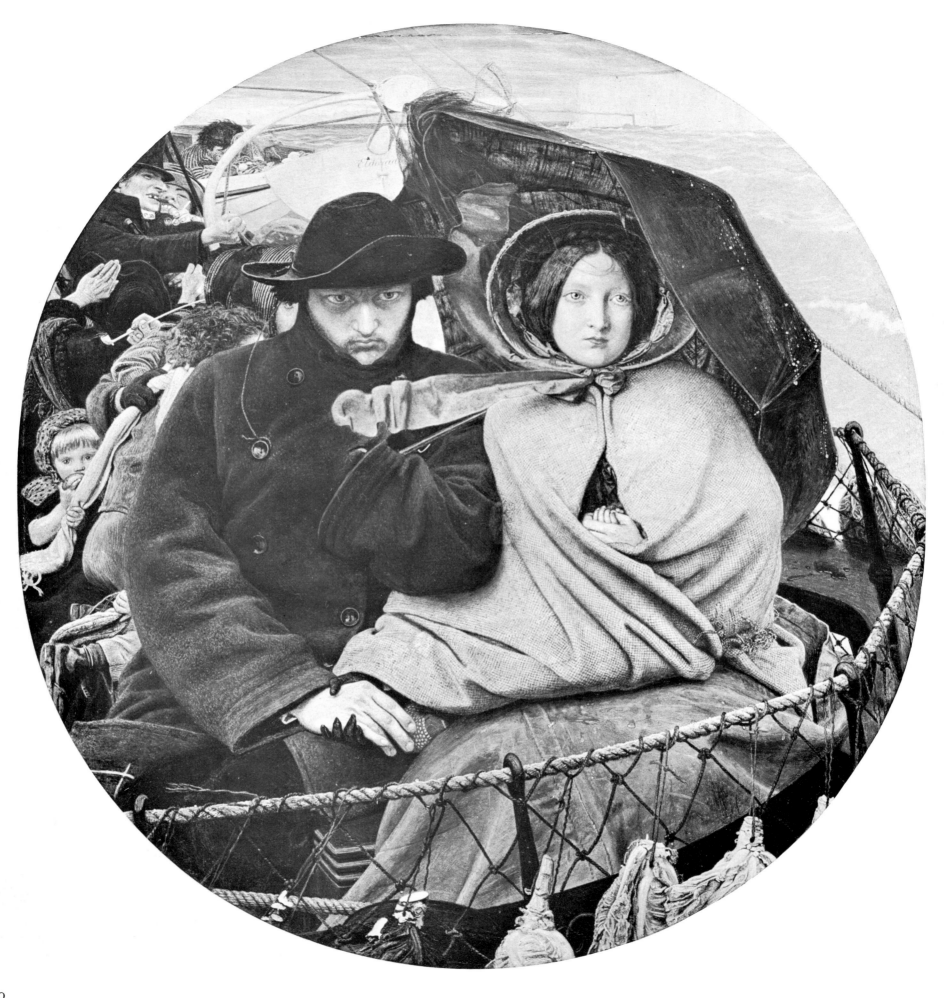

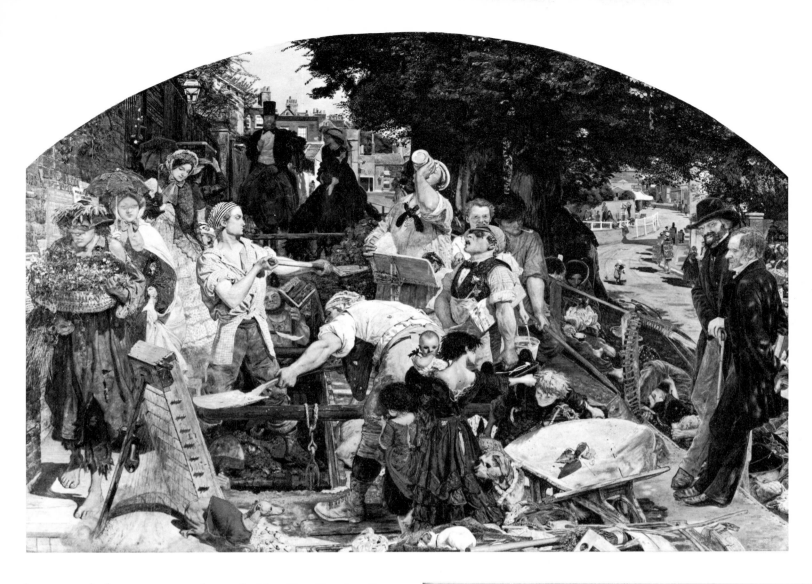

later period are examples of his Pre-Raphaelite stamina, the brilliantly conceived *Lady of Shalott* and the serenely beautiful *May Morning on Magdalen Tower*, for which, characteristically, he mounted the tower roof for several weeks 'about four in the morning with my small canvas to watch for the first rays of the rising sun'. These splendid anachronisms were painted when Whistler's *Nocturnes* were already a memory.

Ford Madox Brown remained the most formidable of the associates. Two of his pictures, *The Last of England* and *Work*, both started in 1852 and painted with true Pre-Raphaelite patience and discipline, are outstanding. In particular, *The Last of England* is one of the most poignant symbols of the Victorian scene and, like *Work*, it treats a contemporary theme. The first is a commentary on the emigration movement of the 'fifties and the departure of Woolner for the Australian goldfields, and the other reflects his admiration for the ideas of Carlyle and F. D. Maurice, in whose Working Men's College he taught for two years. Like William Morris, for whose firm he worked in the 'sixties, Brown was always concerned with social problems. His pictures are often encumbered by long

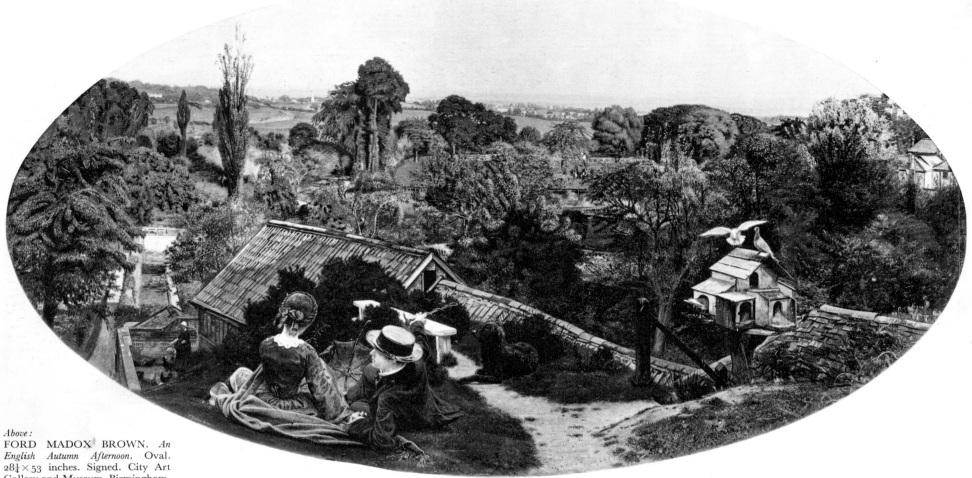

glosses, but he nevertheless intended them to be easily understood. Of his *Pretty Baa Lambs* he stressed that there was no 'meaning beyond the obvious one . . .

This picture was painted out in the sunlight; the only intention being to render that effect as well as my powers in a first attempt of that kind would allow.' Indeed his small out-door scenes of the 'fifties, for which he used a white ground, since there 'is nothing like a good coating of white to get a bright sunny colour', are a vital vindication of Pre-Raphaelite landscape painting, *Walton-on-the-Naze* and *An English Autumn Afternoon* (both at Birmingham), ranking high as examples. Brown never achieved the same degree of worldly success as some other Pre-Raphaelite painters, and later returned to his earlier subject-matter of history and romantic literature, painted in the flatulent baroque manner he had acquired in Belgium under Baron Wappers.

While Rossetti, balanced uneasily between poetry and painting, was groping about the dimly lit world of Dante and Beatrice, 'with the ambiguous light', as Max Beerbohm said, 'of a red torch somewhere in a dense fog', the bright star of Pre-Raphaelitism had become a constellation. If Rossetti was only interested in the social side of Pre-Raphaelitism, to others it was an opportunity, however momentary, to invest their dreams with a burning reality. The luminaries of this second order included some such as William Windus

(1822–1907) and John Brett (1830–1902) who were, in different ways, dimmed by the vehement proselytizing of Ruskin; others, including Henry Wallis (1830–1916), painter of *The Death of Chatterton* (Tate Gallery), and William Shakespeare Burton (1824–1916), painter of *The Wounded Cavalier*, demonstrated that they each only had sufficient afflatus for one Pre-Raphaelite masterpiece, although Wallis's *The Stone-breaker* (Birmingham), as an essay in social realism, comes close in quality. Walter Deverell (1827–1854) was more promising, but *The Pet* (Tate Gallery) remains his only well-known picture; similarly Henry Alexander Bowler (1824–1903) is remembered only for *The Doubt: 'Can these dry Bones live?'* (Tate Gallery); while *Jerusalem and the Valley of Jehoshaphat* is almost the sole monument to the memory of Thomas Seddon (1821–1856). Others such as Augustus Egg (1816–1863), William Dyce and James Smetham (1821–1889) were blown off course in mid-career, albeit achieving a heightened degree of intensity in their paintings, as in Egg's series *Past and Present* (Tate Gallery), and Dyce's *George Herbert at Bemerton*, *Gethsemane* and, one of the greatest of all Victorian paintings, *Pegwell Bay*.

Windus was the first provincial Pre-Raphaelite. He was a Liverpool artist, and his enthusiasm on seeing

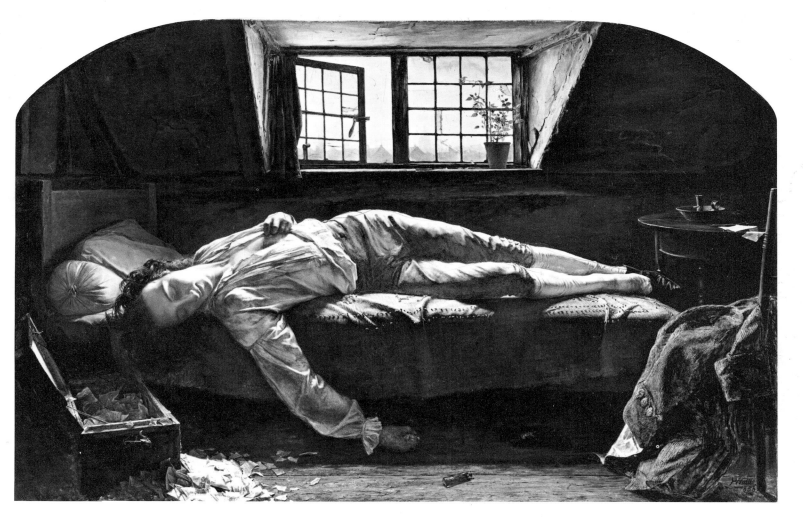

ARTHUR HUGHES. *Bed-Time*. 40 × 52 inches. Harris Art Gallery, Preston.

Exhibited at the Royal Academy in 1862. The painting depicts an honest yeoman having returned from work, while his wife supervises bed-time prayers. 'The Art Journal' of 1862 commented on its 'dull solemnity' and 'cheerless piety'.

The Wounded Cavalier by W. S. Burton is reproduced in colour on p. 156.

Opposite page, below:
FORD MADOX BROWN. *The Traveller*. Panel. 12¼ × 18 inches. Signed with monogram and dated '84. City Art Galleries, Manchester.

The subject of this picture, which was begun in 1868 and finished in 1884, is said to have been taken from a poem by Victor Hugo. There is a water-colour version, dated 1868, at the Fitzwilliam Museum, Cambridge.

HENRY WALLIS. *Chatterton*. 24½ × 36¾ inches, arched top. Signed and dated 1856. Tate Gallery, London.

Exhibited at the Royal Academy in 1856. Popularly known as *The Death of Chatterton*, it was painted in the attic at Gray's Inn where the despairing young poet died by poisoning himself. George Meredith was the model, and two years later the artist eloped with Meredith's wife, who was the daughter of Thomas Love Peacock.

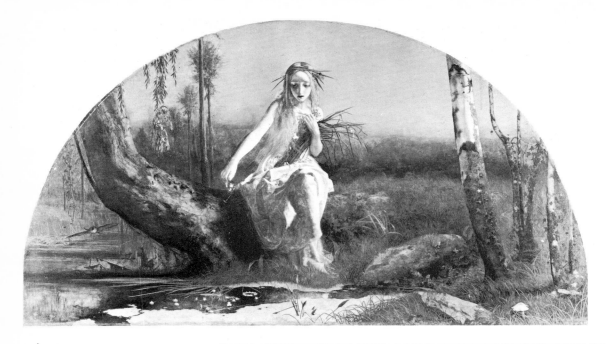

Millais's *Carpenter's Shop* at the Royal Academy in 1850 led to the Liverpool Academy becoming an important centre for Pre-Raphaelite painting. *Too Late* is his best known picture; *Burd Helen*, exhibited three years previously, was his first attempt in the new manner. Ruskin delivered a vicious attack on *Too Late*, 'Something wrong here; either the painter has been ill, or his picture has been sent to the Academy in a hurry . . . in time you may be a painter. Not otherwise.' The effect of this on the artist's neurotic temperament, together with his wife's death, was to cause him virtually to cease production and to make a bonfire of his works twenty-seven years before his death. Brett's failing was to follow too closely the precepts of Ruskin. After one undisputed masterpiece, *The Stone-breaker*, and other works of a high order such as *The Val d'Aosta* and *Glacier of Rosenlaui*, he painted a large number of monotonously geological coastal scenes and seascapes, only occasionally rising above mediocrity.

ARTHUR HUGHES. *Ophelia*. 27 ×48¾ inches. Signed. City Art Galleries, Manchester.

Exhibited at the Royal Academy in 1852. This is Hughes's first important picture, and was exhibited in the same year as Millais's *Ophelia*, although both artists were unaware, until varnishing day, that they had painted pictures identical in subject matter.

April Love by Arthur Hughes is reproduced in colour on p. 140.

AUGUSTUS EGG, R.A. *Past and Present, Number 3*. 25×30 inches. Signed and dated 1858. Tate Gallery, London.

Exhibited at the Royal Academy in 1858. This is the third of a series of three paintings showing the dire consequences of a wife's infidelity. The scene is a bridge near the Strand.

The position of Arthur Hughes (1830–1915) amongst the Pre-Raphaelites was like that of Keats among the Romantic poets. The tremulous lyricism of pictures like *April Love*, *The Tryst*, *The Long Engagement*, *Home from Sea* and *The Nativity*, painted as they are in soft glowing colours, with a sensitivity and sweetness bordering on pain, makes them a pictorial Victorian equivalent of the Odes. Hughes had once studied under Alfred Stevens, and it was not until 1850, through reading 'The Germ', that he made contact with the Pre-Raphaelites. Millais was to have the strongest influence over him, and his work deteriorated, as Millais's did. In contrast to Millais, however, Hughes's

paintings lost their public favour; and he fumbled about on the edge of Fairyland, although he never painted a satisfactory fairy picture. Some of his genius persisted in book illustration. *Bed-time*, exhibited at the Royal Academy in 1862, illustrates the direction his powers as a social commentator might have taken him.

Pre-Raphaelitism took a decisive new turn in 1856, when Rossetti met Edward Burne-Jones (1833–1898), who with William Morris (1834–1896), was an undergraduate at Oxford. At last Rossetti was able to exert the strongest influence of any of the original Brotherhood. Temperamentally unsuited to the rigours of hard-edge Pre-Raphaelitism, Rossetti had painted a

WILLIAM DYCE, R.A. *George Herbert at Bemerton.* 34 × 44 inches. Guildhall Art Gallery, London.
Exhibited at the Royal Academy in 1861. George Herbert (1593-1633), the poet and divine, was Vicar of Bemerton, near Salisbury; the Cathedral spire can be seen in the background. A reviewer in 'The 'Art Journal' wrote of this picture: 'if these trees, and ivy leaves, and grass, and wild flowers, be all painted in oils from nature, without the aid of photography or water-colours, then must this picture be considered . . . a marvellous triumph of manipulative success and skill'.

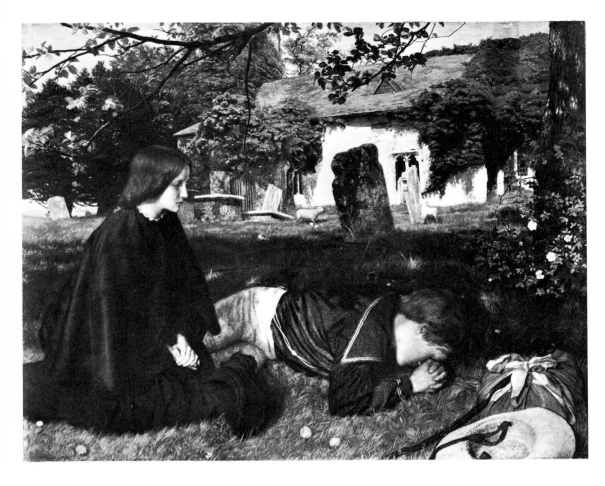

ARTHUR HUGHES. *Home from Sea*. Panel. 20×25¾ inches. Signed and dated 1863. Ashmolean Museum, Oxford.

This picture is characteristic of Hughes's early and best manner.

Right:
JOHN BRETT, A.R.A. *Glacier at Rosenlaui*. 17½×16½ inches. Signed and dated Aug. 23/56. Tate Gallery, London.

Exhibited at the Royal Academy in 1857. This picture, which clearly shows the influence of Ruskin, was the first landscape Brett exhibited.

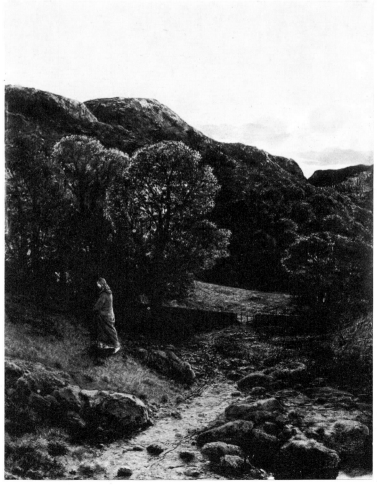

Left:
WILLIAM DYCE, R.A. *Gethsemane*. 16½×12¾ inches. Walker Art Gallery, Liverpool.

Painted in about 1850.

number of pictures symbolizing aspects of ideal love, which, reflecting his own experiences, were weighted with fatalism. He had recently painted *Paolo and Francesca* and *Dante's Dream at the Time of the Death of Beatrice* and *Dantis Amor* (his one realistic work in contemporary dress, *Found*, was left unfinished at the time of his death), but now multiple figure compositions were giving way to single idealized portraits. The love, anguish and remorse following the death of Elizabeth Siddal after a long illness and an overdose of laudanum prompted a series beginning with *Beata Beatrix* (1863), of which he did six replicas. These were followed by portraits of Fanny Cornforth, Alice Wilding, Jane Morris and others, in which the Rossetti type of the ideal woman was created. Redolent of poetry, these luscious visions of long-necked women with backgrounds of intricately curving and twisting plant forms, and their mythological titles such as *Pandora*, *Proserpine* and *Mnemosyne* were to establish, with the aid of Burne-Jones and Morris, the basis of what one might call the mythographic school. The artists who were associated with this late flowering of the Movement, Simeon Solomon (1840–1905), Frederick Sandys (1829–1904), Walter Crane (1845–1915), Frederic Shields (1833–1911) and ultimately Aubrey Beardsley (1872–1898), all played variations on this mythographic ideal. Albert Moore (1841–1893) who matured in a Pre-Raphaelite *milieu*, brought something of its flavour to Neo-classicism, rendering exquisite colour effects from the harmonious arrangement of flesh and drapery: thus was Whistler, who

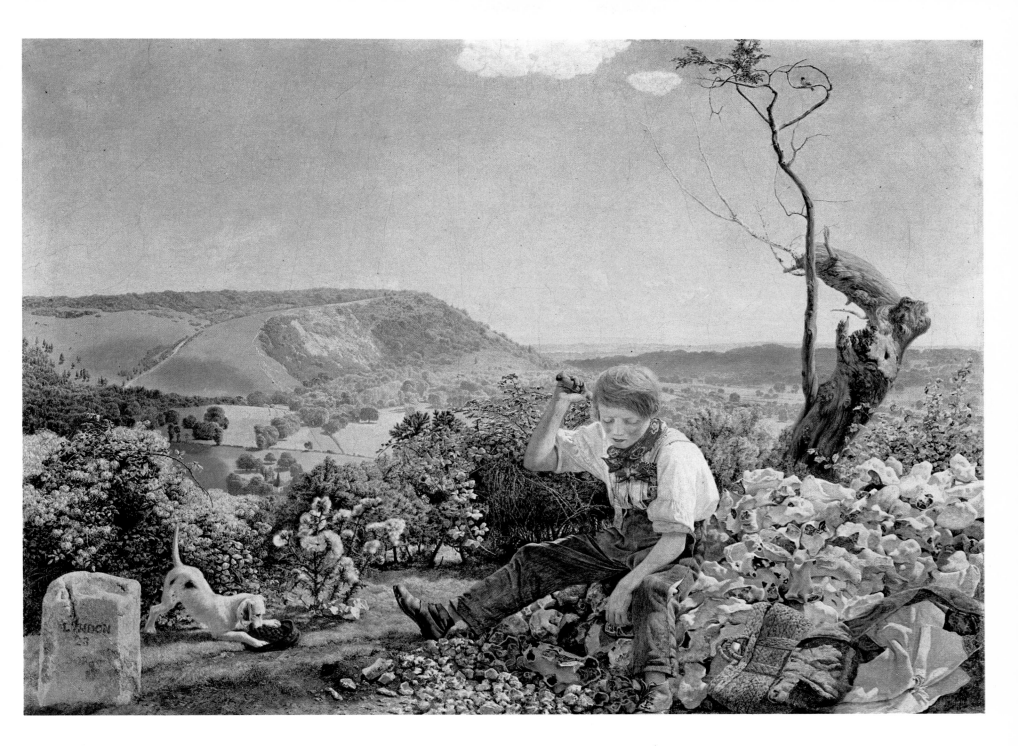

was indebted to Moore, affected by the Rossetti prototype.

Shortly after his meeting with Rossetti, Burne-Jones emerged as an artist in his own right, and when Morris founded his firm, Morris, Marshall, Faulkner & Co., in 1861, with Rossetti, Madox Brown and Burne-Jones as co-directors, Burne-Jones was obliged to furnish an unending supply of decorative figures. He had already, in 1857, made cartoons for stained glass, and he was expected to work in this medium and even in tapestry design. An early familiarity with Malory's 'Le Morte D'Arthur', coupled with the poetic exploration of Northern myth by Morris in 'The Defence of Guenevere' and 'The Earthly Paradise', was to prove

a fertile source of subject-matter. Three visits to Italy, the second with Ruskin in 1862, taught him much about Italian art, and friendship with Leighton, Watts and his future brother-in-law Poynter helped him to overcome technical difficulties. It was the coupling of the 'Rossetti type' with his most abiding love, Arthurian romance, which laid the foundations of his creative life. He forged a bond between the idealistic latin temperament of Rossetti and the ideologically realistic nordic temperament of Morris, fusing the style of one with the mythology of the other. A third factor, of immediate international, or, more specifically, French origin, was to form an apex. This was the Aesthetic movement, an apparently vague but nonetheless real

JOHN BRETT, A.R.A. *The Stonebreaker.* 19½ × 26⅞ inches. Signed and dated 1857-8. Walker Art Gallery, Liverpool.

Exhibited at the Royal Academy in 1858. Painted in Surrey, with Box Hill in the distance. The geological precision delighted Ruskin who wrote in his Academy Notes 'it goes beyond anything the Pre-Raphaelites have done yet ... it is a marvellous picture, and may be examined inch by inch with delight'.

cult which had its origins in the doctrine of *L'Art pour L'Art*, formulated in the daring works of Gautier and Baudelaire, and later, in England, reflected by the writings of Walter Pater. Its main tenet was that art was independent of morality, and was self-sufficient in its ends. This was a concept utterly opposed to the Victorian insistence on moral content in painting, yet, with Whistler (although he had no time for those who posed as aesthetes) for a while at its head, the movement took root in England. At first, it was in a sense amoral, but after the publication of Baudelaire's 'Les Fleurs du Mal' in 1857, it began to take a decadent turn, maintaining an attitude in opposition to morality. The poetry of Swinburne and Dowson, the writings of Oscar Wilde and the work of Aubrey Beardsley are all more or less permeated with this new influence.

The new movement became merged with the Rossetti type of Pre-Raphaelitism, and Burne-Jones

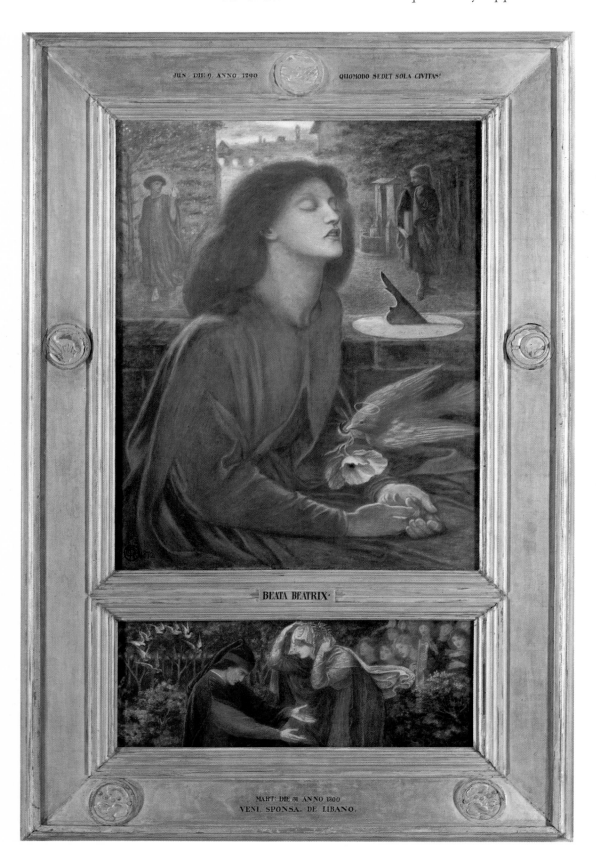

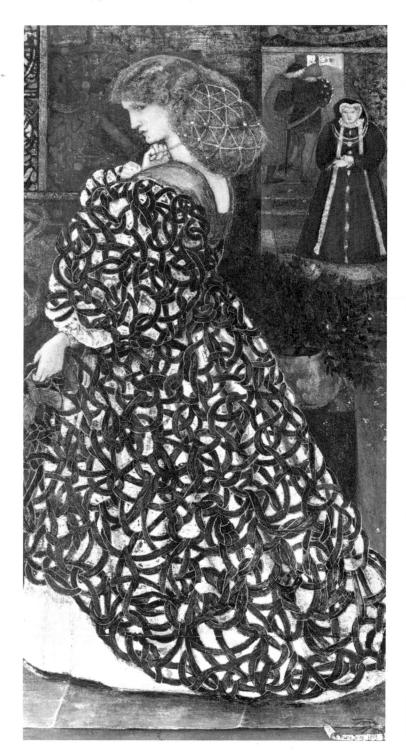

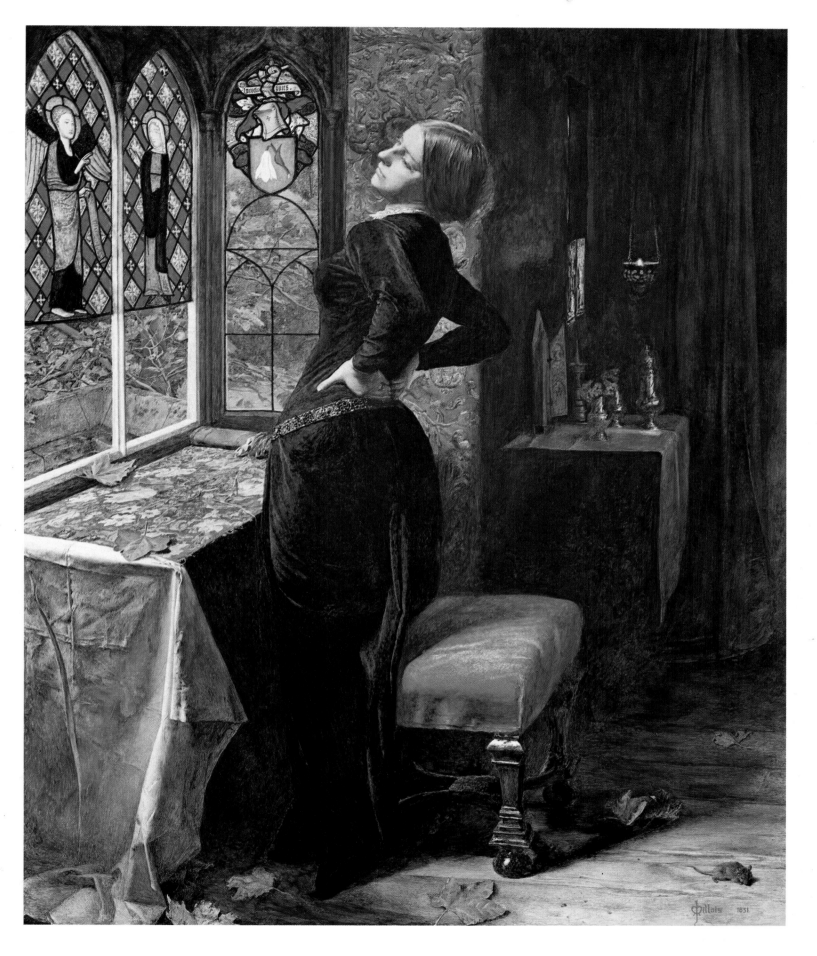

SIR JOHN EVERETT MILLAIS, Bt., P.R.A. *Mariana.* Panel. $23\frac{1}{2} \times 19\frac{1}{2}$ inches. Signed and dated 1851. The Rt Hon. Lord Sherfield G.C.B., G.C.M.G.

Exhibited at the Royal Academy in 1851. The picture was inspired by the following lines from Tennyson's poem 'Mariana': 'She only said, "My life is dreary, / He cometh not," she said; / She said, "I am aweary, aweary, / I would that I were dead!"'. The stained glass was painted from windows in Merton College, Oxford; the garden seen through it was painted from that of his friend, Thomas Combe, at Oxford. The picture was poorly received at the Academy Exhibition. Ruskin, in his letter to 'The Times' on 13 May approved of it, but said he was glad to see that Millais's 'lady in blue is heartily tired of painted windows and idolatrous toilet table'. *See p. 127.*

Opposite page, right:
SIR EDWARD COLEY BURNE-JONES, Bt. *Sidonia von Bork, 1560.* Water-colour, $13 \times 6\frac{3}{4}$ inches. Signed and dated 1860. Tate Gallery, London.

This water-colour and its companion, *Clara von Bork*, clearly reveal the influence of Rossetti, which pervaded Burne-Jones's early work. Sidonia von Bork was a character in 'Sidonia the Sorceress' by the Swiss writer Wilhelm Meinhold, which had aroused the enthusiasm of Rossetti. An English translation of the book by Jane Francisca, Lady Wilde (Oscar Wilde's mother), under the pseudonym 'Speranza', was published in 1893 by the Kelmscott Press.

Opposite page, left:
DANTE GABRIEL ROSSETTI. *Beata Beatrix.* $33\frac{3}{4} \times 26\frac{1}{2}$ inches. Signed with monogram and dated 1872. Predella. $9\frac{1}{2} \times 26\frac{1}{2}$ inches. The Art Institute of Chicago.

This is one of six replicas Rossetti made of the original version, now at the Tate Gallery, which was painted in 1863, a year after the death of his wife, Elizabeth Siddal. Rossetti appended a lengthy gloss on the picture which illustrates the 'Vita Nuova', embodying symbolically the death of Beatrice as treated in that work. The artist gave his wife's features to Beatrice. The Chicago version has a predella showing the meeting of Dante and Beatrice in Paradise. The original frame is characteristic of the type evolved by Rossetti, and often associated with Pre-Raphaelite pictures.

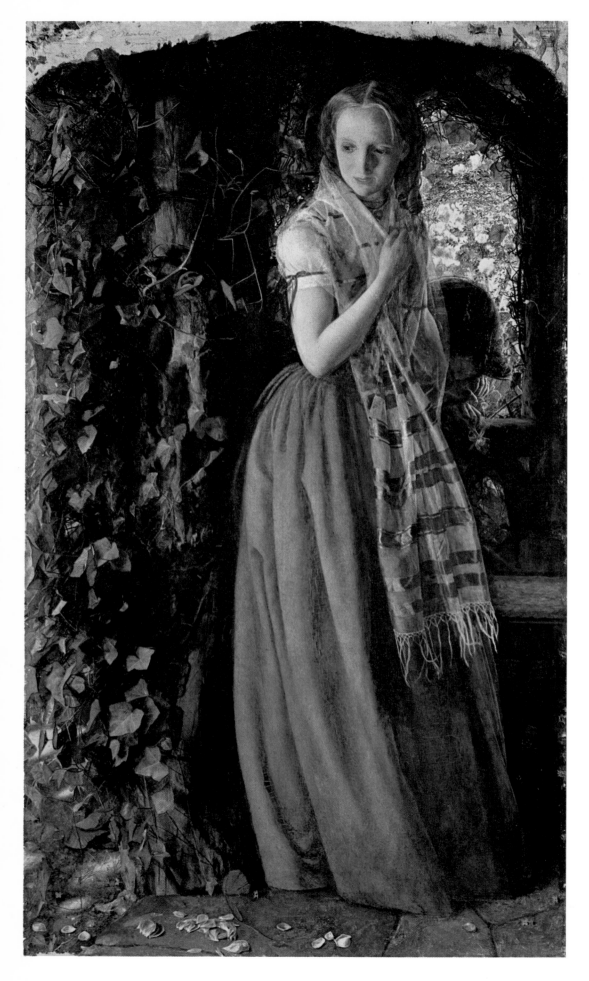

became the torch-bearer. When Burne-Jones said that he meant by a picture 'a beautiful romantic dream of something that never was, never will be—in a light better than any light that ever shone—in a land no one can define or remember, only desire' he was in effect adhering to the new trends of Aestheticism.

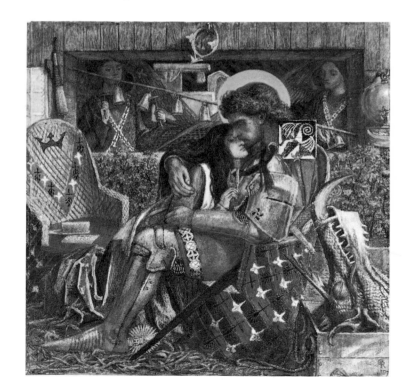

SIR EDWARD COLEY BURNE-JONES, Bt. *Study for Part of the Arras Tapestry made by Morris and Co. for Mr D'Arcy of Stanmore Hall, Middlesex, depicting the Quest for the Holy Grail.* Water-colour and body-colour. $11\frac{1}{4} \times 26\frac{1}{2}$ inches. Mr and Mrs Richard Moore.

Painted in about 1893. The shields are those of King Arthur's knights.

Opposite page, left:
ARTHUR HUGHES. *April Love.* $35 \times 19\frac{1}{2}$ inches. Tate Gallery, London.

Exhibited at the Royal Academy in 1856. The picture was inspired by the following lines from Tennyson's 'Miller's Daughter':
'Love is hurt with jar and fret. / Love is made a vague regret. / Eyes with idle tears are wet. / Idle habit links us yet. / What is love? For we forget: / Ah, no! no!'
The picture was bought by William Morris, then an undergraduate at Oxford, at the Academy exhibition, to the disappointment of Ruskin who had tried to persuade his father to buy it. 'Exquisite in every way', Ruskin wrote in his Academy Notes, 'lovely in colour, most subtle in the quivering expression of the lips, and sweetness of the tender face, shaken, like a leaf by winds upon its dew, and hesitating back into peace'. A study in oils is in the possession of Mr John Gere. *See p. 135.*

Opposite page, above right:
JAMES COLLINSON. *The Empty Purse.* $24 \times 19\frac{3}{8}$ inches. Tate Gallery, London.

Painted in about 1857. Of the three versions of this picture, this is probably the last to be painted. The other versions are at Sheffield City Art Galleries and Nottingham Art Gallery.

Opposite page, below right:
DANTE GABRIEL ROSSETTI. *The Wedding of St. George and Princess Sabra.* Water-colour. $13\frac{1}{2} \times 13\frac{1}{2}$ inches. Signed with monogram and dated 1857. Tate Gallery, London.

In 1857 Rossetti was closely associated with William Morris. A year later Rossetti wrote to the American Charles Eliot Norton: 'these chivalric, Froissartian themes are quite a passion of mine'.

DANTE GABRIEL ROSSETTI. *The Wedding of Saint George.* Water-colour and body-colour. $11 \times 13\frac{1}{2}$ inches. Signed with monogram, inscribed and dated 1864. Dr Jerrold N. Moore.

The composition of this picture was originally conceived as the last of a series of six stained glass windows illustrating the story of St. George and the Dragon, designed for Morris, Marshall, Faulkner and Co in 1861/2. There is a pencil study, drawn in 1857, at Birmingham.

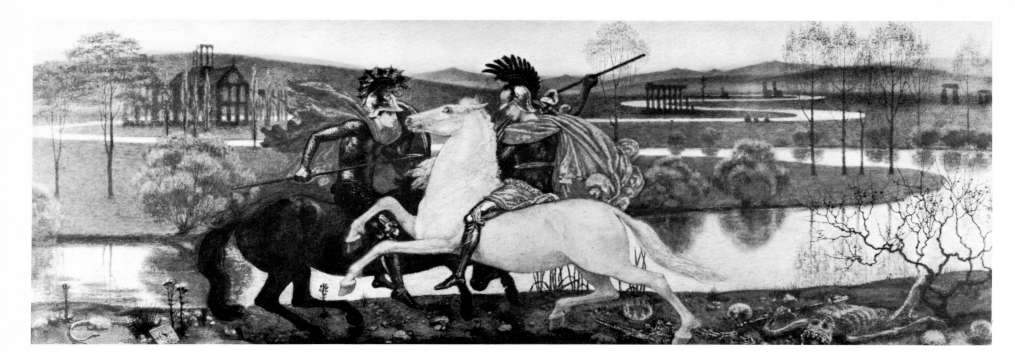

WALTER CRANE. *Ormuzd and Ahrimanes*. Water-colour and body-colour. $10\frac{3}{4} \times 29\frac{3}{4}$ inches. Signed with monogram and dated 1868-70. Charles Jerdein, Esq.

Crane wrote of this, his first allegorical composition, that it was 'an endeavour to suggest the Parsi idea of the struggle of the spirits of good and evil through the ages. The design showed two armed knights fighting on horseback, one white and the other black, by the side of a river winding away in long serpentine curves, showing at each bend some typical relic of time in the shape of a temple of some lost faith —here an Egyptian gateway, there a Celtic dolmen, a classic temple and a Gothic cathedral—the whole effect being of a subdued twilight, as of the dawn'.

Below right:
ELIZABETH SIDDAL. *The Lady of Shalott*. Pen and ink. $7\frac{3}{4} \times 9\frac{3}{4}$ inches. Signed and dated Dec 15, '53. Maas Gallery, London.
The drawing illustrates Tennyson's poem.

Below left:
DANTE GABRIEL ROSSETTI. *Elizabeth Siddal*. Pen and ink. $6\frac{1}{2} \times 3\frac{1}{2}$ inches. Cecil Higgins Museum, Bedford.
Inscribed on the reverse in W. M. Rossetti's hand: 'Liz 1855 as late as '58.'

Burne-Jones's pictures, with their limpid rhythms scarcely seen in English painting since Romney, their wan, 'sublimely sexless' figures moving silently about the half-lit world of ancient legend depicted with finely-graded spatial and colour harmonies, are as entirely free of didactic or moral purpose as the paintings of Whistler, whom Burne-Jones knew well in the 'sixties. After 'seven blissfullest years [with] no publicity, no exhibiting, no getting pictures done against time', he suddenly acquired celebrity with the exhibition of seven of his pictures at the Grosvenor Gallery in 1877. To Henry James, who saw the exhibition, Burne-Jones stood 'quite at the head of English painters of our day'. These pictures included *The Days of Creation*, *The Mirror of Venus* and *The Beguiling of Merlin*. 'It is,' wrote James, 'the Art of culture, of reflection, of intellectual luxury, of aesthetic refinement, of people who look at the world and at life not

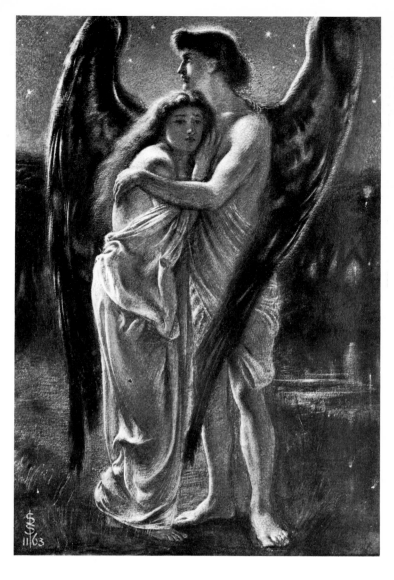

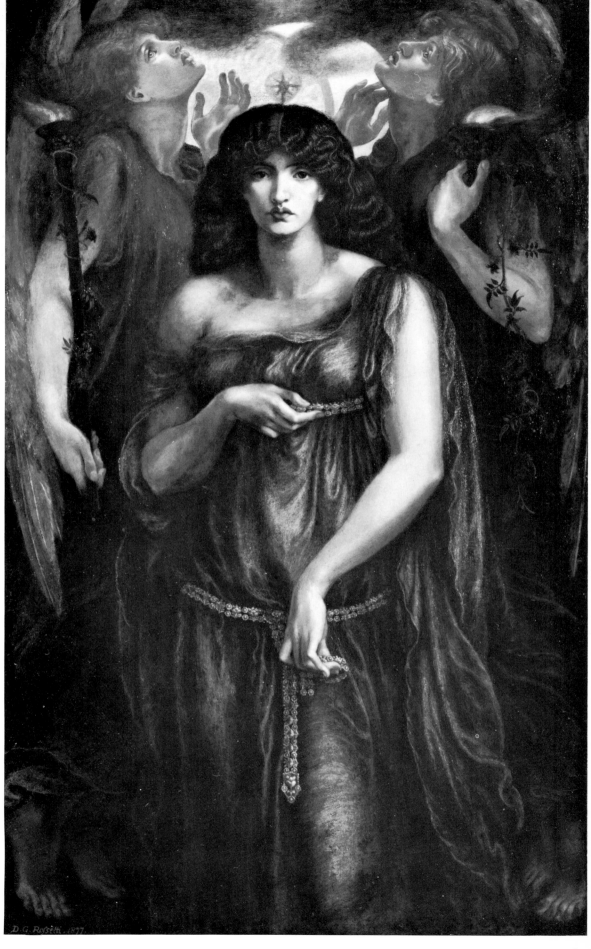

directly, as it were, and in all its accidental reality, but in the reflection and ornamental portrait of it furnished by art itself in other manifestations; furnished by literature, by poetry, by history, by erudition.'

Burne-Jones's pictorial work, in which there was a decreasing distinction between media (Ruskin once declared in Burne-Jones's studio that 'every one of

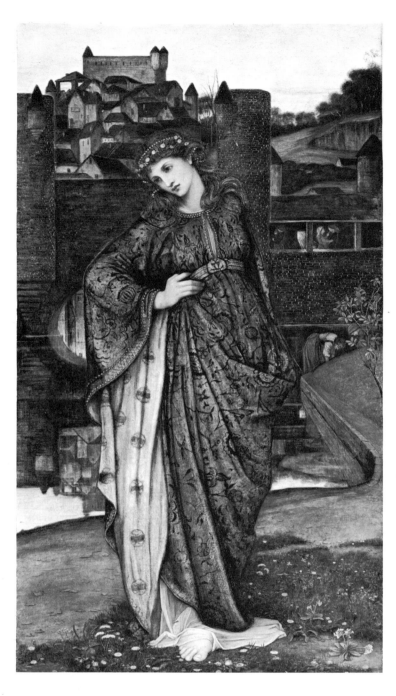

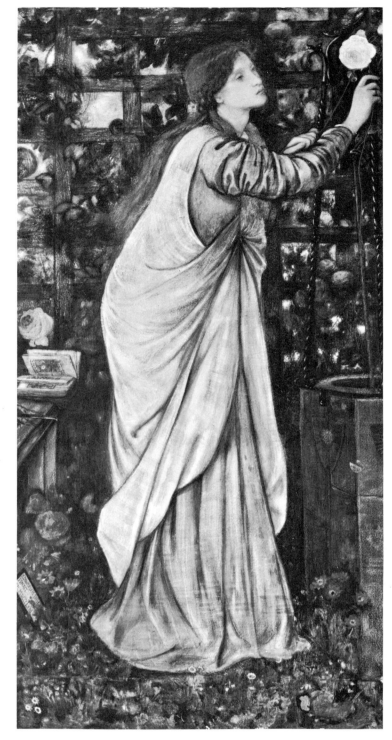

these works is in pure water-colour', when in fact all of them were in oils) ranged from the early exercises like *The Flower of God*, *The Madness of Sir Tristram*, and *Fair Rosamond*, which was owned by Ruskin, to large oil paintings, such as *Laus Veneris*, *The Wheel of Fortune*, *The Golden Stairs* and *Love and the Pilgrim*, many of which occupied him over a number of years. In some of his later work the dramatic element is so reduced that the pictures border on abstraction. Robin Ironside (Horizon, 1; 1940) suggested that, had Burne-Jones's reputation not been submerged by New English Impressionism, the British would have been better equipped to accept the modern movement. As it was, in the 'eighties he was a figure of international importance, first in France, and later in Spain and Germany.

This second wave of Pre-Raphaelitism produced not so much a constellation as a diffuse cluster, less intensified, more vitiated and touched by more influences than the first group. The example of 'Truth to Nature' was followed by many genre and landscape painters; these are the true descendants of the Brotherhood, but many of them worked in a vacuum, cheated of their birthright, like poor relations. A few derived their style more or less directly from Rossetti and ran a somewhat erratic course parallel to that of Burne-Jones: Frederick Sandys, one of the most successful of Pre-Raphaelite portraitists, a painter of mythological subjects, and a

gifted book illustrator; Marie Stillman, *née* Spartali
(1844–1927) a pupil of Madox Brown and one of
Rossetti's prettiest models; and Simeon Solomon.
The latter's story of early promise and final degra-
dation is one of the Pre-Raphaelite tragedies, but his
early friendship with Pater and Swinburne and his
enthusiasm for the new cult both contributed to the
blending of the two strains. Others such as John
Melhuish Strudwick (1849–1935), Thomas Matthews
Rooke (1842–1942), J. R. Spencer Stanhope (1829–
1908), Charles Fairfax Murray (1849–1919) and
Evelyn De Morgan, *née* Pickering (*c*.1850–1919),
derived their manner rather from Burne-Jones.

The Japanese print had already taken a powerful
hold over artists in Paris in the late 'fifties; imported
into London by Whistler in 1863, it was exerting a
profound pictorial influence, contributing to the style
of the Aesthetic movement, and modifying the Pre-
Raphaelite strain inherited from Burne-Jones by
artists like Walter Crane and Aubrey Beardsley.

William Bell Scott (1811–1890) was essentially a
muralist, and is best remembered for his friendship
with Rossetti; Frederic Shields was an interesting
character who devoted himself to painting, decorating
and book illustration. William De Morgan (1839–
1917) is another polymathic artist who rediscovered
the process of making coloured lustres and devoted
much of his last eleven years to writing novels. All
these artists and craftsmen have an interest out of all
proportion to the space that can be devoted to them
here. The invasion of the applied arts and book illus-
tration by Pre-Raphaelitism was a major contribution
to the style known as 'Art Nouveau', and the beauti-
fully depraved, sterile line of Beardsley, in itself
abidingly influential, was Pre-Raphaelitism's last
important convulsion.

X

FAIRY PAINTERS

'In an utilitarian age, of all other times, it is a matter of grave importance that fairy tales should be respected.'
Charles Dickens, in 'Household Words', Vol. 8 (Oct. 1 1853)

On March 31st, 1848, in the town of Hydesville, New York, a family of three sisters named Fox, who had been disturbed in their humble frame-dwelling by strange manifestations, received, by raps, intelligent answers to questions put to the unseen rapper. Thus was modern spiritualism born.

These unusual occurrences in the Fox family received remarkable publicity throughout the United States. In a short time the Fox sisters had started on careers as mediums. Other mediums soon began to gain renown. In 1852 the first American medium of note arrived in England. The new interest became a craze and spread rapidly. Ladies sent out invitations to 'Tea and Table-Turning'. Queen Victoria herself was alleged to have tried to get in touch with Prince Albert's spirit. Certainly some of the Queen's friends and even her family were victims of the new mania. Generally, however, the new table-turning was treated with amusement, sometimes bordering on hilarity. The Queen's favourite sculptor, Boehm, amused the Court with a story of how, when he was at a seance, the alleged hand of a spirit caressing his knee turned out to be his host's stockinged foot. Every section of society was affected. The poet William Allingham maintained that Rossetti's curiosity about spiritualism was more than just superficial: he did, in fact, attend seances and we know that Harriet Martineau once mesmerized Charlotte Brontë. In no time at all the Society for Psychical Research was founded, numbering among its members a bishop, dons and a Minister of the Crown. In the 'sixties psychic literature abounded. In August 1860, 'The Cornhill Magazine', with Thackeray as its editor, contained an article on Spiritualism entitled 'Truth Stranger than Fiction', which caused a great commotion.

The advent of spiritualism, together with the discovery of subject-matter in legend and literature, acted as a peculiar stimulus to Victorian painting, just as the Tennysonian concept of the Arthurian legend was to preoccupy the vision of many artists. It also offered a common ground which the artist and his public could readily share. One aspect of the early history of modern spiritualism must strike one forcibly, and that is its almost exact coincidence with the conception, expansion and revival of the Pre-Raphaelite movement. Many painters in the 'fifties and 'sixties found that they could draw nourishment from the new spiritualism. The fusion of these elements found expression in a unique Victorian contribution to art, fairy painting.

Fairy painting was close to the centre of the Victorian subconscious. No other type of painting concentrates so many of the opposing elements in the Victorian psyche: the desire to escape the drear hardships of daily existence; the stirrings of new attitudes towards sex, stifled by religious dogma; a passion for the unseen; psychological retreat from scientific discoveries; the birth of psychoanalysis; the latent revulsion against the exactitude of the new invention of photography. It was the collision of these elements with the securely held beliefs of former generations which resulted in paintings which are peopled by creatures of the old mythology in fantastic settings, visualized in the obsessive reality demanded by the newly propagated doctrine of 'Truth to Nature'.

The whole of nineteenth century English art and literature is threaded with allusions to the unseen, the occult—from Blake to Lewis Carroll. Foreign influences were also making themselves felt: as early as 1824 the *'Kinder- und Hausmärchen'* by the two German brothers Grimm were published in England under the title of 'German Popular Stories' (now better-known to us as 'Grimm's Fairy Tales') and illustrated by none other than Dickens's illustrator George Cruikshank. 'How,' asked Thackeray, 'shall we enough praise the delightful German nursery tales, and Cruikshank's illustrations of them?' Twenty-three years later the Danish writer Hans Christian Andersen's 'Fairy Tales' were translated and published in this country. And who knows what subtle influences Prince Albert's fey Germanic conception of Christmas may have had on contemporary pictorial imagery? A permanent source of subject-matter lay in the works of Shakespeare—particularly in 'A Midsummer Night's Dream' and 'The Tempest'. These provided a rich quarry for Fuseli, whose *Titania* is a fine example. Thomas Stothard, Francis Danby, Richard Dadd and others found inspiration in Shakespeare. Danby painted an illustration to 'A Midsummer Night's Dream' in 1832. Millais illustrated 'The Tempest', with *Ferdinand and Ariel* and sometime between 1851 and 1858 Arthur Hughes painted another version of *Ferdinand and Ariel*. In Millais's picture Ferdinand is preceded by Ariel, surrounded by a strange flight formation of hallucinatory sprites. In Hughes's picture there is no sign of Ariel, nor any other spirits. Perhaps it is meant to depict *Echo, or Benedict in the Arbour*, under which title it was exhibited at the Tate Gallery in 1923; in any case Hughes has surprisingly resisted the temptation to populate the picture with phantasmagoria, albeit achieving a heightened sense of mystery.

Comparison of these two pictures further illustrates the thinness of the division between purely obsessive paintings of minutely observed grass, weeds and flowers, with the occasional bird's-nest by William Henry Hunt, Oliver Clare and others, and pictures with similar settings but which are peopled by one,

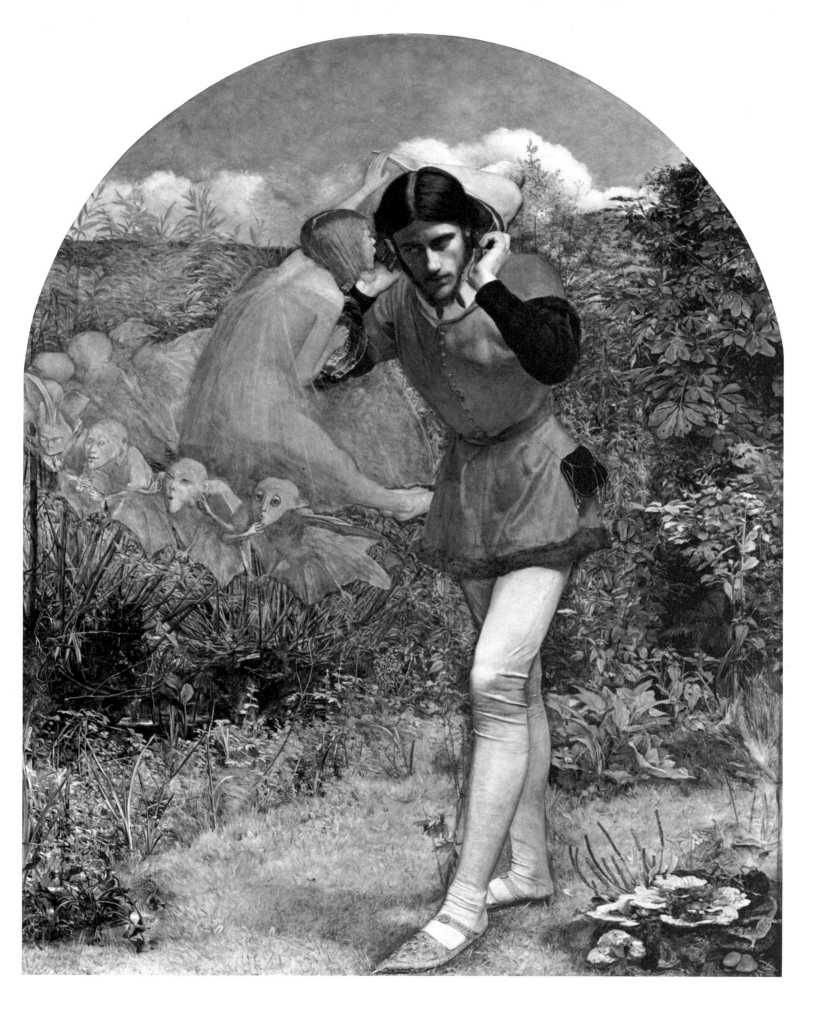

SIR JOHN EVERETT MILLAIS,
Bt., P.R.A. *Ferdinand lured by Ariel*.
Panel, arched top. $25\frac{1}{2} \times 20$ inches.
Signed and dated 1849. The Rt
Hon. Lord Sherfield G.C.B.,
G.C.M.G.

Exhibited at the Royal Academy
in 1850. F. G. Stephens was the
model for Ferdinand. The 'Athen-
aeum' reviewer of the Academy
exhibition considered it 'a scene
built on the contrivances of the
stage manager, but with very bad
success'.

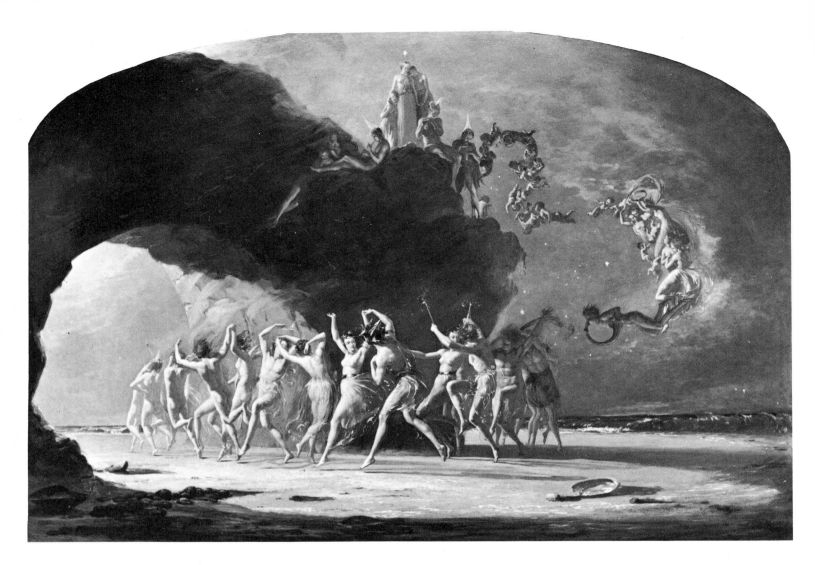

two or more fairy figures, by artists like Richard Doyle, Noël Paton and J. A. Fitzgerald. This relationship between figure painting and landscape goes to the root of Pre-Raphaelite thought. In good Pre-Raphaelite painting figure and landscape arouse equal interest. Dr Jerrold Moore puts the point succinctly thus: 'Beginning with Turner, the English painters of the nineteenth century looked for ever more powerful and individual means of conveying their reaction to the world of nature around them. Samuel Palmer did it by means of characteristic simplification of shapes and contours; John Martin by the introduction of human or miraculous creatures, dwarfed against enormous landscape prospects. The fairy painters achieved an intensification of the landscape experience by the use of these sub-human miniature creatures who live entirely in the landscape, and whose consciousness represents therefore only a sensible extension of the landscape.' Fairy painting, therefore, derives from a new intensity of vision in landscape. Whereas in the eighteenth century, landscape was used primarily as a decorative background, and, by the romantics, as a stimulus to inspiration, painters in the mid-nineteenth century spurred by the visionary intensity of the Pre-

Raphaelites and by Ruskinian 'Truth to Nature', drew so close to the visible world that to go through and beyond its outer surface, like Alice through the looking glass, seemed perfectly natural.

The fusion of landscape with the occult was the concern of most fairy painters. At this stage, however, it is interesting to glance at one of the more curious manifestations of spiritualism, if only because of its bearing, admittedly tenuous, on the works of Richard Dadd, namely Automatic painting. At the London College of Psychic Science there is a volume of remarkable water-colours alleged to have been executed by spirits through the medium of Georgina Houghton, who, in 1882, had published 'Chronicles of the Photographs of Spiritual Beings and Phenomena Invisible to the Material Eye' which contained reproductions of alleged spirit photographs. Perhaps she was the author of 'some drawings said to be done by spirits' which were offered to the Hanging Committee of the Royal Academy in 1872, when Frith was a member. As Frith wrote: 'they were quite indescribable, resembling nothing in heaven above or on the earth beneath, and were necessarily laughed out of the rooms.' The water-colours, which occasionally

achieve a rare unearthly beauty, exhibit all the signs of schizophrenia. Indeed it is generally acknowledged that spiritualism and schizophrenia are sometimes closely linked. The history of painting contains many famous cases of schizophrenic artists, Bosch, Goya, Piranesi and Van Gogh among them. The schizophrenic artist preserves an acuteness of perception, which can be likened to the freshness of a child's outlook; but always at the centre of this awareness lurks a feeling of dread. Louis Wain (1860–1939) was noted for his sentimental water-colours of cats, but towards the end of life his reason became clouded, and the later drawings underwent alarming transformations, achieving bizarre and terrifying kaleidoscopic effects. It cannot be denied that his pictures were all the richer for it. One is tempted to look to schizophrenia, in our own disturbed age, as a possible motivating factor to some modern abstract painters. And conversely, modern therapy often prescribes painting in cases of mental illness.

A painter, the direction of whose life was dramatically changed by schizophrenia, was Richard Dadd (1817–1887). As a student Dadd had been a founder member of 'The Clique'. His early paintings were unremarkable exercises in landscape, marine and animal painting. But by 1841 his choice of subject began to anticipate the astonishing pictures of his last period. In that year he exhibited at the Royal Academy his *Titania Sleeping*. A year later he exhibited *Come unto these yellow Sands*, an illustration to 'The Tempest'. In the same year, encouraged by his friend David Roberts, Dadd embarked on a journey to the Middle East with Sir Thomas Phillips. They travelled to Venice, Corfu, Greece and Baalbek and made their way down the Nile to Thebes. A letter to Frith was prophetic: 'At times the excitement of these scenes has been enough to turn the brains of an ordinary weakminded person like myself, and often I have lain down at night with my imagination so full of wild vagaries that I have really and truly doubted my own sanity.'

On his return to London he entered the competition for the decoration of the Houses of Parliament. His design, a St. George, was rejected, partly on the grounds that the dragon's tail was too long. Shortly after this Dadd's father took his son to the country on the advice of his doctor. While staying overnight at Cobham, Dadd stabbed his father to death, and then fled with all speed to France. He intended to murder the Emperor of Austria, but got no further than stabbing a passenger on a diligence at Fontainebleau before he was arrested. On being brought back to England he was placed in Bethlem, or the Hospital of St. Mary of Bethlehem. After a rough start, he was treated kindly and was given materials for painting and drawing. From then on his drawings and paintings attained a marvellous supranatural quality, but always

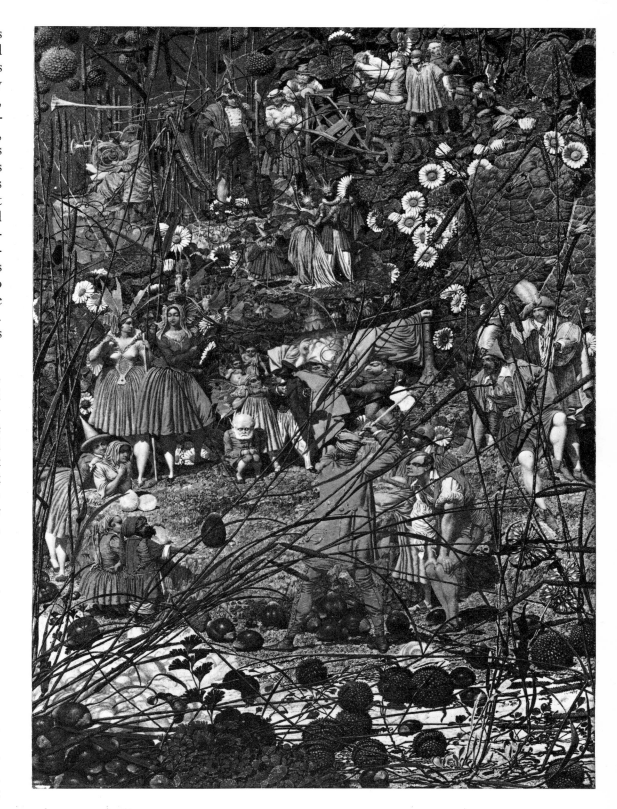

characterized by a gentleness, which was, by all accounts, in accord with his character. Eleven drawings done in 1854, still in the possession of the Bethlehem Royal Hospital, vary in quality and obsessiveness. In 1857 Dadd was engaged in painting the first major work of his sadly unnatural maturity, *Oberon and Titania*. This extraordinary picture, with its congested detail and leaden colouring, is nevertheless a harmonious composition which takes its place among

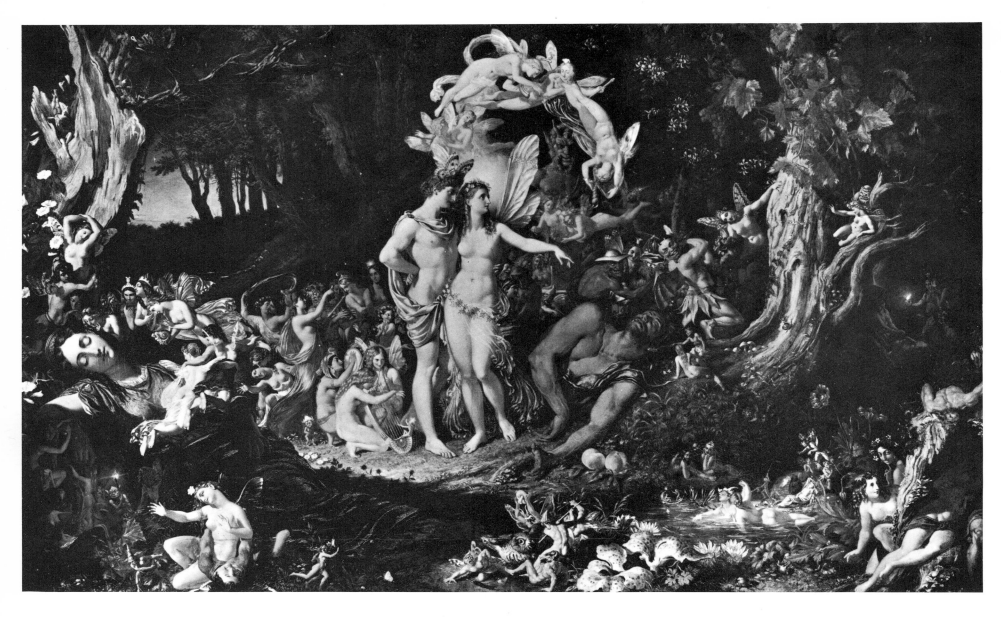

the great imaginative pictures of the Victorian age. But his greatest achievement was *The Fairy Feller's Master-Stroke*, now at the Tate Gallery. The colouring and intensity of observation are similar to *Oberon and Titania*. The picture, which took him nine years to complete, was even then not entirely finished. It reminds one of a mediaeval tapestry with its quaint figures almost invisible to the naked eye. From this period emerged *The Gardener—a Scene at Pope's House, Binfield.* It is naturalistic, but there is a strange air of unreality about it. The observation is as keen as ever, but the house, flowers and figures seem curiously unrelated. Totally different in subject is his *Sailing Ships.* This hauntingly beautiful picture, with its heavily laden Ancient Mariner atmosphere, must be one of the strangest marine pictures ever painted; stranger still when one considers that, for all its naturalism, Dadd had been an inmate of Bethlehem Hospital for an unknown number of years before painting it.

Oberon and Titania were familiar figures to Joseph Noël Paton (1821–1901), whose fairy pictures are charming adornments to the Victorian era. Born in Dunfermline, he was imbued with a wild Celtic imagination and many of the subjects of his pictures were developed from northern legend. His *Fairy Raid* is a *tour-de-force*, rich in invention and clear in observation. *The Quarrel of Oberon and Titania* and its companion, *The Reconciliation of Oberon and Titania*, are quintessential fairy pictures, linking the age of Etty and Frost with the, as yet, unborn Pre-Raphaelite movement. The figures of Titania and Oberon sleeping beside their fairy personifications symbolize the awakening Victorian fascination with the sub-conscious. 'A Midsummer Night's Dream' seemed the perfect vehicle for such an interest: only five years earlier Mendelssohn had composed his incidental music for the play. Nine years earlier Thomas De Quincey had left no doubt as to which Shakespeare play was favourite with the Victorians: writing for the Encyclopaedia Britannica, he singles out this play specifically—'in no other exhibition of this dreamy

population of the moonlight forests and forest lawns, are the circumstantial properties of fairy life so exquisitely imagined, sustained or expressed.' The religious pictures of Noël Paton comprised the greater part of his work, while the fairy pictures were rapt hallucinatory asides.

Even the most unlikely artists attempted fairy painting. Thackeray describes, in his 'Roundabout Papers', a visit he made to the studio of C. R. Leslie shortly after his death in 1859. 'There was his last work on the easel—a beautiful fresh smiling shape of Titania, such as his sweet guileless fancy imagined the ''Midsummer Night's'' queen to be.' It was without the 'fairy elves' which 'no doubt, were to have been grouped around their mistress in laughing clusters'. A far more inventive painter, Daniel Maclise, in a rare essay in fairy painting, chose the subject of *Undine* to render a richly textured composition compounded of menace and enchantment. William J. Webbe (fl. 1850–1860) and John **Anster** Fitzgerald (1832–1906) are remembered only for a handful of highly imaginative works, and about their lives next to nothing is

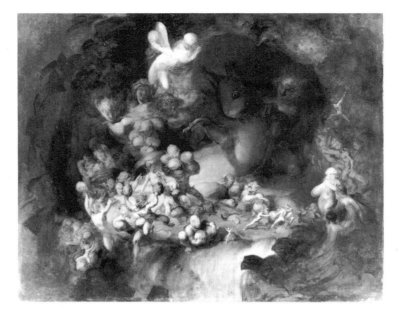

known. Webbe appears to have been influenced by Holman Hunt, and he seems to have worked in the Isle of Wight. His *Chanticleer and the Fox* shows him at

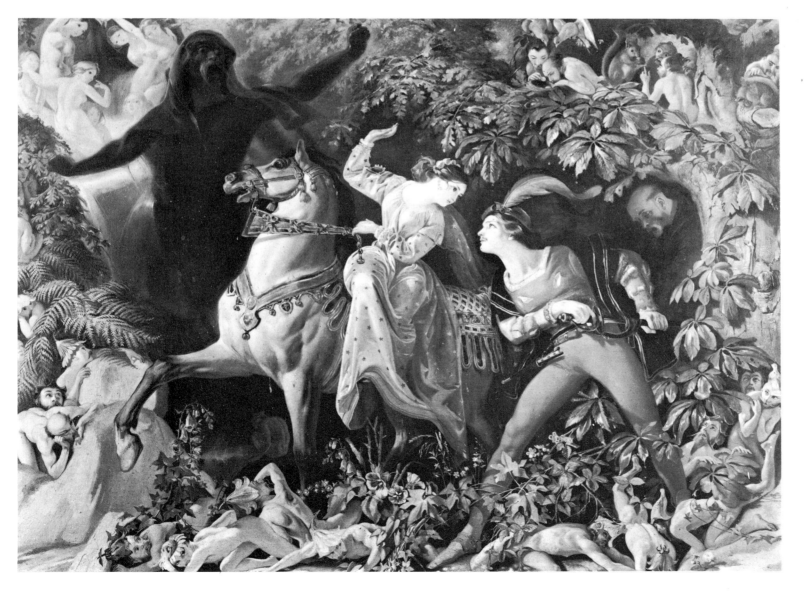

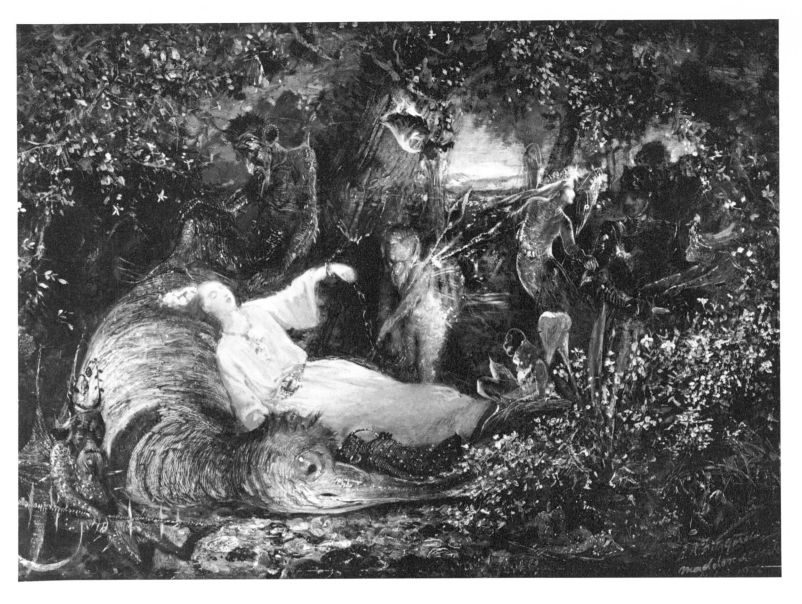

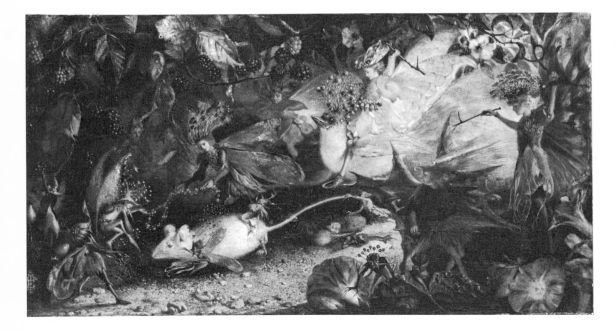

his very best. The painting of the foreground with its minute attention to detail places him squarely in the Pre-Raphaelite tradition. Webbe was not a painter of fairy pictures in the strictest sense, but this picture, with its mythological subject and its subordination of animate life to highly detailed landscape, shows how near fairy painting was to the closely observed studies of nature by artists like William Henry Hunt.

With J. A. Fitzgerald we are back in the world of dreams. His pictures, tinged with eroticism, usually reveal a sleeping man or woman in exotic dress surrounded by hosts of goblins and other nameless beings performing antics suggestive of courtship and matrimony. The colours are bright and lurid, and the drawing slightly weak, but the pictures are redeemed by a certain piquancy of imagination. But *Chase of the white Mice* is a most magical evocation of fairyland. Here no humans intrude, and that which no human can see is perfectly imagined. So beguiling is this small canvas that the eye tends to overlook the delicate sadism. The drawing is stronger than usual and there is a more subtle sense of colouring.

Many a Victorian artist who made his reputation in other fields has left his mark on the world of fairies: such a one was Frederick Goodall (1822–1904) whose little picture of two fairy lovers standing in a bird's-nest, frightened by a white mouse, is the very essence of enchantment. Some artists found it difficult to reconcile the real with the fairy world: Edward Hopley (1816–1869) painted in 1853 a pair of fairy pictures, in one of which we see a fairy taunting a butterfly with a thorn, a startled frog, ferns, briar-roses and hare-bells—and a most palpable train passing in the distance. As evidence of Hopley's diversity may be cited his invention of the trigono-metrical system of facial measurement.

An early friend of the Pre-Raphaelite circle was an Irish Civil servant in the Customs Service called William Allingham (1824–1889), who devoted much of his spare time to the writing of poetry. In 1855 he published 'The Music Master', with illustrations by Millais, Hughes and Rossetti. He was on friendly terms with Rossetti for the best part of eighteen years. Perhaps Carlyle's remark to Allingham: 'Have a care now, have a care, for ye have a tur-r-able faculty for developing into a bore' may explain Rossetti's jetti-soning of him. However, another partnership was to result in one of the loveliest colour plate books of the Victorian age: 'In Fairyland, a series of pictures from the Elf World', by Richard Doyle (1870).

Richard Doyle (1824–1883) was one of seven children, all of whom inherited talent from their father John Doyle (1797–1868). Charles (1832–1893), his youngest brother, entered the Civil Service and spent most of his life in the Edinburgh Office of Works. In his leisure hours he painted many strange fan-tasies, including a nightmarish scene with elves, horses and figures. Charles's son was Sir Arthur Conan Doyle, whose interest in the occult, like that of Lord Lytton before him, was a notable feature of his

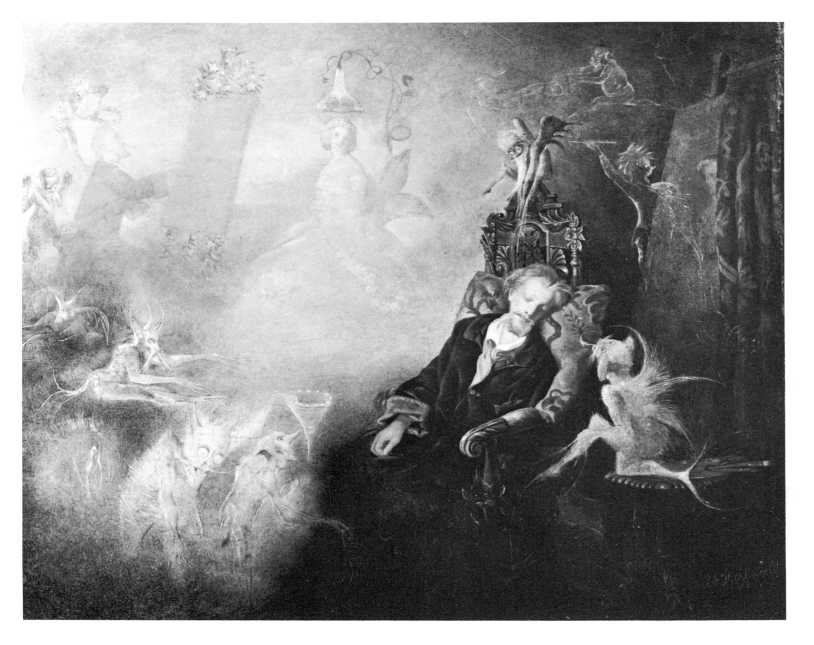

JOHN ANSTER FITZGERALD. *The Dream*. Millboard. $9\frac{1}{2} \times 11\frac{1}{2}$ inches. Signed and dated 1857. Private collection, Great Britain.

Exhibited at the British Institution in 1857. This is a portrait of the artist 'about whom are flitting numberless partycoloured elves'. An unfinished portrait of an old woman stands on the easel to the right while he dreams he is painting a portrait of the beautiful young woman in the centre. An elf pours money into the pocket of his dream personification.

RICHARD DOYLE. *The Fairy Tree*. Water-colour. 29×24½ inches. Alexander Martin, Esq.

Opposite page:
WILLIAM SHAKESPEARE BURTON. *The Wounded Cavalier*. 35×41 inches. Guildhall Art Gallery, London.

Exhibited at the Royal Academy in 1856. The subject is from the Civil War. A Roundhead and his lady display markedly differing reactions to a stricken cavalier. The picture was painted in the summer and winter of 1855 in the grounds of an old cavalier house near Guildford. The artist, in order to observe the flora more accurately, is said to have placed himself and his easel in a deep hole by the scene, wherein he sat and worked for long periods. Owing to the loss of its label, it would have missed being exhibited but for the intervention of C. W. Cope who withdrew one of his own pictures to make way for it. A review in 'The Art Journal' noted that 'the painter has been hitherto unknown, but this picture at once establishes his reputation; he is secure of fame hereafter'. His entry for the Academy next year, *A London Magdalen*, was rejected, and Burton sank into obscurity. See p. 133.

life. Holman Hunt found Richard Doyle 'unique and delightful . . . a man overflowing with strange stories but never with a word of uncharitableness'. Doyle was primarily a book illustrator of themes from everyday life, alternating with fairy subjects. He was also the painter of a number of highly original

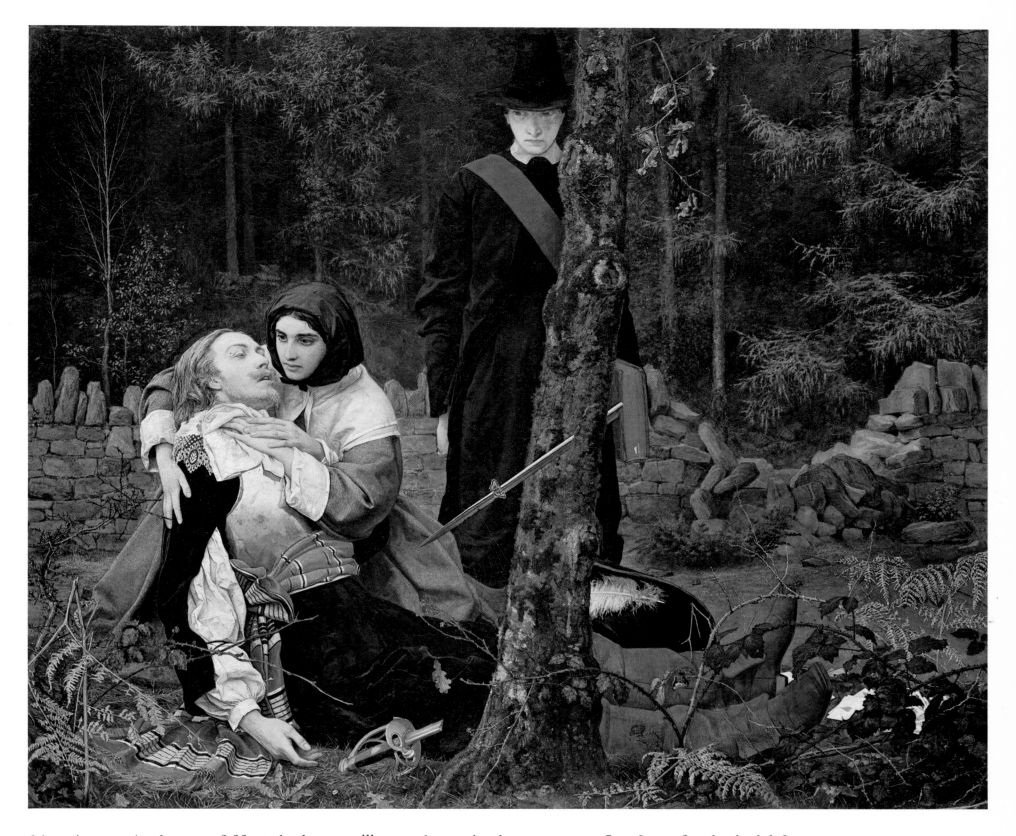

fairy pictures. At the age of fifteen he kept an illustrated diary called 'Dick Doyle's journal' from which it is clear that he had reached full maturity in one bound. In 1843 he joined the staff of 'Punch' in the company of Thackeray, John Leech and Douglas Jerrold. The famous cover of 'Punch' was designed by him in 1849. His first major success was with a series called 'Manners and Customs of ye Englyshe' which

began in the same year. In 1851, after he had left 'Punch', he did some of his first fairyland illustrations in Ruskin's 'The King of the Golden River'. His finest work in this field is 'Fairyland', illustrating Allingham's poems. In this book the gifts of poet, painter and the wood-engraver and printer (Edmund Evans) are felicitously united. The colour plates show Doyle in his element. There is no hint of mawkishness, a

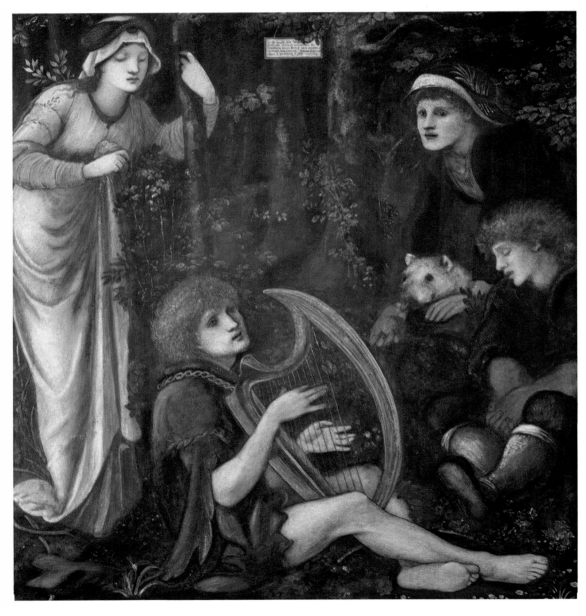

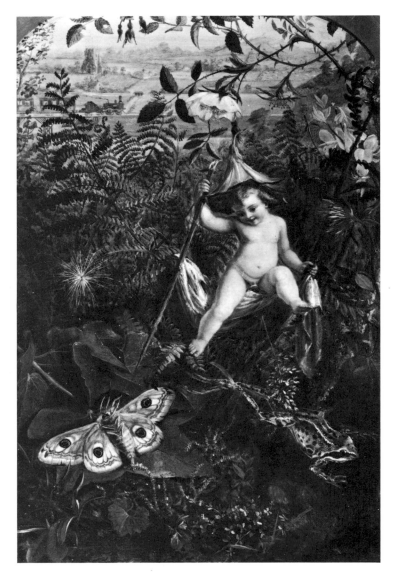

common pitfall in fairy painting, although there is a faint hint of cruelty: the Victorians tended to regard elves as symbols of human spleen. But the impression that prevails is one of purest enchantment.

Richard Doyle painted a number of pictures, both in oils and water-colours, which he exhibited at the Royal Academy and the Grosvenor Galleries. Some of these were very large, and were peopled with hundreds of fairies. The invention was prodigious. As was to be expected, the Victorians invested their fairies with morality, much to the indignation of Dickens, who inveighed against the moralists in 'Household Words', and Doyle's fairies tend to be goody-goodies or mischief makers. Thackeray believed his drawings to be 'quite extraordinary for their fancy, their variety, their beauty, and fun. It is the true genius of fairyland, of burlesque which never loses sight of beauty.' Doyle's standing in the artistic Establishment of the day disappointed him. He tried in vain to gain acceptance of his rather ordinary views of Devon, Wales and Scotland; and towards the end of his life a new

SIR EDWARD COLEY BURNE-JONES, Bt. *The Madness of Sir Tristram*. Water-colour and body-colour. 23 × 24 inches. Initialled. Leger Galleries Ltd., London. Exhibited at the Society of British Artists in 1892. Painted in 1862, it illustrates lines from Malory's 'Morte d'Arthur'. *See p. 144.*

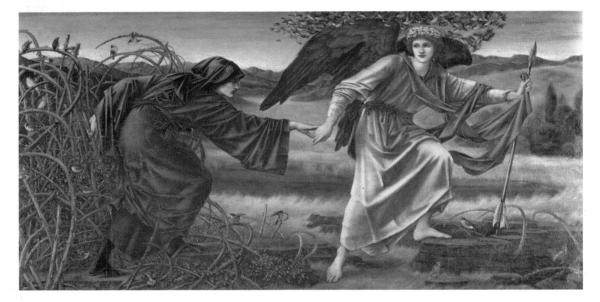

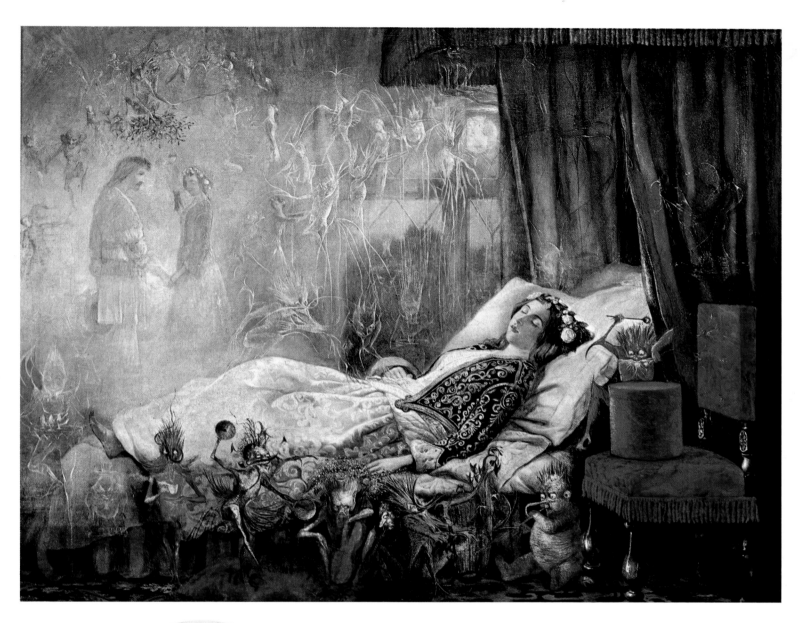

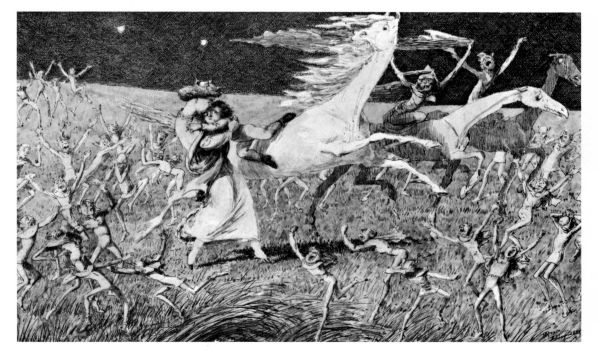

JOHN AUSTEN FITZGERALD. *The Stuff that Dreams are made of.* 14½ × 18 inches. Sir David Scott, K.C.M.G., O.B.E.

Opposite page, below left:
SIR EDWARD COLEY BURNE-JONES, Bt. *Love and the Pilgrim.* 62 × 120 inches. Signed and dated 1896-7. Tate Gallery, London.

As with many of his larger works Burne-Jones worked on this picture for a number of years (1877-97). The subject was suggested by Chaucer's 'Romaunt of the Rose', The God of love, his head 'all with briddes wryen', leads, barefooted, the pilgrim L'Amant who is painfully cumbered by sharp-thorned briars and rough stones. Robert de la Sizeranne wrote of Burne-Jones's figures that they 'always look as if they were coming down stairs, excepting always his angels. They look as if they had been hung with their feet some inches above the earth, and their bodies elongated towards it'. *See p. 144.*

Opposite page, right:
EDWARD·HOPLEY. *Fairy Taunting a Moth.* Board. 10⅛ × 6¼ inches. Lady Clark.

Below, left:
R. HUSKISSON. *The Mother's Blessing.* Panel. 10 × 8 inches. Maas Gallery, London.

Engraved as frontispiece to 'Midsummer Eve' by Mrs S. C. Hall (1848).

CHARLES DOYLE. *Fantasy, with Elves, Horses and Figures.* Pen, ink and wash. 6½ × 10¾ inches. Signed and dated 1885. Anthony d'Offay, Esq.

159

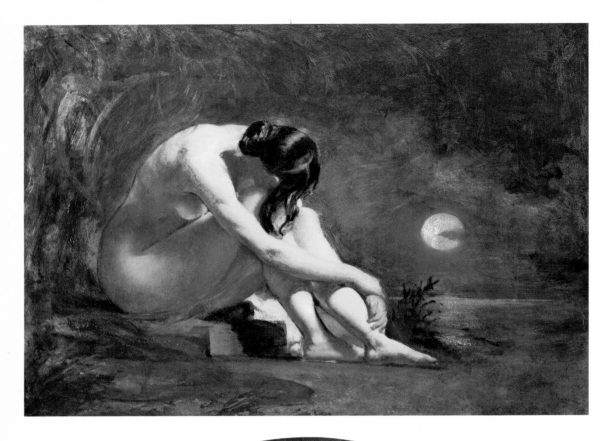

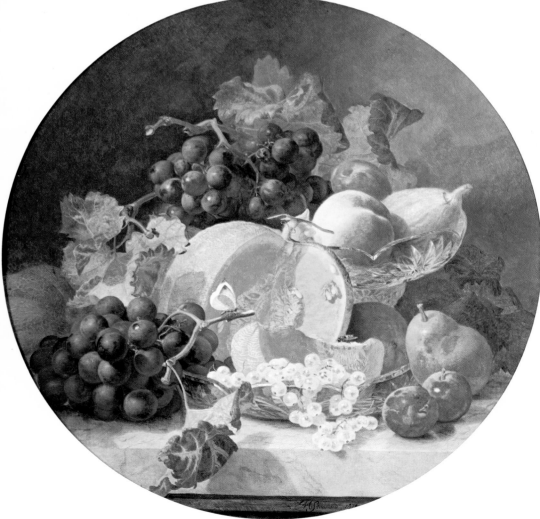

generation of illustrators like Du Maurier, Tenniel and Keene began to supplant him. Troubled by apoplectic fits during his last years, he was finally struck down by an apoplexy upon leaving the Athenaeum Club on December 10th, 1883. Thompson Cooper eulogised him elegantly in the Dictionary of National Biography: 'He left behind him the memory of a singularly sweet and noble type of English gentleman, and of an artist of "most excellent fancy"—the kindliest of pictorial satirists, the most sportive and frolicsome of designers, the most graceful and sympathetic of the limners of fairyland. In Oberon's court he would at once have been appointed sergeant-painter.'

A gentle yet lyrical artist, Robert Huskisson exhibited a number of pictures at the Royal Academy from 1838 to 1854, most of which are now, like his dates of birth and death, in oblivion. In 1847 he exhibited *The Midsummer Night's Fairies*, and in 1854 *Titania's Elves robbing the Squirrel's Nest*. Mrs S. C. Hall's 'Midsummer Eve: A Fairy Tale of Love', with numerous illustrations by Huskisson, had been published in 1848. The original painting entitled *The Mother's Blessing* for the frontispiece of Part One shows what Huskisson might have achieved had he not died so young. Frith describes meeting Huskisson at a dinner party given by Lord Northwick, and concedes that he 'had painted some original pictures of considerable merit' although 'Huskisson was a very common man, entirely uneducated. I doubt if he could read or write; the very tone of his voice was

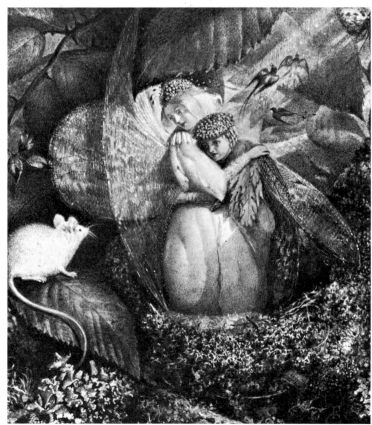

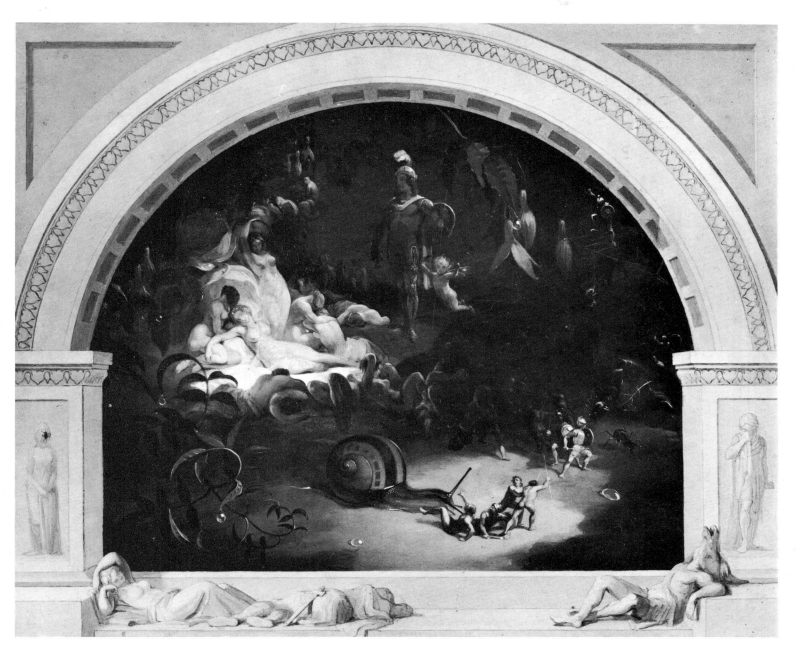

ROBERT HUSKISSON. *Titania Asleep*. Panel. $11\frac{1}{2} \times 13\frac{1}{2}$ inches. Private collection, London.

Exhibited at the Royal Academy in 1847. The subject is from 'A Midsummer Night's Dream'. A writer in 'The Art Union' journal of 1847 commented that the picture was 'hung most advantageously . . . and attracted very great attention, inasmuch as the name of the painter was heretofore comparatively unknown'. It was engraved in the same journal in 1848, Vol X.

Opposite page, above left:
WILLIAM ETTY, R.A. *Eurydice*. Panel. $20 \times 26\frac{1}{2}$ inches. Mr and Mrs Rupert Lycett Green.

Etty was in the habit of making studies from the nude in the Life School of the Royal Academy throughout his career. These would be worked up into finished compositions. It was shortly after his death that the Council of the Royal Academy decreed 'that as a general principle it is desirable that the model in the Life School should be undraped, and that any partial concealment for considerations of decency would rather tend to attract attention to what might otherwise pass unnoticed'. *See p. 166.*

Opposite page, below left:
ELOISE HARRIET STANNARD. *Fruit-piece*. Diameter $19\frac{1}{2}$ inches. Signed. Spenser S.A., London. See *p. 174.*

Opposite page, right:
FREDERICK GOODALL, R.A. *Fairies and Mouse*. Water-colour and body-colour. $8 \times 6\frac{3}{4}$ inches. Signed with monogram. Cecil Higgins Museum, Bedford.

dreadful.' He recalled Lord Northwick calling to him 'Mr Huskisson, was it not a picture-dealer who bought your last "Fairy" picture?' 'No, my lord! no, my lord!' replied Huskisson. 'It were a gent.' Even more obscure than Huskisson is John Simmons (1823-1876), whose illustration to 'A Midsummer Night's Dream', dated 1867, is as accomplished as any of its kind.

By the early 'seventies the vein of fairy painting had been largely worked out, although few Royal Academy exhibitions for the next thirty years or so were complete without a smattering of fairy pictures. Generally the elfin quality is sadly diminished. However, *A Fairy Wooing* by Charles Sims (1873–1928) exhibited at the Royal Academy in 1898, with its *fin-de-siècle* eroticism, shows at least an understanding of the genre. Even if this gifted artist had not lost his reason and eventually committed suicide, his work would have remained an anachronism. The fairy theme continued to survive anaemically in book illustration, in John Tenniel (1820–1914) and others. Early in our century elves and woodlands were revived by Arthur Rackham and Edmund Dulac, although somehow the fairies have lost their transparency and become opaque. The fairy theme found its culmination in literature, particularly in the works of Lewis Carroll and Charles Kingsley. 'The Water Babies' by the latter was published in 1863; Lewis Carroll's 'Alice's Adventures in Wonderland' was published in 1865 and 'Through the Looking Glass' in 1872. These in turn provided the climate for James Barrie's 'Peter Pan' of 1904. In this way a theme which art borrowed largely from literature was returned with interest.

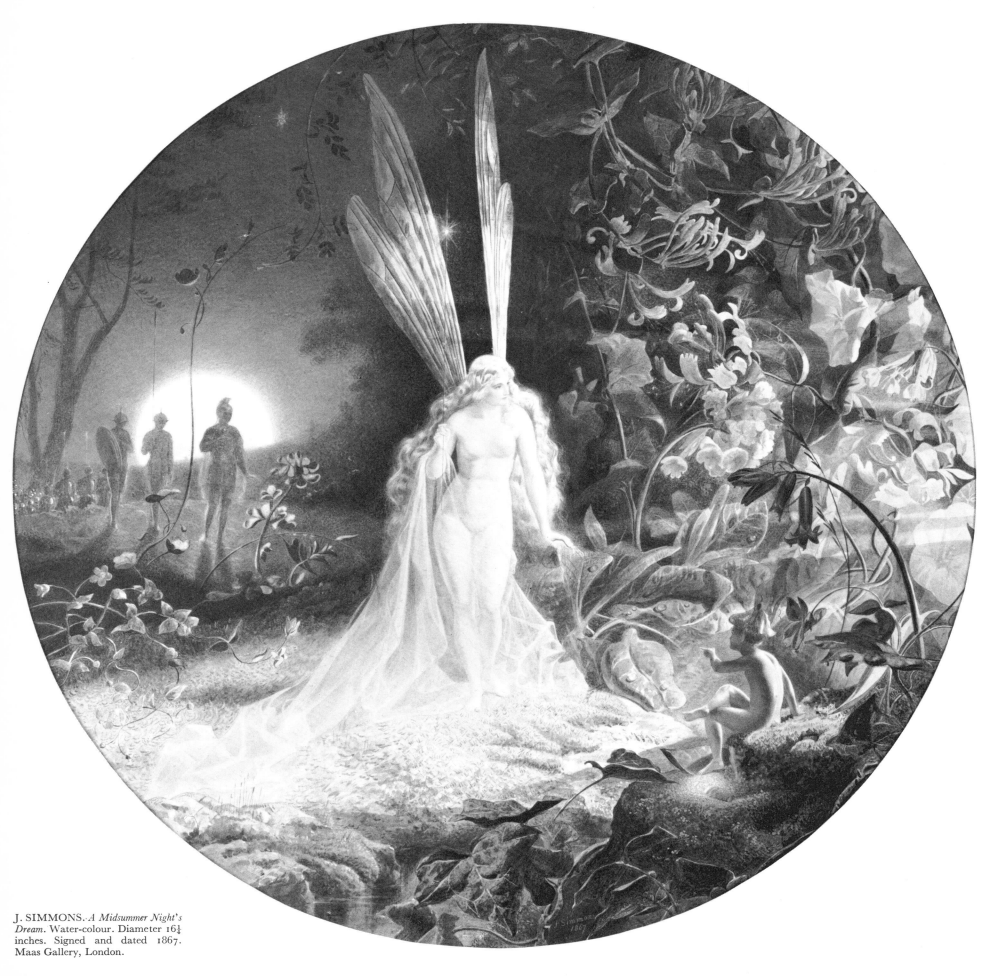

J. SIMMONS. *A Midsummer Night's Dream*. Water-colour. Diameter 16¼ inches. Signed and dated 1867. Maas Gallery, London.

XI

NUDE AND STILL-LIFE

Somehow nude painting managed to thrive in Victorian England, where legs, of human beings or of furniture, were called 'limbs' and always expected to be covered, where one carved not the white breast of a chicken but its bosom, when even Thackeray hesitated before mentioning an ankle, when no one ever went to bed, but 'retired to rest'. How nude painting survived at all might at first sight seem to be not so much a paradox as a miracle. The reasons for its survival through what Sir Kenneth Clark calls 'the great frost of Victorian prudery' appear to be threefold. Firstly, there was the prestige of classical art, which preserved the sanctity of the nude figure; this prestige was never higher than during William Etty's lifetime. Secondly, there was the continued existence of the life class: Etty had attended two, at the Royal Academy and St. Martin's Lane, and there were others at Sass's and Heatherley's Schools, in surprising contrast to the French Academy, which, lacking a female model until the time of Ingres, employed an old soldier to stand duty as both Apollo and Venus. A last, important factor was the increasing patronage of the rising class of merchant collectors, who were beginning to exert a powerful influence on Victorian painters.

Nude and still-life painting have never grown strong roots in England: the inheritors of Cromwellian Puritanism have always tended to prefer paintings that depicted events of everyday life, history and portraiture. Paint, they felt, should never be so vulgar as to draw attention to itself; it should merely be a vehicle for constructing symbols of the visible world. The painting of nudes and still-life tends to break this taboo, and to revel luxuriantly in luscious textural harmonies, which might be all right for the frivolous French or the materialistic Dutch, but not for plain John Bull. But this deeply entrenched attitude was offset by the burgeoning of State, Royal and private patronage. While State patronage was allowing an increasing number of the population to study the Old Masters, and Prince Albert was adding Italian primitives and Flemish fifteenth century paintings to the Royal Collection, the new merchants of the Industrial Midlands, uninhibited by the pruderies of the capital, found it cheaper and safer to buy the works of living painters whose subject matter, it seemed to them, differed not one jot from that of Titian, Rubens and the Dutch masters of still-life. Moreover they were developing into a new species of gentleman, and could afford to establish their own cultural standards.

Notable among these new patrons was John Sheepshanks, a merchant from Leeds, whose collection is now in the Victoria and Albert Museum. The patronage of men like Joseph Gillott, the first mass producer of pen-nibs, whose motto was 'the best of everything is good enough for me', enabled Etty to amass a sizeable fortune, worth £17,000 at his death.

Encouraged by the example of the Queen and the Prince Consort who bought directly from young painters, the new tycoons followed suit. Daniel Grant, the Manchester industrialist, with £250 cash in hand after a day at the Heaton Park Races, bought Etty's *Samson and Delilah*, having examined it, and *The Sirens*, without even having seen it! Others like Charles Meigh, a potter from Hanley, Charles Birch, a Birmingham colliery owner, George Knott, a city grocer, Sir Coutts Lindsay, a merchant banker and Isambard Kingdom Brunel (who bought only Shakespearian scenes) were representative of the new private patrons. Nor were the dealers far behind: in 1847 C. W. Wass paid Etty 2,500 guineas for his *Joan of Arc* triptych, but unfortunately lost on the deal. Two entrepreneurs, a Prussian Jew called Louis Victor Flatow and an amiable Belgian, Ernest Gambart, who introduced Alma-Tadema, were typical. Frith struck a bargain with Flatow in 1860, to paint *The Railway Station* for £4,500, after agreeing to place the dealer by the engine. Flatow showed the painting to 21,150 paying spectators, after which he is said to have sold it for £16,000 to Graves, the print dealer. In the same year, Gambart bought *Finding the Saviour in the Temple* from Holman Hunt for 5,500 guineas, and is then believed to have made £4,000 through exhibition fees, another £5,000 profit from the engraving, and finally to have sold the picture for £1,500. These and other nineteenth century dealers, like Sir William Agnew, made an important contribution to the formation of taste.

In such a climate painters like Etty (1787–1849) and William Frost (1810–1877) were able to flourish, in spite of the icy blasts of prudery. The critic of 'The Spectator' had called Etty's vast *The Sirens and Ulysses* 'a disgusting combination of voluptuousness and loathsome putridity—glowing in colour and wonderful in execution, but conceived in the worst possible taste'. Etty, who had visited London's mortuaries to gain first-hand knowledge before painting the decaying corpses of the Siren's victims, must surely have been grieved by this censure, since he claimed that his aim in all his pictures had been to reveal 'some great moral of the heart'. In spite of the seemingly abandoned relish with which he painted the female nude, he never allowed himself total self-abandonment, reaffirming his 'firm determination to resume my self-denying principles'. Prudery dogged the nude-painter at every step; arguments raged in journals and novels; J. C. Horsley earned himself the nickname 'Clothes Horsley' and Whistler's rebuke 'Horsley soit qui mal y pense' by his attack on nude painting in a paper read to the Church Congress of 1885. The attitude of Ruskin, who had never attended life-class and was almost certainly dismayed by the discovery on his wedding night that women had pubic hair, was predictable: he found Mulready's life studies 'most vulgar'

and 'abominable', and called this sensitive artist 'degraded and bestial'.

Although Etty always worked amongst the students in the life-class, models for the studio were always in great demand; Italians were preferred to English because they were considered more natural in posing. Etty was always on the look-out for promising models: he once sent a seventeen year old girl to Constable, having previously sent him a note pleading that 'she is very much like the Antigone *and all in front memorably fine*'. Many Italians settled in London and became professional models, including Burne-Jones's Antonia Cura. Gaetano Meo and Alessandro di Marco, 'a fine, upstanding slip of a boy' were very popular with painters. Walter Crane was obliged to use this 'slip of a boy' as a model for *The Renaissance of Venus*, as his wife refused to allow him to employ female models. This caused Leighton to cry out 'But my dear fellow, that is not Aphrodite—that's Alessandro!' Leighton's own favourite model was an English girl, Dorothy Dene, who was admired by Watts for 'splendid growth and form such as the ancient Greek never saw.'

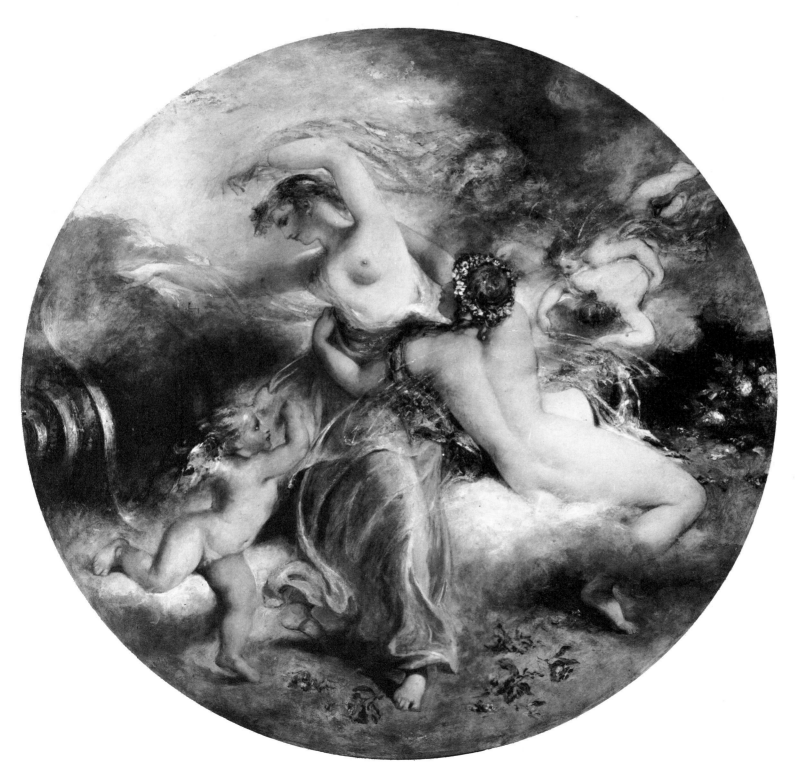

WILLIAM ETTY, R.A. *Aurora and Zephyr*. Panel. Diameter 36 inches. Lady Lever Art Gallery, Port Sunlight.

Exhibited at the Royal Academy in 1845. Reviewing the Academy in this year, Thackeray wrote of Etty: 'It must be confessed that some of these pictures would *not* be suitable to hang up everywhere – in a young ladies' school, for instance. But, how rich and superb is the colour!'

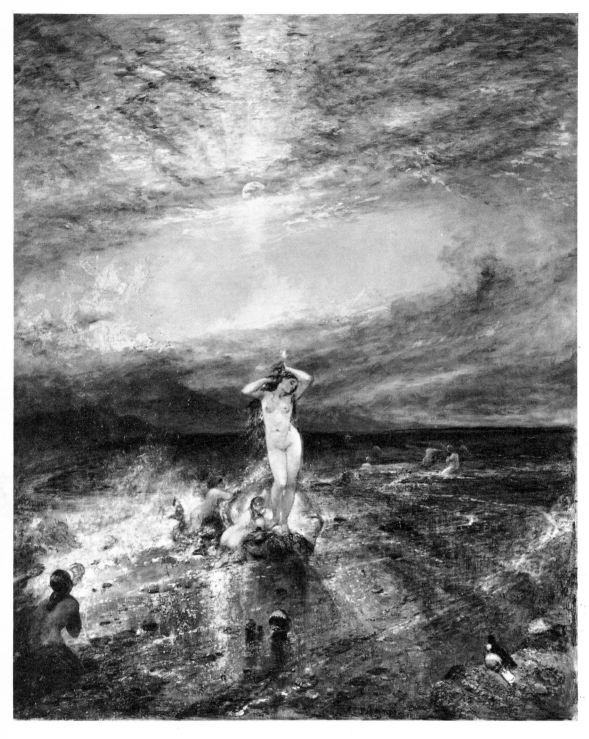

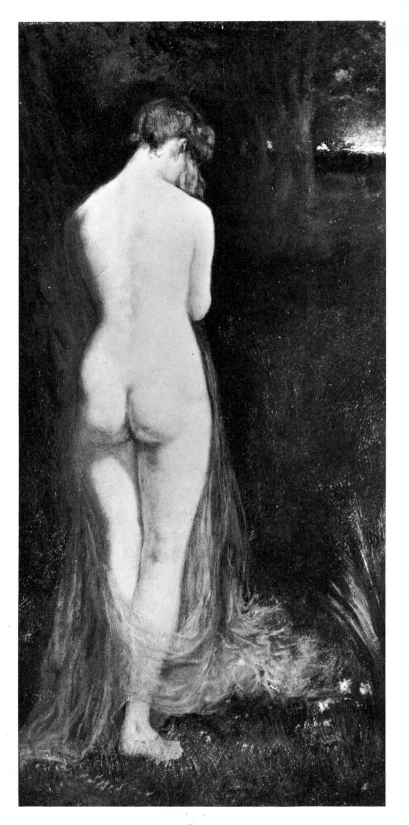

ALFRED JOSEPH WOOLMER.
The Birth of Venus. 44 × 34 inches.
Signed. Maas Gallery, London.

Eurydice by William Etty is reproduced in colour on p. 160

Right:
JOHN AUSTEN FITZGERALD.
Female Nude. 18 × 9 inches. Guildhall Art Gallery, London.
The influence of Etty is clearly evident.

William Etty was the first and only English painter before the present century for whom nude painting was essential to his artistic creation. Indeed his interest became obsessional: nudes were to him, in Browning's words, 'Mistresses with great smooth marbly limbs'. Perhaps only Matthew Smith, a fellow Yorkshireman, in his choice of subject and rich glowing palette, is his true successor in our own century. Etty was born in York, the seventh son of a miller and gingerbread maker. In 1807 he came to London and became a student at the Royal Academy, where he continued to work for the greater part of his life. For a year he worked in Lawrence's studio, and began exhibiting at

the Royal Academy in 1811, startling the public by the literalness with which he painted his sensuous and full-blooded women. In 1816 and 1822 he visited Italy. In Venice he discovered 'the power of colour and chiaroscuro'. From then on, impressed by the Venetian masters, particularly Titian (Thackeray doubted whether 'Titian ever knew how to paint flesh better'), his palette acquired a vibrant richness of colouring

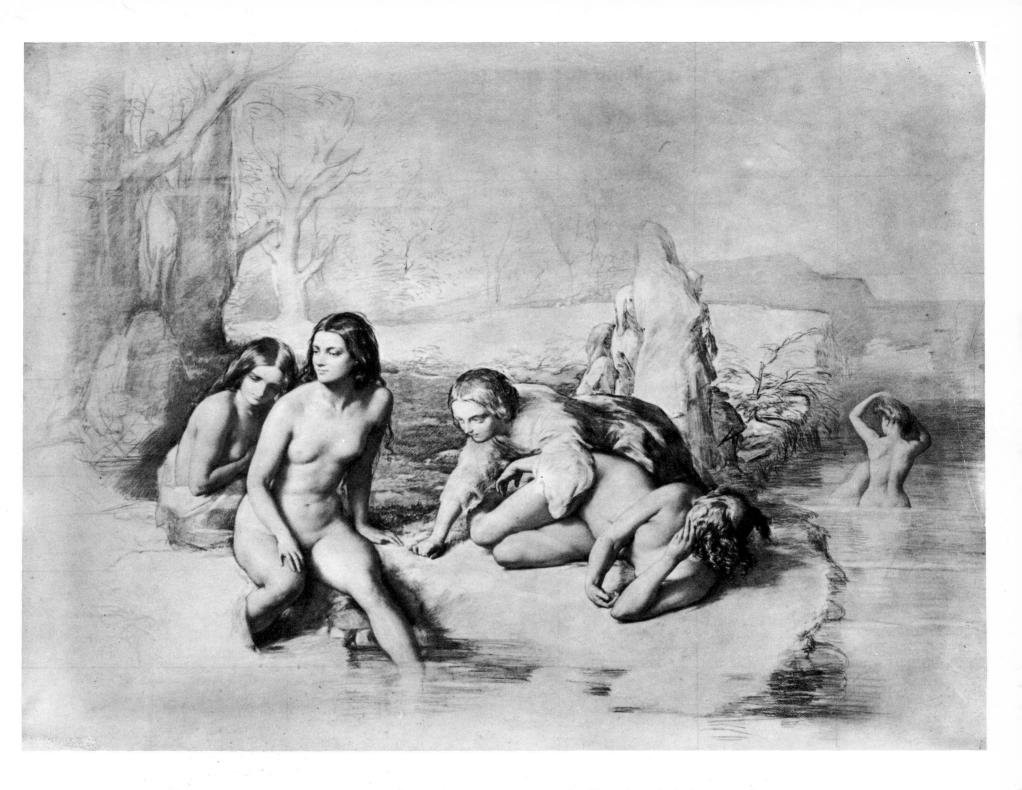

rarely equalled in nineteenth century English painting. Thackeray praised him for painting 'in the grandest and broadest style . . . Look for a while at Mr Etty's pictures, and away you rush, your "eyes on fire", drunken with the luscious colours that are poured out for you on the liberal canvas, and warm with the sight of the beautiful sirens that appear on it.' Etty was elected a Royal Academician in 1828. He returned to York in 1848, a famous man, to die there a year later. His funeral was attended by large numbers of civic dignitaries, citizens, relatives and friends. Etty was a powerful and original artist, but he cannot be placed

in the very front rank. In spite of their naturalness, many of his figures are marred by careless anatomical drawing, and he never finally succeeded in making convincing finished pictures from his sketches; to balance these defects he has a richness and vigour in his colouring which often invites comparison with Delacroix.

Etty's influence was pervasive. Among those who fell under his spell were Edward Calvert and John Phillip. Even Orchardson's early work contains echoes of Etty. Millais, in his student days, was a keen follower of Etty, and was to reaffirm in later years his admir-

WILLIAM MULREADY, R.A. *Bathers*. Black and red chalks. 43 × 55 inches. National Gallery of Scotland, Edinburgh. Drawn about 1849.

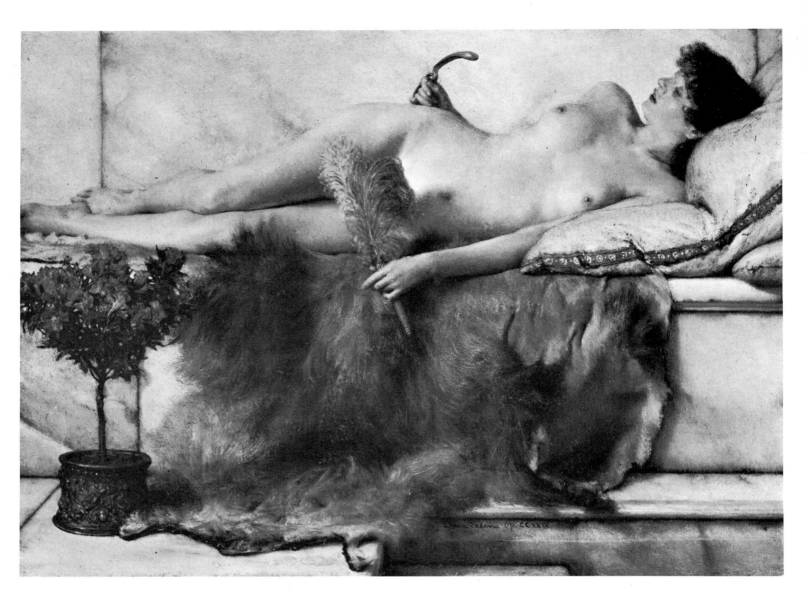

ation for him. G. F. Watts, although more of the
gloomy moralist, and no less pious than Etty, owed
the older artist a profound debt which affected his work
all his life. William Frost was an early protégé. His
work is largely a pallid reflection of Etty's style; but at
its best it bears a distinctive charm, with its pearly-
tinted Victorian nudes. Alfred Woolmer (1805–1892)
translated Etty's subject-matter into Watteauesque
settings.

William Mulready took up nude painting rather
late in life. His *Women Bathing* was exhibited at the
Royal Academy in 1849; in the same year he painted
The Bathers. His biographer F. G. Stephens regretted
that 'he wilfully reduced the extremities of the nudities
till they were out of proportion to the rest of the
figures'. Stephens also applied these strictures to the
so-called 'Academy Studies', which Mulready began
drawing in 1840, at the suggestion of his son, Michael.
They are, nevertheless, perfect models of academic
drawing, generally superior to those of Alfred Elmore.

In academic drawing, pride of place is surely held
by Alfred Stevens (1817–1875), the sculptor and

decorative artist. He was born in Blandford, the son of
a carpenter, decorator and sign painter, and kindly
friends arranged for him to study in Italy. Often near
starvation he copied frescoes in Florence and the works
of Andrea del Sarto in Naples, and sketched at
Pompeii, paying his way by selling his drawings. In
Rome he studied under Thorwaldsen. When he
returned he was fully confident of his very considerable
powers in painting, drawing, carving, sculpture and
design. Stevens's life was spoilt by bad luck and lack of
real recognition; bureaucratic controversy condemned
him during his last eighteen years to spasmodic work
on the Wellington monument. The sheets of figure
studies from which he worked are remarkable for their
extraordinary vigour and assurance; not until the
early drawings of Augustus John (1878–1961) do we
find such clear, incisive, yet fluent line; moreover, the
female nudes in his less academic studies project over-
tones of healthy sexuality, which anticipate those of
the younger artist.

From the 'sixties until the age of Beardsley, Conder,
early Steer and Sickert, nude painting was mainly

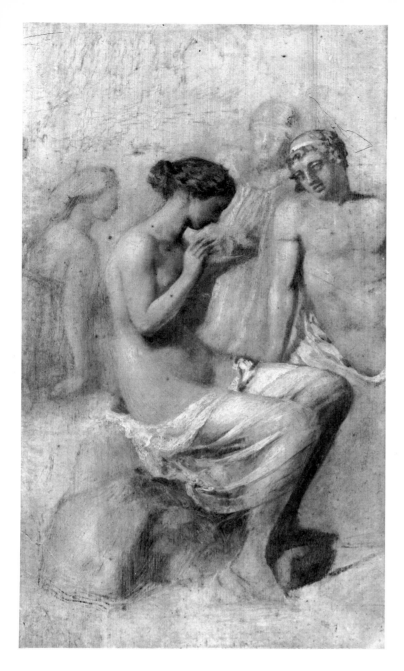

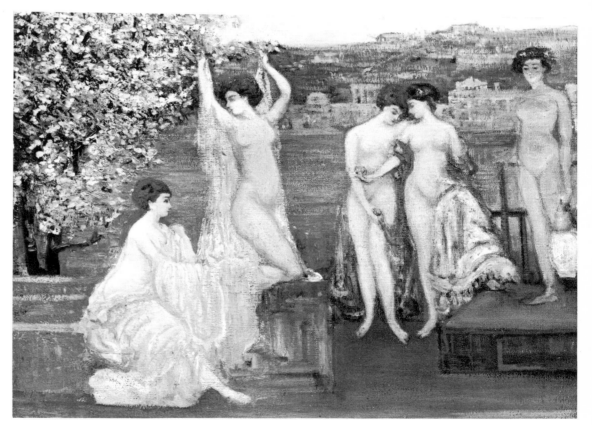

confined to Burne-Jones and his disciples; and the neo-classical painters were able to paint nudes freely by placing them in varying degrees of deshabille in the *tepidarium*, *frigidarium* or *apodyterium*. Many of the most illustrious painters, like Millais and Frith, completely ignored the nude, except in their student days. And with nudes painted by Burne-Jones and Albert Moore, one is often scarcely aware that the figures are nude at all, so completely are they subordinated to the central idea of design on the rarefied plane of High Art. Steer's nudes suffer by usually being compounded of Watteau, Rubens or Boucher, although he was capable of fine work; no less derivative, Conder's nudes are beautiful generalities basking in a silken twilight, with a kind of insubstantial eroticism. It was left to Aubrey Beardsley to be the first to elevate the nude to its most erotic level, particularly in the *Lysistrata* series, but so exquisite is the style, so refined the technique, that

Above right:
PHILIP WILSON STEER. *The Toilet of Venus.* 34×44 inches. Williamson Art Gallery and

Museum, Birkenhead.
This study was painted in about 1898. The finished picture is at the Tate Gallery.

Below right:
CHARLES CONDER. *The Bathers.* 28×36 inches. Mr Robert T. Hamlin, Jr.

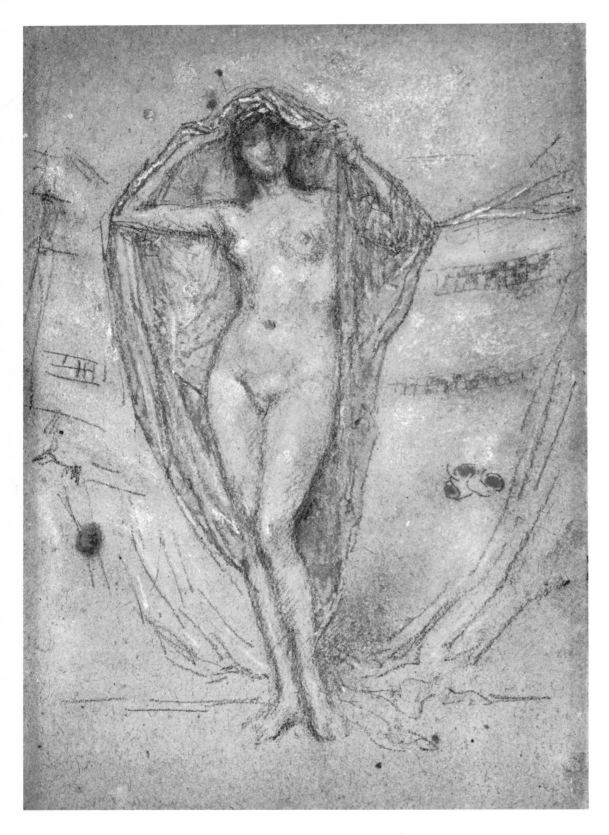

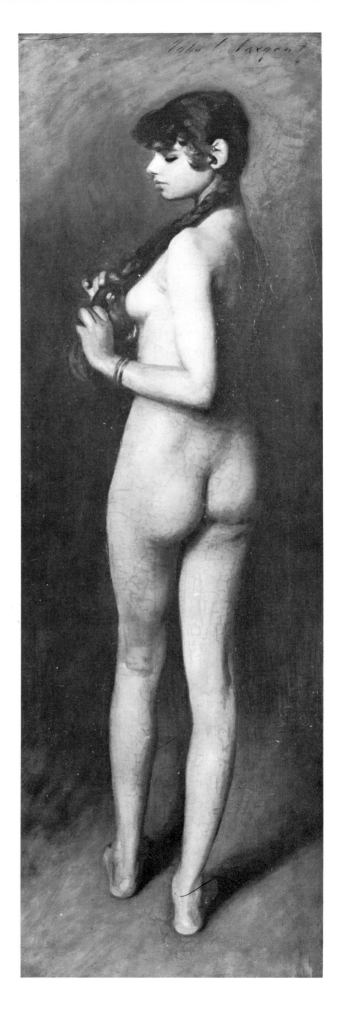

JAMES McNEILL WHISTLER. *Venus Astarte*. Chalk and pastel. $10\frac{3}{16} \times 7\frac{1}{4}$ inches. Signed with butterfly device. Freer Gallery of Art, Washington.

Drawn in the late 'nineties.

his nudes cause less offence than some of the embarrassingly naked goddesses that adorned the walls of the Royal Academy exhibitions of the time. It seems a pity that Whistler should not have painted more nudes: in the late 'nineties he painted and drew a number, which, had he attempted to do so earlier, might have rivalled those of Degas; and in *Venus Astarte*, the essence of classical beauty is achieved.

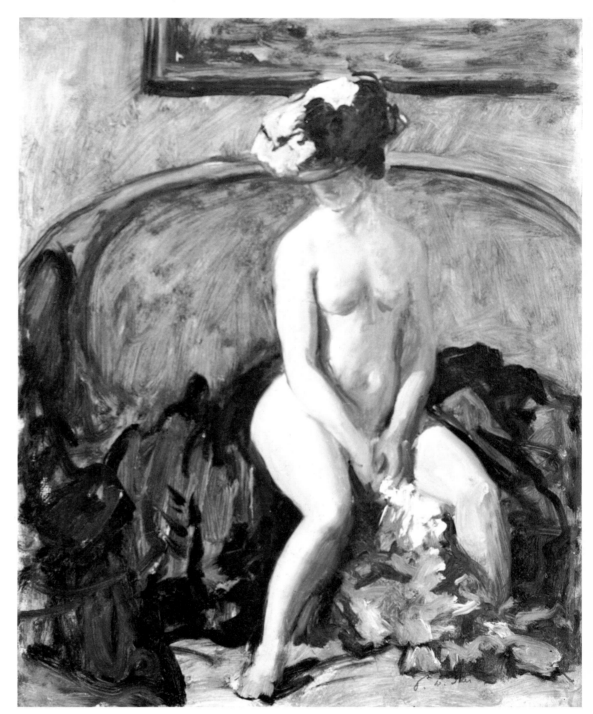

John Singer Sargent (1856–1925) rarely attempted naturalistic nude painting in his early years, but his fondness for dusky exotic beauty resulted in at least one suave essay in sophistication, *The Egyptian Girl*. With the lovely nudes of Ethel Walker (1861–1951), the bathing men and boys of H. S. Tuke, the 'back-bedroom' subjects of Sickert and the lively studies of Augustus John, nude painting was continued into the twentieth century.

The interest in still-life painting grew in response to the increasing materialism of the wealthy middle classes, and, of course, to the pleas of Ruskin for painters to pursue the earnest study of nature. With the exception of **William Etty**, William Henry Hunt (1790–1864) and others of the 'bird's-nest' school, still-life painting was dominated by the East Anglians. Etty strayed into the territory of still-life very late—in September 1839, to be exact—at a time when it might have been supposed that he had no surprises left to spring. Although still-lifes comprise a small fraction of his work, and are inevitably in the Dutch tradition, the painting is spirited and accurate. The very few still-life paintings done by William Müller suggest the

example of Van Huysum. Peter De Wint, as one might expect, considering his Dutch ancestry, painted some of the finest still-lifes in water-colour by any artist of the English School. For a painter whose landscapes are characterized by broad effects, his ability to evoke tactile values is remarkable.

William Henry Hunt, the son of a tin-plate worker, was once the pupil of John Varley, as were Copley Fielding, Linnell and Mulready. He and Linnell formed a close friendship, and between 1805 and 1809 they occupied themselves with sketching tours on the River Thames, as Thomas Girtin and Turner had done before them. By 1807 he was exhibiting at the Royal

PHILIP WILSON STEER. *Seated Nude: The Black Hat.* 20 × 16 inches. Signed. Tate Gallery, London.
Painted in about 1900.

Left:
ALFRED STEVENS. *Girl with a Topknot.* Red crayon and pencil. $14\frac{7}{8} \times 10\frac{7}{8}$ inches. Walker Art Gallery, Liverpool.

Opposite page, right:
JOHN SINGER SARGENT, R.A. *Egyptian Girl.* 73 × 23 inches. Signed. Roger McCormick.
Painted in Egypt in 1891.

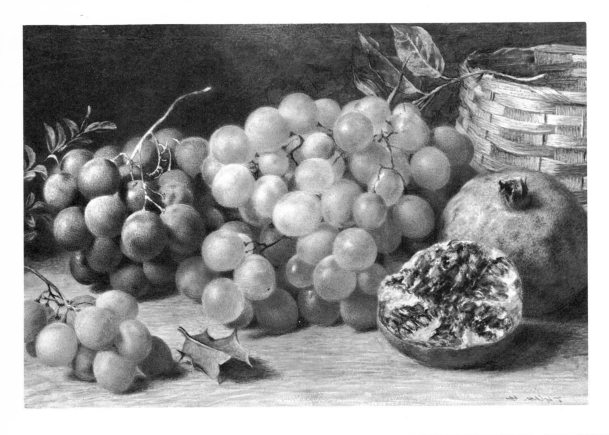

Academy, and, after a period with Dr Monro, he was patronized by the Earl of Essex. By the 'twenties Hunt was already proficient at painting lovely figure subjects and still-life pictures, becoming famous for his

WILLIAM HENRY HUNT *Grapes and Pomegranates.* Water-colour. $7\frac{1}{2} \times 11$ inches. Signed. Mr and Mrs Cyril Fry.

Above right:
WILLIAM CRUIKSHANK. *Still Life with Bird, Bird's Nest and Blossom.* Water-colour and body-colour. Oval. 7×9 inches. Signed. Fine Art Society, Ltd., London.

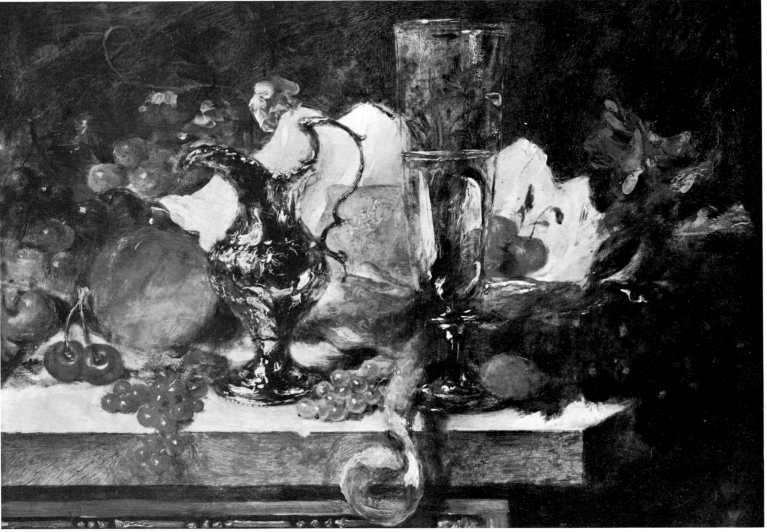

WILLIAM ETTY, R.A. *Still Life with Glass.* Panel. $12\frac{1}{2} \times 16\frac{1}{4}$ inches. Henry E. Huntington Library and Art Gallery, U.S.A.
Exhibited at the Royal Scottish Academy in 1843, where it was entitled *A Study of Fruit.*

PETER DE WINT. *Still Life*.
Water-colour. 7 × 9 inches. J. L. F.
Wright, Esq.

bird's-nest subjects. These earned him the soubriquet 'Bird's-nest' Hunt. Painted in rich water-colour and delicately stippled, these studies, of which nearly eight hundred were shown over the years at the Society of Painters in Water-Colours, became greatly loved by Victorians. 'If I were the Duke of Devonshire,' Thackeray sighed, 'I would have a couple of Hunts in every room in all my houses.' Ruskin commended him for having 'defied all false teaching', hung one in his bedroom at Brantwood, and compared him to 'the best Dutch Masters'. Hunt fathered a large litter of imitators, who at their best came close to rivalling him. These included William Cruikshank, who exhibited at the Royal Academy, William Hough (exhib. 1857–

1894), John Sherrin (1819–1896), and two brothers, George and Oliver Clare. A painting family called Coleman specialized in still-life and flower subjects: of these, the best was Helen Cordelia (1847–1884) who achieved real distinction in her studies of nature. William Hughes (1842–1901), who usually worked in oils, had an accurate eye for detail. These closely detailed studies of nature by Hunt and his followers provided the backcloth for fairy paintings.

Partly due, no doubt, to their traditional affinities with Holland, the most vigorous school of flower and still-life painters was of East Anglian origin. Norwich was the birth-place of two famous botanists, Sir Edward Smith, the founder of the Linnean Society in

EDWARD LADELL. *Still Life*.
17 × 14 inches. R. Clement Wilson,
Esq.

Right:
WILLIAM JAMES MÜLLER.
Still-life. 30 × 25 inches. Fine Art
Society Ltd., London.

Fruit-piece by Eloise Harriet Stannard is reproduced in colour on p. 160.

1788, and Sir William Hooker, one of the great directors of Kew Gardens. Of considerable merit and relatively cheap to buy, the works of the East Anglian painters found favour with the new collecting class. Amongst the school were several women of more than merely professional competence. Mrs Joseph Stannard (1803–1885), well known as Emily Coppin, had studied and copied Van Huysum in Holland; she and her daughter, Emily Stannard, were painters of some merit. Eloise Harriet Stannard (1829–1915), the daughter of Alfred Stannard (1806–1889) himself a landscape and marine painter, painted a large number of particularly luscious flower and still-life paintings: her ability to render the bloom of a plum or the trans-

lucency of a white currant is well conveyed in her circular painting of fruit. A comparable artist was Edward Ladell, a native of Colchester, who exhibited regularly at the Royal Academy between 1856 and 1885. George Lance (1802–1864), a pupil of Haydon, narrowly escaped the trap of historical painting by being discovered by Sir George Beaumont, who bought a still-life which he had painted to improve his technique. Other commissions followed, and soon he was painting still-life almost exclusively, with a sensitive feeling for texture and a rich, although occasionally rather too sharp, palette. His pupil William Duffield (1816–1863) was less lucky than his master: on the threshold of a promising career as a still-life painter, he frequently added dead game to the composition, and 'owed his last illness,' according to the Redgraves, 'to the earnest pursuit of his profession. He was painting a dead stag, which remained in his studio for that purpose until it became extremely decayed. Unfortunately the painter, from a prior illness, had lost his sense of smell' and in 'the presence of miasma, he continued to work unconscious of the danger, until the infection took place which caused his death.' Even still-life painting has its hazards. During the last years of the Victorian age, still-life painting found fewer practitioners: there were occasional exceptions, like Hercules Brabazon Brabazon (1821–1906), who was well able to paint an occasional brilliant flower-piece or still-life.

XII

NEO-CLASSICAL
PAINTERS

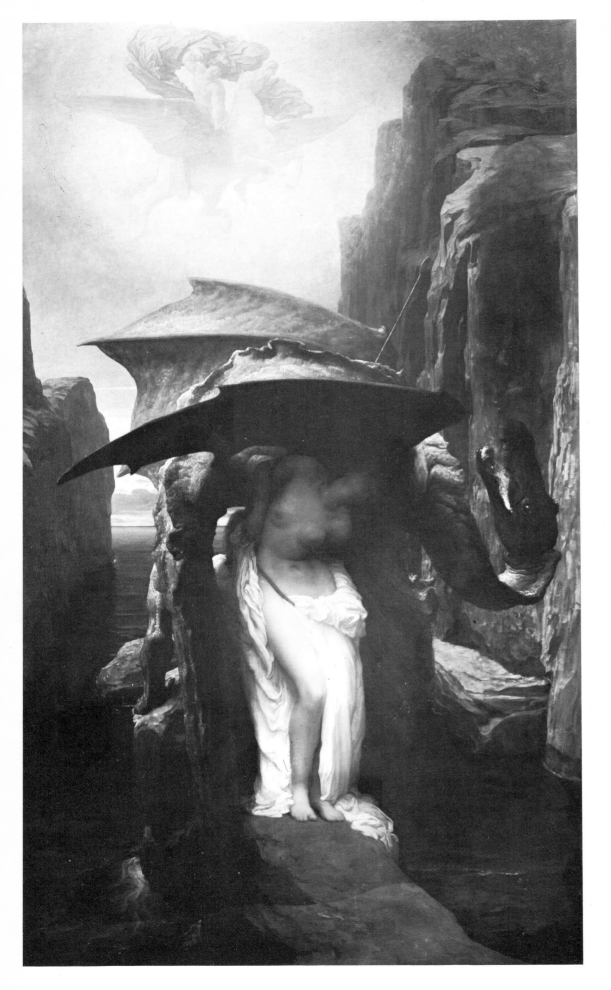

In the second half of the nineteenth century, England had an opulent, powerful and expanding society, with ever-increasing responsibilities. Whatever religious doubts assailed intellectuals, the average middle and upper class Victorians had an unflinching faith in their country's destiny: they believed they were ruled by great statesmen, motivated by high and just ideals; they were secure in the thought that the most powerful navy in the world kept the *Pax Britannica*, and protected the trade-routes of the largest Empire the world had ever known. Its European neighbours may have

LORD LEIGHTON OF STRETTON, P.R.A. *Perseus and Andromeda*. 91 × 50 inches. Walker Art Gallery, Liverpool.

Exhibited at the Royal Academy in 1891. Leighton made figurines of Perseus mounted on Pegasus and of Andromeda. F. G. Stephens wrote of this picture: '*Perseus and Andromeda* . . . has always seemed to me not only the aptest and best sustained version of the legend which art has given us [but] incomparably the most poetical, strong, and refined illustration of the subject from a dramatic point of view'.

been prone to political convulsions, but England was complacent in its well-ordered social system, and civic pride reflected the fundamental stability of Church and State. Even the propagation of liberal ideas was tolerated in a society so soundly constituted. The doctrine propounded by John Stuart Mill, of rebellion against the supine acceptance of conventional opinions, and the collision of Darwinism with religious belief, could be openly discussed only in a society certain of its own strength. This was a public more than ready to accept a kind of painting which mirrored its affluence, sturdiness and sense of justice, its power and its aspirations. And what better reflected its sublime self-assurance than the passion for the ancient civilizations of Greece and Rome?

Classical antiquity enjoyed great prestige. It had, of course, provided many of the themes of painting since the Renaissance; Flaxman's illustrations to

LORD LEIGHTON OF STRETTON, P.R.A. *Cimabue's celebrated Madonna is carried in Procession through the Streets of Florence* . . . 87¾ × 205 inches. Signed with monogram. Her Majesty the Queen.

Exhibited at the Royal Academy in 1855, when it was bought by Queen Victoria for £600. The title continues . . . *in front of the Madonna, and crowned with laurels, walks*

Cimabue himself, with his pupil Giotto; behind it, Arnolfo di Lapo, Gaddo Gaddi, Andrea Tafi, Nicola Pisano, Buffalmacco and Simone Memmi; in the corner, Dante. The picture was begun in the Spring of 1853 and completed in early 1855, in Rome. The design was made with the encouragement and advice of Steinle, and the picture was altered, when almost complete, at the

suggestion of Cornelius. Originally the procession moved straight from right to left; Leighton made it turn and face the spectator. The picture depicts the public glorification of art in early Florence, and reflects Leighton's own artistic idealism. The *Madonna* in Leighton's picture is now generally ascribed to Duccio.

Homer had had a European impact; the Elgin marbles, there for all to see, had been a constant stimulus; Haydon had seen in them 'principles which the common sense of English people would understand'. Antonio Canova, the great exponent of neoclassicism, had praised them highly. Indeed the principles of neo-classicism had been upheld successively by the sculptors Canova, Bertel Thorwaldsen and John Gibson until the death of Gibson in 1866. From mid-

century onwards its appeal was greatly enhanced by
archaeological discovery. 'The Last Days of Pompeii'
by Lord Lytton, published in 1834, soon became a
widely-read classic. The first fully systematic excava-
tions of Pompeii and Herculanaeum were carried out
in 1861 by the Italian government immediately after
the *Risorgimento*. The discovery of a civilization of
A.D. 79, buried since then under a thirty-foot layer of
volcanic ash, was swiftly made available to a fascin-
ated public. 'What a display it is!' said Leighton, 'here
we are admitted into the most intimate privacy of a
multitude of Pompeian houses—the kitchens, the
pantries, the cellars of the contemporaries of the
Plinies have here no secret for us.' It soon became
apparent that Pompeian society was not all that dif-
ferent from Victorian society: there were indications
of a proletarian system on the move, of wealth based
on trade. All this was noted by another painter,
Lawrence Alma-Tadema (1836–1912), a Dutchman
who had settled in London in 1870.

The classical revival in painting had, however, taken
root earlier in England. By the nature of its subject
matter it was specially attractive to the academic
mentality. As a branch of High Art, it was not far
removed from historical painting: it was concerned
with lofty idealism and its themes were a subject of
scholarship. Although they were staunch upholders of
the traditions of the Royal Academy, it would be diffi-
cult to imagine Millais or Frith painting *Helen walking
on the Ramparts of Troy* or *Hercules wrestling with Death
for the Body of Alcestis*. Such themes required a wide
range of classical learning, an alert eye for new archae-
ological discovery and a painting technique to match
the subject.

These conditions were amply fulfilled by Frederic
Leighton (1830–1896). Leighton was born at Scar-
borough in Yorkshire. His father was an enlightened
doctor, something of the *homo universalis* which his son
was later to become. Leighton was encouraged by him
to acquire a thorough grounding in the Greek and
Latin classics. By the age of ten he was fully con-
versant with classical legend; by twelve he was fluent
in French and Italian, and a year or two later, in
German. Before he was twenty, he was widely travelled
in Europe, and deeply responsive to beauty in art,
architecture and music. At an early age he had shown
a strong inclination to become a painter. In the
enlightened and affluent style natural to his family he
was rushed through an intensive period of instruction
from the best continental teachers and academies.
After a short spell with the Roman drawing master,
Francesco Meli, he was admitted to the Florentine
Academy, where he studied under Bezzuoli and
Servolini, considered by the Italians as the Michel-
angelo and Raphael of their day. Leighton by no
means agreed with this evaluation. The quest for a

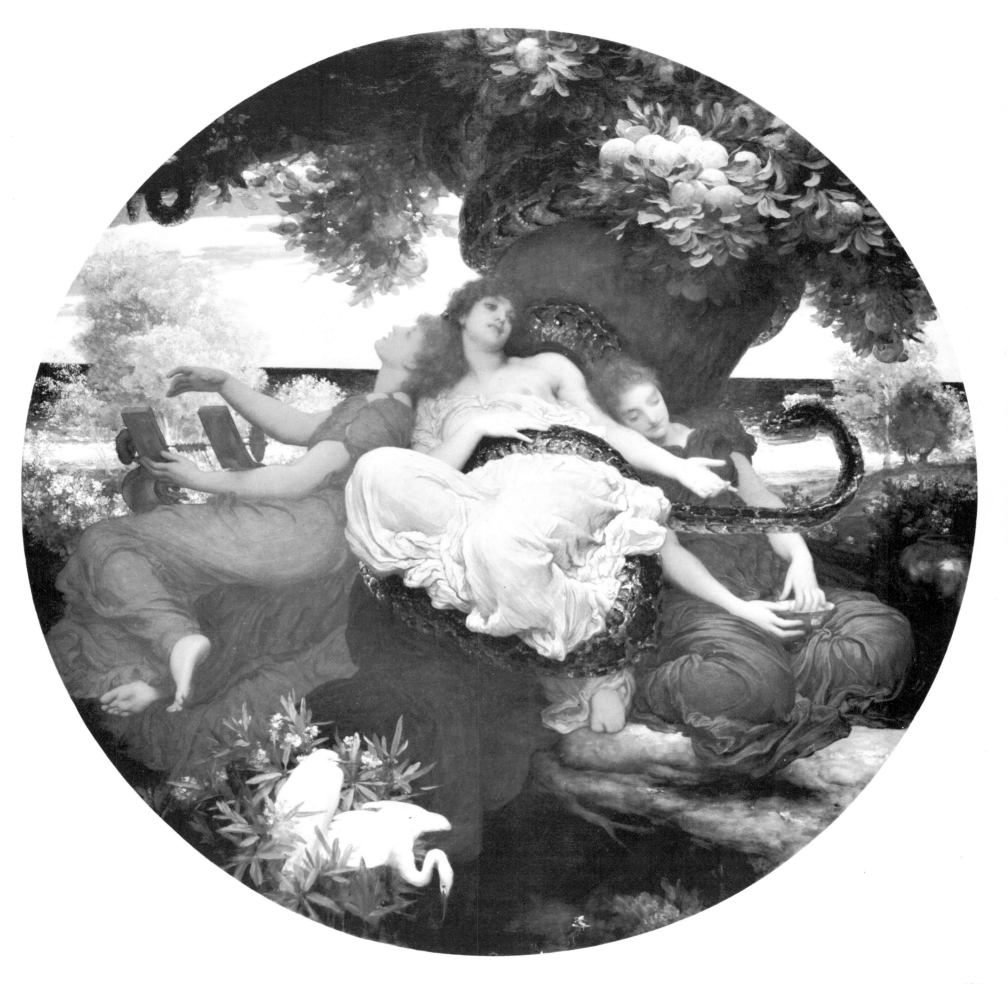

LORD LEIGHTON OF STRET-
TON, P.R.A. *Hercules Wrestling with
Death for the Body of Alcestis.* 52 × 104
inches. Charles Jerdein, Esq.
Exhibited at the Royal Academy
in 1871. Studies for this picture are
at Leighton House. Robert Brown-
ing paid a tribute to the picture and
its painter in 'Balaustion's Adven-
ture', published in the same year.

teacher who could match the exalted tenor of his mind
brought him finally to the last of the Nazarenes, and
the most uncompromisingly earnest of them all,
Edward Jacob von Steinle. On these foundations was
raised the great Olympian.

Leighton was handsome, sociable, fluent in many
languages, and possessed of a certain grandeur of
manner, which seemed already to mark him as one
predestined for high office. Thackeray, who met
Leighton in Rome, remarked to Millais when he
returned to London that he had met 'a versatile young
dog called Leighton, who will one of these days run
you hard' for the presidency of the Royal Academy.
Leighton's formative years were to have a profound
influence on English academic attitudes in the second
half of the century. A meeting with the neo-classical
sculptor, John Gibson, in Rome, the Germanic train-
ing of his intellect, and his spontaneous emotional
response to Italian art were all contributory to the
manner of his maturity. All that was needed now was
a large scale work to send to the Royal Academy: he
selected a subject, and accordingly began work on a
picture which he entitled *Cimabue's celebrated Madonna
is carried in Procession through the Streets of Florence.* It was
while he was engaged on this colossal picture that
there occurred one of those confrontations which con-
stantly lent impetus to movements in Victorian

painting. Edward John Poynter (1836–1919) was in
Leighton's studio when the artist made a drastic
alteration to *Cimabue*, on the suggestion of Peter
Cornelius. Poynter promptly decided to paint grand
subjects with elevated themes and it was he who, with
Alma-Tadema, carried the style into the twentieth
century.

The exhibition of the picture in 1855, in the same
year as Millais's *The Rescue*, which was voted picture of
the year, was another of those decisive events which
marked the progress of English painting. It caused a
sensation. To William Blake Richmond (1842–1921),
then aged thirteen, 'it stood out among the other
pictures to my young eye as a work so complete, so
noble in design, so serious in sentiment and of such
achievement, that perforce it took me by the throat'.
Ruskin considered it 'a very important and very beau-
tiful picture', but, crucially, and to Leighton's dismay,
he nevertheless thought Millais's picture was 'greater'
than *Cimabue*, because, as Leighton wrote to his mother,
'the joy of a mother over her rescued children is a
higher order of emotion than any expressed in my
picture'. *Cimabue* was, in fact, an early forerunner of
the cult of Aestheticism, of art for art's sake, of the
absence of moral content. Moreover, it was seized
upon by academic circles as the ideal counterweight
to Pre-Raphaelite heresies. As Rossetti wrote to

William Allingham in 1855, 'the R.A.s have been gasping for years for someone to back against Hunt and Millais, and here they have him'. Better still, Leighton 'was wholly opposed to their views'. But best of all, the picture was bought by the Queen, on the advice of Prince Albert.

The future of Leighton, now aged twenty-five, was assured. From now on a sense of predestination loomed over him. For the next decade he painted, still in the grip of German influence, scenes from mediaeval legend and the Bible. Shortly after the triumphant exhibition of *Cimabue*, Leighton went to Paris, where he met Poynter again. Poynter had shared rooms for a short time with Whistler, but was now one of the 'Paris Gang', with Thomas Armstrong (1832–1911), Thomas Lamont (d. 1898) and George Du Maurier (1834–1896). Their hearty bohemianism was later recorded in Du Maurier's 'Trilby'. For three years Poynter studied in the *atelier* of Charles Gleyre, a rather feeble apostle of neo-classicism, worn out by diseases contracted in the tropics.

By now, Leighton's allegiance to Teutonism was weakening, and the spirit of Hellenism began to pervade his work. It is this for which he is now best remembered. He had turned to the 'Greek race in the day of its greatest achievements and the most perfect balance of its transcendent gifts'. In his Presidential address of 1888, he gave his reasons for what impressed him most in Hellenic idealism: 'it is, first, that the stirring aesthetic instinct, the impulse towards an absolute need of beauty, was universal with it, and lay, a living force, at the root of its emotional being; and secondly, that the Greeks were conscious of this impulse as a just source of pride and a sign of their supremacy among the nations.' From the mid-sixties until his death in 1896, he painted a series of great neo-classical pictures, like *Venus disrobing for the Bath, Hercules wrestling with Death, The Daphnephoria, Perseus & Andromeda, The Garden of the Hesperides* and *Flaming June*, all fitting subjects for a country conscious of its 'supremacy among the nations'.

Leighton's method of painting was first to make a monochrome sketch of the subject, then a complete nude study of the whole composition, followed by individual nude studies, and finally, before attempting the finished picture, draped figure studies. Occasionally he would make small statuettes of individual figures, and it was this ability to conceive his compositions in the round, this 'perception of comeliness in the human body' which distinguishes the best of his work. Certainly he had better taste in women than either Poynter or Alma-Tadema: his models, whether from North Kensington or Naples, were endowed with classical grace. Moreover, the feeling for sculptural qualities resulted in an immediate acceptance of the sculpture to which he turned later in life. A frequent charge against Leighton is that his pictures lacked passion, but he was in complete accord with the spirit of classicism when he maintained that the artist should observe a sense of responsibility in relation to his emotional force, and the stronger this was the more he should attempt to elevate rather than deprave. A painting like *Flaming June* is a luscious yet unlascivious essay in voluptuousness, redolent of slumbering warmth, while *Perseus and Andromeda* is a restrained yet powerful study in frailty and menace. It is in pictures like these and *The Music Lesson* that one senses passion, and sees how it is kept in check by Leighton's coolly academic approach.

With his commanding presence, enthusiasm and kindliness he enjoyed his full meed of honours, becoming successively a knight, a baronet and a baron. He was elected President of the Royal Academy, which post he was considered to have held with much distinction for the last eighteen years of his life. He was succeeded, for a few months, by Millais.

Alma-Tadema, by contrast, was more earth-bound. A native of Holland, he had first painted Merovingian subjects like *The Death of Galswinthe* and *Clothilde Weeping over the Tomb of her Grandchildren*, after a period

Flaming June by Leighton is reproduced in colour on p. 185.

LORD LEIGHTON OF STRETTON, P.R.A. *The Music Lesson.* 36½ × 37½ inches. Guildhall Art Gallery, London.
Exhibited at the Royal Academy in 1877. The model for the girl receiving the music lesson was Connie Gilchrist (1865-1946), who appeared at the Gaiety Theatre as a skipping-rope dancer and later married the Earl of Orkney. Whistler painted her at about this time in *Harmony in Yellow and Gold: The Gold Girl, Connie Gilchrist*. She also modelled for Frank Holl and other artists.

of tuition from the august Baron Wappers, who had also taught Madox Brown; he later studied under De Keyser and Baron Leys. While honeymooning in Italy, Alma-Tadema had been an early visitor to the site of Pompeii and the ancient ruins in Rome. He was at once inspired to paint scenes of classical antiquity, confining himself to social and military history and not, like Leighton, to the rarefied world of classic mythology. It was Alma-Tadema's intention to attempt, in the light of available knowledge, to reconstruct a view of the antique world, in which the aspiring middle classes could see themselves reflected. To this task he brought the technical resources which had distinguished Dutch painting in the past. He had become a naturalized Englishman in 1873, and converted Tissot's recently vacated house in St. John's Wood into an amazing pseudo-Pompeian palace, paralleling Leighton's exotic house in Kensington.

He frankly aimed the four hundred or so pictures he painted at the *nouveaux riches*, both English and American, for they were 'the best picture-buyers of today.' In fact, the majority of his pictures went to America. While Leighton was Olympian, Alma-Tadema was *bourgeois*: he transplanted the homely realism of the genre painters to the marbled living room and *apodyterium*, with a technique calculated to stun the beholder. He excelled at painting marble: indeed, he was the first of the new species of 'marble painters', whose technical skill for a while attracted Poynter. Many of his highly detailed reconstructions of the past, in spite of an apparent fidelity to archaeological detail, signally fail to convince. Somehow the velvet plush, ornate furniture, and resplendent costume belong more to the world of 'The Forsyte Saga', but without the drama. Only in pictures like *The Roses of Heliogabalus* and *A Coign of Vantage* does Alma-Tadema do more than pull off an effect. In the latter picture he conveys a marvellous sense of height and warm sunlight. He became a staunch Royal Academician (Alma-Tad—of the Royal Acad—Of the Royal Acadamee), was knighted in 1899, and received the Order of Merit in 1907.

Alma-Tadema died within three years of the first great Hollywood classical epic 'Intolerance'. It seems reasonable to suppose that his neo-classical compositions, and pictures like Poynter's colossal *The Visit of the Queen of Sheba to King Solomon*, which was engraved, and *Israel in Egypt*, exerted an influence over the super film spectacles. The pictorial reconstruction of ancient civilizations, the manipulation of crowd scenes, the illusion of depth and space, all foreshadow cinematic productions like 'Intolerance', and the various versions of 'Ben Hur', and 'Quo Vadis'. Alma-Tadema had demonstrated his ability to construct successful stage designs in the productions of Beerbohm Tree's 'Hypatia' at the Haymarket and 'Julius Caesar' at

A Coign of Vantage by Alma-Tadema is reproduced in colour on p. 203.

Israel in Egypt by Edward Poynter is reproduced in colour on p. 186.

SIR LAWRENCE ALMA-TADEMA, O.M., R.A. *Expectations*. Panel. 8½ × 18 inches. Signed with Opus no. CCLXVI. Mr Allen Funt.

Exhibited at the Paris Exhibition in 1889. Robert de la Sizeranne wrote of Alma-Tadema: 'His is not the Rome of David or of Poussin, of public ceremonies, famous actions, great events, which convulse the world around the echoing rostrums. Here we have everyday Rome, Rome as it appears in the letters of Cicero to Atticus, the life of antiquity as it is felt in Terence or Plautus. For the present age, weary of great historical events, and famishing for anecdotes, this is the most interesting side of life, because it is most like our own'.

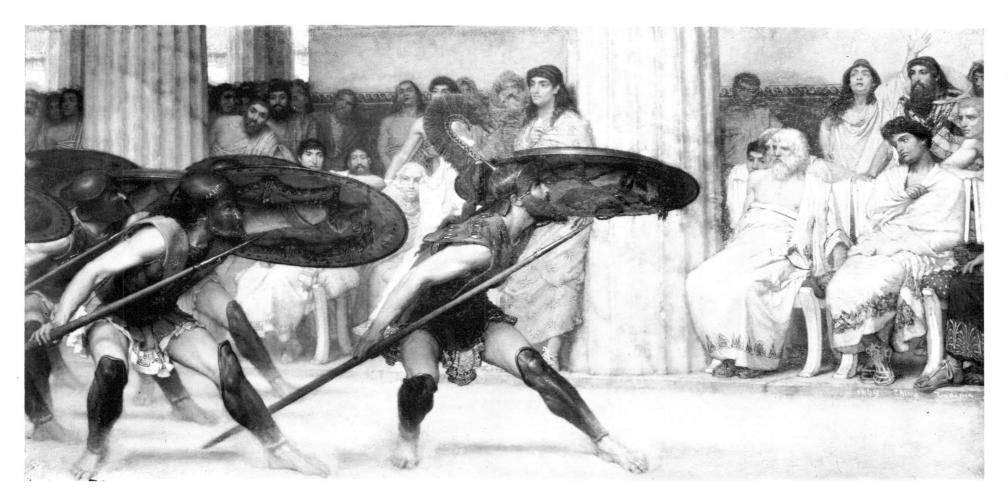

Her Majesty's. His stage design for Irving's 'Corio-lanus' included material based on the latest discoveries of Etruscan civilization. Alma-Tadema, wrote Beerbohm Tree, 'brought ancient Rome on to the stage' in 'Julius Caesar', and 'it was he who taught us the Roman handshake, the mutual grip of the wrist'. (In this context it is pleasant to record another little-known but distinguished ancestor, this time of Walt Disney, in the invention of 'Mr Michael Mouse', in Walter Crane's picture story.) It is tempting to speculate on the extent to which Alma-Tadema's accurate depiction of Roman architecture influenced American civic building.

Poynter lacked the imaginative refinement and grace of Leighton and the technical virtuosity of Alma-Tadema, although he came close to combining the best of both. In the multiplicity of his accomplishments, however, he matched Leighton, for he was a painter, sculptor, etcher, mural decorator and a fine academic draughtsman. In addition to his creative activities he devoted much of his life to the exacting demands of official duties, being the first Slade professor at University College, Director of Art Training Schools at South Kensington, and, to the mounting irritation of younger artists, President of the Royal Academy for twenty-two years until within a year of his death; for eight of those years he combined the office of President of the Royal Academy with the Directorship of the National Gallery, the first to do so since Eastlake. Like other monumental Victorian

SIR LAWRENCE ALMA-TADEMA, O.M., R.A. *The Pyrrhic Dance*. Panel. 16 × 32 inches. Guildhall Art Gallery, London.

Exhibited at the Royal Academy in 1869. This was the first picture the artist exhibited in England and its reception decided Alma-Tadema to remain in England. Ruskin wrote of it in 1878 that 'the general effect was exactly like a microscopic view of a small detachment of black-beetles in search of a dead rat'.

Left:
SIR EDWARD JOHN POYNTER Bt., P.R.A. *Head of a Young Man.* Black chalk. 11 × 9 inches. Bears studio stamp. Andrew Causey, Esq.

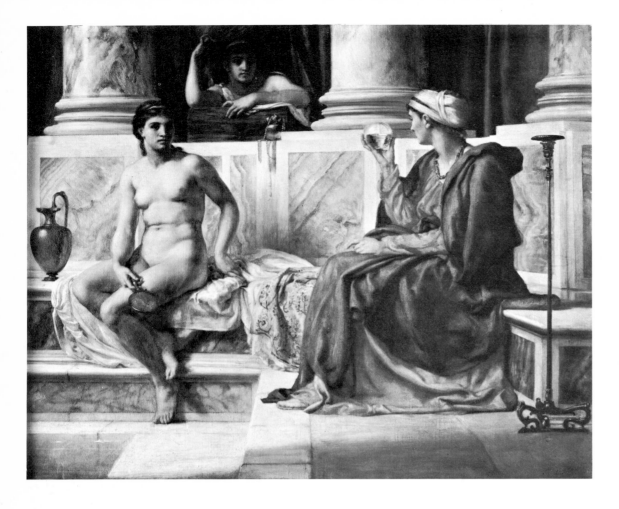

artists, honours attached themselves to him like burrs,
including a baronetcy in 1902. In contrast to the Jove-
like geniality of Leighton, he was considered a reserved
and cantankerous figure by many: Graham Robert-
son, who was repeatedly assured that Poynter's heart
was in the right place, doubted whether his liver was.
In spite of this he could usually rely on the ultimate
loyalty of his models.

The Middle Eastern subjects of Lewis, Lear, F.
Goodall and others paved the way for Poynter's early
series of Egyptian themes, after an initial dalliance
with Dante-esque romance. So also did an involvement
in the 'sixties with the Dalziels' 'Bible Gallery', to which
he contributed ten drawings. His first popular suc-
cesses were Egyptian scenes of the time of the Pharaohs,
coinciding with a similar choice of subject matter by
Alma-Tadema. These compositions reached their
culmination in the spectacular *Israel in Egypt* of 1867.
It was bought by the civil engineer, Sir John Hawk-
shaw, who calculated that Poynter had provided
insufficient Israelite man-power to haul the vast piece
of sculpture: whereupon Poynter painted in slaves up
to the edge of the canvas to achieve credibility. In
deference to the prevailing artistic demands, he had
also introduced a note of moral invigoration by
painting an Egyptian giving a drink of water to a
collapsed Israelite in the foreground. Roman scenes

began to appear at about this time: *The Catapult* of the
following year secured his election as A.R.A. and
gained fame in school history books. Greek mythology
supplied the themes of the lovely *A Visit to Aesculapius*,
Atalanta's Race and *Psyche in the Temple of Love. The
Visit of the Queen of Sheba to King Solomon*, signalled a
return, in 1890, to the themes of the 'sixties, but by
1904 he had, like Alma-Tadema, ceased to exhibit.

Unlike Poynter, Thomas Armstrong, another sur-
vivor of the muscular bohemian set which constituted
the 'Paris Gang', stopped exhibiting after only sixteen
years because of the demands of his official duties. His
early training, which included a period under Ary
Scheffer in Paris, was as international as any; his
work, now barely remembered, shows him to have
been placed at the end of the spectrum dominated by
Whistler and Moore.

Edwin Long (1829–1891) was a rather derivative
artist who painted, in the 'seventies, some spectacular
subjects from dynastic Egypt and Christian martyr-
dom. His celebrated *Babylonian Marriage Market* (Royal
Holloway College), which was bought by a Member
of Parliament for £7,350, was a sensation at the Royal
Academy in 1875.

William Blake Richmond (1842–1921), the son of
George Richmond, was another of those artists, like
Watts, Alfred Stevens, Leighton and Poynter, who

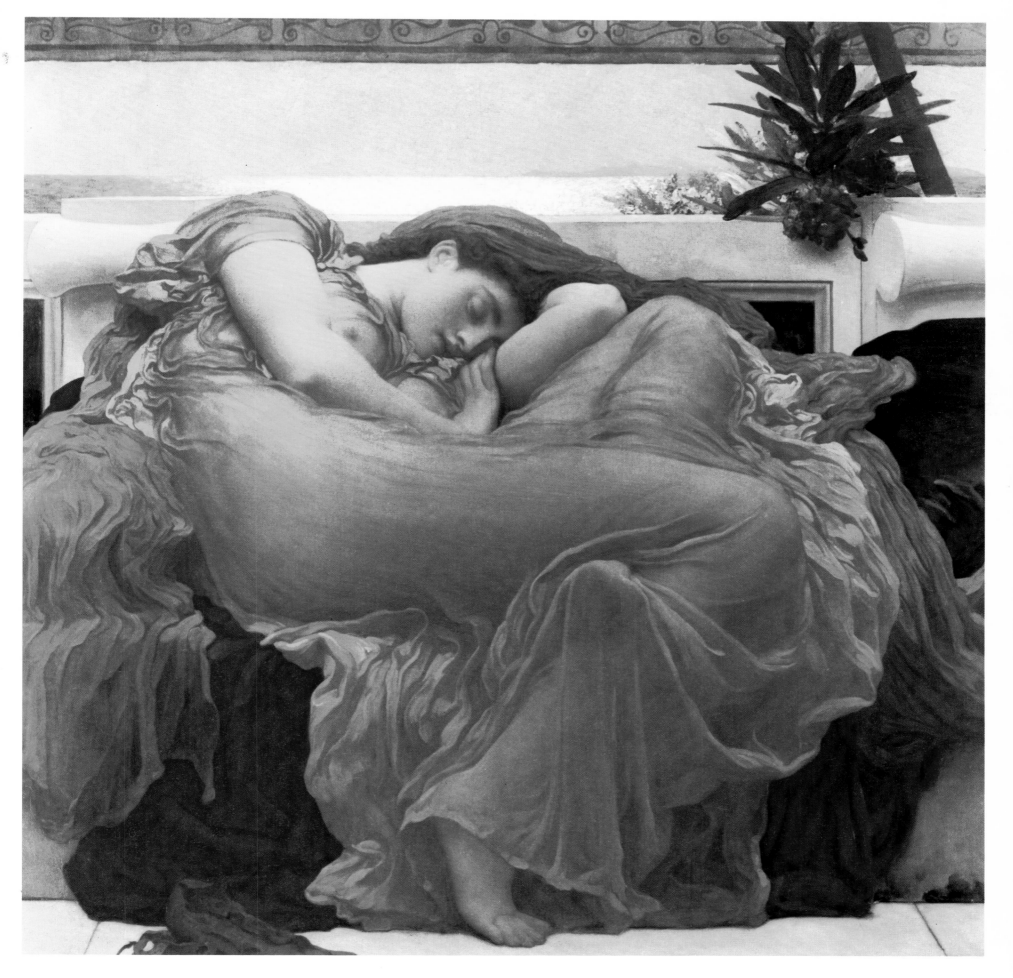

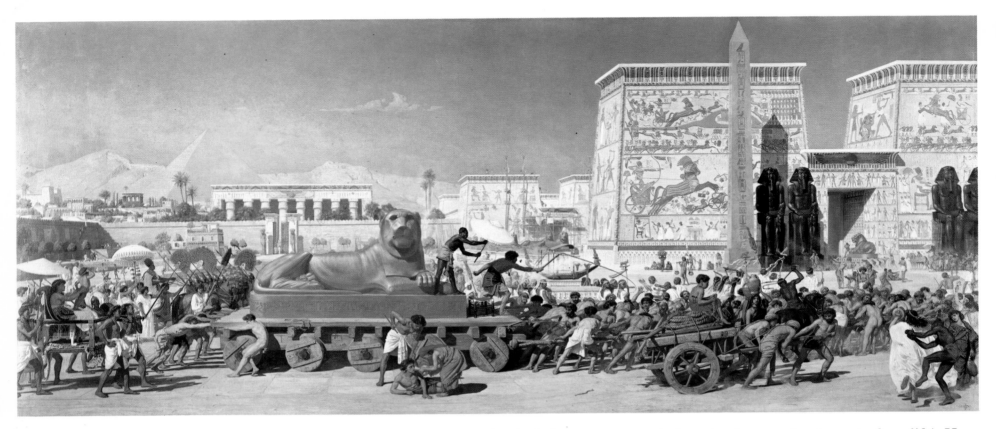

SIR EDWARD JOHN POYNTER, Bt., P.R.A. *Israel in Egypt*. 54×125 inches. Signed with monogram and dated 1867. Guildhall Art Gallery, London.

Exhibited at the Royal Academy in 1867. The picture illustrates Exodus I, 7–11: 'And the children of Israel were fruitful, and increased abundantly, and multiplied, and waxed exceeding mighty; and the land was filled with them . . . therefore [the Egyptians] did set over them taskmasters to afflict them with their burdens. And they built for Pharaoh treasure cities, Pithom and Raamses.' The Pharaoh referred to is said to be Rameses II (1290–1224 B.C.) A reviewer in 'The Art Journal' wrote that 'the painter labours under the disadvantage of having chosen a disagreeable, not to say revolting subject'. *See p. 182.*
Opposite page:
ALBERT JOSEPH MOORE. *Waiting to Cross*. 27×17½ inches. Mrs Robert Frank.

Exhibited at the Grosvenor Gallery in 1888. Later in the same year the artist painted another picture, entitled *A Visitor*, based on a study of the figure on the right.

ALBERT JOSEPH MOORE. *A Summer Night*. 51×88½ inches. Walker Art Gallery, Liverpool.

Exhibited at the Royal Academy in 1890. The titles of Moore's earlier pictures were almost completely inexpressive. Towards the end of his life he gave pictures, like *A Summer Night*, titles which bore some connection with the subject, more for the convenience of cataloguers and hanging committees than from any artistic conviction.

tended toward versatility. As a boy he had been brought up in a Pre-Raphaelite environment; Ruskin had turned his attentions on him, and Richmond, as he said, had had a narrow escape from copying 'bird's nests, fruit and primroses for the rest of my life'. However he soon gravitated into Leighton's dazzling orbit, even painting his *Procession in Honour of Bacchus* in the Roman studio where *Cimabue* had been painted.

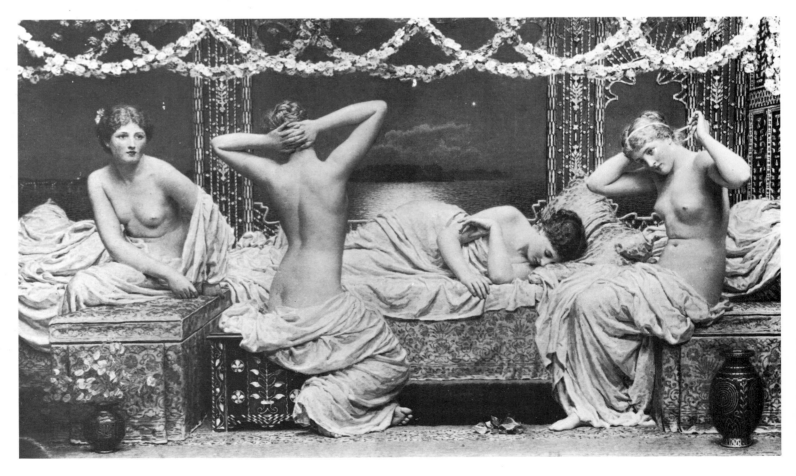

Richmond, one of the family dynasty of painters, touched the peripheries of a number of artistic circles, including the Virgilian world of Calvert and Palmer. But as a whole his work reveals a Hellenic bent. He is now best remembered for the design of the mosaic decorations for St. Paul's. Like Leighton and Poynter he was a sculptor, though of moderate talent, and a fine academic draughtsman.

Albert Moore (1841–1893), another member of an artistic dynasty, also matured in a Pre-Raphaelite environment. A painter of the most refined sensibilities, he was considered by Whistler and George Moore as one of the only true English painters alive. His 'faint, flower-tinted harmonies' had a distinct influence on Whistler. Moore, a Yorkshireman, was the fourteenth child of William Moore (1790–1851), a portraitist, and brother of the marine painter, Henry Moore. His early training had none of the internationalism usually associated with the English neo-classical school, although he did visit Italy in 1859. In the 'sixties he developed a style which marked him as one of the purest exponents of Aestheticism. His pictures, usually composed of one, two or three Grecian ladies attired in diaphanous draperies in various statuesque poses, are essentially subjectless, and they are as rhythmic and reticent as the Japanese prints which Moore so much admired. These compositions were merely excuses for imposing a series of subtly modulated colour schemes, allowing for an infinite number of exquisite variations. To Swinburne his painting expressed 'an exclusive worship of things formally beautiful' and he concluded that Moore's work was to 'artists what the verse of Théophile Gautier is to poets'. It was, in this respect, infinitely more Hellenistic than the laboured reconstructions of classical antiquity by Alma-Tadema and Poynter.

His method of work is described by his pupil Graham Robertson, and is worth quoting at length: 'He built up his compositions very slowly and laboriously, making elaborate charcoal cartoons of the whole group, then of each single figure, first nude, then draped. Then came chalk studies of the draperies, colour studies of the draperies, rough photographs of the draperies, so that before the great work was actually begun he had already produced many pictures . . . after they had served their purpose as studies he would often complete them by adding heads and backgrounds, and thus it came about that many of his pictures were so much alike: two or three slightly varying studies for the same figure, each in turn developing into a finished painting'. All this was before the painting had been started and the arrangements of colour worked out with the most sensitive deliberation. His work never degenerated into sterility, and it is one of his achievements that he was able to combine a feeling for plastic form with a flatness of treatment. There is always an impression

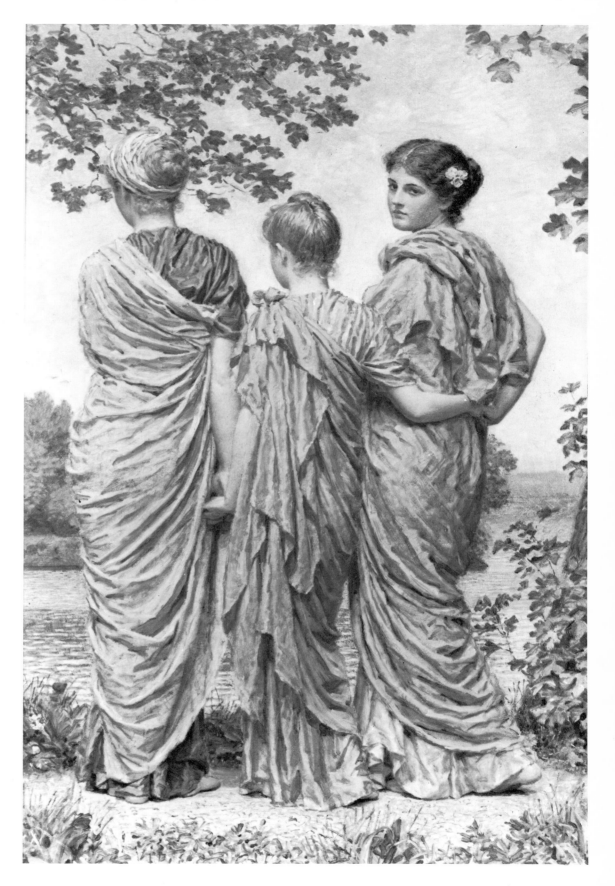

of rightness and in the civilized perfection of his compositions we find the closest approximation to the spirit of Grecian idealism. Unlike the other leading figures of the neo-classical school, Moore, shy and impractical, remained aloof from academic officialdom.

Forget-me-nots by Albert Moore is reproduced in colour on p. 203.

XIII

THE EFFECTS
OF PHOTOGRAPHY

I am glad I have had my day'—Turner, on being shown a daguerreotype

It is difficult for us now to comprehend fully the impact that the invention of photography had on painting in mid-nineteenth century England, and its consequences. For a revolution as far-reaching as this in the technique of transmitting the artist's vision, one would have to go back to Uccello's experiments with linear perspective in the fifteenth century. Since the visual representation of nature had, for centuries, been almost exclusively the concern of painting, it was inevitable that a process which could give what appeared to be an exact representation of the visible world in an instant should have had a profound—if sometimes insidious—effect on the art of painting. It was all the more so because early photography trespassed widely on painting for its subject matter.

Early photography had all the touchiness of a new art and often exaggerated its claims. The literature and letters of the period abound in references to the *parvenu* art, with varying degrees of excitability. In February 1857 'The Journal of The Royal Photographic Society', with quaint rhetoric, threw down the gauntlet; 'Photography is an enormous stride forward in the region of art. The old world is well nigh exhausted with its wearisome mothers and children called Madonnas; its everlasting dead bodies called Entombments; its wearisome nudities called Nymphs and Venuses . . . its dead Christianity and its deader Paganism . . . Then all at once breaks a small light in the far West, a new world slowly widens to our sight . . . This new land is Photography, Art's youngest and

fairest child; no rival of the old family, no struggler for worn-out birthrights, but heir to a new heaven and a new earth, found by itself and to be left to its own children. For photography there are new secrets to conquer, new difficulties to overcome, new Madonnas to invent, new ideals to imagine. There will be perhaps photograph Raphaels, photograph Titians, founders of new empires, and not subverters of the old.' The gauntlet was somewhat gingerly taken up by 'The Art Journal' which, throughout its history, adopted a more cautious attitude towards photography, particularly if it was thought that there was anything in it for the painter. A year earlier it had admitted condescendingly that 'photography has its uses—we fear we see its evils, or abuses, in the way in which some of our artists employ the photographic copy of nature, instead of looking at nature with their own eyes'. All, however, were agreed on one thing: photography had become a fact of life, and could not be ignored.

Photography came early to the notice of Ruskin. In 1845 he was writing to his father from Venice: 'Photography is a noble invention, say what they will of it. Anyone who has worked, blundered and stammered as I have done [for] four days, and then sees the thing he has been trying to do so long in vain, done perfectly and faultlessly in half a minute, won't abuse it afterwards.' In a previous letter to his father he had observed that 'among all the mechanical poison that this terrible nineteenth century has poured upon man, it has given at any rate one antidote—the Daguerreotype. It's a most blessed invention, that's what it is.' And in his diary on July 1849, Ruskin records taking daguerreotypes of the view at Chamonix. It is not surprising that Ruskin was attracted by the process invented by the French artist, L. J. M. Daguerre: the pictures were technically the most perfect to date, although the method produced only single positive pictures, a limitation that prevented any expansion of the technique. It was William Henry Fox Talbot's development of the Calotype process, patented on 8th February, 1841, that proved decisive. It had two special advantages: first, the latent image could be developed after an exposure of only one or two minutes; secondly, the double process involved in the development of the original negative and the transfer of the positive print gave greater control of the image as well as allowing a large number of prints to be made. Fox Talbot's process was to determine the direction of modern photography.

One of the immediate effects of photography on London's painting fraternity was to syphon off members of its ranks. Holman Hunt observed that 'many turned their steps towards photography and business connected therewith, and thus found a much more tranquil career and oft-times ampler fortune'. Madox Brown, for one, provided himself with a regular income

A Photographic Studio. Radio Times Hulton Picture Library, London. 'Pictures of Life and Character by John Leech from Collections of Mr Punch—3rd Series'. Published in 'Punch' 19th June 1858.

The cartoon shows an artist colouring photographs. The caption under the print reads: 'I say, Mister, there's me and my mate wants our fotergruffs took; and mind, we wants 'em 'ansom, cos they're to give to two ladies'.

early in his career by joining Lowes Dickinson in re-touching enlargements. Thus when the first Photographic Club was formed in London by amateur calotypists in 1847, a number of the founder members were originally artists, including Sir William Newton (1785–1869), the miniature painter, and Frederick Scott Archer (1813–1857), the sculptor; the latter was a distinguished pioneer of the new invention, and the inventor in 1850 of the collodion process. Philip Henry Delamotte (1820–1889) also managed to combine painting and photography: in 1857, only a year after being appointed Professor of drawing at King's College, London, he arranged a photographic department at the Manchester Art Treasures Exhibition, in this, as in so many other aspects, a critical event in the formation of later Victorian taste; it was the first occasion when photography was shown alongside the other arts.

The Scottish landscape painter David Octavius Hill (1802–1870) adopted photography to help him paint a gigantic picture immortalizing the resignation of over 470 Scottish ministers from the State Church in May 1843. Shortly afterwards, Hill opened a photographic business with Robert Adamson, and innocently exhibited photographs alongside his landscapes at the Royal Scottish Academy. After the retirement of his partner in 1847, Hill returned to painting. Some of the photographs resulting from this partnership are among the finest of the period.

Other artists, *manqués* or otherwise, to embrace photography included Fox Talbot (1800–1877), an amateur painter who had used a *camera lucida* as an aid to drawing, James Anderson (1813–1877), a water-colour painter, Thomas Annan (1829–1887), a copper-plate engraver, and Lewis Carroll (1832–1898) author of 'Alice', who had sketched for pleasure before taking up photography. Roger Fenton (1819–1869), famous for his Crimean war photographs, had studied art in Paris under Paul Delaroche; Francis Bedford (1816–1894) began life as a lithographer; Oscar Gustave Rejlander (1813–1875) was a Swedish portrait painter who spent most of his professional life in London. Rejlander had originally taken up photography to make studies for his paintings; he soon had a lucrative practice selling photographic studies to other artists. He was also the first photographer of the nude in Britain, and thus provoked the first aesthetic crisis in the new art form. His ambitious 'Two Ways of Life', measuring 16 by 31 inches, with its laborious allegory of Dissipation, Penitence and Industry, created a sensation; it was bought by the Queen for the Prince Consort, who hung it in his study. The semi-nudity of some of the figures outraged public taste, and in Scotland only the respectable part of the photograph was exhibited! Henry Peach Robinson (1830–1901), who was no mean draughtsman, as the

pencilled studies annotating some of his photographic compositions show, had a picture hung at the Royal Academy in 1852 and opened a photographic studio in 1857. He was the most influential artist-photographer in the second half of the nineteenth century, and wrote a number of books on the rules of photography, most of which he derived from painting.

Clearly there had grown up in the early 'fifties a rivalry between painting and photography. The issue was hotly debated throughout the latter half of the nineteenth century. As we have seen, photography claimed a number of defectors, and its novelty and comparative ease guaranteed a one-way traffic. Extravagant claims by both sides, victories, defeats and defections were strewn down the decades. The photographers wavered between triumph and petulance: their aspirations were reflected in H. P. Robinson's disgust when he proclaimed: 'It requires a fifth-rate painter to treat photography with contempt.' While many photographic exhibitions were held, any setbacks were greeted with umbrage. When photography was excluded from the International Exhibition of 1862, on the grounds that it was not a Fine Art, 'The Art Journal' commented indulgently that 'The Commissioners have placed photography amongst Carpenters' tools and agricultural implements, and naturally enough the photographers are offended.' The question as to whether photography was a Fine Art was still being argued by leading artists, art critics and photographers in 1899 when a 'symposium' on the subject was published in 'The

HENRY PEACH ROBINSON (1830–1901). *Study for a Composition Picture.* University of Texas.
Taken and composed in about 1860. Like many early photographers H. P. Robinson was a proficient artist. His method was to draw a sketch of his subject, then photograph each feature or groups of features, cut them out and paste them down on separately photographed foregrounds and backgrounds.

HENRY WHITE (1819-1903).
Bramble and Ivy. University of Texas.
Taken in about 1856. White, who
was a partner in a firm of London
solicitors, was one of the earliest
amateur landscape photographers.

a very literal way. In France, on the other hand, the Impressionists were to react strongly against the 'fixing' of an image, and attempted to synthesize light by separating it into its individual colours. The young American artist, Lilla Cabot Perry, recorded Monet as saying in 1889 'When you go out to paint try to forget what objects you have before you—a tree, a house, a field, or whatever. Merely think, here is a little square of blue, here an oblong of pink, here a streak of yellow, and paint just as it looks to you, the exact colour and shape, until it gives you your own naive impression of the scene before you.' This attempt to represent the appearance and meaning of objects in space through colour is the exact reverse of the photographer's aim, and that of English painting during this period: English artists, especially Victorian artists, always tended to reproduce the literal appearance of nature. This divergence of attitude between England and France was to prove decisive for the eventual course of modern painting.

Photography seemed to support the concepts of Ruskin and the Pre-Raphaelites, and no doubt helped them to gain what public acceptance they could. What better instrument than a camera to follow Ruskin's famous advice: 'Go to nature in all singleness of heart, rejecting nothing, selecting nothing, scorning nothing'? The photograph of bramble and ivy, taken in about 1856 by Henry White, one of the earliest and best of the landscape photographers, appears like the background to many a contemporary picture, Pre-Raphaelite or otherwise: a bird's-nest placed in any section of the foreground could have supplied a subject for William Henry Hunt; the addition of a sad-faced maiden and a suppliant lover would set the scene for any early work by Arthur Hughes; and any fairy painter of moderate ability could have woven delicate fantasies among the ivy and the brambles.

Indeed, the Pre-Raphaelites were often suspected of making use of photography to achieve their effects of exactitude in minute detail. So much so that Ruskin was moved to say in their defence at the Edinburgh Lectures of 1853: 'The last forgery invented respecting them is, that they copy photographs. You observe how completely this last piece of malice defeats all the rest. It admits they are true to nature, though only that it may deprive them of all merit in being so.' This defence was not enough to stifle a writer in 'The Journal of the Royal Photographic Society' ten years later, who suspected that 'Pre-Raphaelitism owes much to photography, or may even spring from it, though its disciples would not willingly admit as much. Post-photography might probably more accurately describe this style of art than Pre-Raphaelitism.' Although few would disagree that this was a gross libel, perhaps it may be allowed that the sudden co-existence of photography and painting—although photography

Magazine of Art', numbering among its contributors Robert de la Sizeranne, Fernand Khnopff, A. L. Baldry, G. A. Storey and the redoubtable H. P. Robinson. Whilst shot and shell were being exchanged by both sides, punctuated by the occasional broadside from Ruskin, whose early enthusiasm had begun to cool, it was soon apparent that although photography was borrowing ideas from painting, painting was learning a few things from its upstart rival, even while that rival remained a threat.

In England, photography underlined a preference for accurate depiction of the subject, thereby strengthening the desire of painters, if not actually to compete, at least to confirm the existence of the visible world in

was in no way contributory to the creative impulse—might at least have had a degree of sub-conscious effect on the Pre-Raphaelites, all the more so as the inception of the movement itself coincided with the growing awareness of photography among creative artists and public alike. One thing is certain, and that is that those painters who were not deprived of a living by the new art, or who even actively embraced it, used photography (as artists in previous centuries had used various kinds of *camera obscura*) with attitudes ranging from frankness to furtive embarrassment. That they were the first painters in history to be able to do so makes their case especially interesting.

In the late 'fifties the London Stereoscopic Company regularly advertised '100,000 charming STEREOSCOPIC VIEWS from all parts of the world, and groups of figures representing almost every incident in human life, from 6/– per doz'. These and others of a similar kind rapidly found their way into the painters' studios. 'The Art Journal' constantly refers to collections of photographs which might prove useful to painters. These photographs covered the whole field of human activities and nature, including photographs of animals, nudes, 'river views with barges', and even 'the forms and massing of clouds in windy weather', which, 'wisely used should be of great service to landscape painters'. It is interesting to find that Charles Allston Collins, in a letter to Holman Hunt some years previously, on February 10th, 1855, had come to

the same conclusion: 'I have lately heard that photography has accomplished the achievement of seizing the forms and modelling of *clouds*, the greatest use as it seems to me it has yet been of to artists.' 'The Art Journal' and 'The Journal of the Royal Photographic Society', however, always reminded artists of the dangers of 'resorting to the folio instead of going to Nature herself'. As early as August 1849, 'The Art Journal', describing the earliest meetings of the Photographic Club, commented on the delight of 'our most eminent landscape painters, at the aid given them by copies of nature produced by the photographic processes'. Beatrix Potter recalled in her diary (February 9th, 1884) that John Brett went 'sailing about the West Coast of Scotland in his sailing yacht in the summer, making oil sketches which he uses for the colour in his pictures which he paints in the winter months, chiefly from memory, though also assisted by photographs, for he is a successful photographer'. Edward Lear once bought a 'photographic machine', since, as he wrote, 'it will be of great service to me in copying plants and in many things which distance, limited time, heat, etc. would prevent my getting'. Doubtless Lear's impractical nature prevented him from making the fullest use of the camera, and he never mentioned his 'photographic machine' again. In 1856 'The Art Journal', referring to a photograph entitled 'Inhaling the Breeze' by a Mr Shadbolt, commented that 'Pre-Raphaelites might study this and

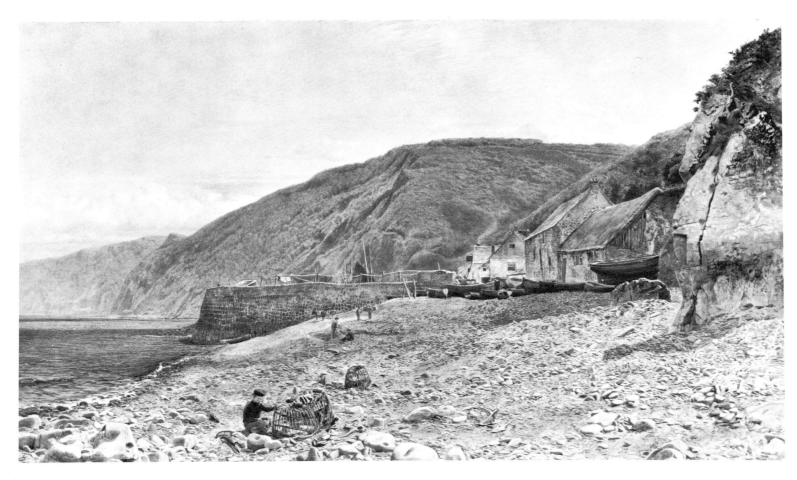

CHARLES NAPIER HEMY, R.A. *Among the Shingle at Clovelly.* 17¼ × 28½ inches. Signed with monogram and dated 1864. Mrs Charlotte Frank.

Exhibited at the Royal Academy in 1865.

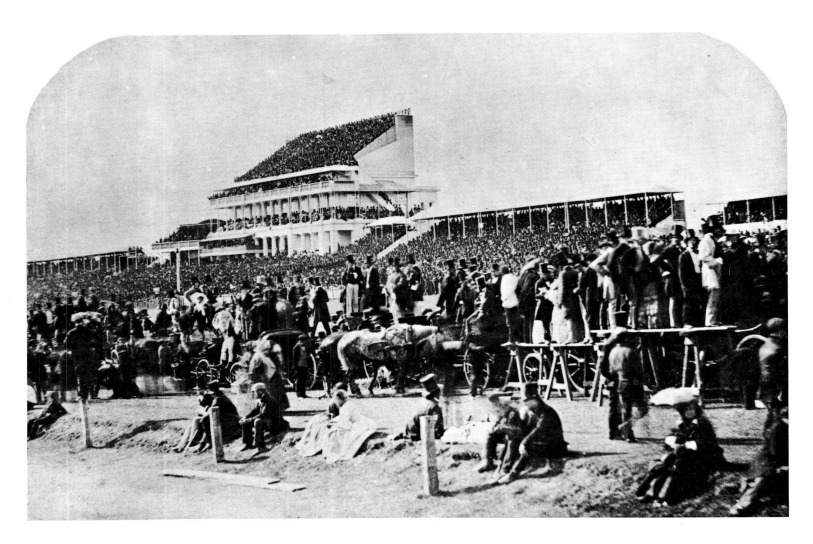

some other photographs, and learn how the sun paints, disclosing every minute line on trunk and leaf —yet blending all into one'. Later in the same year and throughout the years immediately following, 'The Art Journal' noted the influence of the camera in certain pictures in the Royal Academy Exhibitions, specifically those by J. W. Oakes, E. W. Cooke and even, in 1859, Millais's *Vale of Rest* ('painted, by the way, very much as if from photography'). Charles Napier Hemy's early shore-scene betrays the influence of photography quite as much as Pre-Raphaelitism; this can be said of many pictures to which a Pre-Raphaelite label is customarily attached. In 1860, 'The Art Journal' critic, writing of William Dyce's *Pegwell Bay, Kent*, opined that the whole of the foreground was 'painted with a truth equal to that of photography'. After this date, 'The Art Journal' ceases to point out comparisons between paintings and photographs, probably because these cease to be a novelty. 'The Journal of the Royal Photographic Society', however, with a bigger axe to grind, continued to press the claims of photography over painting.

Naturally enough, the letters, diaries and memoirs of the leading artists of the day are rather more reticent on the subject. Generally, it is the chance remark that appears as the tip of an iceberg, and hints at what lies below the surface. The attitudes of a handful of well-known painters may be considered representative. For instance, Frith displayed a querulous attitude to photography all his life. In his memoirs, he quotes Charles Landseer, 'who made better puns than pictures', as saying of photography that its appearance 'was a *foe-to-graphic art*', and 'he little thought how completely his prophecy would be realized'. And yet Frith used photography as an aid on several occasions. He had tried unsuccessfully to use photographs for the background of *Ramsgate Sands*, and again, without success, for a portrait of Dickens. He certainly used photographs to paint various absentees for his painting of the Marriage of the Princess Royal and the Prince of Prussia. Towards the end of his life he was using photographs regularly: he had a student's room at Cambridge and parts of the Old Bailey photographed for *The Road to Ruin* series and 'to insure the verisimilitude of the scene of *The Salon d'Or*, had large photographs made of the room'. It is interesting to find the following note in 'The Journal of the Royal Photographic Society' on January 15th, 1863: 'on *Derby Day*, Mr Frith employed his kind friend Mr Howlett to photograph for him from the

roof of a cab as many queer groups of figures as he could', a revealing fact not mentioned in his memoirs. Nor did he mention that he had engaged a professional photographer, Samuel Fry, to take photographs of the interior of Paddington Station, engines and carriages for *The Railway Station*.

Millais, like Frith, began by being rather critical of photography, but made increasing use of it as an aid to painting, although his earlier references to photography are somewhat guarded. Millais's dealings with the Queen in this connection are interesting.

The Queen and the Prince Consort showed a keen interest in photography. They kept photograph albums, attended photographic exhibitions, appointed Royal Photographers and inspected new inventions. This resulted in the Queen being no longer satisfied if her portrait was painted in an inaccurate or idealized manner. Her Court painter, Alfred Chalon's rejoinder: 'Ah non, Madame! photographie can't flattere', to her assertion that photography might ruin his profession, can only partly have allayed her doubts, since she invariably gave the artist photographs for reference. When Millais was painting for her a small copy of his portrait of Disraeli after his death, she sent him three photographs of the statesman, 'in case they may assist' him. Millais prudently took the Queen's advice, and she was very pleased with the result. On another occasion, when he was painting Princess Marie of Edinburgh, the Queen plied him with photographs, since it gave 'a very good idea of the gracefulness of the

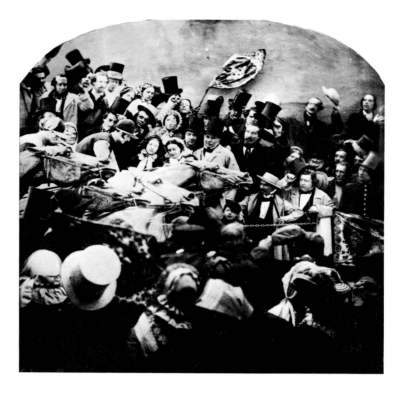

LONDON STEREOSCOPIC COMPANY. *The Race Course*. Radio Times Hulton Picture Library, London.

London Stereoscopic 'Comics' series. Apparently a posed photograph but representing a Derby crowd, of about 1859, a year *after* Frith's *The Derby Day* was exhibited. It does, however, give some idea of the kind of photograph which greatly assisted artists attempting crowd scenes as in Frith's picture. The horses and jockeys were probably made of plaster.

little Princess'.

Millais is recorded in Beatrix Potter's diary as saying in 1884: 'all artists use photographs now'. In the same year Beatrix's father, Rupert, who was a keen photographer, photographed Gladstone in his Oxford D.C.L. robes. The resemblance between the photograph and the second version of the portrait at Christ

WILLIAM POWELL FRITH, R.A. *The Derby Day*. 40 × 88 inches. Signed and dated 1858. Tate Gallery, London.

Exhibited at the Royal Academy in 1858. This was Frith's second ambitious scene depicting every-day life, after *Ramsgate Sands* (1854). It was the first picture to require railings to protect it from its admirers since the exhibition of Wilkie's *Chelsea Pensioners* in 1822. The picture took Frith 'fifteen months' incessant labour' to complete.

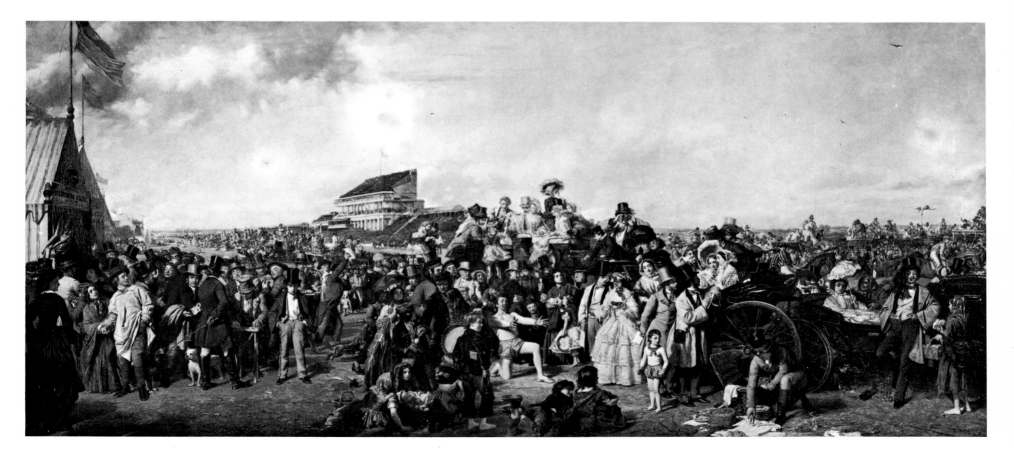

Above left:
RUPERT POTTER. *Photograph of The Rt Hon. William Ewart Gladstone.* National Portrait Gallery, London.

Taken in 1884. Rupert Potter (1832-1914) was the father of Beatrix Potter.

Below left:
SIR JOHN EVERETT MILLAIS, Bt., P.R.A. *The Rt Hon. William Ewart Gladstone.* 36×27½ inches. Christ Church, Oxford.

Painted in 1884.

Above right:
RUPERT POTTER. *Photograph of the Rt Hon. John Bright.* National Portrait Gallery, London.

Probably taken in 1880. John Bright (1811-1889) was an orator and statesman.

Below right:
SIR JOHN EVERETT MILLAIS, Bt., P.R.A. *The Rt Hon. John Bright.* 49½×36 inches. Signed with monogram and dated 1880. The Rt Hon. Lord Aberconway.

Exhibited at the Royal Academy in 1880.

Opposite page, above:
WILLIAM MORRIS GRUNDY. *Photograph of a Fisherman.* Radio Times Hulton Picture Library. London.

Taken in about 1855-6. W. M. Grundy (1806-1859) took up photography as a hobby in 1855. An anthology of poetry, 'Sunshine in the Country', illustrated with twenty of Grundy's photographs was published posthumously in 1861. A larger collection of his photographs was published posthumously with the title 'Rural England'.

Opposite page, below:
SIR JOHN EVERETT MILLAIS, Bt., P.R.A. *John Ruskin.* 31×26¾ inches. Signed with monogram and dated 1854. Mrs Patrick Gibson.

Millais began this portrait at Glenfinlas, Scotland in July 1853; he worked on it until October, but did not complete it until the following year.

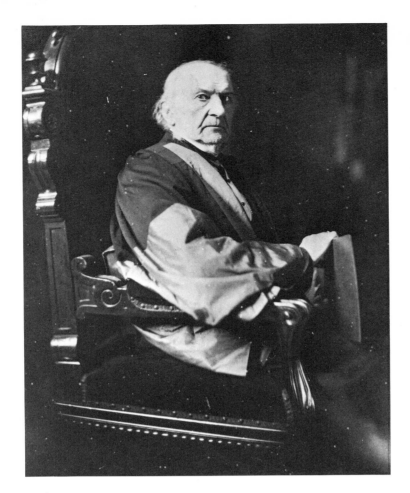
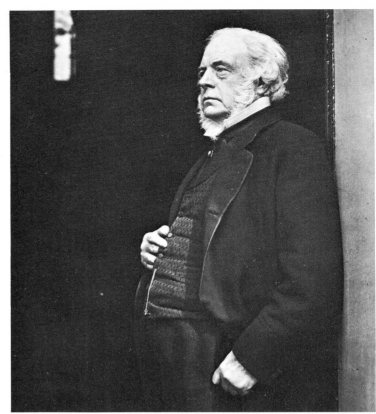
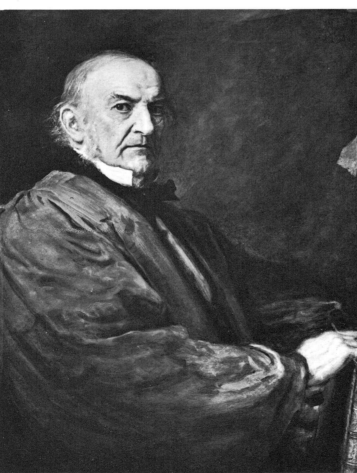
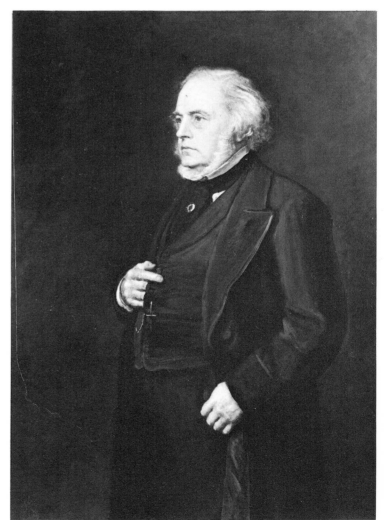

Church, Oxford, is evident. It is noticeable, however, that Millais flattered his famous sitter, by increasing the height of his collar. Similarly, John Bright, the politician, who enjoyed salmon-fishing as much as Millais, was also photographed by Rupert Potter at about the time that his portrait was being painted by Millais in 1880. In the oil painting the lines on his face have perceptibly softened, with a corresponding loss of character. Beatrix Potter, a photographer herself, who was 'constantly in the habit of using' photographs, records that on several occasions Millais used her father for photographing, notably for the stream in *An Idyll, 1745*, for which the drummer-boy himself was photographed, to Millais's complete satisfaction. Millais also used Rupert Potter's photographs of his grandson, who posed for *Bubbles*, as an aid. It is tempting to speculate, in the light of his later use of photography, that Millais might have seen the photograph of the angler by William Morris Grundy (1806–1859), taken in the 'fifties, before painting Ruskin at Glenfinlas in 1853. The similarity in pose of Ruskin and the angler is certainly no more than a coincidence; Ruskin would no less certainly have approved of the rock formations.

On various other occasions Millais made practical use of the camera as an aid. When he was painting *Murthly Moss* he spent several days looking round for the best point of view, '. . . a quest in which my brother Geoffroy's skill as a photographer proved a most valuable help'. And for the painting *Time the Reaper*, he is said to have used a photograph of himself, with the addition of a white beard, as a model!

Rossetti was far less reticent on the subject of photography. Not only did he use photography constantly in later years, but he made a habit of having photographic copies made of all his pictures. In 1862 he made several unsuccessful attempts to paint the portrait of a dead person from a photograph. A year later he wrote to his mother asking her to send his photograph of 'Old Cairo', and any 'stereoscopic pictures which represent general views of cities . . . or anything of a fleet of ships . . . to use in painting Troy' in the background of *Helen*. Rossetti further admitted to painting over a photograph in water-colour, and possessed another such by Thomas Seddon. He was evidently sensitive on this subject since, in a letter to James Anderson Rose in 1867, he stresses that this is 'the only instance in which I ever painted on a photograph and will remain the only one; and were the matter unexplained in this instance, misunderstandings might arise as to the nature of other works of mine'. Six years later we find him asking his mother again to send him some photographs 'as they may be of use to me in painting'. And in 1874 he writes to his brother asking for 'photos representing rocks and water, for the background to *Madonna Pietra* from

Dante's "Sestina".' While painting *Dis Manibus* in the same year he perched a 'photograph of the Fates before my eyes while I painted it and tried to get a faint reflex of that kind of beauty'. Rossetti's models were a matter of abiding importance to him, and in July 1865 he posed Jane Morris for a series of photographs in his garden at 16 Cheyne Walk, Chelsea. One of them at least can be directly related to one of his portraits, *Reverie*, and the close similarity between the two speaks for itself; and certain features in the photographs such as the angles of the hands, the tilting of the head and the folds of the dresses are echoed clearly in other portraits.

Perhaps the most interesting example of a painter associated with the Pre-Raphaelite movement using a

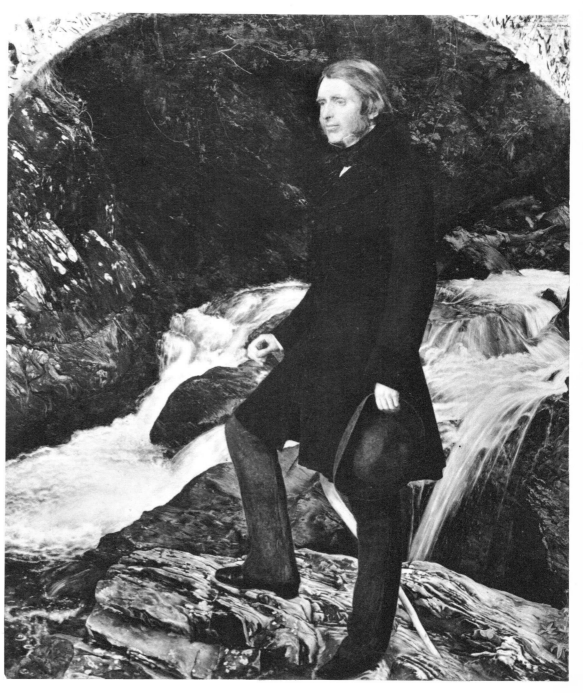

photograph, and certainly one of the earliest so far recorded, was Madox Brown's use of the camera in *Work*. (F. G. Stephens, one of the original members of the Brotherhood, had written earlier to Holman Hunt on August 4th, 1854, mentioning that he had made a portrait 'from a Daguerreotype . . . and tho' extremely unsatisfactory as a work of Art has enraptured the lady who gave me the commission'.) In *Work* Madox Brown placed the figures of the Rev. F. D. Maurice and Thomas Carlyle on the right of the canvas to symbolize the 'brain-workers'. Maurice gave two short sittings in January 1858. In the original pencil study,

Carlyle's head is only faintly indicated but already it is wearing a grimace. Madox Brown wrote to Hunt doubting his chances of ever getting Carlyle to sit, but Carlyle, who had little time for painters, did consent to having himself photographed, minus grimace. In almost every other respect, though, Madox Brown painted exactly from the photograph. So photography had infiltrated deeply into the ranks of Victorian painters. Nor was this development confined to Britain; in France, Delacroix, Ingres and Degas, to name only a few, used photography as an aid to painting; in America, the painter Thomas Eakins became an

accomplished photographer. It is interesting to note that one of the finest photographers in Victorian England, Julia Margaret Cameron, knew many of the leading painters of the day personally, and fell under the spell of the Pre-Raphaelite movement: indeed so impressed was she by Hughes' painting *April Love* that she posed a number of her photographs against an ivy-covered wall. Although she did not take up photography until 1863, at the age of forty-eight, it is reasonable to suspect that her photographs helped to distil the particular flavour of later Pre-Raphaelitism.

The now widespread popularity of photography and its use by artists had a number of distinct effects on Victorian painting. Naturally enough, portrait painting was seriously affected and, more particularly, the art of painting miniatures—which had been ailing for some time—became almost extinct overnight. Referring to photographs, Elizabeth Barrett wrote to Mary Russell Mitford in 1843, 'I would rather have such a memorial of one I dearly loved, than the noblest artist's work ever produced', an attitude as commonly held now as it was then. The effect on the old school of portraiture, of which Lawrence had been the last great exponent, was conclusive (at least until the turn

of the century, when it enjoyed something of a revival): it was no longer easy to elevate a sitter to levels of immortal grandeur when a photograph revealed him

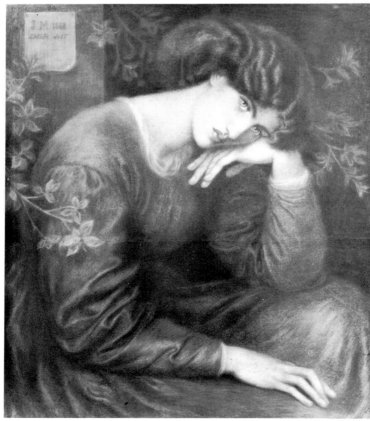

to be just as mortal as everyone else. Moreover, Julia Margaret Cameron's profoundly moving photographs of men like Thomas Carlyle, Sir John Herschel and Alfred Lord Tennyson (who complained that he could not go about anonymously by reason of 'her confounded photographs') showed convincingly, for the first time, the poetry of an old face, wrinkled and furrowed by the ravages of time. And so, for the first time, the Royal Academy walls were hung with almost as many portraits of venerable old men as of pretty young women—and in not a few of these photography was used as an aid. It was certainly used by G. F. Watts. In the archives of the City of Westminster there is a letter from Watts to Sir Charles Dilke, dated January 1st, 1873, prior to a portrait sitting, in which Watts asks Dilke to 'bring some good photographs. They help to make my acquaintance with peculiarities and shorten the sittings necessary.'

 The introduction of the *carte-de-visite* photographic portraits into England in 1857 dealt the final blow to miniature painting. These portraits were cheap and quickly became popular. Camille Silvy, who was known as the Winterhalter of photography, owned a particularly substantial business and ran a famous series of *cartes* entitled 'The Beauties of England'. Photographs were put into elaborate frames and took the place of miniatures in the Victorian drawing-room. Frith mourned 'the imminent destruction by photography of a beautiful art, that of the miniature painter'. Soon the heads began to roll: William Ross, too advanced in years, simply gave up; Henry Tanworth Wells (1828-1903) was driven to oil painting, and almost overreached himself—his diploma work for the Royal Academy was nearly ten feet long and, incidently, somewhat photographic in con-

ception. Some, like Thomas Carrick (1802–1875), adopted the lucrative practice of colouring photographs, inspiring a contemporary critic to congratulate him for having given 'warmth and life, and expression to the cold, dead outline of the original photograph'; others like Sir William Newton, who in 1847 was a founder member of the first Photographic Club, embraced photography with enthusiasm. John Lavery recalled in his autobiography that he had served 'three years apprenticeship as a miniature painter over photographs on ivory'.

Similarly, the profusion of readily obtainable photographic references, the genre scenes popularized by the London Stereoscopic Company in about 1857, and the famous combination pictures by Rejlander and Robinson, all contributed to the decay of genre painting. The photographers pilfered remorselessly from the painters' subject matter, as some of their titles suggest: 'The Geography Lesson', 'The Spinning Wheel', 'Night Out—Homeless' and 'Feeding the Cat'. Some of these photographs achieved wide popularity, although they were considered rather vulgar by the critics. Their popularity grew and declined along with the paintings they emulated.

The effect of photography on landscape painting followed much the same insidious pattern, but the results were perhaps less far-reaching, except in one particular field. It severely curtailed the activities of foreign view painters: David Roberts and James Holland left no real successors. The camera had brought all the four corners of the world into the drawing room. Photographers like Francis Frith made

LONDON STEREOSCOPIC COMPANY. *Alfred, Lord Tennyson.* Radio Times Hulton Picture Library, London.
Taken in 1857-9. Julia Margaret Cameron made some memorable photographic portraits of Tennyson.

Below left:
GEORGE FREDERICK WATTS, O.M., R.A. *Alfred, Lord Tennyson.* 23½ × 19½ inches. National Portrait Gallery, London.
Painted in 1873. Watts painted seven portraits of Tennyson. 'What I try for,' Watts said while engaged on one of them, 'is the half-unconscious insistence upon the nobilities of the subject.'

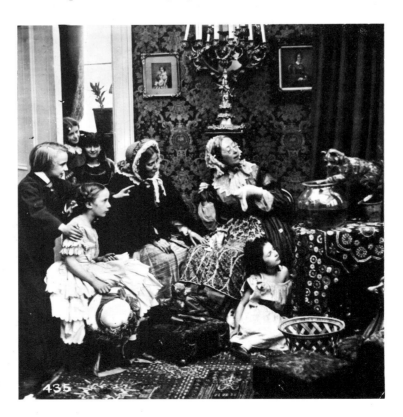

LONDON STEREOSCOPIC COMPANY. *The Cat and the Goldfish.* Radio Times Hulton Picture Library, London.
Posed genre photograph taken c.1860.

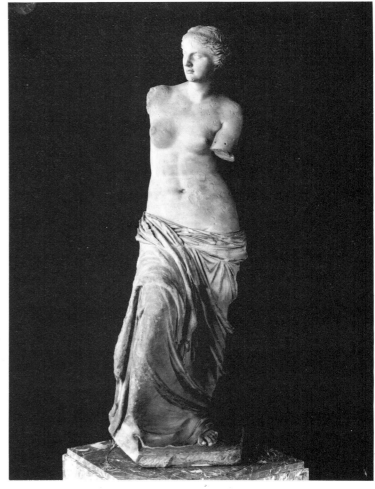

journeys to Egypt, Palestine and Syria, and accurate records of architecture, mountains, archaeological and biblical sites came pouring back to England. Photography ensured once and for all the total collapse of the classical landscape tradition: the ordered assembly of form was simply incompatible with photography. A rhythm began to establish itself between painters and photographers: no sooner had the photographers borrowed subject-matter or effects from the painters than the style of painting which they copied declined in popularity. For instance, the popular moonlight scenes in the Pether tradition, which culminated in the effulgently atmospheric scenes by Atkinson Grimshaw, were closely paralleled by another Yorkshireman, a photographer called Frank Meadow Sutcliffe. Many of his photographic landscapes and scenes of Whitby Harbour contain the very essence of Grimshaw. Significantly, the moonlight tradition died with Grimshaw. This artist's landscapes are permeated with photographic vision, with their mists, the stencilling of branches or masts against a moonlit sky, the reflections of light on water, the dark smudgy figures which seem like shapes that have moved on a time-exposed photograph. Indeed, Grimshaw devised a technique whereby a master-drawing was thrown on to a canvas or board through a photographic enlarger, and by this method was able to paint several versions of the same subject. Antoine Claudet had perfected a process in

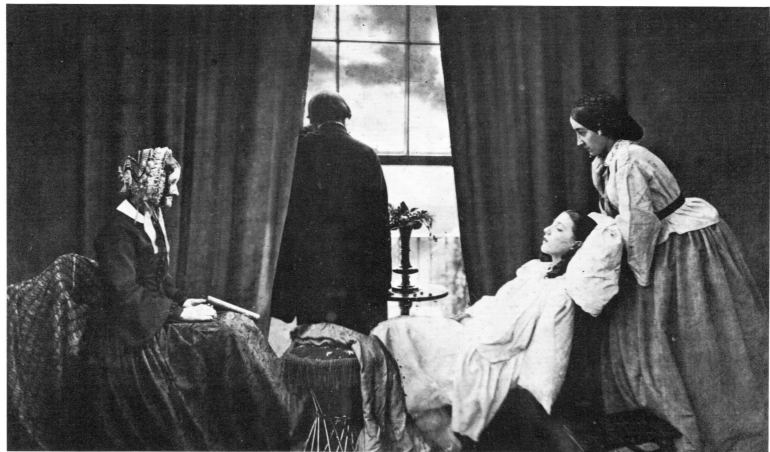

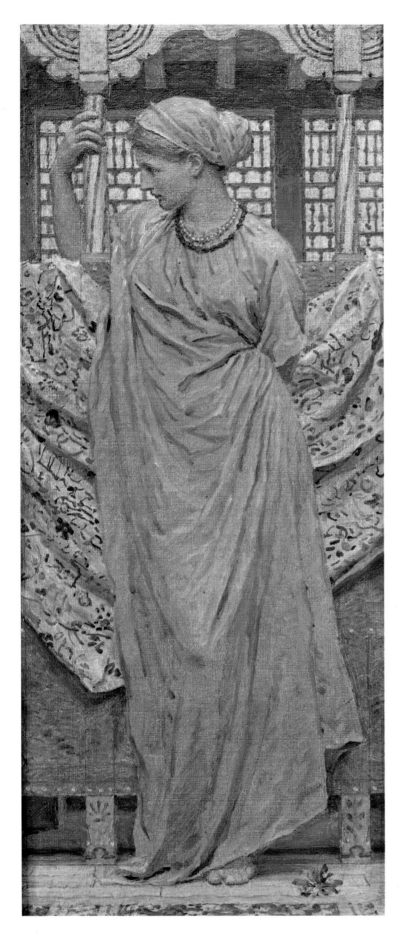

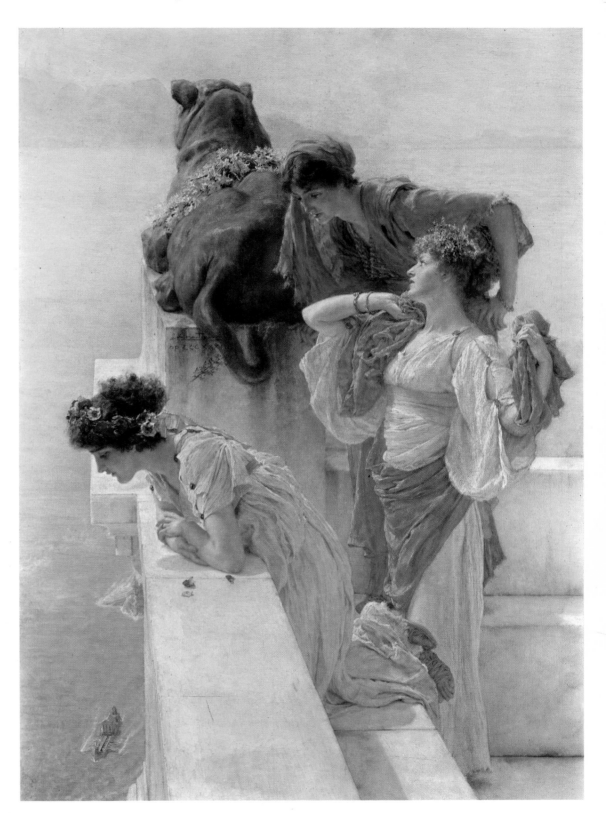

with a magic lantern; perhaps this was the method Grimshaw used. Although his paintings are quite valid as such, it would seem that photography and painting achieved their closest fusion in this artist, and the landscape tradition is none the poorer for the fact.

The art of still-life painting, never strong in England, almost certainly suffered at the hands of photographers. 'Photography,' as a writer in 'The Athenaeum' in January 1859 dared to hope, 'will in time

SIR LAWRENCE ALMA-TADEMA, O.M., R.A. *A Coign of Vantage.* Panel. 25¼ × 17¾ inches. Signed with Opus no. CCCXXXIII and dated 1895. Mr Allen Funt.
Three Roman women watch the return of the galleys. The artist has created an illusion of great height and distance. *See p. 182.*

the 'sixties which he called 'Photosciagraphy', whereby a photographic image could be projected on a canvas

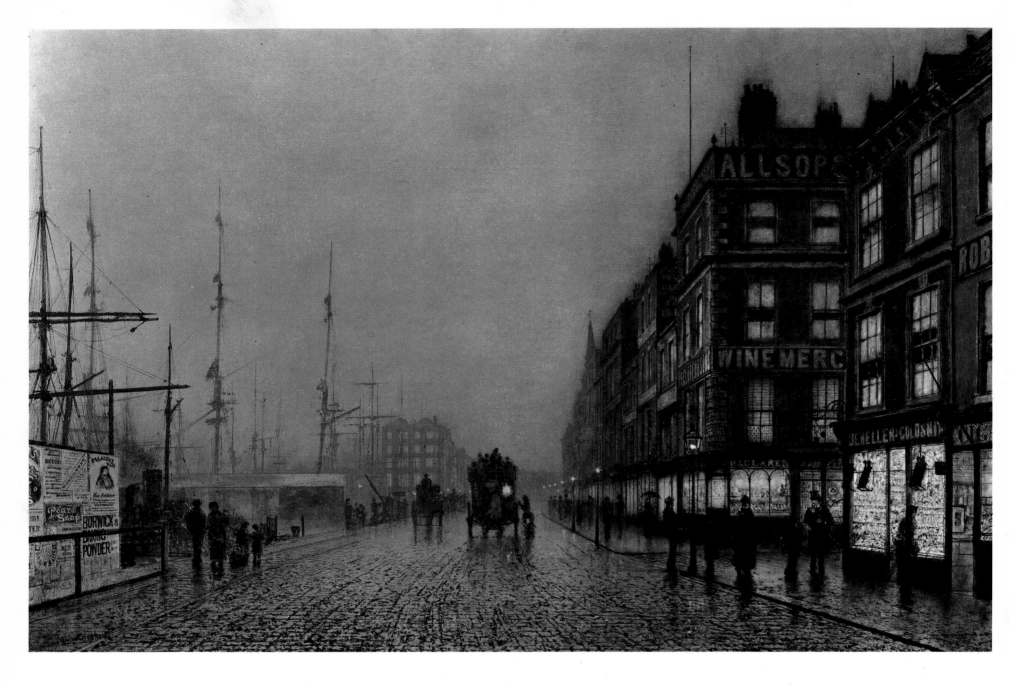

JOHN ATKINSON GRIMSHAW,
Liverpool Quay by Moonlight, 24 × 36
inches. Signed and dated 1887,
Tate Gallery, London.
 When this picture was painted
Grimshaw had been living for the
better part of two years in Chelsea.
He also painted dockland scenes in
Glasgow and Greenock in the same
year. *See p. 229.*

entirely destroy all necessity of men wasting their time in painting still-life.' Certainly the still-life painters like Edward Ladell and George Lance left no successors of any importance, who could subsist almost entirely on still-life painting. And while photographs which used multiple-exposed and superimposed images no doubt helped to encourage a fleeting credence in supernatural and fairy paintings, the large numbers of counterfeit spirit photographs surely hastened the demise of fairy paintings.

Perhaps one of the most fruitful contributions of photography to painting was in recording the appearance and movement of animals. In 1872, an English-born photographer named Eadweard Muybridge, who had emigrated to California, was consulted about an old controversy—whether the flying gallop was the correct posture of the horse in rapid motion. His publi-

cation 'The Horse in Motion' described the results of his experiments. He did further research on the subject for the University of Pennsylvania and published his findings in 'Animal Locomotion' (1887). This monumental work contains 781 plates and is still the most comprehensive work of its kind. The most valuable photographs were those taken of a galloping race-horse, for which he used a row of up to 36 small cameras with clockwork shutters, and showed, for the first time, how a horse lifts all four legs off the ground when it is in fast motion.

An incredulous public rapidly perceived the absurdity of the 'rocking horse' attitude of horses' legs in paintings throughout history. Muybridge's researches, together with those of Marey in France and Eakins in America, all of whom studied both human and animal form in motion, threw an entirely new world at the

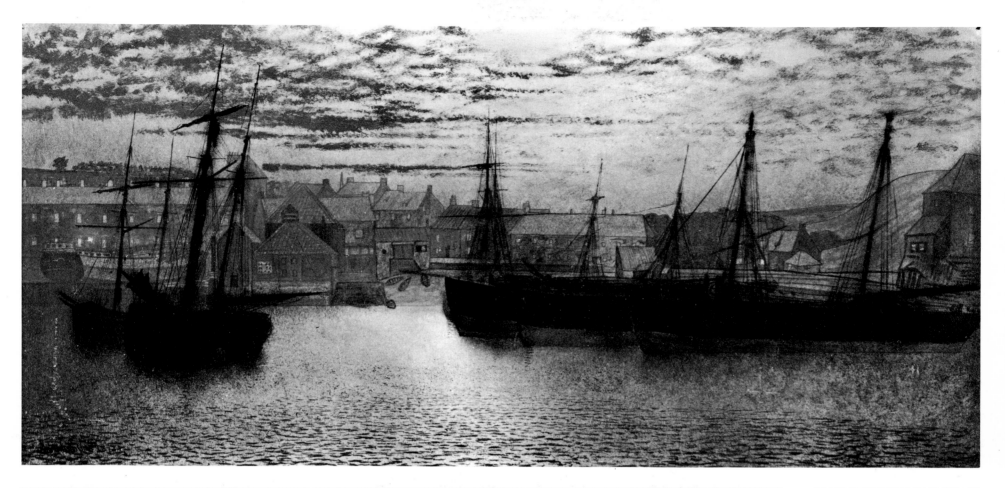

JOHN ATKINSON GRIMSHAW.
Boats at Whitby. Board. $8\frac{1}{2} \times 17\frac{1}{2}$
inches. Signed and dated 1878.
Ferrers Gallery, London.

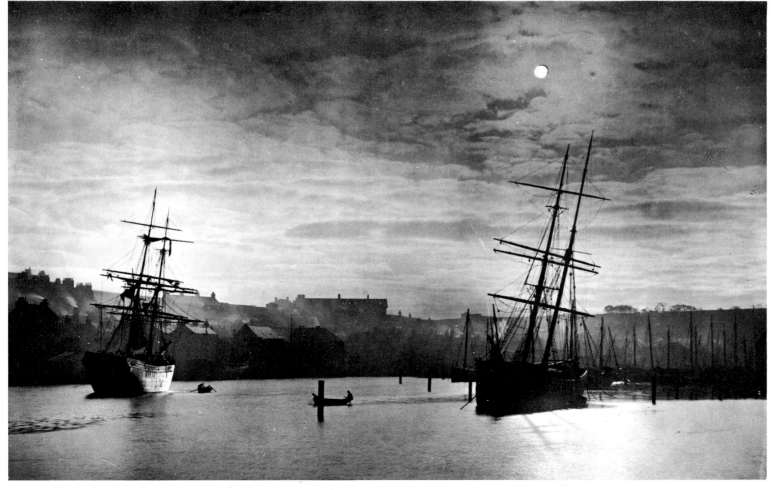

FRANK MEADOW SUTCLIFFE.
Whitby Harbour. Sutcliffe Gallery,
Whitby, Yorks.
 Photograph taken c. 1880–90.

HENRY PEACH ROBINSON.
Day's Work Done. Royal Photographic Society of Great Britain.
 Taken in 1877.

Opposite page, above:
DAVID ROBERTS, R.A. *Great Temple at Baalbek*. Panel. 30 × 42 inches. Mr John Goelet.
 Roberts painted at least nine views of Baalbek between 1840 and 1861.

Opposite page, below:
View of Baalbek. Radio Times Hulton Picture Library, London.
 Sepia photograph taken c. 1870-1880.

Below left:
EADWEARD MUYBRIDGE (1830-1904). *Galloping Horse*. Victoria and Albert Museum, London.
 Taken in 1883-5. Muybridge's experiments, published in 'Animal locomotion' (1887), together with the experiments of E. J. Marey and J. D. B. Stillman revealed for the first time movement which could not be perceived by eye. Also revealed was the unreality of the 'rocking-horse' motion adopted by Sporting and Battle painters for centuries. W. G. Simpson wrote in 'The Magazine of Art' (1883): 'It is not a renaissance we are to expect, but a revolution; for it appears that, except now and again by accident artists from all time have wrongly represented the paces of Quadrupeds.'

Below right:
STANLEY BERKELEY. *For God and the King*.
 From a detail of an etching after *For God and the King* by Stanley Berkeley exhibited at the Royal Academy in 1889.

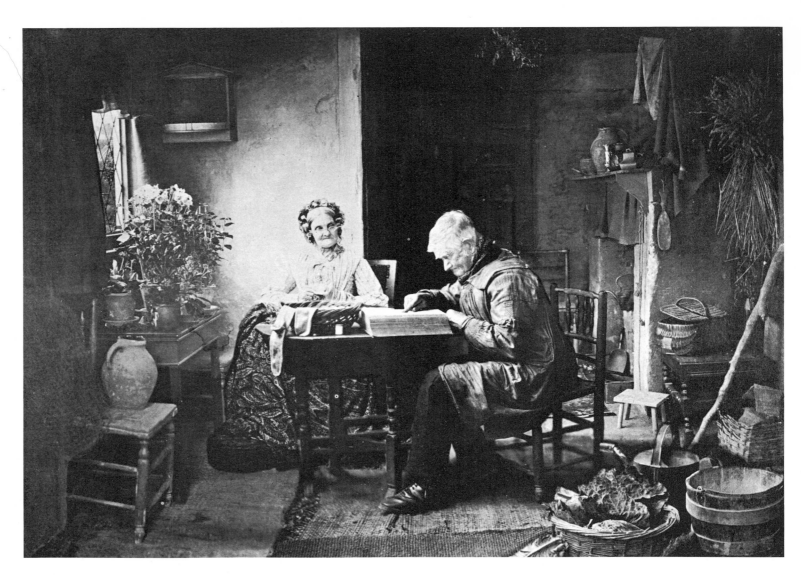

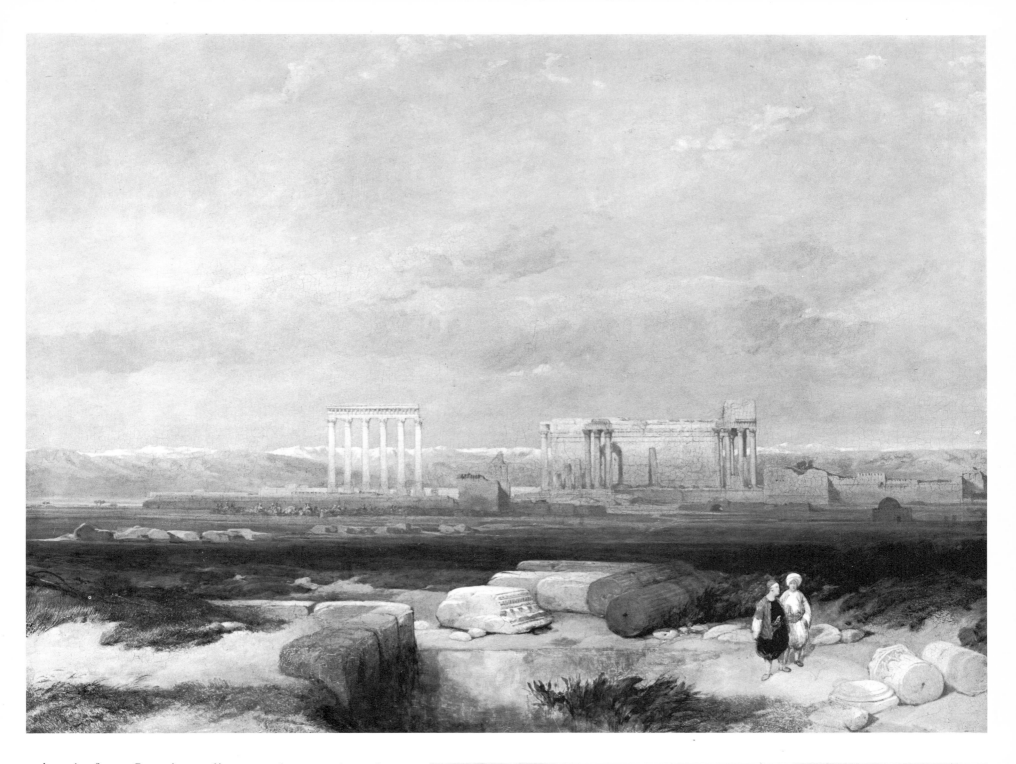

painter's feet. One immediate result was that the Academies of the world were inundated with battle pictures, showing horses charging in every direction, with all four legs off the ground. Not since 1815 had the Battle of Waterloo been so popular! Another result of these movement photographs was more subtle: once it was found the new treatment of movement represented visual truth, the critics of hard-edge Pre-Raphaelitism found the static representation of nature less palatable than ever. Charles Kingsley, for instance, criticized the lack of movement in Pre-Raphaelite pictures for being 'unnatural'. What they tried to represent as still 'never yet was still for the thousandth

WILLIAM HENRY HUNT. *Bird's Nest with Briar Rose.* Water-colour. 7⅞ × 8¼ inches. Signed. Mr and Mrs Cyril Fry.

Painted in about 1850. Hunt occasionally helped photographers to compose the subjects for still-life photographs.

Above right:
LONDON STEREOSCOPIC COMPANY. *Bird's Nest.* c.1852. Radio Times Hulton Picture Library, London.

Whistler's Photograph Album. Department of Fine Arts, The University, Glasgow.

part of a second'. They strove 'to set a petrified Cyclops to paint his petrified brother'. ('Two Years Ago', 1857). Photography had already made panoramic paintings like *Derby Day* a possibility. Now movement, as recorded by the camera lens, had entered the artistic consciousness.

The uses of photography in printing entirely altered the character and direction of the pictorial arts allied to painting. Frith lamented in his memoirs that photography 'bids fair, in the modern shape of photogravure, to destroy line, and all other styles of engraving, as effectually as it has put a stop to lithography'. What Frith does not mention is that photography, in its auxiliary uses, popularised his pictures and those of his contemporaries to a hitherto unattainable degree, thereby enabling many a Victorian artist to lead a life of comfort, or even luxury, on the proceeds of mass distribution. Furthermore, the photographing of treasures throughout the world, the use of photographs in lectures (a practice Ruskin was not slow to adopt), and reproductions in books and periodicals, all led to a rapid dissemination of knowledge and the formation of taste. Photographs of archaeological sites, like Pompeii, and others of antiquities in Greek and Italian museums rapidly familiarized the public with the objects and background in paintings by the

neo-classicists, such as Leighton and Alma-Tadema, who themselves surely benefited from the study of photographs and reproductions to obtain archaeological accuracy. Alma-Tadema was, in fact, an active photographer: Birmingham University owns no less than a hundred and sixty-four volumes of his photographs of archaeological sites and classical antiquities. Whistler, who, after the discovery of Tanagra in the 'seventies, was strongly influenced by Hellenistic terracotta statuettes and other objects of classical antiquity, owned an album of photographs of such pieces. No other invention ever rendered painting such a service.

XIV

PORTRAITURE

'Painting is worthless, except portrait painting'—Carlyle

The death of Sir Thomas Lawrence in 1830 marked the end of the great age of portrait painting in England. Had there been a painter of equivalent mastery who aspired to succeed him, it is doubtful whether, under the prevailing conditions, he could have stayed the course. The irruption of photography, changing social conditions, the popularity of genre painting, the long-awaited triumph of landscape painting for which Gainsborough had earlier hankered, and the prestige of High Art, all conspired to reduce the

chances of the Victorian portrait painter. This is not to say that no portraits were being painted, merely that few painters, and these mostly of moderate talent, succeeded in making a living almost entirely out of portraiture.

Photography had emerged as a symbol of the forces of democracy. The procedure of having one's likeness committed to canvas was regarded as either an act of canonization, or as pleasing documentary evidence that one existed, or, better still, that one had attained, through breeding, money or both, a high level of civilized existence. Now, however, an accurate likeness could be obtained in a few minutes for sixpence or a shilling (Mayhew's 'photographic man' boasted that he took as many as a hundred and forty six photographic portraits in one day, 'and the majority was shilling ones'). So having a likeness recorded was no longer the preserve of the rich and the aristocratic. Moreover, the blandishments of High Art engendered contempt for portraiture. Barry, Haydon and the young Watts all regarded portraiture as a last resort, amounting to no more than a tiresome interruption in their pursuit of lofty idealism. When Lord Holland talked Watts into painting Lady Holland, Haydon could scarcely contain himself. Though Watts, he said, went to Italy 'for Art, for High Art, the first thing the

WILLIAM ETTY, R.A. *Mlle Rachel.* Millboard. 24 × 18 inches. City of York Art Gallery, York.

The identity of the sitter is based on a similarity with other known portraits. The sitter's real name was Eliza Félix (1821-1858), a great French tragedienne. The portrait was probably painted on her first visit to England in 1841.

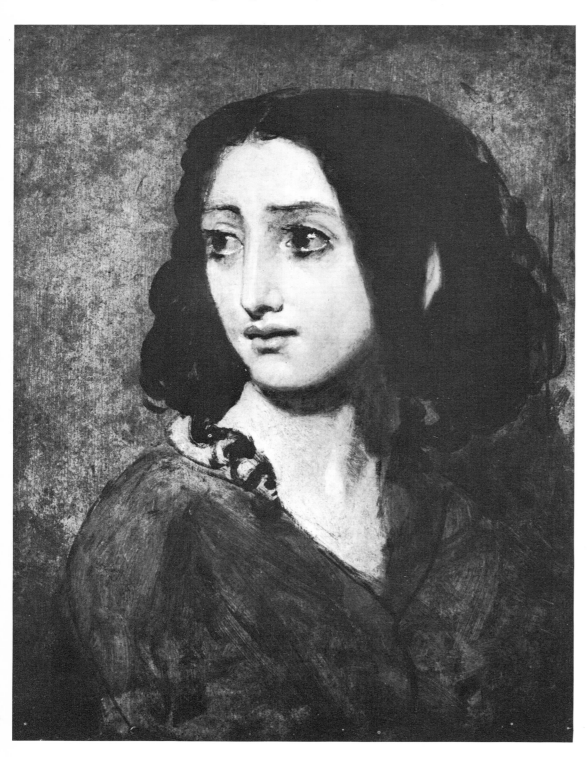

LORD LEIGHTON OF STRETTON, P.R.A. *Sir Richard Burton.* 23½ × 19½ inches. National Portrait Gallery, London.

Exhibited at the Royal Academy in 1876. This portrait of Sir Richard Burton (1821-1890), the famous explorer, was painted in that year.

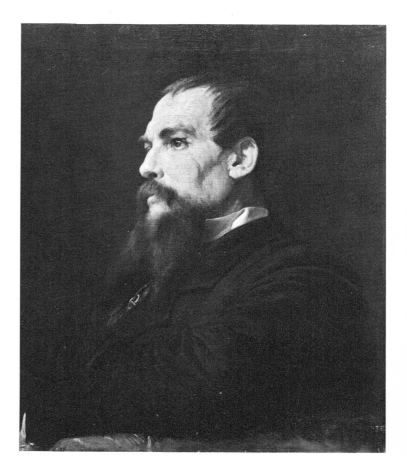

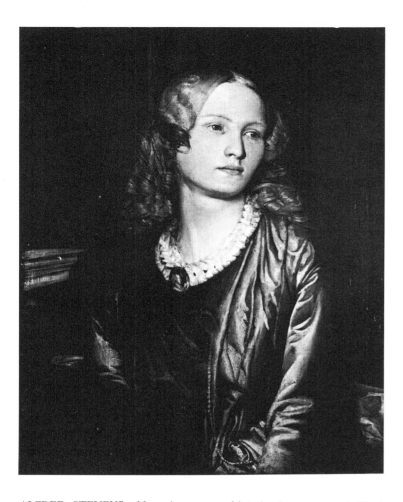

ALFRED STEVENS. *Mary Ann, Wife of Leonard Collmann*. $27\frac{3}{4} \times 21\frac{3}{4}$ inches. Tate Gallery, London.
Leonard Collmann, an architect and interior decorator, was a friend of Stevens and a fellow student in Florence. The picture was painted in about 1854.

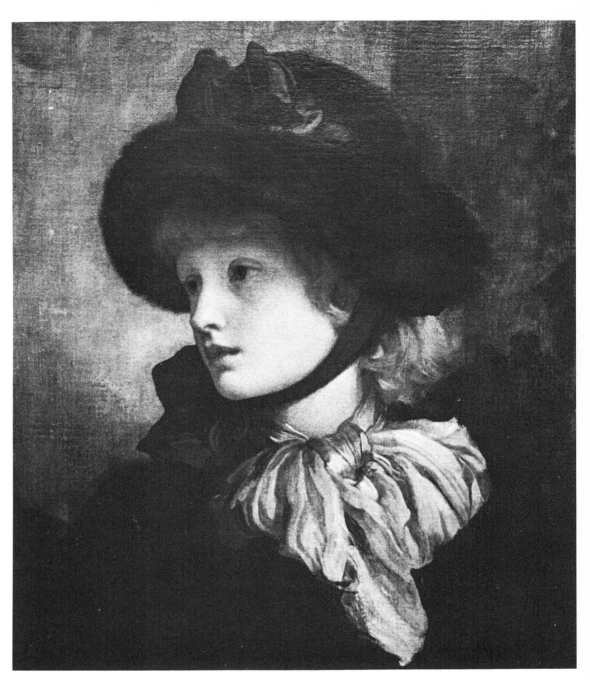

LORD LEIGHTON OF STRETTON, P.R.A. *Letty*. 19×16 inches. Stone Gallery, Newcastle-upon-Tyne.
Exhibited at the Royal Academy in 1884. This is a portrait of Lena Dene, the youngest of five sisters who had lost their parents. Four of the girls became favourite models with Leighton. Among the pictures for which Lena modelled were *Cymon and Iphigenia* (1884) and *Captive Andromache* (1888). The picture was much admired by Ruskin.

English do is to employ him on *Portrait*! Lord Holland I understand, has made him paint Lady Holland!! Is this not exquisite? Wherever they go, racing, cricket, trial by jury, fox-hunting, and portraits are the staple commodities first planted or thought of. Blessed be the name of John Bull!' When Haydon painted ninety-seven portraits in his vast *Reform Banquet*, Lord Jeffrey failed to identify a single person; and yet his ruminative portrait of Wordsworth is a *tour de force*, and evidence of the loss incurred through his sacrificing himself to High Art.

To most Victorian painters portraiture was little more than a side-line, and most of them practised it. In the early years these painters included Wilkie, Etty and Landseer. Frith, William Quiller Orchardson (1832–1910), James Sant (1820–1916), John Collier (1850–1934), James (Joseph-Jacques) Tissot (1836–1902), Hubert von Herkomer (1849–1914), Frank Holl (1845–1888) and Luke Fildes (1844–1927) were all subject painters who achieved, to a greater or lesser degree, distinction as portraitists. Of these, Holl and Fildes devoted themselves almost entirely to portraiture in their maturity. The Pre-Raphaelites and their associates contained some notable portrait-painters in their ranks, including Rossetti, Madox Brown, Sandys, Burne-Jones, Holman Hunt and Millais. With the exception of Madox Brown and Millais, the Pre-Raphaelites were, as would have been expected, very subjective in portraiture, which was usually integrated with their distinctive creative vision. John Linnell was the only notable landscape painter who could turn out the occasional portrait of distinction. Of the neo-classical painters, Leighton, Poynter and Alma-Tadema made successful portraits. Alfred Stevens, whose versatility makes him difficult to classify, painted a handful of outstanding portraits. G. F. Watts, on the other hand, is still considered as the foremost Victorian portrait painter before the arrival of Sargent, although he regarded this genre as second in importance to his allegorical painting.

The effect of photography on portraiture has been

discussed in the previous chapter. It is worth considering here one more aspect of this effect, however, in some statistics culled by Mr David Piper. Out of a total of 1,278 exhibits at the Royal Academy exhibition of 1830, just over half were portraits, of which three hundred were miniatures or small water-colours, and about eighty-seven in sculpture. At the 1870 Academy, portraits accounted for a bare fifth of the exhibits, while the number of sculptures (fulfilling a three-dimensional function denied to photography) actually increased to one hundred and seventeen. And what were the portraits like? As Dickens's Miss La Creevy says, 'there are only two styles of portrait painting; the serious and the smirk'. Thanks to the searching camera lens, the 'serious' was gaining ground, but throughout the century there was a steady demand for the pretty full-length, which could hang alongside ancestral portraits by Reynolds, Gainsborough and Romney. One of the best and most typical of the painters who supplied these was Richard Buckner (exhib. 1842–1877), 'a most kind and honest man', who had advised Leighton on the despatch of *Cimabue* from Rome. Millais, whose portraits contain echoes of

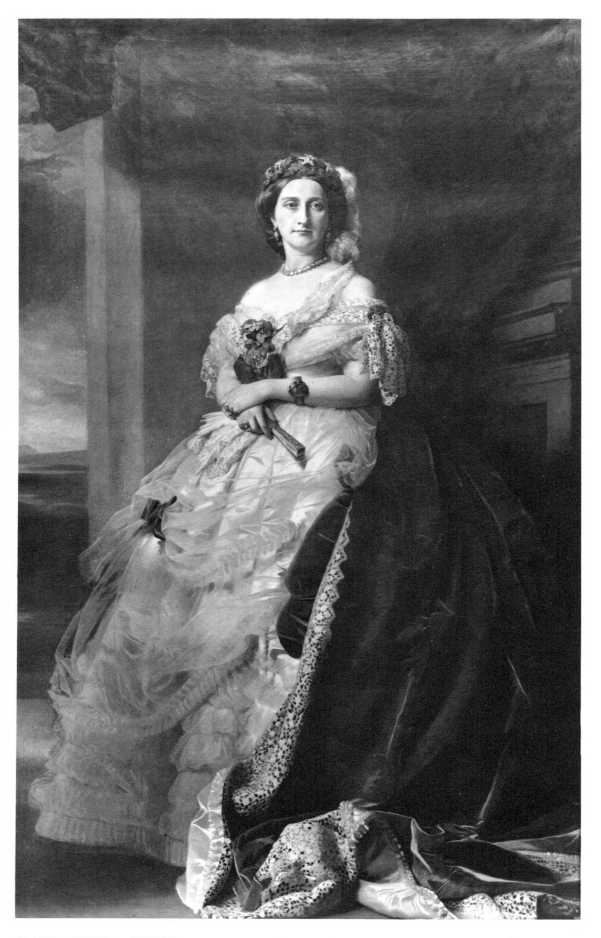

FRANZ XAVER WINTER-HALTER. *Lady Middleton*. 94 × 58 inches. Signed and dated 1863. The Rt Hon. Lord Middleton.

Julia Louisa Bosville married Henry, 9th Lord Middleton in 1843.

SIR JOHN EVERETT MILLAIS, Bt., P.R.A. *Only a Lock of Hair*. Panel. 14⅜ × 10⅜ inches. City Art Galleries, Manchester.

Painted in about 1859. The sitter was Helen Petrie.

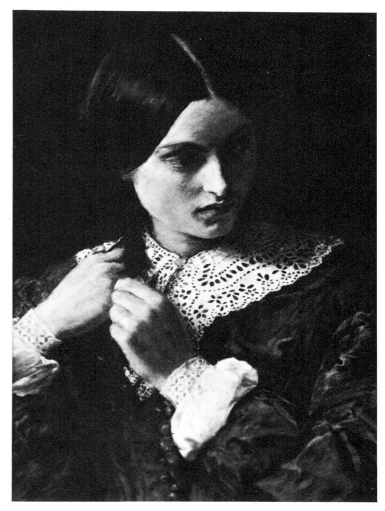

Velasquez, Titian and Van Dyck, clearly sought to rival Reynolds's *The Ladies Waldegrave*, which he had seen at Strawberry Hill, in his lovely *Hearts are Trumps*. While, on the face of it, Velasquez gradually became the example to Victorian portrait painters (Francis Grant admitted that much of his success was owed to the Spanish painter, and Frank Holl became known as 'the English Velasquez'), Van Dyck, Reynolds and Gainsborough were still clearly discernible influences. New fashions in clothing tend to obscure this lineage. While the emergence of the hooped skirt in the 'forties, followed by the flowering of the crinoline, was grist to satirical draughtsmen, like John Leech and George Cruikshank, it was generally played down by the portrait painters, who often portrayed their subjects seated. Only the court painters, like the international Franz Xaver Winterhalter (1806–1873), and to a lesser extent, George Hayter, managed to do full justice to the crinoline.

The vanity, availability, ubiquity or downright reluctance of famous people to sit for portraits, and the accidents of chance, all played an important role in the Victorian era, as in any other. Thomas Carlyle, in many ways the embodiment of his age, was both vain and ubiquitous. In spite of his expressed contempt for artists, he regarded portraits as important documents. Even so, Carlyle's rugged features were frequently subordinated to the dictates of the artists'

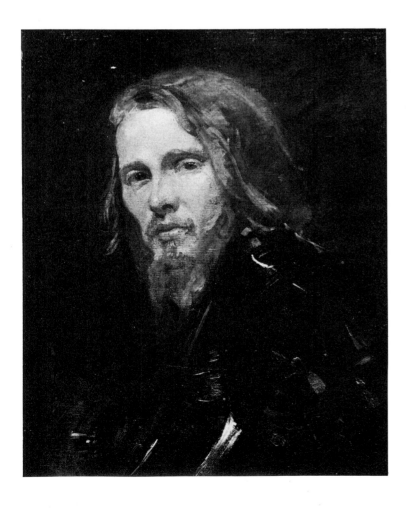

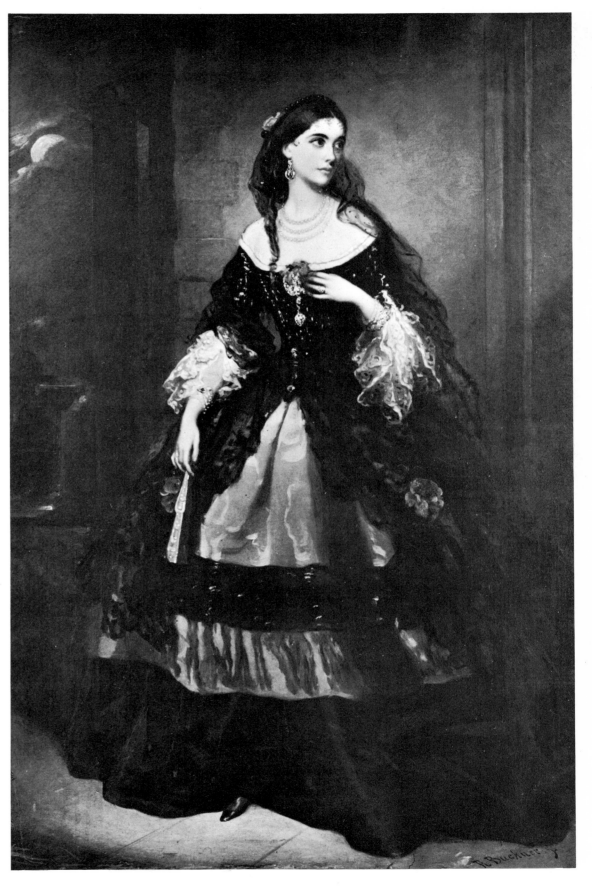

Left:
ALFRED STEVENS. *John Morris Moore.* 23½ × 18¾ inches. Tate Gallery, London.

Moore, a well-known connoisseur and 'Verax' of 'The Times' shared a studio in Rome with Stevens in 1840. This portrait probably dates from that year.

RICHARD BUCKNER. *Adeline, 7th Countess of Cardigan.* 48 × 30 inches. Signed. Edmund Brudenell, Esq.

Painted between 1858 and 1868.

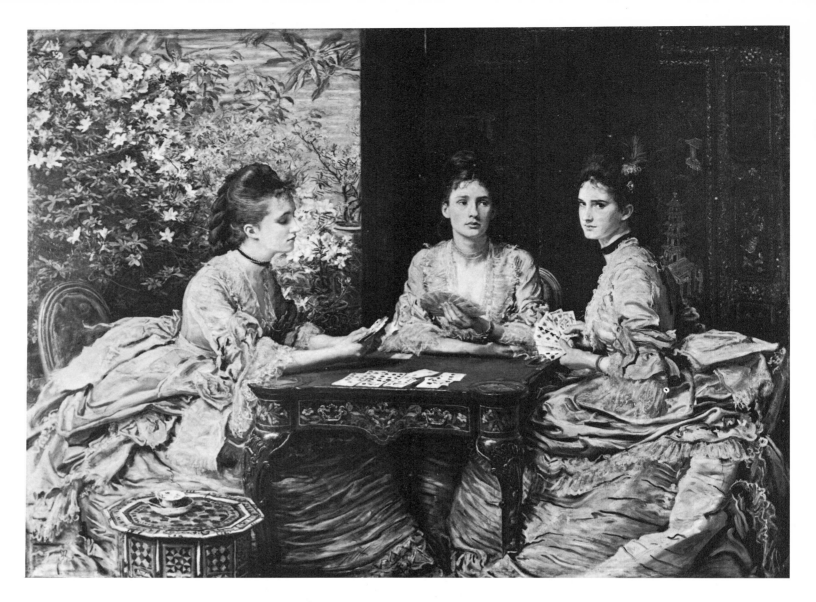

SIR JOHN EVERETT MILLAIS, Bt., P.R.A. *Hearts are Trumps*. 65¼ × 86½ inches. Signed with monogram and dated 1872. Tate Gallery, London.

Exhibited at the Royal Academy in 1872. Portraits of Elizabeth, Diana and Mary, daughters of Walter Armstrong, playing at dummy whist. Their dresses were designed by Millais.

creative vision, whether as a means to evoking a mood as in Whistler's famous portrait, or as part of the intense search for fundamental reality as in the case of Watts's apparently wayward portrait. G. K. Chesterton quotes Carlyle's disgusted conclusion on seeing it, that Watts had made him look 'like a mad labourer'. On reflection, Chesterton himself concluded that 'Watts painted Carlyle "like a mad labourer" because Carlyle was a mad labourer.' Watts and Millais could both enjoy the certainty of an endless supply of illustrious sitters, but a more wilful personality like Whistler was a frequent victim of chance. Clash of temperament no doubt contributed to his failure to go beyond one sitting for his portrait of Sarah Bernhardt. A long cherished desire to paint Disraeli seemed on the verge of fulfilment when he chanced upon the great man seated alone in St. James's Park. In answer to Whistler's hesitant request for the honour of painting his portrait, Disraeli 'gazed at him with lack-lustre eyes and murmured "go away, go away, little man".' As Graham Robertson, who tells the story, wrote, 'Whistler went, and with him

the great Poseur's chance of immortality on canvas. He shortly afterwards graciously assented to sit to Millais, who produced nothing in particular – to everybody's entire satisfaction.' On the other hand, Millais's finest portrait, which was also the finest portrait of Ruskin, resulted from the fraught propinquity of the two men at Glenfinlas prior to the breakdown of Ruskin's marriage to Effie and her elopement with Millais. Effie herself was a frequent model in Millais's pictures and the subject of many of his best portraits. Similarly, the women in Rossetti's life were transfigured in the mysteries of his poetic vision.

When Queen Victoria came to the throne, a number of portrait-painters practised in the long shadow cast by Lawrence. None of them attained his eminence. They included Martin Archer Shee (1769–1850), who succeeded Lawrence as President of the Royal Academy in 1830, an office which he held until his death twenty years later; in addition to his painting and official duties, he managed to publish poems, two novels and a play. Thomas Phillips (1770–1845) who in the early years of the century had painted sitters like

Byron, Blake, Scott, Southey, Crabbe and Coleridge, had a cool attractive style. Henry Perronet Briggs (1791–1844), as Baron Briggs, was the first, it will be remembered, in Thackeray's hierarchical exercise. Briggs, who was rescued from historical painting by portraiture, is best seen in his delightful studies and sketches. Francis Grant (1803–1878) was a portraitist of considerable style, at his best in an equestrian context. Grant became President of the Royal Academy, succeeding Eastlake in 1866 after the offer had been declined by Maclise and Landseer, and much to the disgust of Queen Victoria, who

wrote that Grant 'boasts of *never* having been in Italy or studied the Old Masters'.

The most indefatigable portraitist of all was Henry William Pickersgill (1782–1875), who was exhibiting portraits from 1806, a year after the Battle of Trafalgar, until 1872, a year after the Franco-Prussian war; few of the eminent escaped his brush, and when Phillips died in 1845, Pickersgill almost cornered the market. His portraiture was rarely more than adequate: the portrait of Wordsworth, for instance, is dully inarticulate compared with Haydon's. James Sant's exhibiting years were only two less than Pickersgill's. His picture

JAMES SANT, R.A. *The 7th Earl of Cardigan relating the Story of the Cavalry Charge of Balaclava to the Prince Consort and the Royal Children at Windsor.* 72 × 96 inches. Edmund Brudenell, Esq.

Portraits of James Thomas, 7th Earl of Cardigan (1797-1868) relating the story of the Charge of the Light Brigade to the Prince Consort and the Royal children at Windsor, 1854.

of *The 7th Earl of Cardigan relating the Story of the Cavalry
Charge of Balaclava to the Prince Consort and the Royal
Children at Windsor* is a typical Victorian group portrait.
He excelled, like Millais, in painting women. C. W.
Cope painted an interesting group portrait in *Selecting
Pictures for the Royal Academy,* which also provided a
glimpse inside this institution in the mid 'seventies.
Henry Tanworth Wells, the erstwhile miniaturist, who
turned to large scale portraiture in 1861, was a may-fly
by comparison with Sant, exhibiting for a mere fifty-
eight years. *Volunteers at the Firing Point,* though, reveals
a similar ability to paint a portrait group. His wife
Joanna Mary (1831–1861) was also a portraitist.
George Richmond (1809–1896), a member of a
dynastic painting family, and a friend of Blake, was a
distinguished artist whose ability to catch a likeness
was famous. His life-size chalk drawings of heads were
a formidable challenge to photography; he strained
after truth – 'Ah! but the truth lovingly told'. He only
began to paint in oils in 1846 and gave up regular

work in 1881, when he devoted some of his time to
sculpture. His sons, Thomas (1802–1874) and W. B.
Richmond were also very able portraitists. The
Scottish tradition of portraiture, stemming from
Raeburn, maintained by William Dyce in the
'thirties, persisted, though with a higher degree of
finish, through the work of John Watson-Gordon
(?1790–1864) to George Fiddes Watt (1873–1960).

The painters associated with the Pre-Raphaelite
movement were, on the whole, too preoccupied by the
literary content of their themes to spare time for
portraiture. This is something of a loss, since their
meticulous regard for detail and intensity of vision
were qualities which lent themselves to portrait
painting. However, their habit of using each other and
their friends as models resulted in a number of like-
nesses in their subject pictures, notably in the portraits
of the artist and his wife in Madox Brown's *The Last of
England* and the multiple portrait group in Millais's
Lorenzo and Isabella. According to W. M. Rossetti,

Elizabeth Siddal's best likeness is in *Ophelia*. Holman Hunt's portraits were all too few. The head of the fanatical Canadian fruit-farmer, *Henry Wentworth Monk*, at the National Gallery of Canada, conveys with subtle insight his subject's fervour. The Pre-Raphaelite movement produced at least one outstanding portrait painter in Frederick Sandys, a constantly impecunious but elegant friend of Rossetti, who considered him 'the most brilliant of living draughtsmen'. Esther Wood, who wrote a monograph on the artist during his life-time, saw in him a 'fearless portrayer of the more malignant aspects of womanhood'. Although she was referring to the tragic subject pictures, such as *Medea* and *Morgan Le Fay*, his portraits of old ladies such as *Mrs Anderson Rose* and *Mrs Jane Lewis* and old gentlemen like *The Rev. James Bulwer*, show him as an artist of penetrating yet not unkindly perception. His crayon portraits with their naturalistic facial features against mannered backgrounds, reminiscent of Rossetti, are the best of their kind since the early work of George Richmond.

It is to Watts that we must turn for the strongest link between the vanishing glories of the school of Lawrence and the new era of portraiture heralded by Sargent in the 'eighties. Compelled by the necessity to earn a living on his return to England from Italy in mid-career, he reluctantly took to portraiture with the bashful disdain of a retired army major obliged to augment his pension by administering the accounts of a golf-club. His friends, Lord Holland and the Prinseps, promised to introduce him to the most eminent people of his time. Thus Watts was confronted with a seemingly endless succession of the greatest, noblest and most powerful of the Victorians, and he brought to his portraiture the same high-minded attitude which had

CHARLES WEST COPE, R.A.
The Council of the Royal Academy selecting Pictures for the Exhibition. 57 × 86½ inches. Initialled and dated 1876. Royal Academy, London.
Exhibited at the Royal Academy in 1876. The group includes portraits of the President, Sir Francis Grant, J. F. Lewis, Leighton, Millais and the artist himself.

WILLIAM HOLMAN HUNT, O.M. *Henry Wentworth Monk*. 20 × 26 inches. Signed with monogram and dated 1858. National Gallery of Canada, Ottawa.

Exhibited at Liverpool in 1860. H. W. Monk (1827-1896) who was an early advocate of world peace and Zionism, was born and died in Canada. He met Holman Hunt in Palestine.

Below left:
ANTHONY FREDERICK AUGUSTUS SANDYS. *The Revd James Bulwer*. Panel. 29¾ × 21¾ inches. National Gallery of Canada, Ottawa.

Probably painted between 1861 and 1866. Bulwer (1794-1879) was a naturalist, antiquarian, and friend and pupil of John Sell Cotman.

Above right:
FORD MADOX BROWN. *Lucy Madox Brown*. Board. 6¼ inches diameter. Mrs Roderic O'Conor.

Lucy Madox Brown (1843-1894), herself to become a talented artist, was the artist's daughter by his first wife Elizabeth Bromley. This portrait probably dates from about 1848.

Below right:
SIR FRANCIS GRANT, P.R.A. *Mary Isabella Grant*. 50 × 40 inches. Leicester Museum and Art Gallery.

Exhibited at the Royal Academy in 1850. The sitter, who was the artist's daughter, died in 1854.

guided his essays in allegorical painting. It is difficult to escape the same conclusion as that arrived at by Chesterton, that Watts was as allegorical in his portraits as he was in his allegories, that 'he is allegorical when he is painting an old alderman'. To Watts, a portrait

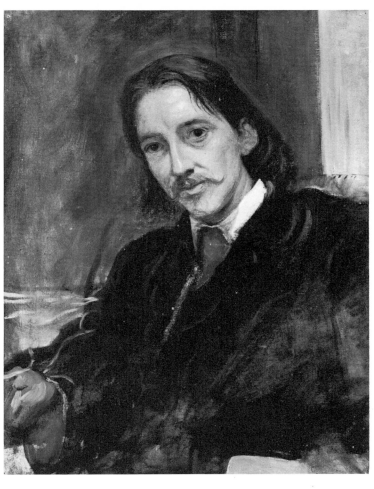

person, not the record of accidental position or arrangement of light and shadows.' No doubt this was a tilt at the way portraiture was going in the 'seventies. Whistler entitled two of his outright masterpieces, the portraits of his mother and of Carlyle, as *Arrangement in Grey and Black No 1* and *Arrangement in Grey and Black No 2*. Portraiture to Whistler was primarily a means to an induction of mood and the sitter was always carefully related to the background: it was an act of progressive refinement. Theodore Duret recalled that Whistler, with careful regard for colour and tone, brought his portrait nearly to completion, and then rubbed it out, starting all over again for as many as ten times. Like Sargent, Whistler brought to English portraiture the influence of Frans Hals, as well as the

Left:
SIR WILLIAM BLAKE RICHMOND, R.A. *Robert Louis Stevenson.* 28×21 inches. National Portrait Gallery, London.
This portrait of R. L. Stevenson (1850–94), the writer, was painted in 1887.

ANTHONY FREDERICK AUGUSTUS SANDYS. *Cyril Flower.* Coloured crayons. 25×20½ inches. Signed and dated 1872. Anthony Crane, Esq.
Exhibited at the Royal Academy in 1878. Cyril Flower was born on August 30th, 1843. Sandys was a friend of the Flower family, and painted portraits, similar in manner, of Cyril Flower's relations.

was not merely a likeness, but an interpretation and a revelation, compounded of mind and soul, of the sitter's greatness: 'He scarcely ever paints a man,' wrote Chesterton, 'without making him five times as magnificent as he really looks. The real men appear, if they present themselves afterwards, like mean and unsympathetic sketches from the Watts original.' The portraits of his friend Tennyson appear to us as sombre evocations of grandeur, but withdrawn and detached, and existing on a plane beyond the comprehension of ordinary mortals. The portrait of Tennyson when he was about fifty-four, at the National Portrait Gallery, bears a striking but fortuitous resemblance to the face on the Turin Shroud. It has been said that Watts could not paint women, but this is hardly true of his early period which produced, for example, *Lady Holland*, painted in 1844, and the portrait of *Lady Margaret Beaumont and her Daughter*, in the collection of Viscount Allendale. In charming portraits such as these, and in *Lady Holland in a Chapeau de Paille* in the Royal collection, Watts could forget himself and revel in sumptuous textures and alluring colours. His portraits are more accessible to us as paintings than are his allegories, and yet they appear as formidable symbols of an age which is still, to many, one of irritating grandeur and complacency.

'A portrait,' said Watts, 'should have in it something of the monumental; it is a summary of the life of a

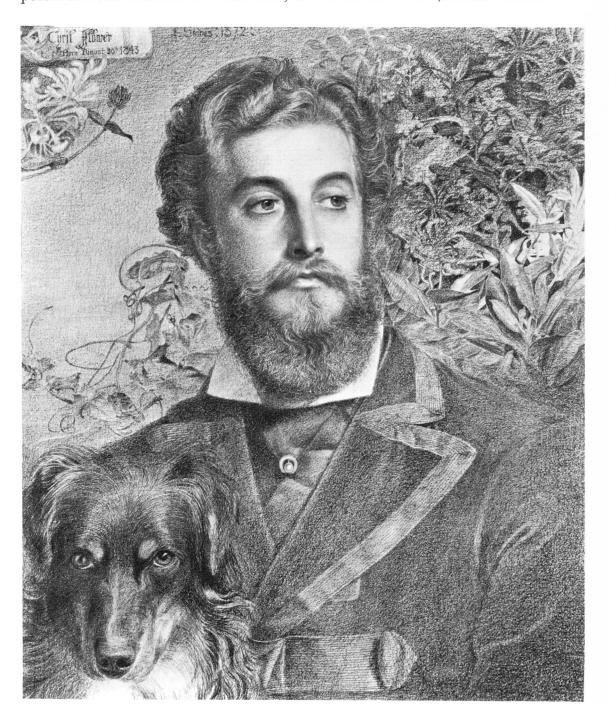

GEORGE FREDERICK WATTS,
O.M., R.A. *William Morris.*
$25\frac{1}{2} \times 20\frac{1}{2}$ inches. National Portrait
Gallery, London.
Painted in 1880. This portrait of
William Morris (1834-1896), soci-
alist, poet, artist and manufacturer,
is posed, appropriately, against a
background of wall-paper.

Opposite page, above left:
GEORGE FREDERICK WATTS,
O.M., R.A. *Lady Holland on a Day
Bed.* $14 \times 18\frac{1}{2}$ inches. Watts Gallery,
Compton.
This portrait of Mary Augusta,
Lady Holland (1812-1889) was pro-
bably painted at the Villa Roccella,
Naples where Watts stayed with the
Hollands in 1844-5.

Opposite page, below left:
JAMES McNEILL WHISTLER.
*Arrangement in Grey and Black, No 2:
Thomas Carlyle.* $67\frac{3}{8} \times 56\frac{1}{2}$ inches.
Signed with Butterfly device. Glas-
gow City Art Gallery and Museum.
Exhibited at 48 Pall Mall, 'Mr
Whistler's Exhibition', 1874. This
portrait of Thomas Carlyle (1795-
1881), painted in 1872-3, was one
of Whistler's earliest on a large
scale. *Arrangement in Grey and Black,
No 1: The Artist's Mother* had been
exhibited at the Royal Academy in
1872. Whistler recorded that when
Carlyle was ready for the first sitting,
he said: 'And now, mon, fire away!'
Noticing Whistler's surprise, he
added: 'If ye're fighting battles or
painting pictures, the only thing to
do is to fire away!'

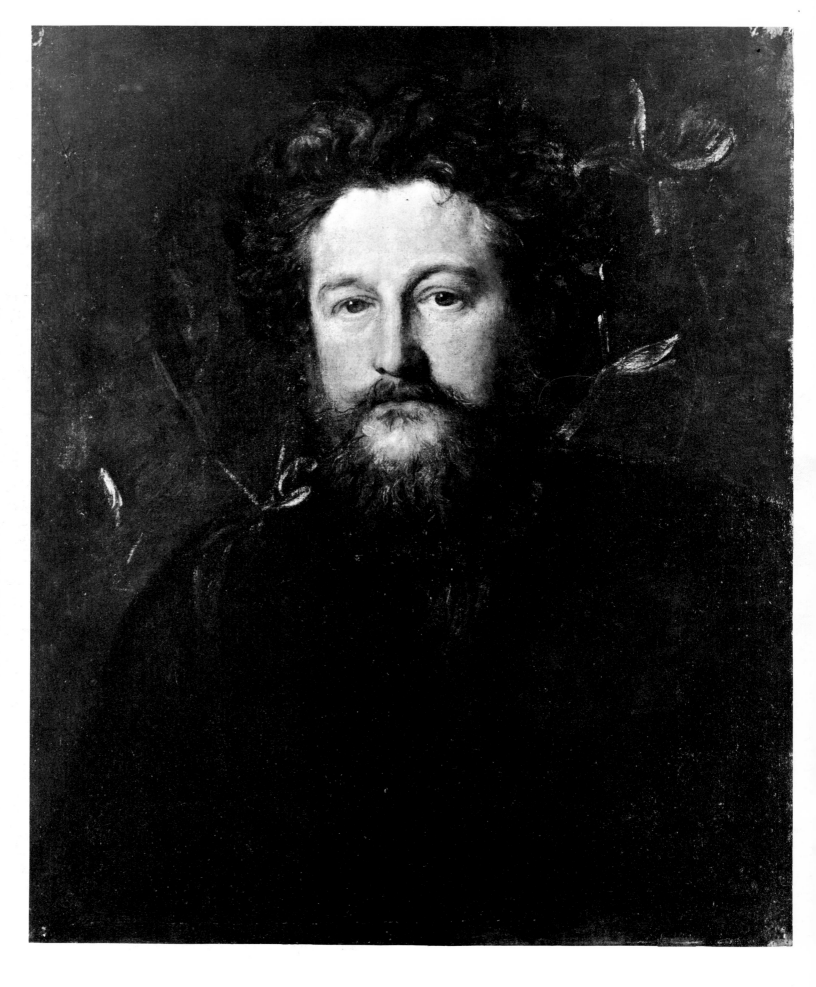

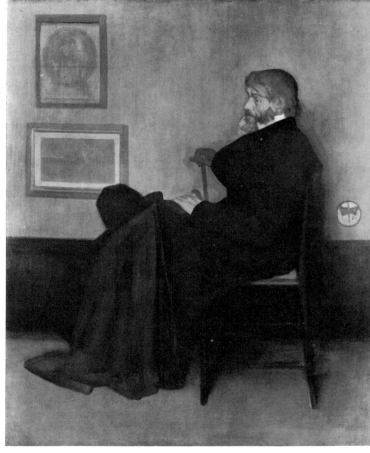

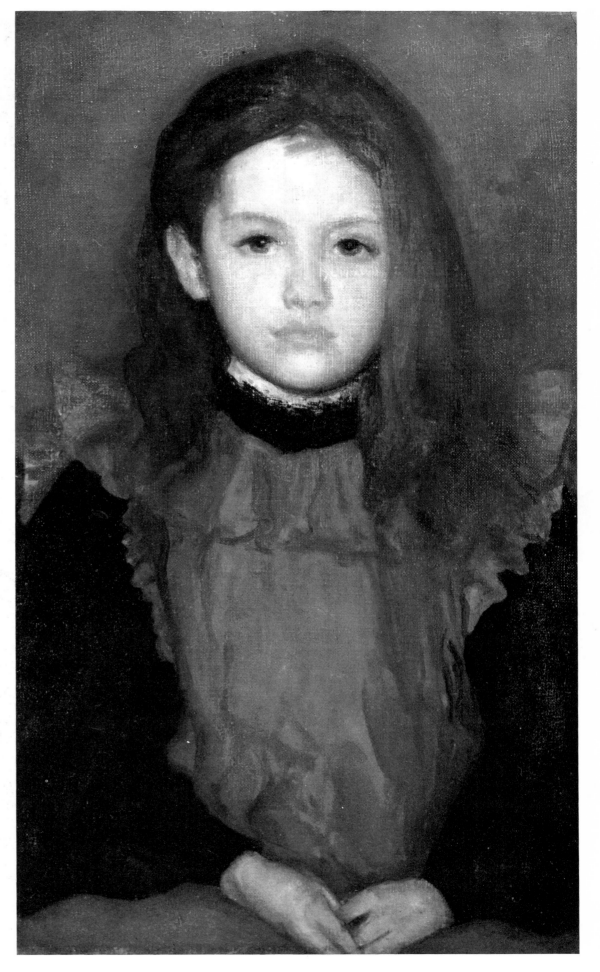

deepest influence of all, Velasquez, under whose spell he had fallen shortly after his first arrival in Paris. The broad silver-grey strokes of Velasquez's brush exactly suited his own means of expression. Whistler's portraits bear nothing of the artist's abrasive nature: even the thorny Carlyle is rendered into an endearing old man, but with no corresponding loss of power. His pictures, particularly of women and girls, are

JAMES McNEILL WHISTLER. *Little Rose of Lyme Regis.* 20¼ × 12¼ inches. Museum of Fine Arts, Boston, Mass.

Painted in the summer of 1895, while Whistler was staying at the Red Lion Hotel, Lyme Regis, Dorset.

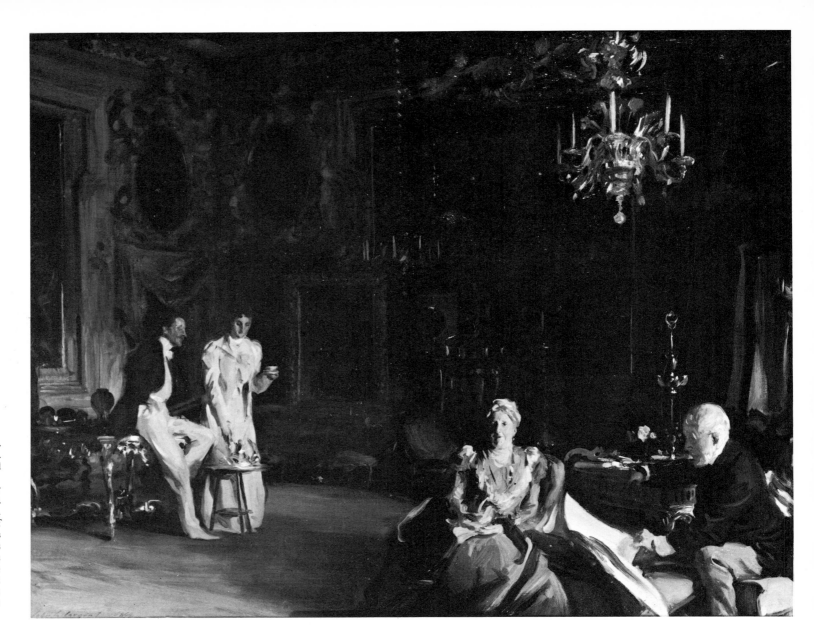

always charmingly affecting, even in the memory.

John Singer Sargent (1856–1925), who was born in Florence of American parents and settled – more or less – in London from 1885, was, even more than Whistler, a truly international figure. Apart from his European travels, especially in Italy, he crossed the Atlantic no less than twelve times between 1884 and 1906. With Sargent, portraiture took on an elegance and panache not seen since the time of Lawrence, and he portrayed a society no less glittering than that of the Regency. The Society which flocked to Sargent's studio was, however, more variegated than were Lawrence's aristocratic contemporaries, because it was a blend of the new, self-made, but cultured Jewish aristocracy, such as the Wertheimers, of the old aristocracy, which would have delighted Van Dyck, like Lord Ribblesdale and the Sitwell family, and of bevies of intellectuals and aesthetes. He oscillated between what Sickert called the 'wriggle-and-chiffon' school of Boldini, and a style of acute psychological

penetration, always deceptively cloaked with elegance. It was this last factor which gave Sargent's portraits their peculiar quality. No matter how beautifully Sargent would paint a lady's French gown, her satin and her furs, if she was vain and stupid, he could not refrain from saying so. The most that some people could hope was that the excellence of the former would conceal the discomfiture caused by the latter. 'It is positively dangerous to sit to Sargent,' an aspiring sitter said, 'it's taking your face in your hands.' But such was his reputation that the rich and the aristocratic, particularly the rich, donned their sartorial plumage and left the exploitation of their character to chance. This analysis of the sitter's character was the opposite to Whistler's method, which relied upon the psychological effect of his picture on the beholder. Sargent's outstanding portraits enshrined a whole way of life which ended with the Great War.

After Sargent and Whistler, portraiture in the 'eighties and 'nineties was in the familiar Victorian

pattern, a side-line mainly for painters whose real interests lay elsewhere. There were exceptions to the general rule, such as James Jebusa Shannon (1862–1923), a third painter of American birth, who was considered by some to rival Sargent; Charles Wellington Furse (1868–1904), who revived the equestrian portrait, out of favour since the days of Francis Grant; and John Lavery (1856–1941), an Irishman by birth, who became a leading artist of the Glasgow School.

These last three came to be known as 'The Slashing School'. Another trio, Frank Holl, Hubert von Herkomer and Luke Fildes, all at one time exponents of social realism in genre painting, made a success of society portrait painting. Holl was an extremely serious and gifted portraitist whose aim was 'to drag upon canvas the identity of the man himself'. In the period of nine years before his early death in 1888 he painted a hundred and ninety-seven portraits. Solomon Joseph Solomon (1860–1927), a convert from biblical and classical themes, did some of his best work in portraiture. The portraits of Wilson Steer, Henry Tonks, William Orpen (1878–1931), Ambrose McEvoy (1878–1927), William Nicholson and Sickert connect the Victorian era to modern times. When a way of life was extinguished in 1914, so was the flamboyant society portrait. After 1914, the dominant facial expression of nobility, rectitude or well-bred pride was replaced by one reflecting anxiety and uncertainty.

JOHN SINGER SARGENT, R.A. *The Misses Vickers.* 54 × 72 inches. Signed and dated 1884. Sheffield City Art Galleries.

Exhibited at the Royal Academy in 1886. The sitters are Florence, Mabel and Clara, daughters of Col. Thomas Vickers. It is said that the hanging committee of the Royal Academy finally accepted it only after Herkomer had threatened to resign.

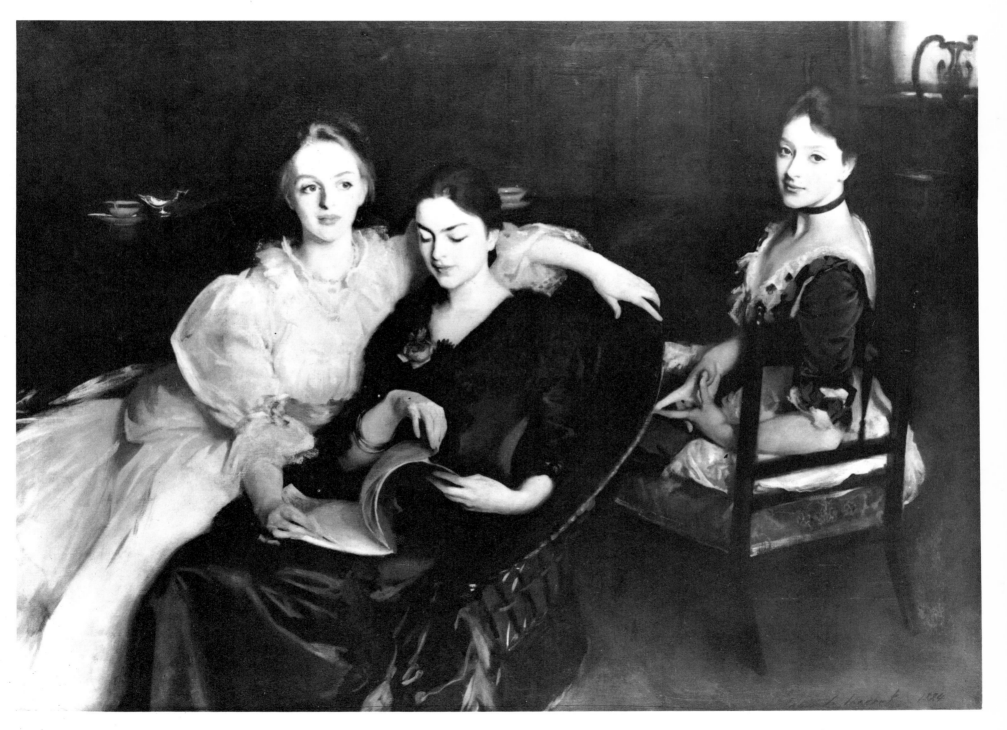

XV

LATER LANDSCAPE AND GENRE

JOHN WILLIAM INCHBOLD. *In Early Spring.* 20×13 inches. Signed. Ashmolean Museum, Oxford.
Exhibited at the Royal Academy in 1901.

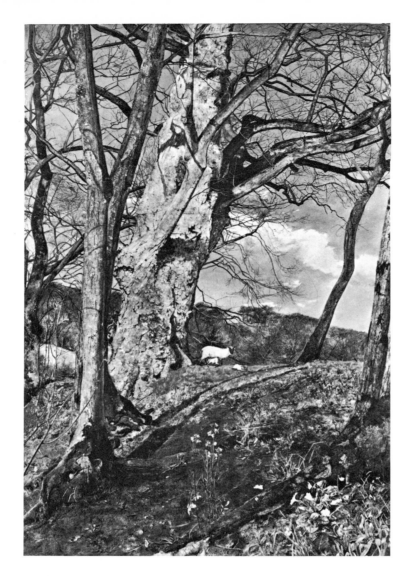

JOHN RUSKIN. *The Walls of Lucerne.* 14⅛×20 3/16 inches. The Ruskin Galleries, Bembridge School, Isle of Wight.
Cook and Wedderburn tentatively date this drawing 1866, but there is no evidence that Ruskin stayed in Lucerne at that time.

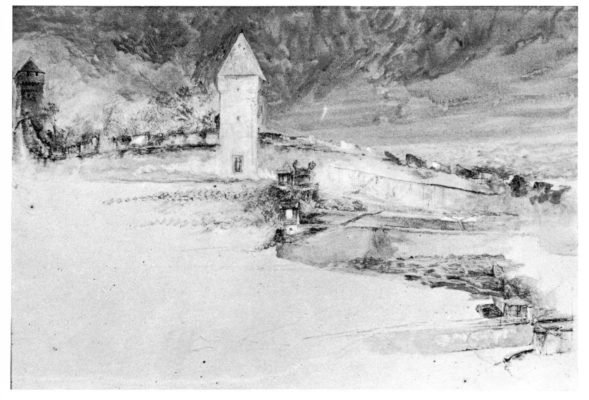

Landscape painting in the second half of the century ran a placid course, momentarily invigorated by the absorption of Pre-Raphaelite principles, until the late 'seventies and 'eighties, when the impact of Whistler and then of Impressionism, or rather the *pleinairisme* of Bastien-Lepage and the Barbizon School, had a strong effect. Had the indigenous influence of Constable been more directly felt, the English landscape tradition might have coped more readily with the unseasonable transplanting of foreign creative attitudes and techniques. Even the isolated attempts of Steer to pick up the threads direct from Constable were of little avail, and the English landscape painters continued to experiment in low-keyed approximations to Impressionism, long after the original movement had lost momentum and was being superseded by new ideas in France.

Meanwhile, old conventions died hard. Much of this was due to the prolonged survival of members of the old guard. Thomas Creswick and F. R. Lee, leaders of the popular landscape tradition, died in 1869 and 1879 respectively, although the latter ceased to exhibit in 1870 and, in well-breeched retirement, devoted the last years of his life to yachting and travelling. William Witherington, born three years after the death of Richard Wilson, was still exhibiting in 1863, the year after Whistler had made Chelsea his permanent home. Francis Danby had only ceased exhibiting in 1860 and Roberts showed his last two pictures in the following year. Palmer and Linnell, erstwhile friends of William Blake, were still active ten and eighteen years later; indeed Palmer lived until 1881, seven years after the first Impressionist exhibition was held in Paris. At this time the English, and for that matter almost everyone else, imagined that the French were painting landscapes in dark muddy colours, and Ruskin himself could single out the pictures of Edouard Frère for their 'quite immortal beauty'.

In England the great age of landscape painting was over, but a number of artists, some of more than casual interest, devoted all or part of their careers to it. Whereas in the pictures of Turner or Martin figures were literally dwarfed by landscape, and in the hands of Constable or Cox were, at the most, incidental, now, due largely to the Pre-Raphaelites, figures and landscape enjoyed equal status. Moreover, such a situation would be demanded in any picture with Pre-Raphaelite pretensions, since each part of the picture ideally required equality of treatment without favouritism. We have seen how outdoor naturalism had been pioneered in paintings like Hunt's *Strayed Sheep*, Madox Brown's *An English Autumn Afternoon* and *Walton-on-the-Naze*, and Dyce's *Pegwell Bay* and *George Herbert at Bemerton*. Dyce's landscape technique was not so adventurous as that of some of his contemporaries,

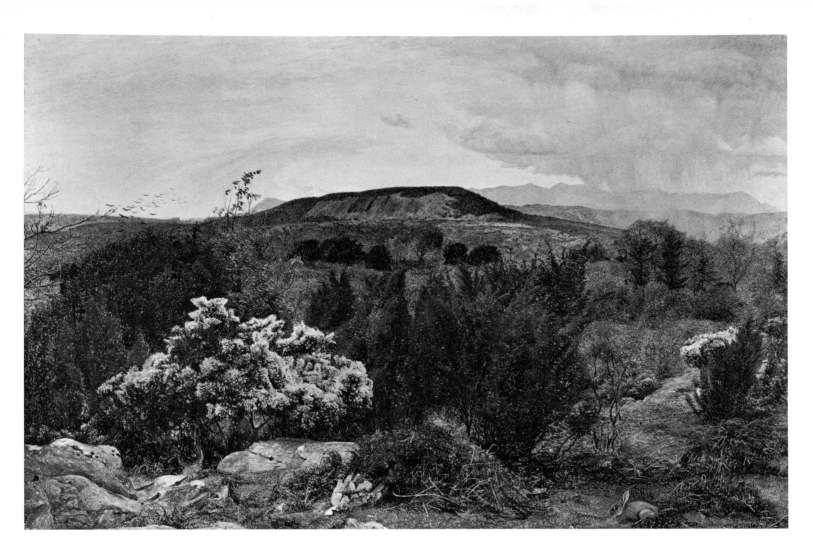

DANIEL ALEXANDER WIL-
LIAMSON. *Spring, Arnside Knot and
Coniston Range of Hills from Warton
Crag.* Panel. 10 × 16 inches. Walker
Art Gallery, Liverpool.
 Painted while the artist was living
in Warton-in-Carnforth, Lancashire
1861-4.

but it did avoid some of the excesses to which Pre-
Raphaelite technique was prone, such as congested
detail and unnatural colouring. Now other artists
demonstrated that they could successfully transfer
Pre-Raphaelite principles to landscape. John William
Inchbold (1830–1888), a native of Leeds, and Daniel
Alexander Williamson (1823–1903) were pre-eminent.
Inchbold enjoyed the blessing of Ruskin, who almost
killed him with critical kindness, chiding him like a
schoolboy when acting as his host in Switzerland. His
work was uneven but at his best he excelled at ren-
dering distant mountains, lakes and atmospheric
effects. Williamson, after a humble start, became a
well-educated man, an excellent musician as well as a
painter and the possessor of a pleasing tenor voice. The
landscapes of his middle period are no less effective
than those of Inchbold, but, perhaps because he lacked
the right kind of encouragement, he was later com-
pelled to adopt a broad Cox-like technique. William J.
Webbe (fl. 1850–1860) shows in his work the influence
of Holman Hunt, particularly in his fondness for sheep.
Richard Richards (1839–1877), another native of
Liverpool, is a little-known artist of limited output
who, at his best, could rival Brett. The landscapes of
William Davis (1812–1873), an Irishman who made

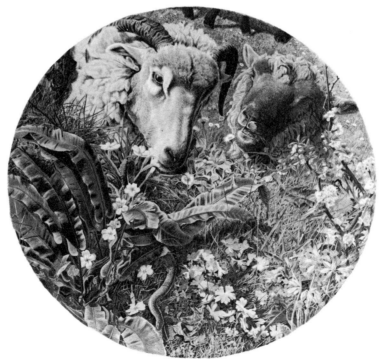

Liverpool his home, have much in common with those
of Madox Brown, and were admired by him and
Rossetti. Richard Redgrave (1804–1888), owing to the

Pegwell Bay by William Dyce is
reproduced in colour on p. 237.

WILLIAM J. WEBBE. *A Hedge-
Bank in May.* Diameter 11 inches.
Signed and dated May 1854. Dr
Jerrold N. Moore.

JOHN RUSKIN. *View of the Salève*. Water-colour. $4\frac{1}{2} \times 7$ inches. Inscribed and dated 'Feb 18 1863'. Mr and Mrs Eliot Hodgkin.

The Salève was a favourite haunt of Ruskin. On the 12th February 1863 Ruskin wrote to his father: 'This afternoon at 4 o'clock I was lying all my length on the grass on the precise and exact summit of the Salève, in a calm of soft sunset . . . The summit, owing to the strong drift of wind over it in storms, is quite free of snow and the perpetual sunshine of these last days has dried it into a summer bank. All round the snow lay in sweet, crisp fields . . .'

Opposite page, above:
JOHN ATKINSON GRIMSHAW, *Shipping on the Clyde*. Board. 12 × 20 inches. Signed and dated 1881. A. Class, Esq.

BENJAMIN WILLIAMS LEADER, R.A. *The Churchyard at Bettws-y-Coed*. 32 × 53 inches. Signed. Guildhall Art Gallery, London.

This picture may be *A Welsh Churchyard* exhibited at the Royal Academy in 1863.

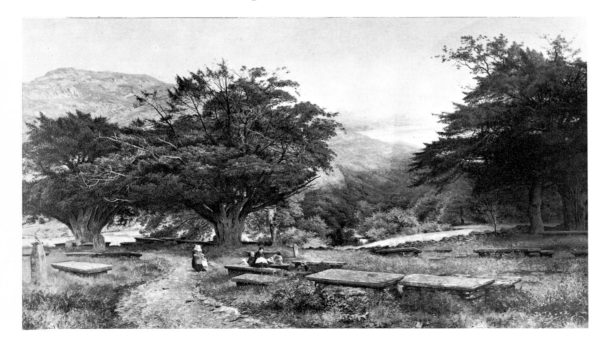

pressure of official duties, confined himself to painting landscapes out of doors during summer holidays: '*The Valleys also stand thick with Corn*', at the Victoria and Albert Museum, is a delightful example of his talent. At the same museum is the sole surviving landscape painted by Richard Burchett (1815–1875), *A Scene in the Isle of Wight*, which is no less successful than Redgrave's.

February Fill-Dyke, painted in 1881 by Benjamin Williams Leader (1831–1923), represents the popular equivalent in landscape of Millais's *Bubbles*. As an expression of mood it rivals the work of Atkinson Grimshaw. It also represents the ultimate, or perhaps the nadir, of the applied principle of 'Truth to Nature', as it was understood at the time; and to those who imply a criterion when they say 'it is as good as a photograph', the picture is an unqualified success. Leader, who assumed, in his day, the mantles of both Creswick and Lee, matched their achievement. Cecil Gordon Lawson (1851–1882) and Frederick Lee Bridell (1831–1863) were individualists who died early. Lawson achieved a certain celebrity before the age of twenty-five; his landscapes are permeated with poetry and reflect his early love for Dutch landscape painting. The paintings of the Farquharsons, David (1840-1907) and Joseph (1846–1935), are, within their modestly prescribed limits, far from contemptible: Joseph's, in particular, with their snowy landscapes and sheep bathed in the light of the setting sun, have a kind of sentimental primitiveness about them. William White Warren (c.1832–c.1912), is one of the very few artists who continued to paint successfully within the shadow of Constable. Working in London and Bath, he exhibited until 1888. But he made little impact in comparison to George Vicat Cole (1833-1893), who achieved almost the popular success of

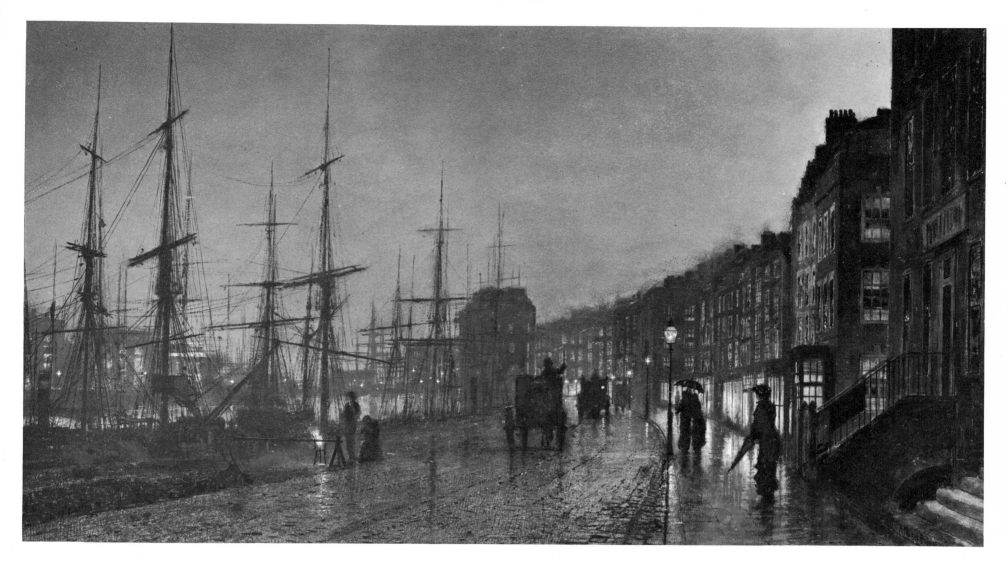

Leader. Vicat Cole's smaller landscapes have the same easy accessibility as those of Lee and Creswick, but *The Pool of London* at the Tate Gallery shows that he was quite capable of grander effects.

Two artists made a highly individual contribution to late nineteenth century landscape painting. George William Mote (?1832–1909) was the gardener and caretaker for Sir Thomas Phillipps, the famous collector of manuscripts, who lived at Broadway, Worcestershire. Mote was a genuine primitive, rather akin to the *Douanier* Rousseau. His early landscapes, especially, are strange, very personal evocations of the countryside, often seen through an open window. He eventually became a full-time painter, but his later work shows that he had lost some of the original intensity of his vision. John Atkinson Grimshaw (1836–1893) on the other hand managed to sustain, if unevenly, a deeply poetic vision until the end of his life. His scenes of urban and rural lanes, with leafless trees etched against the moonlit sky, and the nocturnal views of Whitby and Liverpool, are a powerfully evocative Victorian extension of the 'moonlight Pether' tradition. That he was repetitive is undeniable,

GEORGE WILLIAM MOTE.
Snow at Middle Hill. 13½ × 21½ inches.
Signed and dated 1861. Mr and Mrs

John Rickett.
Middle Hill is at Broadway, Worcestershire.

Liverpool Quay by Moonlight by Atkinson Grimshaw is reproduced in colour on p. 204.

MYLES BIRKET FOSTER. *The Hillside*. Water-colour. 12 × 17 inches. Signed with monogram. Guildhall Art Gallery, London.

but, as the Handbook of the Old Leeds Exhibition of 1926 says, 'this criticism may also be applied to the moon'. He was treated by contemporary artists with suspicion. The writer of his obituary in the 'Leeds Mercury' observed that his pictures 'showed no marks of handling or brush work, and not a few artists were doubtful whether they could be accepted as paintings at all'. Whatever his methods were (the affinity of his pictures to photography has already been discussed), the doubt still lingers. Yet his pictures are deservedly admired as an instance of late Victorian romanticism. Grimshaw's daughter has recorded that he helped Whistler, who was for a short time his near neighbour in Chelsea, with perspective. His son-in-law noted that Whistler 'confessed to Grimshaw that he had regarded himself as the inventor of "nocturnes" until he saw Atkinson Grimshaw's moonlights'.

Albert Goodwin (1845–1932) and Arthur Severn (1842–1931) were protégés of Ruskin, whom they accompanied to Italy in 1872. Goodwin, who had worked briefly for Holman Hunt and Arthur Hughes,

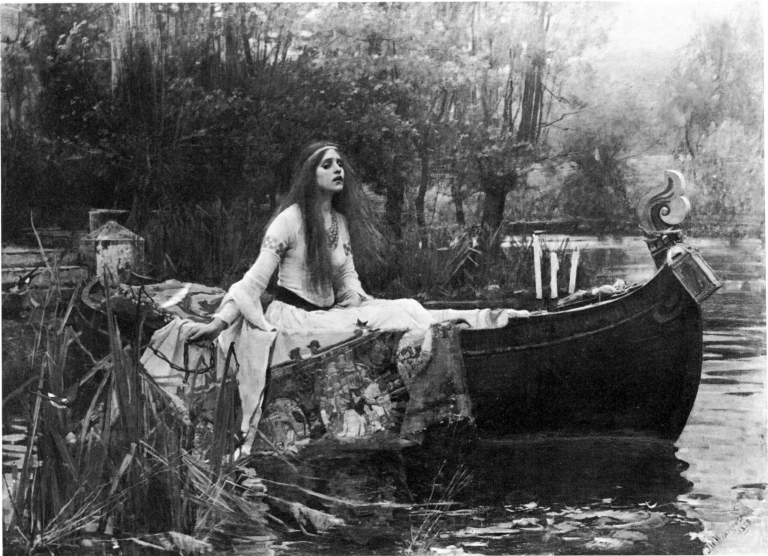

JOHN WILLIAM WATERHOUSE, R.A. *The Lady of Shalott*. 60¼ × 78¾ inches. Signed and dated 1888. Tate Gallery, London.

Exhibited at the Royal Academy in 1888. Waterhouse's career was a progression from classical restriction to a free application of *plein-air* techniques to subjects drawn from mythology.

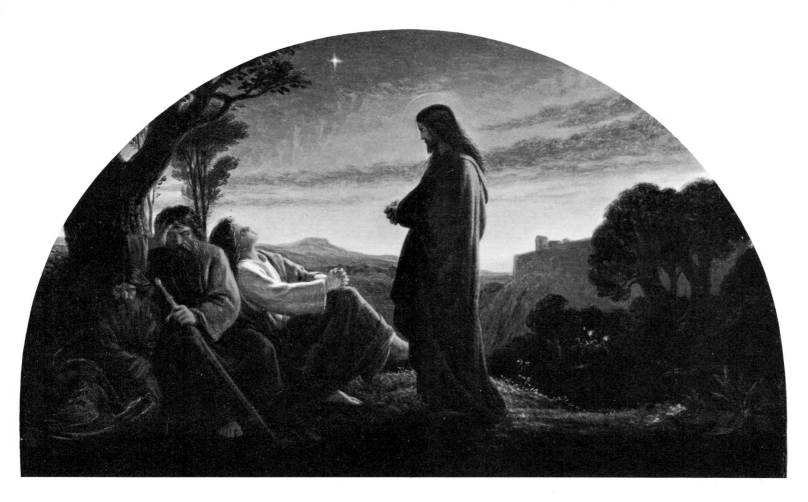

was introduced by the latter to Ruskin, who employed him to copy objects just as William Ward had been used for copying Turners. On their way to Italy, Ruskin took them up the Salève, where Severn and Goodwin made sketches of the setting sun. 'I think Arthur has beaten Master Albert this time', declared Ruskin. Goodwin, however, was the more accomplished painter. He had the ability to convey a sense of atmosphere with areas of nebulous washes flecked with calligraphic touches. Three other artists admired by Ruskin, Helen Allingham (1848–1926), Kate Greenaway (1846–1901) and Myles Birket Foster (1825–1899), all of them essentially illustrators, reflect the Victorian love for pictures of children frolicking in the countryside.

The borders between later Victorian landscape and genre painting were dominated by an amalgam of religious and mythological allegory and Arthurian and Dante-esque romance, all deeply permeated with diluted Pre-Raphaelitism. Henry Holiday (1839–1927) devoted much of his career to designing for stained glass; his attachment to the realistic treatment of Italianate romance is evident from *Dante and Beatrice*, at Liverpool, one of the most widely reproduced pictures of the late Victorian age. John William Waterhouse (1849–1917) began his creative life as a disciple of Alma-Tadema; never entirely deserting the Graeco-Roman world, he absorbed something of Rossetti's influence in the 'eighties, and illustrated themes from Tennyson. The Royal Academy's election of Frank Dicksee (1853–1928) as President four years before his death and twenty-eight years after Millais's election appears, although obviously not so intended, as a belated condonement of Pre-Raphaelitism in official circles. Following the pattern of Holiday, themes from chivalry and romance pervade Dicksee's work. Similarly the work of the Scotsman James Archer (1823–1904) underwent an Arthurian phase in the 'sixties, after which he devoted himself mainly to portraiture. The religious and mythological pictures of Joseph Noël Paton (1821–1901), who was once a fellow student of Millais at the Royal Academy Schools, often achieved, when they were not on too large a scale or when the artist was not too advanced in years, an almost mystical intensity, no doubt owing something to an early admiration for Blake. A beautiful and gifted amateur artist was Louisa, Marchioness of Waterford (1818–1891); a friend of Ruskin, Burne-Jones and Watts, she brought some of the rich Venetian colouring and some of the allegorical vein of the latter to her watercolours. The mythographic work of three painters, Edwin Austin Abbey (1852–1911), Robert Anning Bell (1863–1933) and Frederick Cayley-Robinson (1862–1927) was essentially decorative. Abbey, an

La Mort d'Arthur by James Archer is reproduced in colour on p. 256.

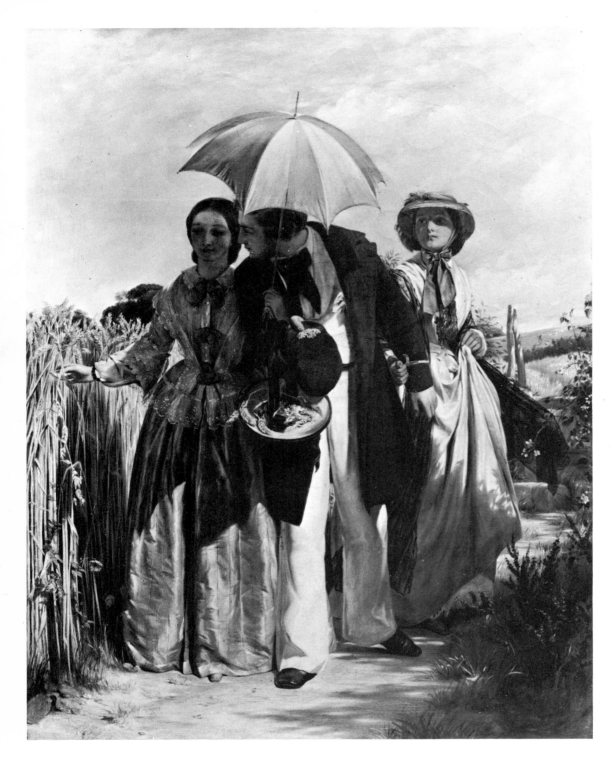

was an intimate friend of G. F. Watts, George William Joy (1844–1925), Henrietta Rae (1859–1928), whose *Psyche before the Throne of Venus* was one of the wonders of the 1894 Academy, Solomon J. Solomon (1860–1927), who later turned his talents to camouflage in the First World War, and Herbert Draper (?1863–1920), whose magnificent *The Lament for Icarus* is now at the Tate Gallery.

Genre painting pursued its variegated course till the end of the century. The strong position of Frith and the survival of those who practised in the Wilkie/Mulready tradition helped to shore it up until it could no longer withstand the onslaughts of Aestheticism. In the 'sixties and early 'seventies the prestige of the black and white illustrators, who turned to genre in oils and water-colours, lent it support; so also did the new element of social realism in the 'seventies. At this time the monopoly of scenes of rustic simplicity and urban squalor was broken by the intrusion of scenes from high-life, while French influence made for greater breadth of handling and a diminution of clutter. Two groups of painters kept the earlier tradition of genre alive. The first was a colony of artists who lived at Cranbrook in Kent. Its leader, Thomas Webster (1800–1886), in his affinity with William Mulready, appears as a link with the older artist. John Callcott Horsley (1817–1903) began his creative

American, was engaged for most of the 'eighties in painting murals for the Public Library at Boston, before exhibiting for the first time in England in 1890; Anning Bell and Cayley-Robinson were both experimental and versatile artists, who were clearly indebted to Puvis de Chavannes.

A number of other artists, who made regular contributions to the Academy exhibitions at this time, steered a somewhat opportunist course between themes taken from the Bible, classical antiquity and Northern legend. These included the illustrator John Gilbert (1817–1897), Val Prinsep (1838–1904), who

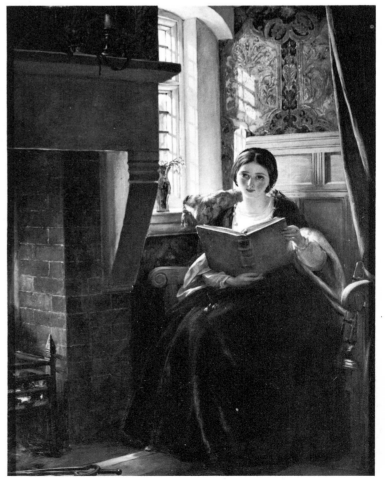

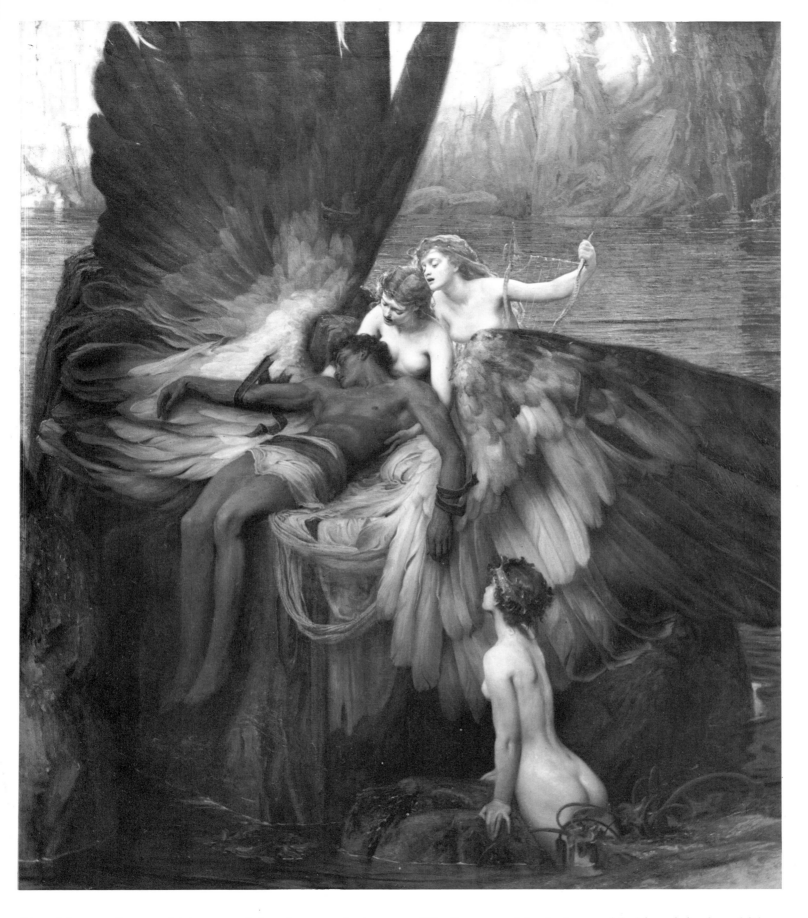

HERBERT JAMES DRAPER.
The Lament for Icarus. 72×61¼
inches. Tate Gallery, London.

Exhibited at the Royal Academy
in 1898, and purchased under the
terms of the Chantrey Bequest for
£840.

Opposite page, below:
JOHN CALLCOTT HORSLEY,
R.A. *A Pleasant Corner.* 30×22
inches. Royal Academy, London.

Exhibited at the Royal Academy
in 1866. This was Horsley's Diploma
Work; he had been elected R.A. in
1864.

life with grandiose ambitions, studying fresco painting in Munich and Italy and winning two prizes in the competition for decorating the Houses of Parliament.

His fresco perished along with his original ambitions and he devoted himself to painting scenes from rural and domestic life with sweetness and elegance.

233

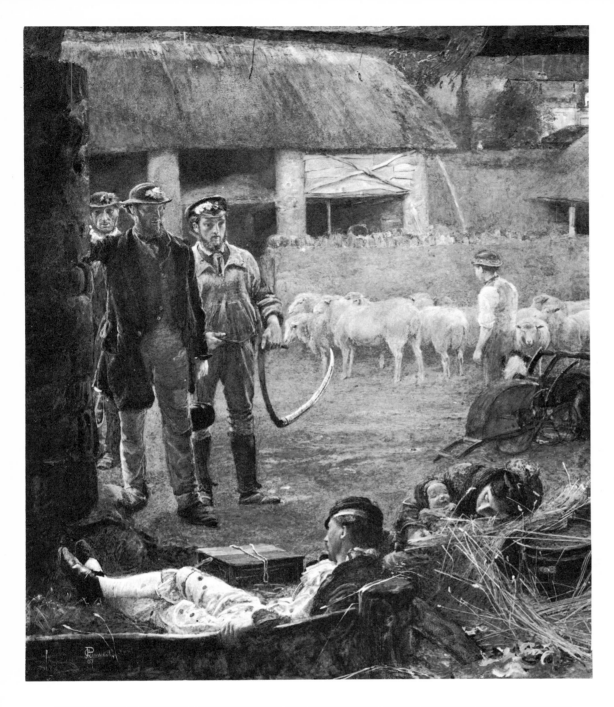

Webster's relative, Frederick Daniel Hardy (1827–1911), painted mainly domestic interior scenes, as did George Bernard O'Neill (1828–1917), who survived for twenty years after the last occasion on which he exhibited a picture. Possibly the most interesting of this group is A. E. Mulready (exhib. 1863–1886). This artist, about whom little is known, was, to risk a contradiction in terms, a sentimental social realist. Like so many of the more intriguing minor Victorian artists, he was repetitive, but the numerous little pictures of waifs, strays and ragamuffins are a true commentary on late nineteenth century poverty which, notwithstanding Lord Shaftesbury's philanthropic reforms, was still part of the social scene.

The second and larger group, known as the 'St John's Wood Clique', was more diffuse, its most unifying bond being a fondness for practical jokes. Its leader, Philip Hermogenes Calderon (1833–1898), was the son of a truant Spanish priest who joined the Protestant Church and later became Professor of Spanish literature at King's College in London. Calderon's first successful picture, *Broken Vows*, is a sharp essay in Pre-Raphaelitism. William Frederick

Yeames (1835–1918) was born in Russia, the son of a British consul. His *And when did you last see your Father?* represents to many the consummation of the historical genre picture, its very title a subject of mirth.

The work of the black and white illustrators of the 'sixties in such periodicals as 'Punch', 'The Cornhill Magazine' and 'Once a Week' had a strong formative effect on later genre painting. 'The Graphic' founded in 1869 by W. L. Thomas was the most influential of all. Some artists including Luke Fildes (1844–1927) and Frederick Walker (1840–1875), often later worked up their illustrations into oil paintings. 'The Graphic' was deeply committed to social observation, and from this stemmed the brief period of social realism in the 'seventies. Charles Keene (1823–1891) was an incisive graphic commentator, who too rarely digressed into oils. The successive deaths in 1875 of Frederick Walker, Arthur Boyd Houghton (b. 1836) and George John Pinwell (b. 1842), at the age of thirty-five, thirty-nine and thirty-three respectively, were a sad loss for English painting. All three were artists of tan-talizing promise. Even so, the work of Fred Walker took a strong hold over the imagination of his contem-poraries. He was described by Tom Taylor as a 'nervous, timid, sensitive young fellow, frail and small of body, and feverish of temperament'. Walker exhibited *The Lost Path* in 1863: although it was 'skied' at the Royal Academy and sold for a meagre sum, it was engraved six years later in 'The Graphic'. The pathetic figure of the woman carrying her child in the snow was reflected in Fildes's engraving, 'Houseless and Hungry', which he painted five years later under the title *Applicants for Admission to a Casual Ward*. Walker's friend Pinwell had a more volatile temperament, and his work is uneven; it seems that he never fully understood the chemical qualities of body-colour. 'Ah! my boys,' prophesied Arthur Boyd Houghton with rueful accuracy at Pinwell's funeral, 'you will be planting me here also before three months'. One of the ablest of the illustrators, he painted intermittently in oils throughout his short life. John William North (1842–1924) was more fortunate, surviving well into the present century. North influenced Walker, who occasionally drew the figures in North's pictures, as

FREDERICK WALKER, A.R.A.
The Lost Path. 36×28 inches. Signed and dated 1863. The Rt Hon. Lord Sherfield, G.C.B., G.C.M.G.

Exhibited at the Royal Academy in 1863. This picture, for which his sister, Mary, was the model, was Walker's first important oil-painting. Salt was used to convey an impression of snow on her dress. The subject was first used by the artist as an illustration to a poem, 'Love in Death' in 'Good Words' (March 1862). He used photographs as an aid, since, as he wrote in his diary, he felt 'anxious to begin carefully and from nature'.

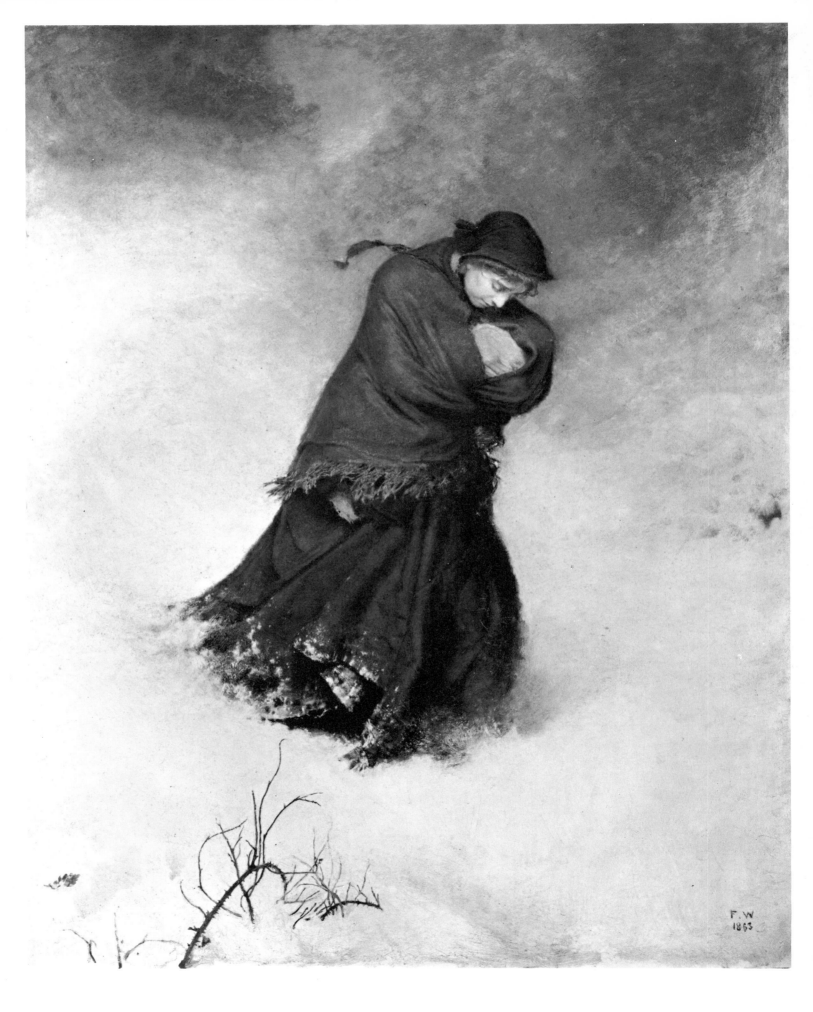

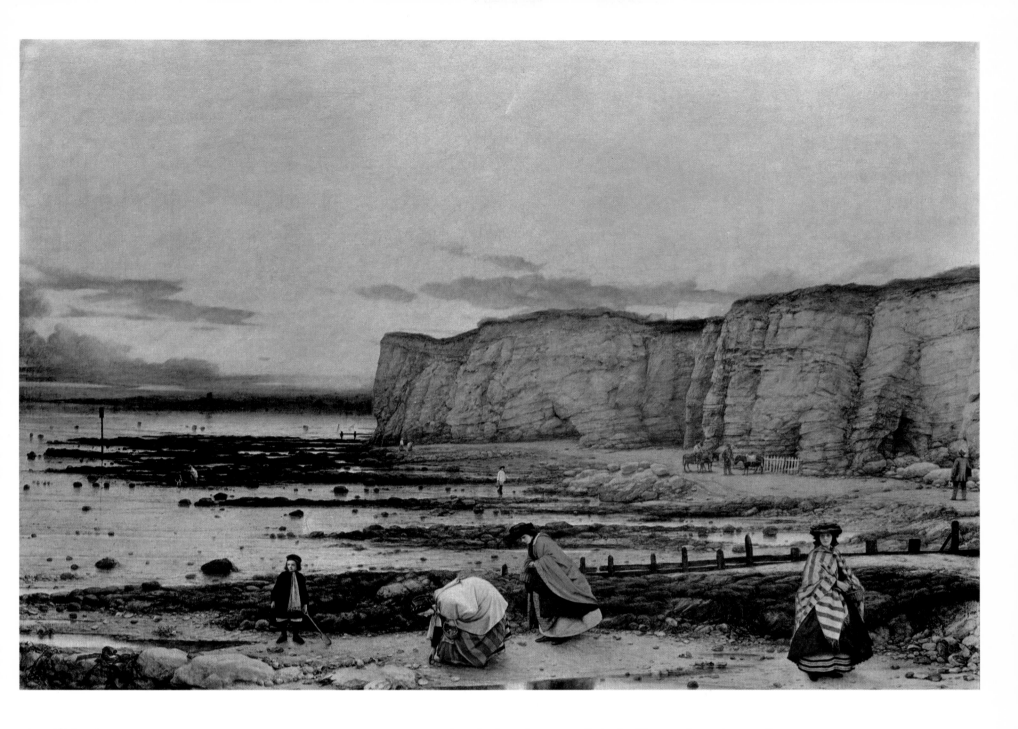

also did Pinwell. George Heming Mason (1818–1872) was another talented painter whose untimely death in the early 'seventies was a further blow to English painting; older than any of the young illustrators, he began to gain recognition at the same time as they did. John Dawson Watson (1832–1892) exhibited a number of domestic and outdoor scenes; *Children At Play* shows the application of Pre-Raphaelite principles. Although he was not an illustrator, the work of John Lee (fl.1850–1860), a Liverpool artist, is a striking testimony to the triumph of Pre-Raphaelitism in the provinces.

Frank Holl, Hubert von Herkomer (1849–1914), and Luke Fildes, were all early contributors to 'The Graphic'; they wrought pathos from social realism,

translated the themes of their illustrations into oil-paint, and, when genre painting began to fall out of favour, they all took to portraiture. Holl's *Newgate: Committed for Trial* is a movingly expressive picture, full of compassion. Herkomer, who was born in Bavaria and died in Budleigh Salterton, became a famous Victorian figure, gathering money and honours. An early admirer of Fred Walker, he was also an original stage-designer, and lived to design sets for the cinema. Herkomer claimed to have learned in England that 'truth in art should be enhanced by sentiment'. He was rarely sentimental, but his social realism is rather heavy-handed and clogged with over-emphasis, as can be seen in *On Strike*. Fildes painted some of the finest later genre pictures. He used to search for

WILLIAM DYCE, R.A. *Pegwell Bay, Kent – a Recollection of October 5th*, 1858. 25×35 inches. Tate Gallery, London.

Exhibited at the Royal Academy in 1860, this picture represents a continuation of the tradition of scenes at the seaside. Frith's *Ramsgate Sands* had been exhibited in 1854. The figures in the foreground of Dyce's picture are, from the right, his wife, her two sisters and one of his sons. Donati's comet is in the sky. *See p. 227.*

Children at Play by J. D. Watson is reproduced in colour on p. 256.

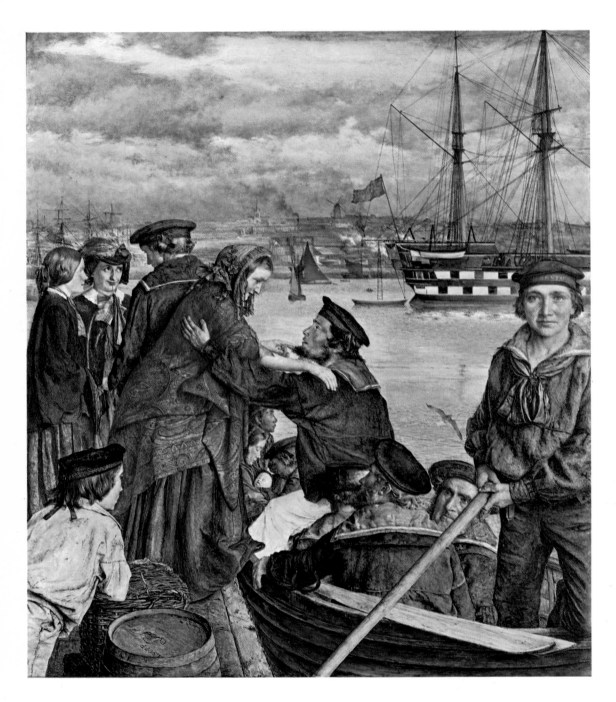

JOHN J. LEE. *Sweethearts and Wives.* 33¼ × 28 inches. Signed with monogram and dated 1860. Mr and Mrs Norman Parkinson.

The scene is Liverpool Docks. In the middle distance to the right is H.M.S. Majestic, a wooden screw ship of the line, which had done service in the Baltic during the Crimean War. At the time the picture was painted, she was on Coast Guard service. It has been suggested that Lee's models did duty for more than one head, and that the sailor on the right is a self-portrait. It seems probable that this was the picture exhibited both at the Liverpool Academy (no. 227) and at Suffolk Street (no. 443) in 1861.

characters in his nightly wanderings in the streets of London: the top-hatted central figure in *Applicants for Admission to a Casual Ward* was made to stand on sheets of brown paper sprinkled with Keating's Powder, a pint mug of porter at his side. *The Doctor*, a wholly unsentimental study of medical compassion, enjoyed immense popularity, especially in America. Eyre Crowe (1824–1910), who in 1852 accompanied his cousin Thackeray on his lecture tour of America, was another painter with a penchant (only too rarely indulged) for social comment. A pupil of Delaroche and a friend of Gérôme, he was, however, naturally addicted to themes from history, and these comprised the greater part of his work.

Other painters of anecdotal subjects, some of them remembered for a handful of works or even for single works, defy classification. Samuel Baldwin (exhib. 1843–1858) combined a Ruskinian eye for landscape with figure painting in *Sketching Nature*. Sophie Anderson (1823–after 1898) is now remembered for the exquisite *No Walk To-day*. Charles West Cope (1811–1890) is best remembered for his charming scenes of mothers and children. Abraham Solomon (1824–1862), elder brother of the ill-fated Simeon, began by exhibiting pictures of the 'V–c–r of W–kef–ld' variety, and scored a great success in 1854 with the exhibition of two scenes from contemporary life, *First Class—The Meeting . . . and at first meeting loved* and *Second Class – The Parting*, both set in railway carriages with the popular themes of love and emigration. *The Travelling Companions*, painted in 1862 by Augustus Egg, and now at Birmingham, one of the loveliest of Victorian pictures, is also set in a railway carriage, and is distinguished by a complete absence of moralizing. Pre-Raphaelitism

FREDERICK SMALLFIELD. *First Love.* 30⅛ × 18⅛ inches. Signed and dated 1858. City Art Galleries, Manchester. The picture illustrates a ballad by Thomas Hood.

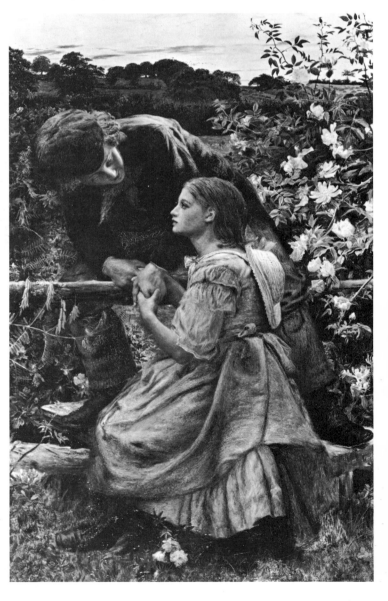

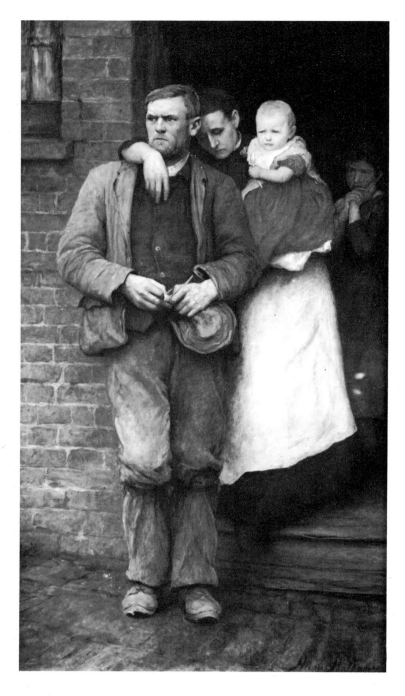

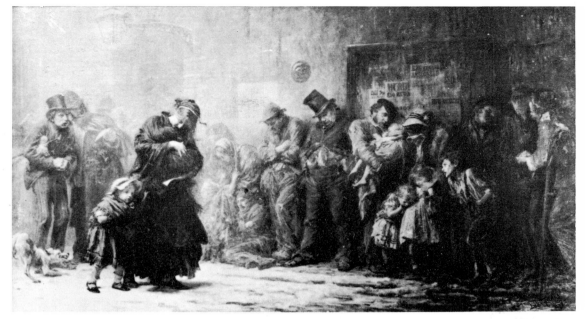

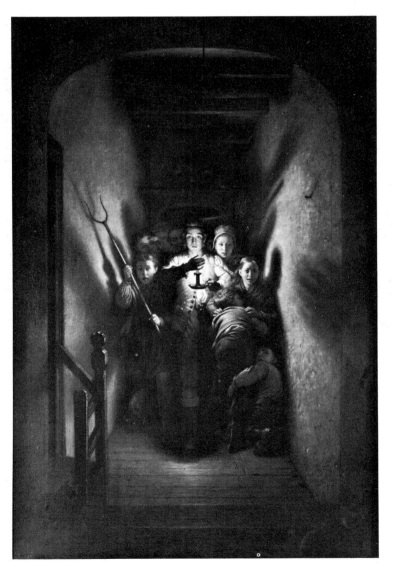

figures in the treatment of another public transport subject, *Omnibus Life in London*, painted three years earlier by William Maw Egley (1826–1916). George William Joy treated a similar metropolitan subject in *The Bayswater Omnibus*, thirty-six years later. Frank Stone (1800–1859) and his son Marcus (1840–1921) both reflected the styles of their successive generations: Frank in his sharpness of outline and bold colouring, and Marcus in his fondness for foppish quasi-Regency subject matter and looser treatment. Alfred Elmore (1815–1881) seems like a ghost from the past; born while the Battle of Waterloo was in progress, he ran the full gamut from historical painting to full-blooded

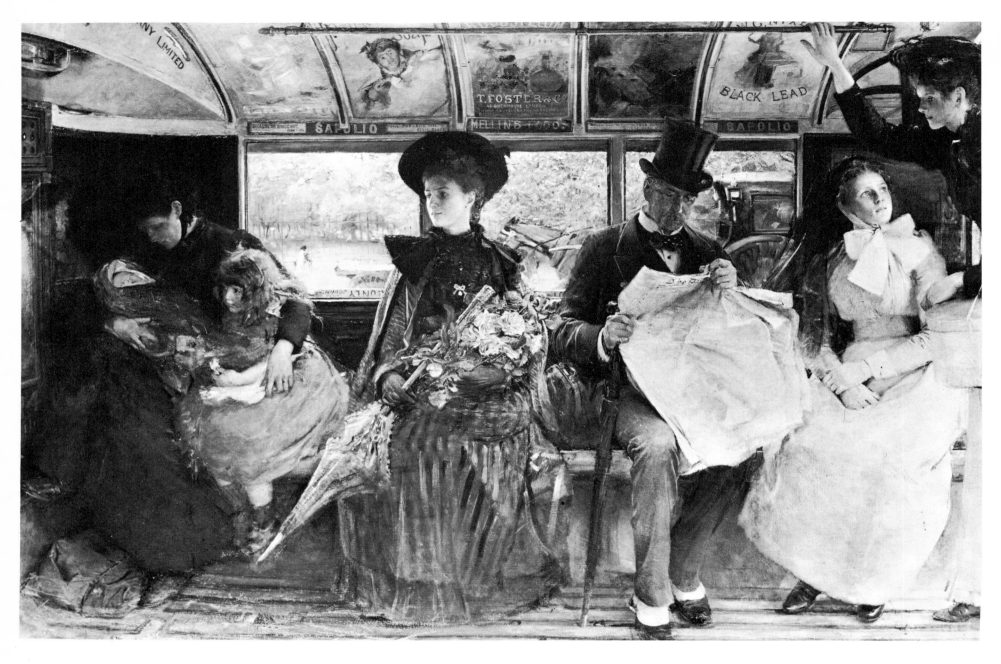

modern genre. Like Frith's picture *The Salon d'Or*, his *On the Brink*, painted in 1865, is set at the gaming rooms of Homburg. Elmore was still exhibiting up to within a year of his death.

Three artists, Frank William Topham (1838–1924), John Seymour Lucas (1849–1923) and W. Dendy Sadler (1854–1923), grafted the anecdotal and costume subject in the manner of C. R. Leslie on to the popular international manner of Meissonier. The period of the Regency was by now sufficiently romantic to be used as a setting for costume pieces, and the public acceptance of social realism had made it possible to treat the less savoury themes from history, such as the plague of 1665. Other subjects which appealed to the baser elements of public taste were besotted cavaliers, laughing monks, lecherous highwaymen ogling at serving wenches, unctuous seventeenth century connoisseurs brooding over their treasures beneath ana-

chronistic Regency mirrors, and Napoleon in various postures of post-Waterloo discomfiture. Meissonier possessed two indefatigable disciples in Elizabeth Thomson (Lady Butler) (1846–1933), Alice Meynell's sister, and Ernest Crofts (1847–1911). Lady Butler was watching army manoeuvres one day in 1872, when she was inspired to paint battle scenes. In pictures like *The Roll Call* and *Scotland for Ever*, which attained national popularity, she demonstrated an extraordinary knowledge of military uniforms and accoutrements, while her soldier husband was no doubt able to advise her on the distribution of her troops. Ernest Crofts, who treated mainly the English Civil War, the Napoleonic Wars and the recent Franco-Prussian War, achieved more success as an illustrator.

At about the same time in the 'seventies as genre painting took a downward turn in the social scale by the realistic treatment of matters of social concern, it

also treated subjects drawn from High Society and the comfortable middle classes. James (Joseph-Jacques) Tissot (1836–1902) was the foremost painter of this latest trend. French by birth, he was contributing cartoons to 'Vanity Fair' in 1869, and by 1871 had made London his home, after the fall of the Commune. In Paris he had been a friend of Whistler and Degas, and a fellow pupil of the Impressionists. Like Whistler

he had assimilated the Japanese influence, but to a lesser degree. From shortly after his arrival in England until 1879 he exhibited a series of pictures of contemporary life in a minutely detailed and bland technique. Many of these were painted on board ship at Greenwich. Tissot was a handsome person, became a fashionable figure in society, and had a romantic career: like those of Rossetti, his pictures are haunted

CHARLES WEST COPE, R.A. *Florence Cope at Dinnertime.* 23 × 27½ inches. Robin Carver, Esq.

Exhibited at the Royal Academy in 1852. Florence Cope was the artist's daughter. The silver mug is in the possession of a descendant of the artist.

Boarding the Yacht by Tissot is reproduced in colour on p. 255.

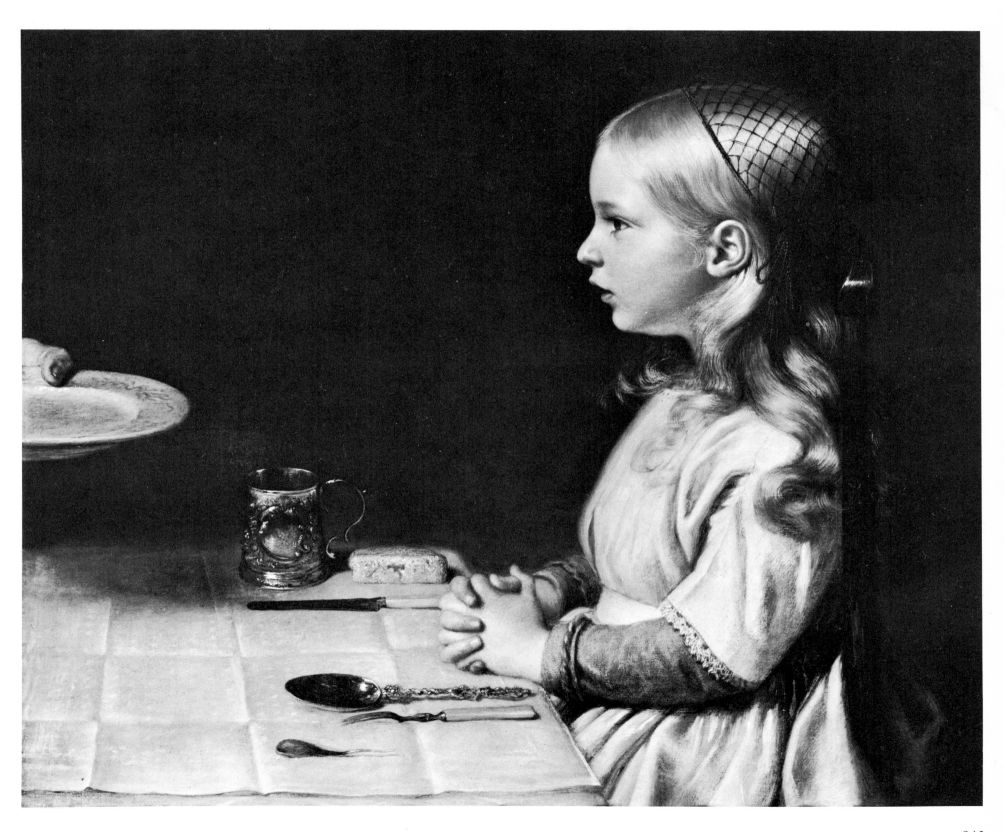

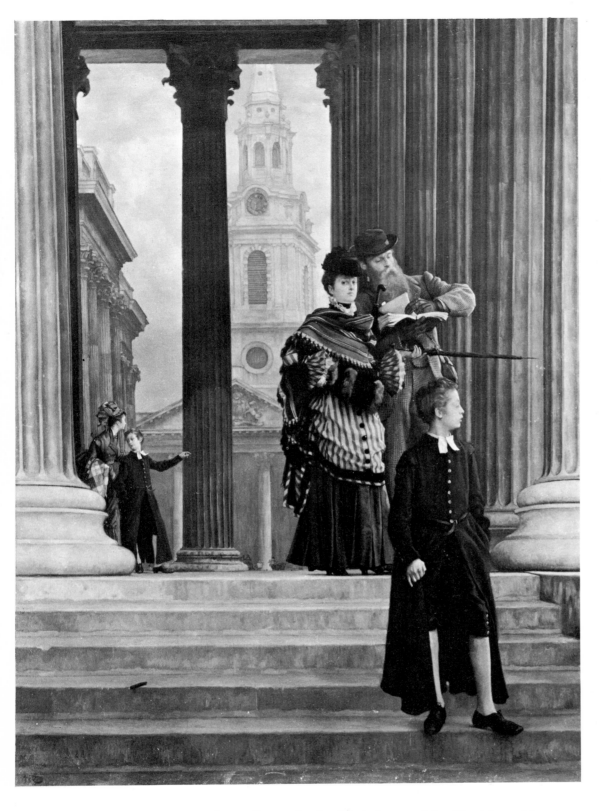

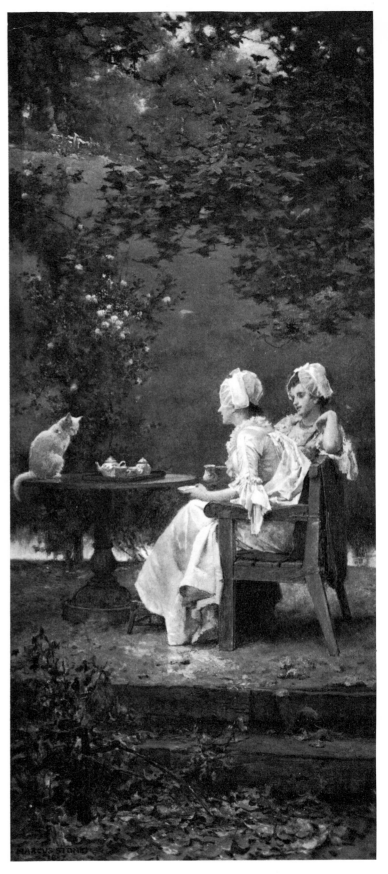

by a *femme fatale*; Tissot's was Mrs Kathleen Newton.
Mysteriously hidden from society, from which Tissot
himself increasingly withdrew, she died of consump-
tion at the age of twenty-eight. After her death,
Tissot's scenes from contemporary life ceased abruptly,
and, filled with grief, he took to spiritualism and
religion. Like Wilkie and Holman Hunt, he went to
the Holy Land, where he made studies for his *Life of
Christ*. Tissot's pictures are characterized by a sophis-

ticated sleekness, and an ability to render texture not
seen since the early days of Pre-Raphaelitism. Imme-
diately below the celebrated jibe which occasioned the
débâcle with Whistler, Ruskin wrote of Tissot's pictures

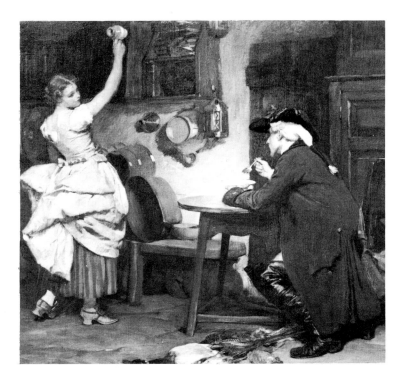

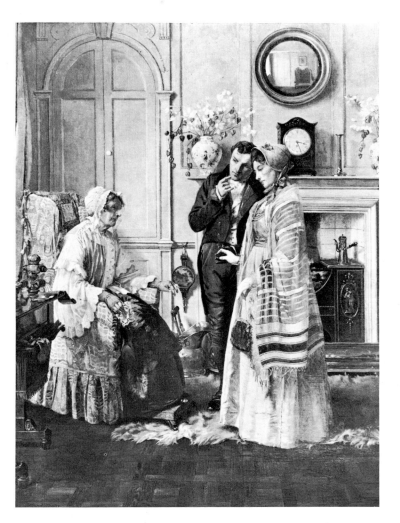

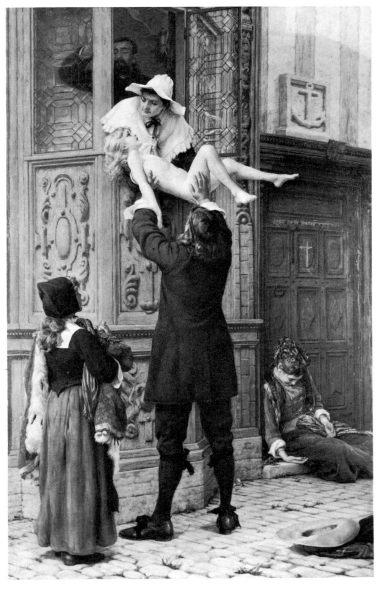

WALTER DENDY SADLER. *Sweethearts*. 34 × 26 inches. Signed and dated 1892. Guildhall Art Gallery, London.

Exhibited at the Royal Academy in 1892. The subject is evidently an elderly matron's critical inspection of her son's beloved.

Above left:
JOHN SEYMOUR LUCAS, R.A. *Flirtation* (detail). 22 × 30 inches. Signed and dated 1885. Guildhall Art Gallery, London.

Opposite page, left:
JAMES (JOSEPH-JACQUES) TISSOT. *London Visitors*. 63 × 45 inches. Signed. Toledo Museum, Ohio.

Exhibited at the Royal Academy in 1874. The scene is under the portico of the National Gallery, London. The boys are wearing Christ's Hospital uniform. A reviewer in 'The Art Journal' wrote of the picture, that it 'is without any distinct or intelligible meaning, and, lacking this, it also lacks the higher distinction of pictorial grace'. There is a smaller variant of the picture at the Layton Art Gallery, Milwaukee. Tissot made an etching of the same scene in 1878, without the two figures on the left, but with the addition of his mistress, Kathleen Newton, in the foreground.

Opposite page, right:
MARCUS STONE, R.A. *Good Friends*. 19½ × 8½ inches. Signed and dated 1887. Royal Academy, London.

Exhibited at the Royal Academy in 1888. This was the artist's Diploma Work; he had been elected R.A. 1887.

Below left:
FRANK WILLIAM TOPHAM. *Rescued from the Plague*. 72 × 45 inches. Signed and dated 1898. Guildhall Art Gallery, London.

Exhibited at the Royal Academy in 1898. The picture illustrates an incident during the Plague of London, (1665), described in Pepys's Diary. 'It was the child of a very able citizen of Gracious Street, a saddler, who had buried all the rest of his children of the plague, and himself and wife now being shut up in despair of escaping did desire only to save the life of this little child; and so prevailed to have it received stark naked into the arms of a friend'.

Below right:
CHARLES WEST COPE, R.A. *Widow and Children*. 7¾ × 6¼ inches. Maas Gallery, London.

243

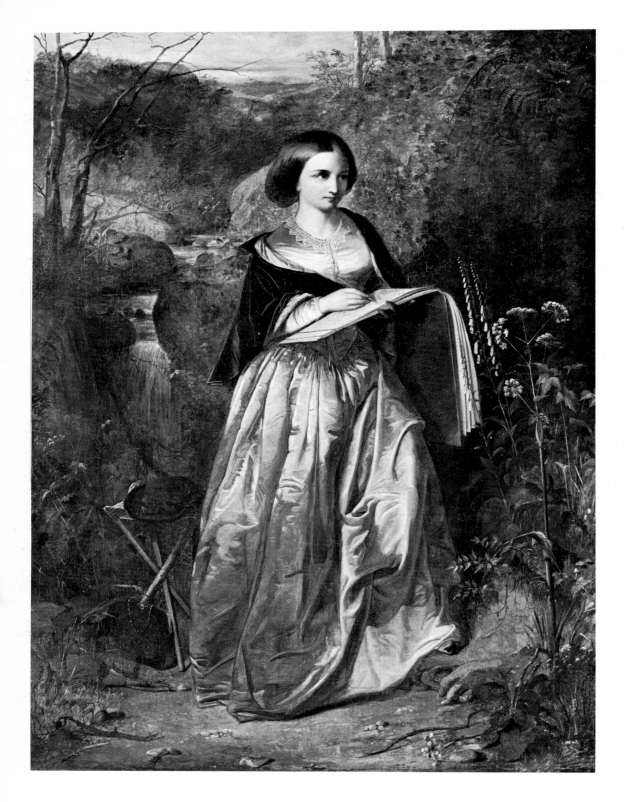

SAMUEL BALDWIN. *Sketching Nature*. 23¾ × 16¾ inches. Signed and dated 1857. Alexander Martin. Esq.

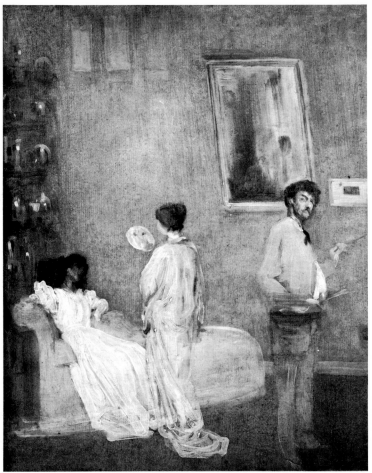

JAMES McNEILL WHISTLER. *The Artist in his Studio*. Panel. 24¾ × 18¾ inches. The Art Institute of Chicago.

Whistler was engaged on a large-scale version of this subject in 1867-8.

Most of this picture was subsequently dismembered. However a portrait of the artist survived, and is now at the Freer Gallery, Washington. Another sketch is at the Municipal Art Gallery, Dublin.

that 'most of them are, unhappily, mere coloured photographs of vulgar society'. This comment and his rebuke that Tissot lacked gravity, while they contain a measure of truth, also reflect Ruskin's weakening touch.

Scenes from high life dominated the work of William Quiller Orchardson (1832–1910); so also did what George Moore considered was 'a vicious desire to narrate an anecdote'. Discussing Orchardson's *Napoleon directing the Account of his Campaigns*, Moore lamented further 'the supreme vice of modern art which believes a picture to be the same thing as a scene in a play'. Orchardson, who, like McTaggart, had been a pupil of Robert Scott Lauder (1803–1869) in Edinburgh, was the most eminent of a group which later came to London, and included painters like John Pettie (1839–1893) and Tom Graham. Orchardson's well-composed pictures were at first illustrations to Shakespeare, Scott and others, and, more often than not, scenes from high life. Like Fildes's, his career included a Venetian interlude. His first subjects in contemporary dress, like *Mariage de Convenance* and *The First Cloud*, were painted in the 'eighties, only after he had reluctantly taken leave of Regency costume, which had become a favourite with him. Orchardson's pictures are distinguished by a superb understanding of the value of empty spaces and the dramatic placing of figures. He was a colourist of some originality and painted in subdued yellowish brown tints, with a thin dry finish. Pettie, at his best, came close to rivalling Orchardson as a colourist, but his work was coarser in technique and vitiated by over-production. James Sant is not a

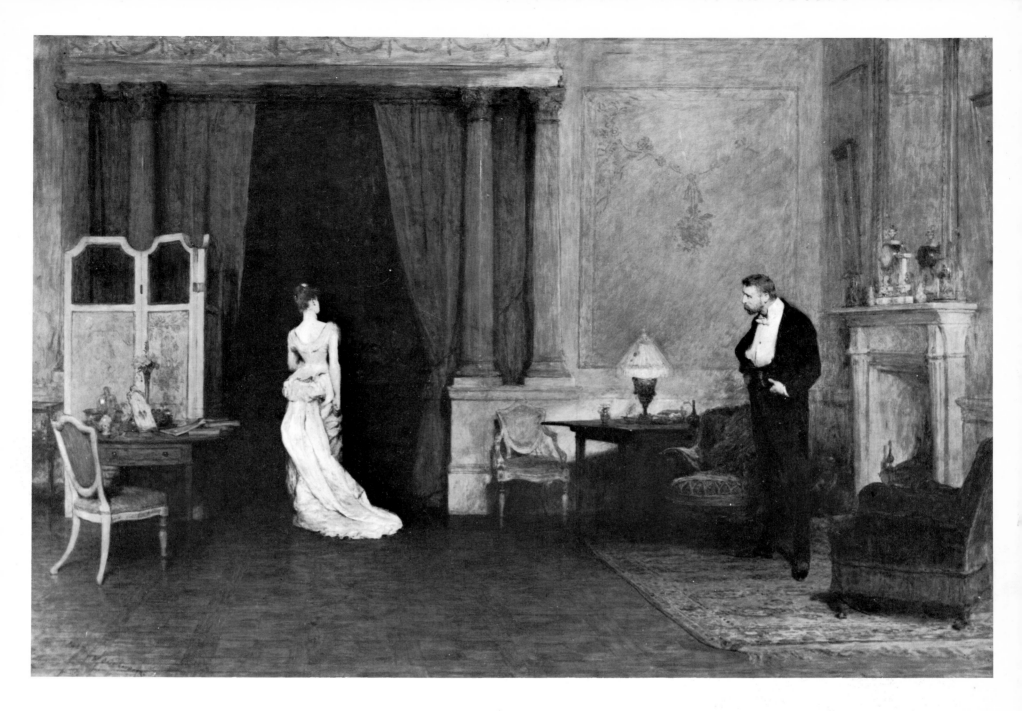

name one sees often in accounts of the period yet, in a long life, he was a tireless exhibitor of portraits and genre scenes: he was, in fact, exhibiting before the death of Wilkie in 1841 and after the death of Whistler in 1903. That he was well able to paint an elegant scene is evident in *Miss Martineau's Garden*, done when he was over half-way through his career.

James McNeill Whistler (1834–1903), who had already been in England as a child when the Pre-Raphaelite rebellion was hatching, was in himself a one-man revolution. An American by birth, he brought over from France an entirely new concept of pictorial values. While the prevailing accent was on the particular, Whistler advanced the notion of generalization. Far more than that of Leighton or Poynter, his internationalism was rooted in the attitudes of those French

artists who were to shape the course of modern painting, like Courbet, Manet and Degas. He had also painted seascapes in the company of Monet and Daubigny. It was not long after this, with his discovery of oriental art in the 'sixties (a taste for which he shared with Rossetti who befriended him soon after he finally settled in London), that he turned his back on the realism of Courbet. He was now learning from Japanese art the virtues of simplification and reticence: the effect of this new influence on his interiors was the banishment of superfluous paraphernalia, a hitherto essential ingredient of Victorian creative vision, and the introduction of a delicate new sense of poise and rhythm in spatial and colour relationships. This refinement spread to his landscapes, of which the *Nocturnes* were the outcome. The titles of his pictures, like

SIR WILLIAM QUILLER OR-CHARDSON, R.A. *The First Cloud.* $32\frac{3}{4} \times 47\frac{3}{4}$ inches. Signed and dated 1887. Tate Gallery, London.

This is a smaller replica of the picture which was exhibited at the Royal Academy in 1887, and is now at the National Gallery of Victoria, Melbourne. The artist Tom Graham posed for the husband. Orchardson was averse to pictorial didacticism: what did appeal to him was the dramatic moment.

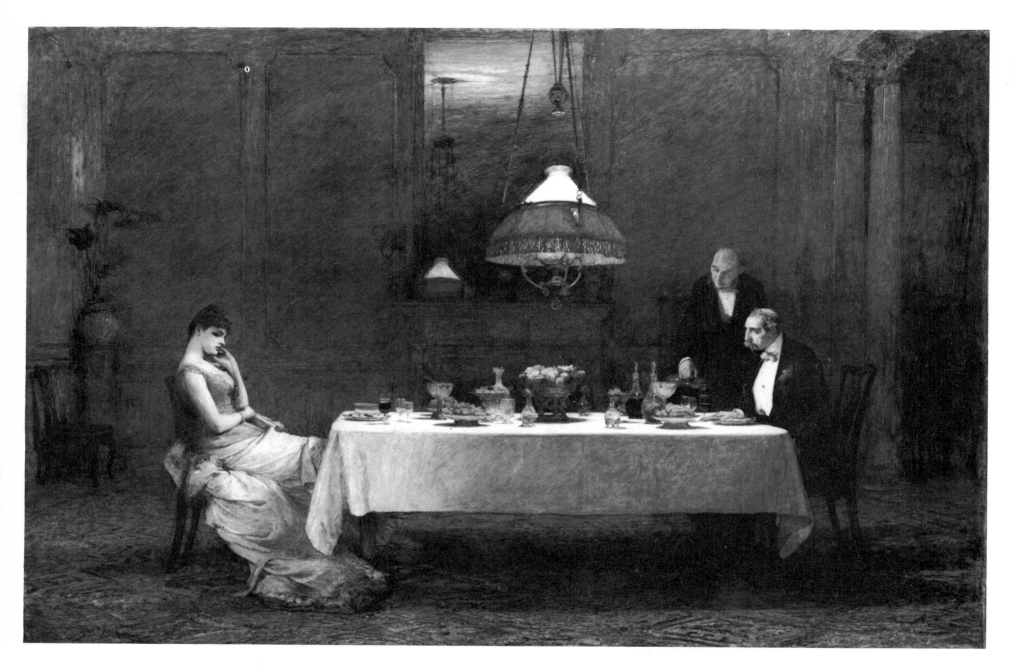

'Harmonies', 'Symphonies' and 'Arrangements', were
very significant indeed. The celebrated passage in 'The
Gentle Art of Making Enemies' reads, as it was
intended, as the death-knell to English subject
painting: 'Art should be independent of clap-trap—
should stand alone, and appeal to the artistic sense of
eye or ear without confounding this with emotions
entirely foreign to it, as devotion, pity, love, patriotism,
and the like. All these have no kind of concern with it;
and that is why I insist on calling my works "arrange-
ments" and "harmonies".' Albert Moore maintained
the same attitude toward naming pictures: if anything,
the titles *Battledore*, *Shuttlecock*, *Follow my Leader* and
Yellow Marguerites are even more provocative, as though
his studies, with their subtle colour harmonies, did not
really need titles at all. In this respect, he was not
unlike William Henry Hunt, who wrote to Linnell
that he longed for people to regard his still-lifes of fruit

'as bits of colour instead of something nice to eat'.

The advance of these new trends was catalysed by
the trial in 1878 of the action Whistler had brought
against Ruskin for the loss of sales due to vituperative
criticism of the works he had shown at the Grosvenor
Gallery in the previous year. Ruskin claimed that
Whistler, in *The Falling Rocket*, was 'flinging a pot of
paint in the public's face'. In the days when some
artists took a decade to complete a painting, to ask
200 guineas for a picture which he claimed had taken
two days to finish, must have seemed excessive.
Whistler won his action and a farthing damages. The
expense of the case contributed to Whistler's bank-
ruptcy; but the power of Ruskin, and all that he stood
for in contemporary painting, was broken. Whistler's
Nocturnes had won the day, although the public was
slow to recognise it. They were painted in a low key
with a careful regard for tonal values, the colours

mixed on the palette (for he was not an Impressionist), to induce a mood. Whistler had already directed attention from the Graeco-Roman world of the Academicians to the art of the Orient, but one major consequence of the trial (together with the quarrel with his patron, Leyland, and a trivial action against Sir William Eden in the 'nineties) was that it contributed to the rupture of the long-established relationship between artists and public which the Victorians enjoyed, a rift which exists to this day. It was the anecdotal picture that suffered most. Some artists such as Tissot, whose groups of figures chatter away without seeming to say anything at all, and Alma-Tadema whose Greeks and Romans have even less to say, showed themselves to be in tune with the times.

In landscape, Whistler's most faithful disciple was his boatman Walter Greaves (1846–1930), who, after receiving lessons from Whistler, aped his master in style, mannerisms and dress; his paintings, however, show him to be an apt pupil. Paul Fordyce Maitland (1863–1909), on the other hand, probably realised more fully than anyone else except Sickert the

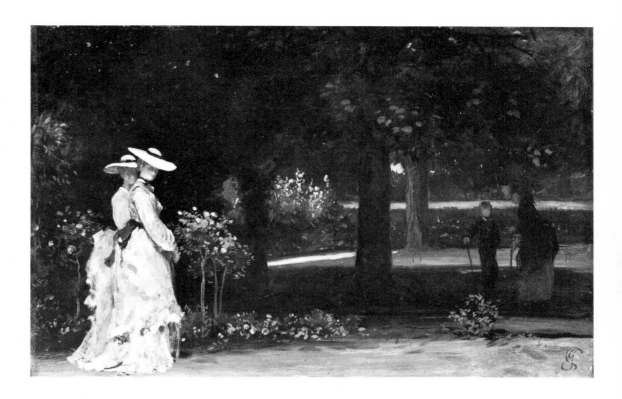

JAMES SANT, R.A. *Miss Martineau's Garden*. 12¼ × 18½ inches. Initialled. Tate Gallery, London. Painted in 1873.

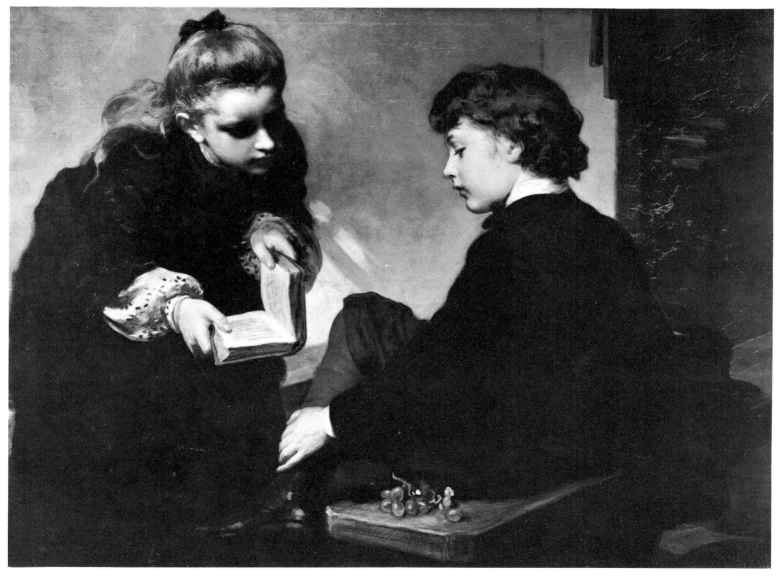

JAMES SANT, R.A. *The Schoolmaster's Daughter*. 33½ × 43½ inches. Signed. Royal Academy, London. Exhibited at the Royal Academy in 1871. This was Sant's Diploma Work; he had been elected R.A. in 1869. The artist's son, later Captain M. L. Sant, modelled for the boy in the picture.

247

Whistlerian concept of tonality, in his small studies of the Thames and the London parks.

Meanwhile, as the 'reactionary' Holman Hunt put it, 'wild revolt shows itself in the art of our day in the form of Impressionism'. The belated arrival of French influence was due mainly to the exertions of those artists such as W. J. Laidlay (1846–1912), Fred Brown (1851–1941) and Thomas Benjamin Kennington (1856–1916) who had studied in Paris and had been intoxicated by the painting techniques of Bastien-Lepage and Daubigny. From these sources the young English artists developed a high regard for comprehensive tonal values and the need to capture the essence of light, although Sickert complained that Bastien-Lepage's low, overall grey-green tonalities did little to convey the effect of sunlight at noon, for instance, on a summer's day. Millet too was to have a discernible influence on the choice of subject matter.

Whereas in 1848 rebellion against the traditionalism of the Royal Academy was confined to a small group of Pre-Raphaelite revolutionaries, in the last two decades of the century rebellion was rooted more in a general feeling of malaise amongst artists. 'That nearly all artists dislike and despise the Royal Academy is a matter of common knowledge,' wrote George Moore in 1893; 'from Glasgow to Cornwall, wherever a group of artists collects, there hangs a gathering and a darkening sky of hate.' Moore was an indifferent critic (he considered Mark Fisher (1841–1923), a pleasing painter of moderate talent, to be 'our greatest living landscape painter') but as a self-appointed taker of temperatures he was very perceptive. He considered that 'the younger men practise an art purged of all nationality. England lingers in the elder painters, and though the representation is often inadequate, the English pictures are pleasanter than the mechanical

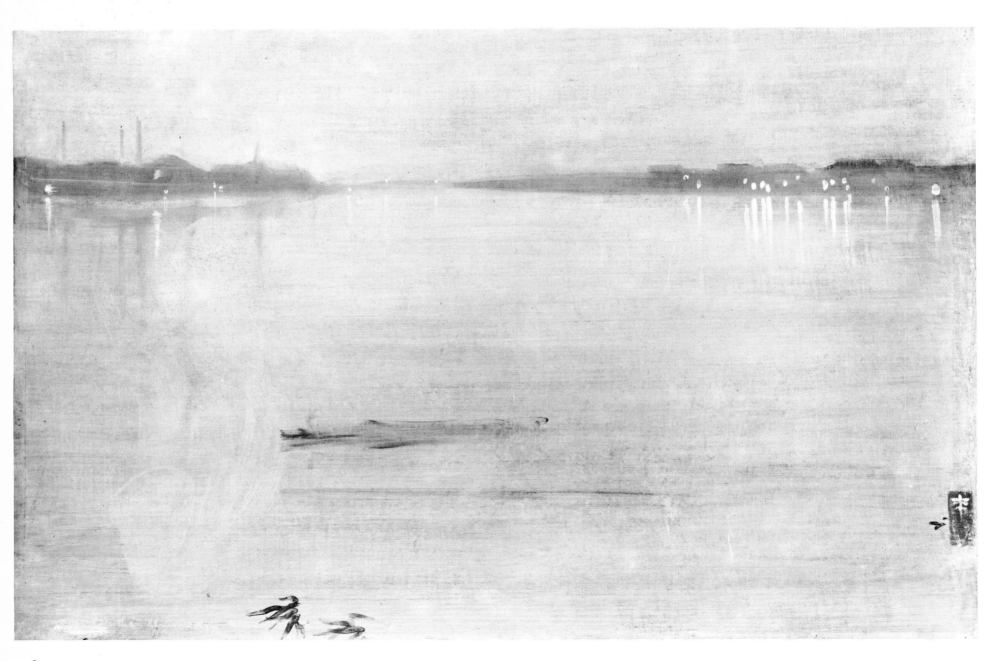

JAMES McNEILL WHISTLER. *Nocturne in Blue and Silver: Cremorne Lights*. 19¾ × 29¼ inches. Signed with butterfly device and dated 72. Tate Gallery, London.

Exhibited, probably at the Dudley Gallery, 1872. One of Whistler's early *Nocturnes*.

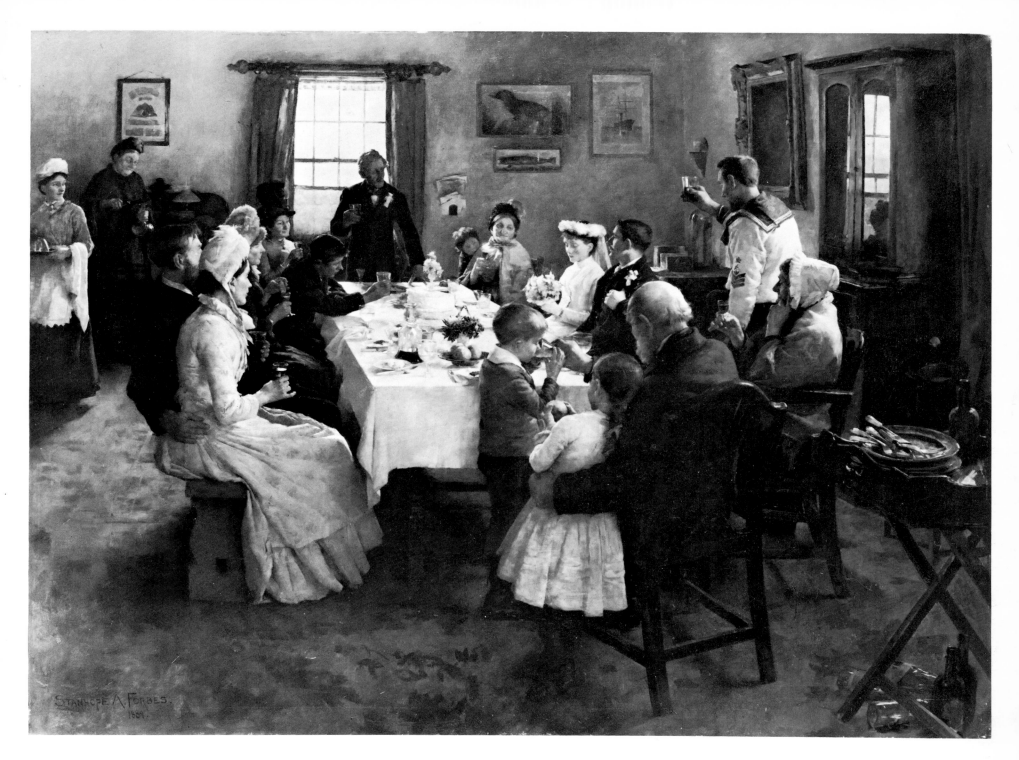

art [presumably referring to Seurat and his circle] which has spread from Paris all over Europe, blotting out in its progress all artistic expression of racial instincts and mental characteristics.'

The application to landscape painting of the Pre-Raphaelite and Ruskinian precept of 'Truth to Nature' by painters who ignored the natural development of English landscape tradition (so strikingly exemplified by Cox's self-assured painting of *Rhyl Sands* in 1855), left artists who were unsympathetic to this trend with no apparent alternative but the absorption of French influences. The dissemination of these new enthusiasms found expression in the various artistic groups

of the 'eighties; one such was the amorphous Glasgow School, whose members included John Lavery, the portraitist, David Young Cameron (1865–1945), whose powerful northern landscapes are more suggestive of Daumier than of the Impressionists, and Ernest Atkinson Hornel (1864–1933), a painter of lyrical landscapes, often showing children in woods and meadows or by streams. *Plein-air* painting ran riot in the 'eighties, and the village of Newlyn in Cornwall became a centre for it. Painters like Whistler, Walter Richard Sickert (1860–1942) and Mortimer Menpes (1860–1938) were early visitors to Newlyn.

Frank Bramley (1857–1915) and Stanhope Forbes

STANHOPE ALEXANDER FORBES, R.A. *The Health of the Bride*. 60 × 78¾ inches. Signed and dated 1889. Tate Gallery, London. Exhibited at the Royal Academy in 1889. The people depicted were all residents of Newlyn. The artist married Elizabeth Armstrong (1859-1912), herself an artist, in August of the same year.

(1857–1947), two of the last great genre painters, were leading members of the Newlyn School and founder members of the New English Art Club. Bramley's *A Hopeless Dawn* and Forbes's *The Health of the Bride*, both at the Tate Gallery, two classics of late Victorian genre painting, betray their Newlyn origins by a similarity in technique, and yet the marvellous quality of these works is evident. The formation of these groups was essentially anti-Academy. The Grosvenor Gallery, which enjoyed its hey-day in the 'eighties, as the New Gallery did in the 'nineties, was, as a kind of *salon des refusés*, a welcome alternative to the Royal Academy. It was at the Grosvenor Gallery in 1886 that The New English Art Club held its first exhibition; in the same year Whistler had been elected President of the Society of British Artists, temporarily injecting new vigour and determination into its policies. The importance of these groups lay mainly in their capacity for encouraging the interchange of ideas. At this distance of time it does not seem to matter greatly to which of these bodies various artists belonged; and many of their members, such as Alfred Parsons (1847–1920), George Clausen (1852–1944), Arthur Hacker (1858–1919), Henry Herbert La Thangue (1859–1929) and Maurice William Greiffenhagen (1862–1931) make more interesting Edwardians than Victorians. The same may be said of William Strang (1859-1921), who was a distinguished pupil of Alphonse Legros (1837–1911) at the Slade School; although he rarely painted in oils, he brought something of his master's austere realism to his easel work and engraving.

Philip Wilson Steer (1860–1942) and Sickert both made their débuts in the early 'eighties, but while Sickert made his greatest contribution to the twentieth century, Steer seems to have said all he had to say, in

SIR GEORGE CLAUSEN, R.A. *Evening.* 12×14 inches. Signed and dated 1887. A. Rampton, Esq.

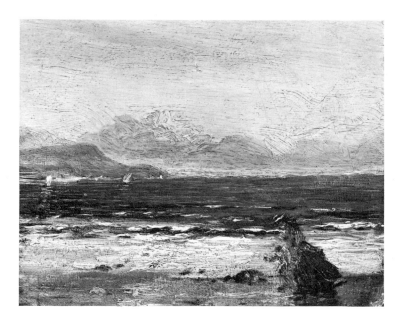

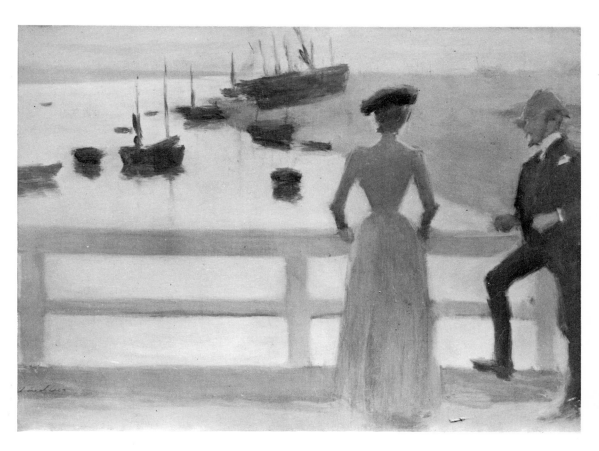

oils, at least, by the end of the Queen's reign. His early work, particularly the shore-scenes, is delicate yet expressive: *The Bridge at Etaples* and *Children Paddling* are fine examples. Steer's work began to suffer early in life from over-eclecticism and later from over-refinement. Steer was a far more estimable character than

PHILIP WILSON STEER. *The Bridge.* $19\frac{1}{2} \times 25\frac{3}{4}$ inches. Signed. Tate Gallery, London.

Exhibited at the Grosvenor Gallery in 1888. A reviewer in the 'Daily Telegraph' considered it 'either a deliberate daub or so much mere midsummer madness'.

PHILIP WILSON STEER. *Children Paddling, Walberswick.* 25×36 inches. Signed and dated 1894. Fitzwilliam Museum, Cambridge.

Included in Steer's first one-man exhibition at the Goupil Gallery in 1894. George Moore, reviewing the exhibition in 'The Speaker' on March 3rd, 1894, described the children, in a celebrated passage, as forgetting 'their little worries in the sensation of sea and sand, as I forget mine in that dreamy blue which fades and deepens imperceptibly, like a flower from the intense heart to the delicate edge of the petals. The vague sea is drawn up behind the breakwater, and out of it the broad sky ascends solemnly in curves like palms. Happy sensation of daylight; a flower-like afternoon; little children paddling; the world is behind them too; they are as flowers, and are conscious only of the benedictive influences of sand and sea and sky.'

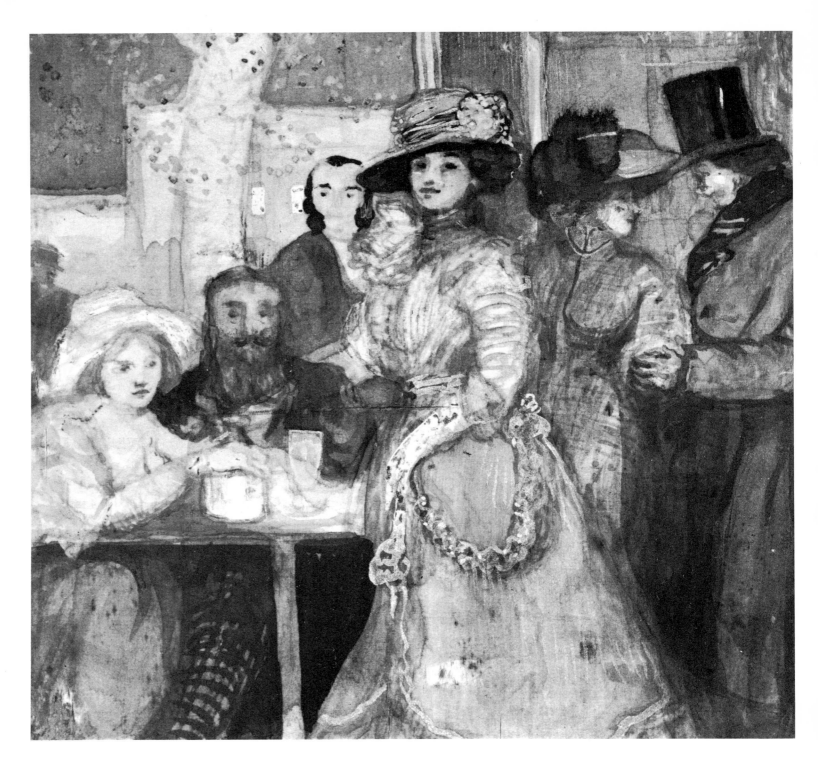

Woodland Scene with Figures by Charles Conder is reproduced in colour on p. 255.

Charles Conder (1868–1909) but when personal memories of both painters have receded, Conder is likely to emerge as the more interesting of the two. Conder was essentially a decorative painter, and his water-colours on silk, a sadly fragile substance, are drowsy evocations of *fin-de-siècle* lassitude. He was an uneven artist, but his shore-scenes bear comparison with those of Steer's early period. Three Scotsmen of a rather older generation made varied contributions to late nineteenth century landscape painting: William McTaggart (1835–1910) liked to paint in the open air, particularly by the sea, with a rather rugged technique; John MacWhirter (1839–1911), who achieved fame with his Alpine views, and Tom Graham (1840–1906), who painted in the Fifeshire fishing villages and the west coast of Scotland. MacWhirter and Graham were, if less advanced, both somewhat gentler artists than McTaggart.

Many excellent painters born in the 'sixties and 'seventies did not attain fulfilment until the twentieth century. These include James Pryde (1866–1941), William Nicholson (1872–1949), his brother-in-law, the inseparable friends Charles Ricketts (1866–1931) and Charles Shannon (1863–1937), nicknamed 'Orchid'

and 'Marigold' by Oscar Wilde, William Orpen (1878–1931), the portrait and genre painter, and William Rothenstein (1872–1945) and Henry Tonks (1862–1937). Ethel Walker (1861–1951), born three years after H. S. Tuke, successfully absorbed a wide range of international influences in her paintings of nudes in the open air, as well as in her portraiture and still-life painting. Two interesting namesakes, both born in the late 'fifties, Edward Stott (1859–1918) and William Stott of Oldham (1857–1900), were exhibiting in the early 'eighties. Edward, who studied under Carolus Duran and at the Ecole des Beaux Arts, succeeded in bringing something of the world of Palmer and Linnell to that of Millet and Bastien-Lepage; and William, who had studied under Gérôme in Paris, demonstrated an ability to wear with ease the mantle of French influence. An Irish painter, Walter Osborne (1859–1903), who had studied at Antwerp, painted a number of sensitive genre scenes set in landscapes, before devoting himself mainly to portraiture.

Looking over the reproductions in 'Royal Academy Pictures' for the 'nineties is a disheartening experience. 'The helplessness, vulgarity [and] violent imbecility' that Henry James noted in 1877 were no less rampant. Embarrassing pictures of mermaids in the thrall of unspecified ecstasy, views of cloud-filled skies on the Sussex Downs, Spanish Galleons plying the Golden

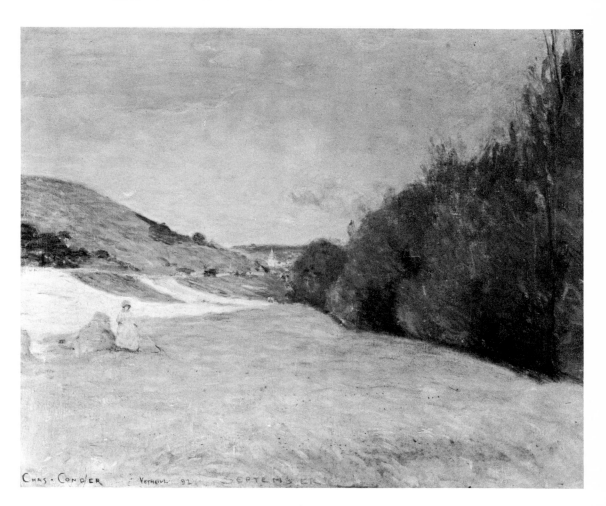

CHARLES CONDER. *Landscape: Vétheuil.* $18\frac{3}{4} \times 23$ inches. Signed, dated and inscribed 'Chas. Conder 92 September Vetheiul [*sic*]'. Peyton Skipwith, Esq.

Vétheuil became a favourite haunt of Conder's; he had already paid a visit there in June 1892 in the company of Anquetin.

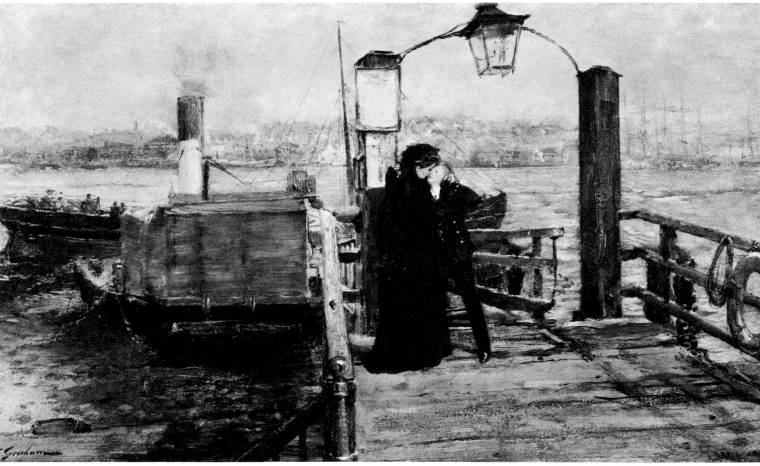

TOM GRAHAM. *The Landing Stage.* $12\frac{1}{2} \times 21\frac{1}{8}$ inches. Signed. Victoria and Albert Museum, London.

This picture has been variously entitled *Going to Sea* and *Adieu*.

EDWARD STOTT, A.R.A. *The Penfold*. 24 × 21½ inches. Signed. Fine Art Society, London.
Exhibited at the Royal Academy in 1898.

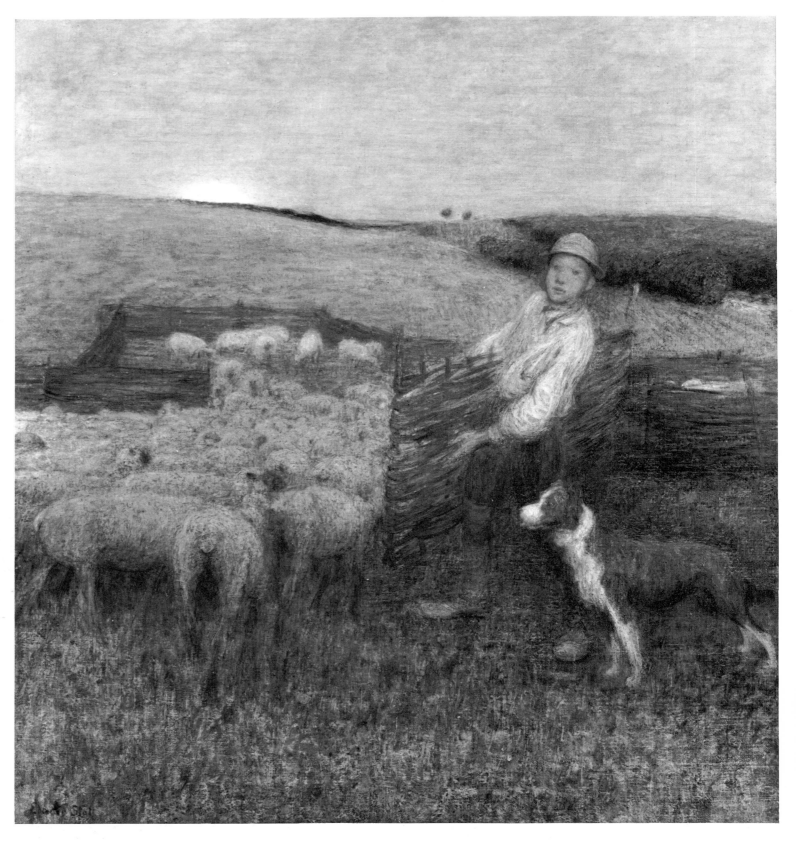

Opposite page, above left:
AUGUSTUS (?) E. MULREADY
A London Crossing Sweeper and a Flower Girl. 27⅛ × 20 inches. Signed and dated 1884. London Museum, Kensington Palace.
This picture is inscribed on the reverse in the artist's hand: 'London Flower Girl and Street Arab – mutually giving and receiving aid – they set each other off like light and shade'. *See p. 234.*

Opposite page, below left:
CHARLES CONDER. *Woodland Scene with Figures*. Signed. 25½ × 21¼ inches. David Hughes, Esq.

Main, dragons impaled by St. George's lance, portraits of recently ennobled patricians, all jostled the walls of the Royal Academy. 'Everything,' wrote the German critic, Richard Muther, 'must be kept within the bounds of what is charming, temperate and prosperous, without in any degree suggesting the struggle for existence'. It is what Mr Quentin Bell has called 'the poetry of evasion'. The rift between artist and public, which began with Whistler, was widening perceptibly. The best painting of the period was already beginning to demand an active response from a public which it was not wholly prepared to give it, and there were then, as now, any number of painters content to pander to the lowest taste. Such was the state of the

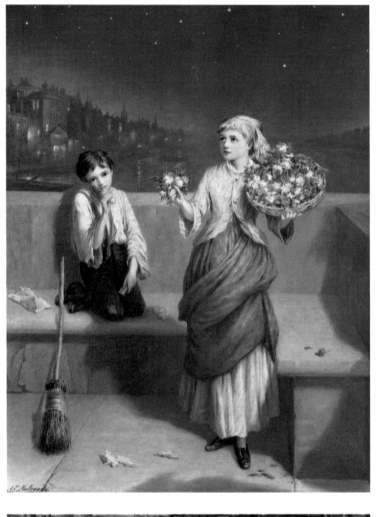

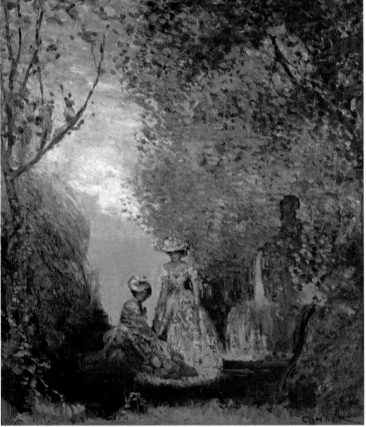

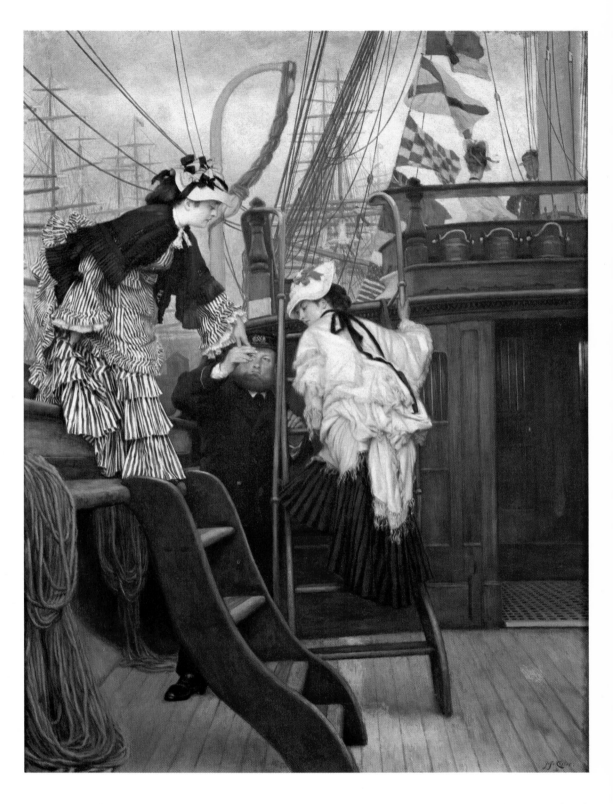

picture-loving public when it was confronted by the Post-Impressionist exhibition mounted by Roger Fry in 1910. The complete bafflement and subsequent abuse with which it was met was a measure of this rift. Fortunately there were also a number of painters with whom the honour of English painting was vested, notably Walter Richard Sickert (1860–1942). Although he lived forty-one of his years during Queen Victoria's reign, and was active as a painter for about half this period, he is not considered to be as much of a Vic-

JAMES (JOSEPH-JACQUES) TISSOT. *Boarding the Yacht.* 30 × 21¾ inches. Signed and dated 1873. The Hon. P. M. Samuel.

Tissot was no doubt prompted by Whistler's etchings of the Thames to go down to Greenwich to paint scenes on board ship, as in this picture. *See p. 241.*

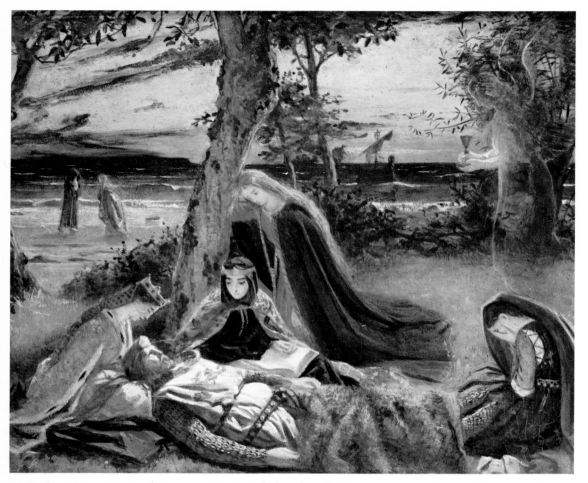

JAMES ARCHER. *La Mort d'Arthur*. Paper laid down on panel. $6\frac{1}{2} \times 7\frac{1}{2}$ inches. Private collection. This is a study for the painting exhibited at the Royal Academy in 1861, now at Manchester. *See p. 231.*

Above:
WALTER RICHARD SICKERT. *The Laundry.* 5×6 inches. Bodycolour. Signed and dated 1885. Peyton Skipwith, Esq.

Below:
WALTER OSBORNE. *An October Morning* (detail). 28×36 inches. Signed and dated 1883. Guildhall Art Gallery, London.

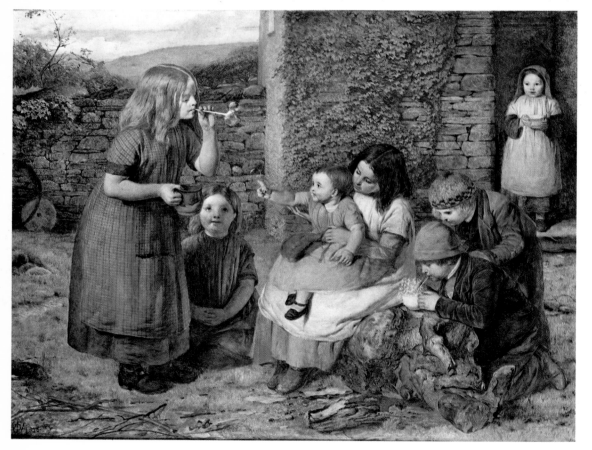

Left:
JOHN DAWSON WATSON. *Children at Play.* Millboard. $14 \times 17\frac{3}{4}$ inches. Signed with monogram and dated 1856. Private collection, London.

This picture is an early essay, by an artist not himself a member of the Brotherhood, in the application of Pre-Raphaelite principles and techniques to a subject from everyday rural life. It has been suggested that Watson may have been influenced in his choice of colour for the hair of the girl standing on the left by the hair of Christ in Madox Brown's *Jesus Washing Peter's Feet*, which was exhibited in 1852. The colour of the woman's hair in Millais's *Mariana* and the hair of the young Christ in *The Carpenter's Shop* is of a similarly arresting shade. *See p. 237.*

torian as is Landseer, who was a Victorian for five years less. Sickert began as a disciple of Whistler, and became a friend of Degas. He brought the low-keyed palette of the one and the quiet observation of the other to his paintings. The realities of human behaviour and reticent but telling commentary characterise his work. By his example as a teacher, Sickert was a pervasive influence in English painting during the first three decades of the twentieth century, as was Lucien Pissarro (1863–1944), who had finally settled in England in 1890.

The extreme individuality of Sickert reflected the consummation of the subtle change which the status of painting underwent during Queen Victoria's reign. In whatever light she and her subjects regarded artists in 1837 (the high social status of some was manifest), artists considered themselves as superior tradesmen, who painted subjects more or less to order, or at least in a way that was expected of them. By the close of the Queen's reign, the painter, no less dependent on his work for a living, had become 'modern', in that he was an individual whose works were valued as an expression of his own artistic personality, independent of capricious patronage.

Below:
WILLIAM STOTT OF OLDHAM. *The Ferry.* 43×84¼ inches. Signed. Fine Art Society, London. Exhibited at the Royal Academy in 1893.

WILLIAM McTAGGART. *Autumn Sunshine, Sandy Dean.* 24×31 inches. Signed and dated 1890. Mr and Mrs George Black. Exhibited at the Royal Scottish Academy in 1891.

BIBLIOGRAPHY

DICTIONARIES

BRYAN, M. *Dictionary of Painters and Engravers;* 1st ed. 1813-16; revised by G. Stanley (1849) and by G. C. Williamson (1903-4); reprinted, New York 1964.

CLEMENT, C. E. and HUTTON, L. *Artists of the Nineteenth Century and their Works;* revised edition, New York (1884).

Dictionary of National Biography (1885-1937).

Encyclopaedia Britannica.

GRAVES, Algernon. *The Royal Academy: dictionary of contributors, 1769-1904.* 8 vols. (1905-1906).

JOHNSON, Jane. *Works Exhibited at the Royal Society of British Artists 1824-1893 and at The New English Art Club 1888-1917;* 2 vols. (1975).

MALLALIEU, Huon L. *The Dictionary of British Watercolour Artists up to 1920* (1976).

REDGRAVE, Samuel. *A Dictionary of Artists of the English School;* revised edition (1878).

WOOD, Christopher. *Dictionary of Victorian Painters* (1971).

PERIODICALS

The Art Union (1839-1848).

The Art Journal (1849-1912); a continuation of the above.

The Athenaeum (1828-).

The Cornhill Magazine (1860-).

Frazer's Magazine for Town and Country; (1830-1869).

The Germ, Nos. 1 and 2; continued as *Art and Poetry,* Nos. 3 and 4 (1850).

The Magazine of Art (1878-1904).

Punch (1841-).

The Saturday Review (1855-).

The Studio (1893-).

Current periodicals containing frequent articles on Victorian painting and allied subjects:

Apollo
Arts Review
Burlington Magazine
Connoisseur
Country Life
Victorian Studies; published by Indiana University.

CATALOGUES

Academy Notes, 1876-1906; ed. Henry Blackburn.

The Collections of the Tate Gallery: British Painting: Modern Painting and Sculpture (1967).

Commemorative Catalogue of the Exhibition of British Art; Royal Academy of Arts, London, January-March 1934 (1935).

THE DETROIT INSTITUTE OF ARTS *and* PHILADELPHIA MUSEUM OF ART. *Romantic Art in Britain — Paintings and Drawings 1760-1860;* with essays by Robert Rosenblum, Frederick Cummings and Allen Staley (1968).

GRAVES, Algernon. *The British Institution 1806-1867* (1908).

—— *A Century of Loan Exhibitions (1813-1912);* 5 vols. (1913-1915); reprinted, New York, (No date)

Great Victorian Pictures: their Paths to Fame: catalogue of a touring exhibition given by the Arts Council; with an introduction by Rosemary Treble (1978).

The Modern British paintings, drawings and sculpture; Tate Gallery Catalogues, by Mary Chamot, Dennis Farr and Martin Butlin; 2 vols. (1964-5).

THE NATIONAL GALLERY OF CANADA, OTTAWA. *An Exhibition of Paintings and Drawings by Victorian Artists in England;* with an introduction by Allen Staley (1965).

Painting in England (1700-1850): the Collection of Mr and Mrs Paul Mellon: a catalogue of an Exhibition at Virginia Museum of Fine Arts, Richmond, U.S.A.; 2 vols. (1963).

Paintings, Water-colours and Drawings from the Handley-Read Collection: catalogue of an exhibition at the Fine Art Society (1974).

The Royal Academy Pictures (1888-1915).

The Royal Academy (1837-1901) Revisited: Victorian Paintings from the Forbes Magazine Collection: catalogue of an exhibition at the Metropolitan Museum of Art, New York and Art Museum, Princeton University; with an introduction by Allen Staley (1975).

TATLOCK, R. R. *English Painting of the XVIIIth-XXth Centuries . . . :* a record of the collection in the Lady Lever Art Gallery; with an introduction by Roger Fry (1928).

"This Brilliant Year", Catalogue of an exhibition at the Royal Academy to commemorate the Golden Jubilee of Queen Victoria; with an introduction by Jeremy Maas (1977).

VICTORIA AND ALBERT MUSEUM. *Catalogue of Water Colour Paintings by British Artists and Foreigners working in Great Britain* (1927), and Supplement (1951).

Victorian Paintings: a Victoria and Albert Museum publication (1963).

Victorian Painting: catalogue of an exhibition at the Nottingham University Gallery; with an introduction by John Woodward (Nottingham, (1959).

Victorian Painting, 1837-1887: catalogue of an exhibition given by Thos. Agnew & Sons; with an introduction by Graham Reynolds (1961).

Victorian Paintings: catalogue of an exhibition given by the Arts Council; with an introduction by Graham Reynolds (1962).

Victorian Paintings: catalogue of an exhibition at the Mappin Art Gallery, Sheffield (1968).

Victorian Social Conscience: catalogue of an exhibition at the Art Gallery of New South Wales, with an introduction by Renée Free (1976).

GENERAL LITERATURE

AMES, Winslow. *Prince Albert and Victorian Taste* (1967).

BELL, Mrs Arthur. *Representative Painters of the XIXth Century* (1899).

BELL, Quentin. *Victorian Artists* (1967).

BOASE, T. S. R. *English Art, 1800-1870 (Oxford History of English Art,* Vol. X.) (1959).

BRION, Marcel. *Art of the Romantic Era;* trans. by Donald Carroll (1966).

DAVIS, Frank. *Victorian Patrons of the Arts* (1963).

EVANS, Joan. *The Victorians* (1966).

FRITH, William Powell. *My Autobiography and Reminiscences;* 2 vols. (1887).

—— *Further Reminiscences* (1888).

FRY, Roger. *Reflections on English Painting* (1934).

GAUNT, William. *A Concise History of English Painting* (1964).

HAMERTON, P. G. *Thoughts about Art* (1873).

HAYDON, Benjamin Robert. *Correspondence and Table Talk, with a Memoir by his son, Frederick Wordsworth Haydon;* 2 vols. (1876)

—— *Diary,* ed. Willard B. Pope; 5 vols. (Harvard, 1960-3).

HUBBARD, Hesketh. *A Hundred Years of British Painting (1851-1951)* (1951).

—— *Some Victorian Draughtsmen* (1944).

IRWIN, David and Francina. *Scottish Painters at home and abroad 1700-1900* (1975).

JAMES, Henry. *The Painter's Eye:* ed. by John L. Sweeney (1956).

KLINGENDER, Francis D. *Art and the Industrial Revolution* (1947); ed. and revised by Sir Arthur Elton (1968).

LA SIZERANNE, R. De. *La Peinture anglaise contemporaine* (Paris, 1895); Eng. trans. (1898).

LAVER, James. *The Age of Optimism: Manners and Morals, 1848-1914* (1966).

LONGFORD, Elizabeth. *Victoria R.I.* (1964).

MAAS, Jeremy. *Gambart: Prince of the Victorian art world* (1975).

MACCOLL, D. S. *Nineteenth Century Art* (1902).

MOORE, George. *Modern Painting* (1893).

MUTHER, Richard. *Geschichte der Englischen Malerei* (Berlin, 1903).

PYE, John. *Patronage of British Art* (1845).

REDGRAVE, S. and R. *A Century of Painters of the English School;* 2 vols. (1886); ed. by Ruthven Todd as *A Century of British Painters* (1947).

REITLINGER, Gerald. *The Economics of Taste,* Vol. I. (1961).

REYNOLDS, Graham. *Victorian Painting* (1966).

RUSKIN, John. *The Works of John Ruskin;* Library Edition, 39 vols.; ed. by E. T. Cook and Alexander Wedderburn (1902-12).

SHEPHERD, George H. *A short History of the British School of Painting* (1891).

TEMPLE, A. G. *The Art of Painting in the Queen's Reign* (1897).

THACKERAY, William Makepeace. *Miscellaneous Essays, Sketches and Reviews;* Vol. XXV of *The Works of W. M. Thackeray* (1886).

TURNER, W. J. (*ed.*) *Aspects of British Art* (1947).

WEST, W. K. and SPARROW, W. S. *The Royal Academy from Reynolds to Millais;* ed. by Charles Holmes (1904).

WILMOT-BUXTON. H. J. *English Painters* (1883).

WOOD, Christopher. *Victorian Panorama* (1976).

YOUNG, G. M. (*ed.*) *Early Victorian England;* 2 vols. (1934).

HISTORICAL PAINTERS

ANDREWS, Keith. *The Nazarenes* (Oxford, 1964).

BLUNT, Wilfrid. *George Frederic Watts, 1817-1904;* no. 37 in The Masters series (1966).

BLUNT, Wilfrid. *"England's Michelangelo"* [G. F. Watts] (1975).

BOASE, T. S. R. *The Decorations of the New Palace of Westminster, 1841-1863;* in Journal of the Warburg and Courtauld Institutes, vol. XVII (1954).

CHAPMAN, Ronald. *The Laurel and the Thorn: a study of G. F. Watts* (1945).

CHESTERTON, G. K. *G. F. Watts* (1904).

DAFFORNE, James. *Pictures by Daniel Maclise, R.A.* (1873).

DAFFORNE, James. *The Life and Works of Edward Matthew Ward, R.A.* (1879).

(Dyce, William). *Dyce Centenary Exhibition:* catalogue of an exhibition at Aberdeen and Thos. Agnew & Sons, London; with an introduction by Charles Carter (1964).

(Eastlake, Sir Charles Lock). Catalogue of an exhibition given at the City Art Gallery, Plymouth; with an introduction by Eugene I. Schuster (1965).

GEORGE, Eric. *The Life and Death of Benjamin Robert Haydon* (1948).

HAMERTON, P. G. *Edward Matthew Ward* (1895).

HAYDON, Benjamin Robert, *Lectures on Painting and Design;* 2 vols. (1844-6).

(Maclise, Daniel). Catalogue of an exhibition given by the Arts Council at the National Portrait Gallery and the National Gallery of Ireland, with an introduction by Richard Ormond (1972).

O'DRISCOLL, William Justin. *A Memoir of Daniel Maclise, R.A.* (1871).

SCOTT, William B. *Memoir of David Scott, R.S.A.* (1850).

WATTS, M. S. *George Frederic Watts;* Vols. I and II; *Annals of an Artist's Life;* Vol. III: *His Writings* (1912).

(George Frederic Watts). Catalogue of an exhibition given at the Tate Gallery; with an introduction by David Loshak and R. W. Alston (1954).

LANDSCAPE

ADAMS, Eric. *Francis Danby: Varieties of Poetic Landscape* (1973).

ARMSTRONG, Sir Walter. *Memoir of Peter De Wint* (1888).

BALSTON, Thomas. *John Martin, 1789-1854: his Life and Works* (1947)

BUNT, Cyril G. E. *The Life and Work of William James Müller of Bristol* (1948).

BURY, Adrian. *John Varley of the 'Old Society'* (1946).

BUTLIN, Martin. *Turner Watercolours* (1962).

BUTLIN, Martin and JOLL, Evelyn. *The Paintings of J. M. W. Turner;* 2 vols. (1977).

COLLINS, W. Wilkie. *Memoirs of the Life of William Collins;* 2 vols. (1848).

COOPER, T. S. *My Life;* 2 vols. (1890).

COX, Sir Trenchard. *David Cox* (1947).

(Danby, Francis). Catalogue of an exhibition given by the Arts Council at Bristol, Birmingham and Bradford; with an introduction by Eric Adams (1961).

DICKES, W. F. *The Norwich School of Painting* (1905)

FEAVER, William. *The Art of John Martin* (1975).

FINBERG, A. J. *The Life of J. M. W. Turner, R.A.* (1939); 2nd edition (1961).

GRANT, M. H. *A Chronological History of the Old English Landscape Painters;* 8 vols.; new, revised and enlarged edition (1957).

GRIGSON, Geoffrey. *Some Notes on Francis Danby, A.R.A.;* article in Cornhill Magazine, CLXII (1946-47).

GRIGSON, Geoffrey. *Samuel Palmer: The Visionary Years* (1947).

HALL, William. *A Biography of David Cox* (1881).

HARDIE, Martin. *Water-Colour Painting in Britain;* ed. by Dudley Snelgrove with Jonathan Mayne and Basil Taylor; Vol. II: *The Romantic Period* (1967) and Vol. III: *The Victorian Period* (1968).

KITSON, Sydney D. *John Sell Cotman* (1937).

LISTER, Raymond. *Edward Calvert* (1962).

LONG, Basil S. *Robert Hills;* Walker's Quarterly 12 (1923).

(Martin, John). Catalogue of an exhibition given by the Whitechapel Art Gallery; with a foreword by Thomas Balston and an essay by Eric Newton (1953).

OLD WATER-COLOUR SOCIETY'S CLUB Annual Volumes (1924-).

OPPÉ, A. Paul. *The Water-Colour Drawings of John Sell Cotman* (1923).

PALMER, A. H. *Samuel Palmer, A Memoir* (1882).

—— *The Life and Letters of Samuel Palmer* (1892).

ROGET, J. L. *History of the Old Water-Colour Society;* 2 vols. (1891).

ROTHENSTEIN, Sir John and BUTLIN, Martin, *Turner* (1964).

SOLLY, N. Neal. *Memoir of W. J. Müller* (1875).

—— *Memoir of the Life of David Cox* (1875).

STORY, Alfred T. *The Life of John Linnell;* 2 vols. (1892).

WHITEHOUSE, J. Howard. *Ruskin the Painter and his works at Bembridge* (1938).

WILLIAMS, I. A. *Early English Water-Colours* (1952).

MARINE PAINTERS

(Cooke, Edward William). Catalogue of an exhibition given at the Guildhall Art Gallery; with an introduction by J. L. Howgego (1970).

ARCHIBALD, Edward H. H. *The English School of Shipping Painters of the Eighteenth and Early Nineteenth Centuries;* in The Connoisseur's 'The Concise Encyclopaedia of Antiques', Vol. V (1961).

EMANUEL, Frank L. *Edward Duncan, Painter in Oil and Water-Colour and Engraver;* Walker's Quarterly 13, (1923).

MACLEAN, Frank. *Henry Moore, R.A.* (1905).

ROE, F. Gordon. *Sea Painters of Britain from Constable to Brangwyn* (1948).

STEPHENS, F. G. *J. C. Hook, R.A.* (1888).

WARNER, Oliver. *An Introduction to British Marine Painting (1948).*

WYLLIE, M.A. *We Were One: A Life of W. L. Wyllie, R.A., R.E., R.I.* (1935).

SPORTING PAINTERS

BURY, Adrian. *English Eighteenth and Nineteenth-Century Sporting Pictures;* in The Connoisseur's 'The Concise Encyclopaedia of Antiques', Vol. V (1961).

GROHMAN, W. A. Baillie. *Sport in Art* (1913).

SPARROW, Walter Shaw. *British Sporting Artists* (1922; new edition 1965).

—— *Angling in British Art* (1923).

—— *A Book for Sporting Painters* (1931).

ANIMAL PAINTERS

Animal Painting. Catalogue of an exhibition given at The Queen's Gallery, Buckingham Palace; with an introduction (1966-7).

ARMSTRONG, Sir Walter. *Briton Riviere, R.A.* (1891)

BURY, Adrian. *Joseph Crawhall: the Man and the Artist* (1958).

GILBEY, Sir Walter. *Animal Painters of England;* 3 vols. (1900-1911).

GRAVES, Algernon. *Sir Edwin Landseer* (1876).

GRUNDY, C. R. *James Ward: His Life and Works* (1909).

(Huggins, William, of Liverpool). Catalogue of an exhibition given by Oscar and Peter Johnson Ltd.; with an introduction by C.P. (1966).

(Landseer, Sir Edwin). Catalogue of an exhibition given by the Royal Academy; with an introduction by John Woodward (1961).

MANSON, James Alexander. *Sir Edwin Landseer, R.A.* (1902)

MARKS, Henry Stacy. *Pen and Pencil Sketches;* 2 vols. (1894).

MOORE, Anne Carroll. *The Art of Beatrix Potter* (1955).

NOAKES, Aubrey. *The World of Henry Alken* (1952).

(Potter, Beatrix). Catalogue of an exhibition given by the National Book League; with an introduction by L. Linder (1966).

STEPHENS, Frederic George. *Memoirs of Sir E. Landseer* (1874).

PAINTERS ABROAD

BALLANTINE, James. *The Life of David Roberts, R.A.* (Edinburgh, 1866).

BERRY-HILL, Henry and Sidney. *George Chinnery, 1774-1852, Artist of the China Coast* (1963).

(Chinnery, George). Catalogue of an exhibition given by the Arts Council; with an introduction by Allan Carr (1957).

(Chinnery, George). *Jardine, Matheson Company: an historical sketch* (1960).

DAVIDSON. Angus. *Edward Lear* (1938); reprinted 1968.

EMANUEL, Frank L. *William Callow;* Walker's Quarterly, 22 (1926).

EYRE-TODD, George (ed). *The Autobiography of William Simpson R.I.* (1903).

GOODALL. Frederick. *Reminiscences* (1902). (1902).

HOFER, Philip, *Edward Lear as a Landscape Draughtsman* (Harvard, 1967).

LEAR, Edward. *Views in Rome and its Environs (1841).*

—— *Illustrated Excursions in Italy;* 2 vols (1846).

—— *Journal of a Landscape Painter in Albania and Illyria* (1851).

—— *Journal of a Landscape Painter in Southern Calabria* (18??).

—— *Views in the Seven Ionian Islands* (1863).

—— *Journal of a Landscape Painter in Corsica* (1870).

(Lear, Edward). Catalogue of an exhibition at the Arts Council; with an introduction by Brian Reade (1958).

MARTYN, Sheila. *Alfred Stevens;* an article in 'Arts Review' (23.12.67).

(Phillip, John R.A.). Catalogue of an exhibition given by the Aberdeen Art Gallery; with an introduction by Charles Carter (1967).

QUIGLEY, Jane. *David Roberts as a Water-Colour Painter;* Walker's Quarterly, to (1922).

(Roberts, David and Stanfield, Clarkson). Catalogue of an exhibition of Paintings, Drawings and Relics, given at the Guildhall Art Gallery; with an introduction by J. L. Howgego (1967).

STANNUS, Hugh. *Alfred Stevens and His Work* (1891).

STOKES, Hugh. *James Holland;* Walker's Quarterly, 23 (1927).

—— *John Frederick Lewis;* Walker's Quarterly. 27 (1929).

TOWNDROW, Kenneth Romney. *Alfred Stevens;* a publication of The Walker Art Gallery (Liverpool, 1951).

—— *The Works of Alfred Stevens Sculptor, Painter. Designer in the Tate Gallery (1950).*

—— *Alfred Stevens: a Biography with New Material* (1939).

GENRE PAINTERS

BAYNE, William. *Sir David Wilkie* (1903).

COPE, Charles Henry. *Reminiscences of Charles West Cope, R.A.* (1891).

GOWER, Lord Ronald Sutherland. *Sir David Wilkie* (1902).

LESLIE, C. R. *Autobiographical recollections of the Life of C. R. Leslie;* ed. by Tom Taylor; 2 vols. (1860).

LISTER, Raymond. *Victorian Narrative Paintings* (1966).

MAAS, Jeremy. *The Prince of Wales's Wedding* [W. P. Frith] (1977)

(Mulready, William). Catalogue of an exhibition given by the City Art Gallery, Bristol; with an introduction by A.D.P.W. (no date).

Narrative Pictures. An illustrated handbook issued by the Guildhall Art Gallery (1953).

REDGRAVE, F. M. *Richard Redgrave: a memoir, compiled from his Diary* (1891).

REYNOLDS, Graham. *Painters of the Victorian Scene* (1953).

SITWELL, Sacheverell. *Conversation Pieces* (1936).

—— *Narrative Pictures* (1937).

STEPHENS, Frederic George. *Memorials of William Mulready* (1867).

(Wilkie, Sir David, R.A.). Catalogue of an exhibition given by the Royal Academy; with an introduction by John Woodward (1958).

THE PRE-RAPHAELITES

A full bibliography for the Pre-Raphaelite Movement would be beyond the scope of this survey. A few important publications, including some recently published, are listed below. The most comprehensive bibliography of the movement is:

FREDEMAN, William E. *Pre-Raphaelitism: a Bibliocritical Survey* (Harvard, 1965).

BATE, Percy H. *The English Pre-Raphaelite Painters: their Associates and Successors* (1899).

BELL, Malcolm, *Sir Edward Burne-Jones: a Record and Review* (1892).

(Brown, Ford Madox). Catalogue of an exhibition given by the Walker Art Gallery, Liverpool; with an introduction by Mary Bennett (1964).

(Burne-Jones, Sir Edward Coley). Catalogue of an exhibition given at Fulham Library; with an introduction by John Gordon-Christian (1967).

(Burne-Jones), Catalogue of an exhibition given by the Hayward Gallery, Southampton Art Gallery and Birmingham City Art Gallery; with an introduction by John Christian (1975-76).

BURNE-JONES, Georgiana. *Memorials of Edward Burne-Jones;* 2 vols. (1904).

FITZGERALD, Penelope. *Edward Burne-Jones* (1975).

HARRISON, Martin and WATERS, Bill. *Burne-Jones* (1973).

(Crane, Walter). *The Work of Walter Crane with notes by the artist;* extra number of 'The Art Journal' (1898).

FALK, Bernard. *Five Years Dead: a postscript to 'He laughed in Fleet Street';* with chapters on Simeon Solomon (1937).

GAUNT, William. *The Pre-Raphaelite Tragedy* (1942).

GRYLLS, Rosalie Glynn. *Portrait of Rossetti* (1964).

HENDERSON, Philip. *William Morris: his life, work and friends* (1967).

HUEFFER, Ford Madox. *Ford Madox Brown: a Record of His Life and Work* (1896).

—— *The Pre-Raphaelite Brotherhood: a Critical Monograph* (1907).

HUNT, William Holman. *Pre-Raphaelitism and the Pre-Raphaelite Brotherhood;* 2 vols. (1905).

(William Holman Hunt), Catalogue of an exhibition at the Walker Art Gallery, Liverpool and the Victoria and Albert Museum; with an introduction by Mary Bennett (1969).

IRONSIDE, Robin. *Pre-Raphaelite Painters,* with a descriptive catalogue by John Gere (1948).

MARILLIER, Henry Currie. *Dante Gabriel Rossetti: an illustrated Memorial of His Art and Life* (1899).

(Millais, Sir John Everett). Catalogue of an exhibition given by the Walker Art Gallery,

Liverpool, and the Royal Academy; with an introduction by Mary Bennett (1967).

MILLAIS. John Guille. *The Life and Letters of Sir John Everett-Millais*; 2 vols. (1899).

MILLS. Ernestine. *The Life and Letter of Frederic Shields* (1912).

PARRIS. Leslie. *The Pre-Raphaelites*; a Tate Gallery Publication (1966).

Präraffaeliten; catalogue of an exhibition at the Staatliche Kunsthalle Baden-Baden; with introduction by John Christian (1974).

The Pre-Raphaelite Era 1848-1914: catalogue of an exhibition at the Delaware Art Museum (1976).

ROSSETTI. William Michael. *Some Reminiscences*; 2 vols. (New York, 1906).

—— *Dante Gabriel Rossetti: His Family Letters, with a Memoir*; ed. by Willaim M. Rossetti (1895).

(Dante Gabriel Rossetti: Painter and Poet). Catalogue of an exhibition at the Royal Academy; with an introduction by John Gere (1973).

(Frederick Sandys 1829-1904). Catalogue of an exhibition at the Brighton Museum and Art Gallery and the Mappin Art Gallery, Sheffield, with introductions by Raymond Watkinson and Anthony Crane (1974).

STALEY. Allen. *The Pre-Raphaelite Landscape* (1973).

SURTEES. Virginia. *The Paintings and Drawings of Dante Gabriel Rossetti (1828-1882): A Catalogue Raisonné*; 2 vols. (1971).

WOOD. Esther. *A Consideration of the Art of Frederick Sandys* (1896).

FAIRY PAINTERS

ALLDERIDGE. Patricia. *The Late Richard Dadd, 1817-1886* (1974).

BRIGGS. K. M. *The Fairies in tradition and literature* (1967).

BROWNLOW. C. A. L. *1848-1948: The Spirit Ladder of a Hundred Years*; a lecture delivered to the London Spiritualist Alliance (1948).

CARSTAIRS. Morris. *The Madness of Art*; an article in 'The Observer Magazine' 12.6.66.

Dream and Fantasy in English Painting, 1830-1910. Catalogue of an exhibition given by Anthony d'Offay; with an introduction by Paul Grinke (1967).

HAMBURG: Daria. *Richard Doyle* (1948).

RICKETT. John. *Rd. Dadd, Bethlem and Broadmoor*; an article in 'The Ivory Hammer', II (1964).

Victorian Fairy Paintings: catalogue of an exhibition at the Maas Gallery (1978).

NUDES AND STILL-LIFE

FARR. Dennis. *William Etty* (1958).

GILCHRIST. Alexander. *Life of William Etty, R.A.*; 2 vols. (1855).

(Hunt. William Henry). Catalogue of an exhibition of water-colours and drawings from the collection of Mrs Cyril Fry given at the Maas Gallery; with an introduction by Cyril Fry (1967).

MAAS. Jeremy. *Victorian Nudes*, chapter in *The Saturday Book*, (1971).

The Nude in Victorian Art. Catalogue of an exhibition given by the City Art Gallery, Harrogate; with an introduction by Jennifer Stead (1966).

STEEN. Marguerite. *Willaim Nicholson* (1943).

NEO-CLASSICAL

(Sir Lawrence Alma-Tadema), Catalogue of an exhibition given by the Royal Academy (1913).

(Sir Lawrence Alma-Tadema), Catalogue of an exhibition given by the Sheffield City Art Galleries and Laing Art Gallery, Newcastle; with an introduction by Anne L. Goodchild (1976).

AMAYA, Mario: *The Painter who Inspired Hollywood* [Alma-Tadema]; an article in 'The Sunday Times Magazine' 18.2.68.

BALDRY, A.L. *Albert Moore: his Life and Works* (1894).

BARRINGTON, Mrs Russell. *The Life, Letters and Work of Frederic Leighton*; 2 vols. (1906).

CRANE, Anthony. *My Grandfather, Walter Crane*; a reprint of a lecture delivered on October 3, 1956; *in* The Yale University Library, Vol. XXXI, no. 3 (1957).

GAUNT, William. *Victorian Olympus* (1952).

MONKHOUSE, Cosmo. *Sir E. J. Poynter, Bt., P.R.A.* (1897).

ORMOND, Leonée and Richard. *Lord Leighton* (1975).

RHYS, Ernest. *Sir Frederic Leighton, Bart., P.R.A.: an illustrated Chronicle*; with prefatory essay by F. G. Stephens (1895).

STANDING, Percy Cross. *Sir Lawrence Alma-Tadema, O.M., R.A.* (1905).

STIRLING, A. M. W. *The Richmond Papers* (1926).

SWANSON, Vern G. *Sir Lawrence Alma-Tadema* (1977).

Victorian Olympians: catalogue of an exhibition at the Art Galleries of New South Wales, Victoria and South Australia, with an introduction by Renée Free (1975).

PHOTOGRAPHY

CARROLL, Lewis. *Diaries*; ed. R. L. Green (1953).

Creative Photography 1826 to the present. Catalogue of an exhibition of the Gernsheim Collection, given at Detroit; with an introduction by Helmut and Alison Gernsheim (1963).

GERNSHEIM, Helmut. *A Concise History of Photography* (1965).

—— *Lewis Carroll: Photographer* (1949).

—— *Julia Margaret Cameron* (1948).

—— *L. J. M. Daguerre* (1956).

—— *Queen Victoria* (1959).

—— *Roger Fenton, Photographer of the Crimean War* (1954).

—— *Creative Photography: aesthetic trends 1839-1960* (1962).

Journal of the Royal Photographic Society (from 1853).

McKENDRY, John *Four Victorian Photographers* (New York, 1967).

MARTIN, Paul. *Victorian Snapshots* (1939).

NEWHALL, Beaumont. *History of Photography: from 1839 to the Present Day* (1964).

POTTER, Beatrix. *Journal*; transcribed from her writings by Leslie Linder (1966).

SCHARF, Aaron. *Creative Photography* (1965).

—— *Painting, Photography, and the Image of Movement*; article in Burlington Magazine (May 1962).

—— *Art and Photography* (1968).

STRASSER, Alex. *Victorian Photography* (1942).

PORTRAITS

British Historical Portraits: a selection from the National Portrait Gallery; with biographical notes (Cambridge, 1957).

LAVERY, John. *The Life of a Painter* (1904).

ORMOND, Richard. *John Singer Sargent* (1970).

ORMOND, Richard. *Early Victorian Portraits*; 2 vols. (1973).

PIPER, David. *The English Face* (1957).

POLLOCK, Walter H. *The Hon. John Collier* (1914).

REYNOLDS, A. M. *The Life and Work of Frank Holl, R.A.* (1912).

(Sargent. John Singer, and James McNeill Whistler). Catalogue of an exhibition given by the Art Institute of Chicago and the Metropolitan Museum of Art; with an introduction by Frederick A. Sweet (1954).

(Sargent. John Singer, R.A.). Catalogue of an exhibition given by the City of Birmingham Museum and Art Gallery; with an introduction by Richard Ormond (1964).

(Watts, George Frederick). *see Historical Painters*.

LATER LANDSCAPE AND GENRE

BALDRY: A. L. *Henry Holiday*; Walker's Quarterly, 31-32 (1930).

BALDRY, A. L. *Marcus Stone, R.A.* (1896).

BIRCH, Mrs. Lionel. *Stanhope A. Forbes, A.R.A., and Elizabeth Stanhope Forbes, A.R.W.S.* (1906).

BROWSE, Lillian. *Sickert* (1960).

BUTLER, Elizabeth. *An Autobiography* (1923).

(Conder, Charles). Catalogue of an exhibition given by the Graves Art Gallery, Sheffield; with an introduction by David Rodgers (1967).

The Early Years of the New English Art Club. Catalogue of an exhibition given by the Fine Art Society; with an introduction by Bevis Hillier (1968).

EWART, Henry C. (ed.) *Toilers in Art*, with essays on John Tenniel, Frederic Shields, Frederick Walker, George Pinwell, Thomas Faed, etc. (after 1888).

FEA. Allan. *J. Seymour Lucas, R.A.* (1908).

FILDES, L. V. *Luke Fildes, R.A., a Victorian Painter* (1968).

GAUNT, William. *The Aesthetic Adventure* (1945).

GIBSON, Frank. *Condor: his Life and Work* (1914).

GRAY, Hilda Orchardson. *The Life of Sir William Quiller Orchardson, R.A.* (1930).

(Grimshaw, Atkinson). Catalogue of an exhibition given at the Ferrers Gallery (1970).

E. B. G. *Charles Shannon* (1924).

HARDIE, Martin. *John Pettie, R.A.* (1908).

HERKOMER, Sir Hubert von. *The Herkomers*. 2 vols. (1910-11).

HORSLEY, J. G. *Recollections of a Royal Academician*, ed. by Mrs. Edmund Phelps (1930).

HUISH, Marcus B. *Birket Foster: his Life and Work* (1890).

IRONSIDE, Robin, *Wilson Steer* (1943).

JACKSON, Holbrook. *The Eighteen-Nineties* (1913).

LAIDLAY, W.J. *The Origin and First Two Years of the New English Art Club* (1907).

LAVER, James. *Whistler* (1930).

—— *Vulgar Society: the Romantic Career of James Tissot* (1936).

LAVERY, Sir John. *The Life of a Painter* (1940).

LUSK, Lewis. *B. W. Leader, R.A.* (1901).

MARKS, J.G. *The Life and Letters of Frederick Walker* (1896).

MILLS, J. Saxon. *Life and letters of Sir Hubert Herkomer, C.V.O., R.A.* (1923).

MOORE, T. Sturge. *Charles Ricketts, R.A.* (1933).

(Nicholson, Sir William). Catalogue of an exhibition given by Marlborough Fine Art Ltd; with an introduction by Alan Bowness (1967).

PHILLIPS, Olga Somech. *Solomon J. Solomon: A Memoir of Peace and War* (n.d.).

(Ricketts, Charles, R.A.). Self-Portrait taken from the Letters and Journals of Charles Ricketts, R.A.; collected and compiled by T. Sturge Moore, editred by Cecil Lewis (1939).

ROBERTSON, W. Graham. *Time Was* (1931).

ROTHENSTEIN, Sir John. *The Life and Death of Conder* (1938).

ROTHENSTEIN, William. *Men and Memories: recollections*; 2 vols. (1931-2)

R. P. *Sir William Orpen* (1923).

SCHMUTZLER, Robert. *Art Nouveau* (1964).

SICKERT, W. R. *Bastien Lepage: Modern Realism in Painting* (1892).

SINCLAIR, Archdeacon. *Joseph Farquarson, R.A.* (1912).

SKETCHLEY, R. E. D. *J. W. Waterhouse, R.A.* (1909).

SPEAIGHT, Robert. *William Rothenstein: the Portrait of an Artist in his Time* (1962).

(Steer, P. Wilson). Catalogue of an exhibition given by the Arts Council; with an introduction by Andrew Forge (1960).

STOREY, G. A. *Sketches from Memory* (1899).

SUTTON. Denys. *James McNeill Whistler* (1966).

THOMSON, D. Croal. *Sir Luke Fildes, R.A.* (1895).

(Tissot, James [Jacques-Joseph]). Catalogue of a Retrospective Exhibition given at the Museum of Art, Rhode Island School of Design, Providence, and The Art Gallery of Ontario, Toronto; with an introductory essay by Henri Zermer (1968).

WHISTLER, James McNeill. *'Ten o'clock'* lecture, delivered 1885 (1888).

(Whistler, James McNeill). Catalogue of an exhibition jointly given by the Arts Council and Knoedler Galleries. New York; with an introduction by Andrew MacClaren Young (1960).

WILLIAMSON. George Charles. *Charles J. Pinwell and his Works* (1900).

INDEX

EDWARD
LEAR.

LORD LEIGHTON
OF STRETTON, P.R.A.

CHARLES ROBERT
LESLIE, R.A.

JOHN FREDERICK
LEWIS, R.A.

DANIEL
MACLISE, R.A.

HENRY STACY
MARKS, R.A.

SIR JOHN EVERETT
MILLAIS, Bt., P.R.A.

ALBERT JOSEPH
MOORE.

SIR WILLIAM QUILLER
ORCHARDSON, R.A.

SAMUEL
PALMER.

SIR JOSEPH NOËL
PATON.

JOHN
PHILLIP, R.A.

SIR EDWARD JOHN
POYNTER, Bt., P.R.A.

RICHARD
REDGRAVE, R.A.

SIR WILLIAM BLAKE
RICHMOND, R.A.